Design@Yourself Newsletters

686.2252 G795n

Copyright © 2002 by Chuck Green

All rights reserved. No part of this book may be reproduced in any form without written permission of the copyright owner. The author and publisher have used their best efforts in preparing this book and the instructions contained herein. However, the author and publisher make no warranties of any kind, express or implied, with regard to the documentation contained in this book, and specifically disclaim, without limitation, any implied warranties of merchantability and fitness for a particular purpose. In no event shall the author or publisher be responsible or liable for any loss of profit or any other commercial damages, including but not limited to special incidental, consequential, or any other damages, in connection with or arising out of furnishing, performance, or use of this book.

Copyrights on individual photographic and clip art images reproduced in this book are retained by their respective owners.

PANTONE® and other Pantone, Inc., trademarks are the property of Pantone, Inc.

First published in the United States of America by:
Rockport Publishers, Inc.
33 Commercial Street
Gloucester, Massachusetts 01930-5089
Telephone: 978 282 9590
Facsimile: 978 283 2742
www.rockpub.com

ISBN 1-56496-767-0

10987654321

Design: Chuck Green

Printed in Hong Kong

ACKNOWLEDGMENTS

A newsletter designer is a composer and arranger. We take the words, photographs, artwork, and typefaces created by others and assemble them into something that we hope is worthy of their efforts. To all those who contributed, I thank you.

Thanks, too, to the folks at Rockport Publishers for allowing me the creative freedom to take their vision for the Design-it-Yourself series and make it my own. I am especially grateful to Publisher Winnie Prentiss, Managing Editor Jen Hornsby, Acquisitions Editor Kristin Ellison, and Copy Editors Don Fluckinger and Sarah Sacks Dunn.

Finally, thanks to my wife, Leslie, and sons, Jeffrey and Robert, for supplying the support and energy that have allowed me to weave another small thread into the ever-growing fabric of ideas.

Design®Yourself Newsletters

A Step-by-Step Guide CHUCK GREEN

Contents

PART 1

Learn the steps necessary to research, design, and produce a newsletter. Part 1 includes everything from defining your goals to checking the final printed pieces.

Introduction				
PART	1	Step-by-Step Design	8	
Step	1	Establish Your Mission	10	
Step	2	Do Some Research	12	
Step	3	Create a Plan	16	
Step	4	Choose a Format	18	
Step	5	Choose a Style	20	
Step	6	Define the Steps and Stages	22	
Step	7	Choose Your Tools	26	
Step	8	Create a Name, a Defining Phrase, and a Nameplate	28	
Step	9	Compose the Content	30	
Step	10	Illustrate the Message	34	
Step	11	Assemble the Pieces	36	
Step	12	Find a Printer	40	
Step	13	Prepare, Print, and Proof It	44	
Step	14	Mail It	48	

PART 2	Design Recipes	50
How to U	Jse the Recipes	52
Style 1	Ad Banner (6 pages)	54
Style 2	Bulletin (4 pages)	62
Style 3	Elements (16 pages)	70
Style 4	Icons (12 pages)	78
Style 5	Jacket (16 pages)	86
Style 6	Lines (12 pages)	94
Style 7	Newspaper (2 pages)	102
Style 8	Objects (16 pages)	110
Style 9	Postcard (2 pages)	118
Style 10	Squared (8 pages)	126
Style 11	Tabs (8 pages)	134
Style 12	Tall (20 pages)	142
Style 13	Wing (4 pages)	150
Glossary		158
Index		160

PART 2

Create a design using any of thirteen Design Recipes. Each includes in-depth, detailed information about designing a newsletter using different styles, typefaces, illustration techniques, and color schemes. INTRODUCTION

This is not a design theory book— it is a design instruction book.

A design theory book examines abstract concepts such as contrast, symmetry, and white space, under the assumption that if you learn to think the thoughts of a designer, you will become a designer.

I'm not sure it's that easy. In my opinion, the capacity to visualize and compose is influenced by more than theory. It involves a mix of natural talent and experience; I doubt many of us could get the desired result simply by understanding a premise.

I propose an entirely different approach—to demonstrate how one designer does it.

You and I will tackle a real project from the initial idea to the final printed piece and I'm going to tell you how I handle each detail, every step of the way.

Think of it as a cookbook. Instead of discussing the history of the stove and the intricacies of milling flour, I'm going to show you how to bake a cake. And if I've done my job well, following one of my design recipes will result in a newsletter that looks and communicates as if it were designed by a pro.

Who this book is for

The Design-it-Yourself series is written for both designers and non-designers, in layman's language. It endeavors to include all the information necessary to produce real-world, professional-quality results. All people, of course, are designers in the sense that they make artistic judgments about everything from the clothes they wear to the way they decorate the rooms in which they live. By "non-designer," I simply mean those who don't make their living at it.

But even chefs use cookbooks. I hope even an experienced designer will profit from seeing how another designer navigates familiar territory. I'm a much better designer for having studied my colleagues' work—their justifications for making subtle choices, the tips and tricks they use in everyday production, and the resources they tap for the details they don't handle in house.

How to use it

The book is divided into two parts. *Part 1: Step-By-Step Design* (beginning on page 8) covers the steps necessary to research, design, and produce a newsletter. I discuss how to establish your mission, define your audience, develop content, and choose the right tools and the most effective resources. It includes lots of different layout ideas—some you may not have considered. I'll even help you find a commercial printer and choose the right paper on which to print your newsletter.

I suggest you read Part 1 start to finish before beginning your project, then use the checklists included with each step as a guide. The checklists summarize the key points and are coded to the text so you can easily review the details as necessary.

Part 2 (beginning on page 50) features thirteen Design Recipes, each including in-depth, detailed information about designing a newsletter using different styles, typefaces, illustration techniques, and color schemes. Each recipe includes page layouts and dimensions, typeface names and sizes, specific color suggestions, even the sources of graphics and photography. And, because they are created specifically for the Design-it-Yourself series, you are free to copy any recipe in whole or in part to create your own materials.

What you need

This book is not about a particular software program and does not require a specific computer system—Mac or PC. Most of the projects are easiest to produce using a desktop publishing program such as QuarkXPress, Adobe InDesign, Adobe PageMaker, or Microsoft Publisher. The other software you will

need depends on the recipe you choose to follow. Some of the newsletters incorporate elements that require a drawing program such as Adobe Illustrator, Macromedia FreeHand, or CorelDRAW; or an image editing program such as Adobe Photoshop or Jasc Software's Paint Shop Pro. Program suggestions are listed throughout.

Continue the discussion at www.designiy.com

Want to share your side of the experience? I've established a place for you and other readers to share your insights and experiences about the Design-it-Yourself series—www.designiy.com. In addition to posting selected comments from readers, I'll keep you current on the latest resources and upcoming titles.

This is just the beginning of what is possible. As more and more of us learn to master today's powerful design-oriented software programs, the appreciation of good design, based on honest marketing principles, will increase dramatically. I hope, in some small way, what you find here furthers that outcome.

Chuck Green chuckgreen@designiy.com

PART 1 Step-by-Step Design

Establish Your Mission

"Newsletter" is an ambiguous term. The words "news" and "letter" point to its origins but no longer adequately describe the scope or potential of today's hybrid publications. Contemporary newsletters serve many functions and take many forms.

For the purposes of this book, a newsletter is defined as a condensed periodical used to communicate specialized editorial information. "Condensed" means it is shorter than the average newspaper or magazine and provides lots of information in limited space. "Periodical" means it is published regularly. "Specialized" means it focuses not on a broad subject area such as finance, but on a subject-within-a-subject, such as real estate finance—not on organizations in general, but a specific organization.

"Editorial information" means articles as opposed to purely marketingoriented content. The difference between a newsletter and a brochure, for example, is that a newsletter includes information of value to the reader whether they buy your idea, product, service, or not.

That definition is where the similarity between newsletters ends—or at least it should. The best newsletters develop their own personalities through the way they talk, the way they look, and the unique mix of reader-oriented benefits they offer. They instruct, entertain, solve problems, offer useful opinions and insights, recommend resources, inspire action, and are a reliable source. You might even consider the best of them a respected colleague or friend in fixed form.

Publishing an effective newsletter is not an easy job. Even in its simplest form, it requires a significant commitment: a clearly defined goal, a thorough understanding of your reader, a meticulous plan, and the skills and resources necessary to execute it. Anything less could end up doing your product, your service, or your cause more harm than good.

considerable journey is to *choose a destination*. Where are you heading? What's your goal in publishing your newsletter? There are some obvious destinations: to sell a product or service, to promote a cause, to develop your client base or membership, or perhaps even to develop a group of people who are willing to pay for your information.

There are also some important provisos. First, be sure your goal requires a long-term relationship. There is little sense in using a newsletter to sell products or services that constitute a one-time purchase. Think of a newsletter as a friendship instead of a one-time meeting.

Second, before you begin, be sure that you have the will to persevere. If your business makes it difficult to meet deadlines, if you're not sure you will have the time, or you can't depend on others to help, a less ambitious vehicle might be more realistic.

Next, be sure your publication's subject matter is important to your prospective subscriber. Excellent content and expert execution will not interest an uninterested reader. Your topic must be significant in their eyes.

Finally, be sure you're in shape for the journey. A sedentary person who attempts a marathon without the necessary training is going to encounter great pain. Publishing a monthly eightpage newsletter without adequate resources, skills, and stamina exacts a cost.

you choose a model. There are three basic types: If your mission is to market your product, service, or ideas, the vehicle is a promotional newsletter. The reader benefit of a promotional newsletter is that it educates them about a certain area of interest and provides solutions, some of which come in the form of your products, services, or your way of thinking.

If the mission is to build rapport with your audience, the answer is a *relationship newsletter*. Its benefit is to inform the reader about a group to which they belong or might consider joining. It promotes the group's shared philosophy, a

calendar of events, notices of meetings, individual and group milestones, member profiles, and so on.

If you want to sell information for profit, the vehicle is an *expert newsletter*. What makes an expert letter different from its counterparts is that it is sold for a profit. The benefits are far more clearcut—information, statistics, advice, and instruction—for the price of a subscription.

There are, of course, no absolutes in the newsletter-publishing world; your newsletter may well include components of all three.

measure your success. How will you know your newsletter is building toward success or that it has arrived—from your point of view and from the reader's? Be specific, writing from the reader's perspective, instead of setting a blanket goal such as educating clients about your manufacturing process. Incorporate a means to prove they are learning. From your perspective, instead of projecting a goal of increasing sales, set a goal to increase out-of-state orders by ten percent.

Step 1: MISSION CHECKLIST

1.1 Choose a destination

1.2 Choose a model

1.3 Define how you will measure success

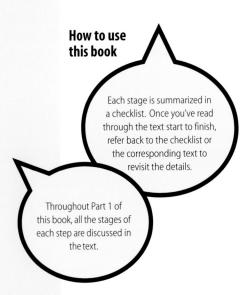

Do Some Research

If you don't have the time or budget to do some research, you don't have the time or budget to create a newsletter. To compete effectively, you need to know as much as possible about your competition, your supporters, and the field of play.

your competition—organizations in the same business—especially those reaching a similar audience with a newsletter. Don't make the mistake of assuming your idea is so unique that no one else could possibly be doing the same thing. Discovering a significant competitor late in the game can be costly.

SOURCE Illustrations:
Orange from Everyday
Objects 1 by CMCD,
Apple from Image Club
ArtRoom, Sketches On
The Town, 800-661-9410,
403-294-3195,
www.eyewire.com.
© Eyewire, Inc., all rights
reserved.

Search for rivals and find out as much as you can about them and their history. History is important because you may be able to avoid some of the mistakes they have made. And don't limit yourself to local competitors. Even if you operate in just one region of the country, check out what others are doing elsewhere. Studying how stiff competition alters a market in another area may offer insights for leapfrogging competition locally.

tors' marketing materials. This oncedaunting task is easier now that so many organizations have sites on the World Wide Web. There is a huge amount of extraordinarily valuable competitive information available—you have only to use an online search engine. Some organizations even provide conventional newsletter issues or issue samples in a form you can download and print. Read everything you can get your hands on to see how competitors attempt to move their audience to action.

research involves creating a reader profile: identifying and outlining who you think will read and support your publication.

Do it in the form of a list of attributes that classifies the readers you already have and those you hope to attract. Following are some of the possible characteristics from which to choose your demographics.

Personal characteristics classify readers by gender, age, marital status, and style preferences for everything from the type of clothing they wear to the colors they prefer.

Financial status might include income, spending habits, specific dollar amounts spent on particular products and services, and so on.

Professional and personal affiliations such as employment status, memberships, and formal and informal associations with business and private groups may prove valuable.

In some cases the *location* of where the reader lives or works is significant.

Special interests such as preferences in entertainment or dining, the reader's health status, hobbies, and the like are pivotal in defining interest.

An accurate reader profile can lead you to other prospects. If, for example, you find that a significant number of your readers are volleyball players, you might construe that people who play volleyball are good prospects. Making assumptions, of course, entails risk. Before you acquire a list of 5,000 volleyball players, test a representative sample to exercise your theory.

Don't hesitate to survey prospects directly—done right, asking their opinion can be the highest form of flattery. It telegraphs you value their opinion and appreciate the fact that they have a perspective you and your organization do not.

2.4 With a basic picture of who the reader is, you need to *identify the* degree of reader interest.

Just because, for example, you purchase a palette of cardboard boxes from a local supplier does not necessarily make you a prospect for a box-industry newsletter. You might have a passing interest in saving money on box purchases or box recycling, but chances are you won't devote thirty minutes a month reading about it.

Be realistic—is your subject one that lends itself to newsletter-length information and frequency? Could you realistically create interest with a first-class publication? If the answer is not a resounding yes, your dollars may be better spent with a periodic direct-mail letter campaign, a series of informational fliers, or a benefits-oriented brochure.

You might also consider motives for why readers might lend their support. Do they have a significant interest in the subject and/or a compelling reason to read about it? Do they stand to save significant time, money, or energy by consuming the information in your newsletter? Will they gain some other important benefit? Are they likely to take the prescribed actions?

2.5 Once you understand who your prospects are, you can begin to research sources of names. The importance of access to lists of qualified and prospective readers cannot be overstated. It alone does not ensure success, but the absence of such sources guarantees failure.

Your first most obvious source is your house list—your existing list of members, clients, customers, prospects, inquiries, visitors, e-mail contacts, colleagues, and so on. You might also arrange to buy or trade lists with a noncompeting organization that is in contact with the same audience. If you publish a newsletter for teachers, for example, you may arrange to swap lists with a teacher's organization.

Second, you can rent or buy lists of people or organizations that have purchased consumer or business products. There are many sources for such lists. Standard Rates and Data Service (SRDS), a well-respected provider of media rates and data to the advertising industry, publishes the Direct Marketing List Source, a source of more than 35,000 lists from 200-plus market classifications from air conditioning to welding. The company's publication (available in some libraries and at www.SRDS.com) details the organization and audience the list represents, reveals information such as ranges of the amounts they spent, the ratio of females to males, and the usage basics such as cost and who to contact for more information.

You can also rent or buy lists that are compiled from general sources such as the Yellow Pages, the names and addresses of people who live within a specific zip code, organizations that have some affiliation with the federal government, and so on. The key to building a list is to continually seek sources of names that match some characteristics of your reader profile.

If you intend to build a completely new audience, you'll need to do extensive research and develop a complete reader profile. If you are developing a full-fledged, paid-subscription publication, more formal research may be called for. Research conducted by a firm that

specializes in information gathering through direct mail questionnaires, telephone surveys, or focus groups may provide more reliable results.

your belt, you can go about collecting effective examples of newsletters published by other organizations. Search for ideas at all levels—content, design, layout configuration, color, paper, type, illustrations, and so on. Not just in your field but any material that catches your eye. Collect enough of them and you will begin to discover similarities—compelling content, unusual benefits, the typefaces you find most attractive, the page layouts that look most professional, the colors that attract you, and so on.

Another way to acquire samples is to use Adobe's PDF Search Web at http://searchpdf.adobe.com. It allows you to type in a search term such as "newsletter" along with a word or phrase that describes your area of interest and locate Adobe Acrobat Portable Document Format (PDF) files of newsletters from all over the Web. You can then view and print them using the free-of-charge Adobe Acrobat Reader.

2.7 Your final research objective is to gather mailing information and expertise. Why address the final step of newsletter publishing at such an early stage? Because mailing regulations can significantly affect a newsletter's content, design, weight, and so on.

Mailing preparation and postage can command a significant percentage of your budget. To qualify for U.S. Postal Service's periodical postage rates, for example, regulations governing such things as publication frequency, continuity, purpose, and content must be understood and followed. If you were to save ten cents per piece on 750 pieces mailed once a month, you'd save \$4,500 over a five-year period, a handsome return for a few hours of legwork.

For complete overview of designing and mailing periodicals, start by reviewing the "Eligibility" section of the "Domestic Mail Manual" (DMM) at the USPS Postal Explorer at http://pe.usps.gov/, or visit your local post office. Then consult a mailing services expert—you'll find them listed in the Yellow Pages under "mailing services." For more about the process, see Step 14: Mail It, page 48.

Do not leave research for later. After launching a newsletter, finding out about a significant competitor, realizing that your readers are not sufficiently interested, learning that a list you assumed was available isn't, or concluding that the cost of renting a particular list puts it beyond reach can all be showstoppers. Immerse yourself in the details of getting to know your competition, your readers, and the process—the more you know, the more confident you will be about the content you create and the development process.

Step 2: RESEARCH CHECKLIST

2.1	Identify your competition
2.2	Collect your competitors' marketing materials
2.3	Create a reader profile
2.4	Identify the degree of reader interest
2.5	Research sources of names
2.6	Collect effective newsletter example:
2.7	Gather mailing information and expertise

Create a Plan

Every successful product, service, or idea does one of two things for its consumer— it provides pleasure or eases pain—and some do both. That simple proposition is known as a customer benefit. Explaining and communicating it is what marketing is all about.

The problem is, millions, perhaps billions of marketing dollars are wasted each year disguising those benefits with witty advertising headlines, vague analogies, and ambiguous images. They are hidden among lists of features and data and concealed within descriptions of an organization's history, employees, and systems.

To create a successful newsletter, or for that matter, a successful *anything*, you must uncover, express, and communicate those benefits. Think in big-picture terms. Throw out your preconceptions about newsletters and how they are typically used, and focus on creating a hybrid publication that speaks to your unique circumstance. See *Jolt Your Thinking*, on the next page.

3.1 Start by *creating a list of the customer benefits* in order of their importance. For example, the top three benefits a hypothetical retailer offers its customers might be:a lowest-price guarantee, the area's largest equipment selection, and support and service for what they sell twenty-four hours a day, seven days a week.

The benefits a professional organization offers its members might be: opportunities to network with colleagues, access to local and national industry information, and links to unusual or unexpected resources.

For supporters of a charitable organization: a venue for solving a specific problem, a place of service, and an opportunity to become educated about associated issues.

For users of a particular software program: a vehicle for learning to use specific features, a forum for understanding advanced functions, and a place for getting a behind-the-scenes look at the software publisher.

Take time to articulate every benefit you can—an obscure, tenth-level advantage to a small group of prospects could result in an idea that entices a whole class of readers.

3.2 Next, translate benefits into articles. A newsletter, simply put, is a medium for providing benefits in the form of words and pictures. To build a foundation for your publication you have only to translate your list of benefits to the working elements of a newsletter. For example, a low-price guarantee might translate into a feature about equipment costs and financing. Local and national industry information translates to an insider column by a respected expert. A place of service could take the form of regular profiles of its volunteers. And an understanding of advanced software program functions might translate to an issue-by-issue focus on each primary software function.

a.3. This is also the time to develop a rough marketing plan to promote your newsletter. Ask and answer a few general questions: How will you market your newsletter? How will you distinguish it from its competition? What are the top venues for reaching prospective readers? What is the best way to demonstrate its benefits? What other ways can you use your newsletter and the reputation it develops to generate income?

In some cases, you should consider enlisting sponsors and/or advertisers. Is there a noncompeting product, service, or cause that is interested in the same audience? If so, you can defray costs, perhaps even turn a profit by selling advertising space or enlisting ongoing sponsorship.

You'll find books about developing marketing plans on the shelves of any library. But if you are looking for an excellent, solid overview of commonsense marketing—get the most recent edition of the standard that started a marketing revolution: *Guerrilla Marketing: Secrets for*

Making Big Profits from Your Small Business, by Jay Levinson (Houghton Mifflin, 1998).

3.4 In the end, you must calculate the risks of any project. If good research, thorough analysis, careful planning, big budgets, and skillful execution guaranteed success, lofty manufacturers, service providers, and institutions would never fail. They, of course, can provide volumes of evidence attesting to the fact that even the best intentions and the most perfect execution can elude success. The planning, design, and publication of a successful newsletter, like anything else, requires an indefinable confluence of the right audience, information, design, timing, and talent. Don't let anyone tell you differently.

Jolt Your Thinking

When you travel a road over and over it develops a rut—a well-worn path of least resistance. The same is true with publishing and marketing. Jaded thinking envisions a newsletter as a certain size and shape with a certain type of content. Once you've created a few, it's easy to forget their true purpose and why and how they work. It's easier to simply repeat a formula.

Good designers and marketers avoid ruts—they carve new roads to different places. You do it with "jolt thinking"—thinking that questions the basic premise—the what, why, and how of doing something. It challenges you to examine your mission, strategy, and execution of a project by posing and answering three basic questions:

- 1. What is the purpose?
- 2. Why is it done the way it's done?
- 3. How can I do it more effectively?

Step 3: PLANNING CHECKLIST

3.1 Create a list of customer benefits
3.2 Translate benefits into articles
3.3 Develop a marketing plan
3.4 Calculate the risks

Choose a Format

The results of the first three steps—a well-conceived goal, informed understanding, and a clear plan—are the foundation of a newsletter. It's time to envision what you plan to build.

Based on the editorial model you chose in *Step 1.2: Choose a model,* page 11—a promotional newsletter, a relationship newsletter, or an expert newsletter—the next step is to *select a page configuration.*

The only limitation on the size, shape, and arrangement of your newsletter is your preconceptions.

The newsletter's namesake is news in letter form—typically 8.5 by 11 inches folded in half or in thirds as a self-mailer or to fit a conventional business envelope. If you need a bit more space you can use a standard legal sheet—8.5 by 14 inches. You can fit just as much information on a standard page in one-column letter form as you can in three columns.

Most of us probably picture a newsletter as a *booklet*—one or more 11 by 17 inch pages folded in half to 8.5 by 11 inches. Some other common booklet sizes are a 8.5 by 11 inches folded to 5.5 by 8.5 inches, and a tabloid booklet: a 17 by 22 inch sheet folded to 11 by 17 inches. Booklets, of course, often include more than four pages. You can add as many four-page signatures (the folded sheet) as are necessary and practical.

If you want the advantages of a newsletter with less preparation and cost, consider using a postcard format. See *Style 9: Postcard*, page 118. Using both sides of a 4.25 by 6 inch to 6 by 9 inch card will accommodate a surprising amount of information. Less content means less preparation.

Beyond letters, booklets, and post-cards there are plenty of ways to make your newsletter unique. Custom-folds are an easy way to organize and present your information in an out-of-the-ordinary way—Z-folds, M-folds, gatefolds, roll-folds, accordion-folds, and many others.

4.2 Although it's difficult to determine before you begin creating actual articles and illustrations, this is a good time to decide just how broad a range of information your publication will cover—to *plot the content*.

First, look at the scope in terms of the subject. How broadly will you cover the themes you are developing? Remember, a newsletter is "specialized," focusing on a subject-within-a-subject—instead of farming, aquatic farming.

At one extreme, a church newsletter, for example, might simply offer a calendar of events and a few paragraphs about programs and church business. At the other extreme is a comprehensive production that touches all aspects of church life, including articles by clergy, staff, and lay-leaders; contact information; a calendar; events information; missions focus; membership news; a financial report; letters to the editor; a Bible verse to cut out and put on the refrigerator; a list of recommended Web links; and so on.

Second, look at the scope in terms of the number of pages. Assuming you can fit roughly 500 to 800 words per page, consider how many pages you intend to fill and how many articles and other forms of content it will take to fill them. The simple church newsletter would likely fit on the front and back of a single sheet while the more comprehensive version could easily take eight or more pages.

Consider this—adding pages later on is a sign of success to your readers. Biting off more than you can chew at the beginning and having to cut back may be a letdown.

frequency of publication. The theory is simple: The more frequently you publish, the more visible you are to your audience. Every organization cannot, however, justify publishing a sixteen-page letter twice a month.

Do a commonsense analysis. Determine frequency on the basis of whether your publication is free or paid—most paid publications are published at least once a month. Another factor to consider is whether the information is time sensitive. Take into consideration how many other venues you have for maintaining interest in your theme, and how often readers will be receptive to paying attention.

Step 4: FORMAT CHECKLIST

4.1 Select a page configuration4.2 Plot the content4.3 Determine the frequency of publication

Choose a Style

Each of us develops two types of style: a style of thinking and a style of expression. Our style of thinking shows up in what we choose to talk about, the way we emphasize our points, our tone of voice, level of self-confidence, and so on. Our style of expression manifests itself in our choice of colors, the clothes we wear, the car we drive, the music we appreciate, and so forth. Everyone has it—an absence of overt style is a style in itself.

A publication exhibits the same sensibilities—the design is the expression and the words are the thinking. Why commit to a style? From the first moment they meet your organization, prospective customers begin to form an opinion of it. You can take a passive role by allowing them to form their own opinions, or you can use your style to influence it.

- your other marketing decisions, should be made from the customer's point of view. Review the research you gathered about who your prospective readers are, the benefits they seek, and what turns them on or off. Study what attracts them to other products they buy and other causes they embrace. Read the magazines they read, study their workplace, become acquainted with the relevant facts.
- on the differences between you and your competition. Stylistic clues are found everywhere in an organization's corporate environment, its advertising and marketing materials, the makeup of its workforce, its geographical location, the color scheme of its logo, the attitude of its management, and so on.
- your organization—don't try to make it something it is not. Sheep in wolves' clothing stand a good chance of being devoured.

Consider two examples. Organization one manufactures signs, has a gregarious owner, and works in a casual, upbeat environment. Its readers are typically young marketing professionals and the owners of small to medium-size businesses. Organization two works to prevent spousal abuse, has a Ph.D. serving as its director, and a very businesslike office environment. This organization's readers are associated with shelters, hospitals, and law enforcement.

The style of the newsletters they publish should be quite different. Organization one might choose a style that expresses its creative product—a casual voice, four-color printing using bold typefaces, bright colors, and whimsical illustrations. Organization two might speak in a more sober voice and present a frugal two-color format, with serif typefaces, clean photographs, and a realistic style of illustration.

- mind, you're ready to formally establish a voice. Sober and serious, casual and credible, or something in between—make it a conscious decision. In any case, speak like a person and not like a term paper. Initiate a conversation with your readers and develop a relationship. Speak to them one-on-one as you would in person, and they will come to consider your publication a message from a friend rather than a formal communication with an anonymous author.
- tions of design as there are designers. For the purposes of this book, design is defined as the process of arranging elements and information on a page in a way that improves its communication. How readable the text is and how well the artwork illustrates the ideas set forth is every bit as important as the overall look and feel of the page. Designers, in short, should be as concerned about function as they are about form.

The second part of this book, beginning on page 50, presents thirteen different design recipes from which to choose a layout style. You can combine styles, or you can choose part of a style you like and add your own touches. The designs were created specifically for the Design-it-Yourself series. You are free to copy any recipe in whole or in part to produce your own materials. The only restriction is that you cannot assume ownership of the copied design.

ing experts use negative or controversial messages under the guise of attracting the attention of a product's prospective buyers. Savvy communicators *build* on the positive. Why risk repelling a single person if you can achieve the same goal without offending anyone?

Step 5: STYLE CHECKLIST

5.1 Review the research
5.2 Play on the differences between you and your competition
5.3 Match the style to your organization
5.4 Establish a voice
5.5 Choose a layout style

5.6 Build on the positive

Define the Steps and Stages

With a basic format and style in mind, it's time to do a big-picture assessment of what it will take to produce your newsletter—how much it will cost, how long it will take, and how many people will be necessary to make it all happen.

Making that assessment now will help prevent surprises later.

Budgets, schedules, and workforces are interdependent—an ample budget, lots of help, and a lengthy schedule produces a different set of expectations than a thin budget, few hands, and a tight schedule. On pages 24 and 25, a production planning form shows basic tasks that need to be performed and space for specifying a person, a schedule, and a budget for each stage. The list is designed to flesh out potential problems. As you make your designations and estimates, you'll be forced to deal with many of the issues that will present themselves throughout the process.

Start with the categories you know the answers to. If, for example, you know you only have a certain number of dollars to commit to the project, start allocating those dollars to specific categories. If, on the other hand, you have a schedule limitation, begin to allocate a time for each process and see how those limitations increase the cost and the number of people necessary to complete the project.

Don't attempt to budget to the last hour and dime—make broad estimates on the first go-round, then fine-tune your answers as the project evolves.

6.1 Don't mistake the meaning of Design-it-Yourself. It does not mean you must wear all the hats in the design, editing, and production of your news letter. In fact, for a full-blown publication, expecting to produce all the parts singlehandedly is probably downright unrealistic. For that reason, it pays to take the time, early on, to clearly outline your role in the process. You might, for example, be willing to tackle the design and production of your newsletter but prefer to rely on others to provide the content. If that's the case, by all means enlist help. You may even go so far as to take the preliminary research and planning steps and hire others to complete the project using this book as a guide.

Use the "Who will do it?" column to identify your team. Pinpoint the role or roles you will play and the players necessary to complete the other tasks. For a simple newsletter in postcard form (see page 118), all the roles above could conceivably be accomplished by one person. A thirty-two-page monthly publication, on the other hand, could easily require a full-time staff of four or five.

There are eleven major roles to be played in the production of a typical newsletter. Don't confuse roles with job descriptions—different organizations might divide up the editor's role, for example, in different ways—editor, managing editor, editorial director, assistant editor, contributing editor, and so on. The descriptions below summarize general responsibilities.

The *publisher* is the sponsor. Publishers establish the purpose and goals of the publication, manage its financial and editorial course, and help other players make broad-ranging decisions.

The *editor* typically organizes and manages the action. Editors plan and dictate the type of content that goes into the publication, find the right people to do the right things, and make and manage assignments. Editors are into the big picture and small details. They read and edit content to ensure that it meets the objectives of the publication and matches the publication's personality.

The writer is a composer. Whether they are employed by the publisher or write on a freelance basis, writers are charged with researching and writing articles of a specific length on assigned subjects. They must understand the broad goals of the publication and translate each piece into a vehicle for pursuing them.

The designer's responsibility is to translate written information into the form that best communicates it to the reader. Designers use type, layout, and illustration like writers use words to dress the publication in a way that sends the appropriate signals to the reader—instilling confidence, exuding style, and communicating effectively.

The production artist takes the plans and builds the house. These computer graphics people place, scale, compose, move, format, and edit the elements into a cohesive layout, shepherd it through the proofing process, and prepare it for printing.

The *illustrator*—artist or photographer—creates the images that express ideas, realities, or style and mood in a way words cannot. These artists provide bold visual headlines and quiet aesthetic details that draw readers in and help them to absorb information on the fly.

The *legal expert* protects the enterprise. These people develop a model, file the forms, extract the permissions, and research and register the copyrights and trademarks that keep the publication from unwarranted legal exposure.

The *printer* is part engineer and part artist. Printing vendors endeavor to strike a balance between the publisher's budget, the editor's schedule, and the designer's vision. The printer's job is to take one copy and turn it into 10,000 with no discernible difference between copy 73 and copy 6,899.

The distributor controls the outcome. If a newsletter is destined for the wrong reader or delivered to the wrong address, the party's over. The distributor develops and manages the mailing list, prepares each piece for shipping, and troubleshoots delivery.

The *promoter* leads the cheers. Through advertising and public relations, promoters broadcast the benefits of the publication, its reputation, and authority to prospective readers and to forums that connect with prospective readers.

The administrator runs the mill. Administrators develop and maintain the physical systems, do the accounting, meet the professional needs of the players—in short, allow for everything else to happen.

on how complex your newsletter will be and how many people are involved. Use the "How long will it take?" column to rough out a schedule—not every minute and hour, but rough figures to help you assess whether you are headed toward a realistic goal. Your situation will vary based on what you are proposing, but here's a rough idea of the amount of time it might take to produce a typical page.

- 0.5 hour to plan the issue
- 2–5 hours to write the copy
 - 0.5 hour to edit the copy and layout
 - 1.5 hours to lay out the page, including positioning and formatting type, finding and placing illustrations, and arranging the elements to fit
- 10 working days for printing
- 2 days for mail preparation
- 5 working days for delivery

cost?" column to estimate costs. Rates for production talents and services vary widely. The fees of a technical writer for a high-end business publication and a contributor to a local charitable organization's newsletter are incongruent. Prices for printing in a suburban community are often significantly different from its urban counterpart. Suffice it to say, you'll need to do some homework here—to find out how much local vendors and potential contributors charge. Don't try to account for every nickel and dime, but do develop a realistic range of prices.

Production Planning Form

Task	Who will do it? (title/name)	How long will it take? (hours/days)	How much will it cost? (dollar amounts)
Editor			
Choose > Format			
Plan > Content mix			
Plan > Editorial calendar			
Develop > Content model			
Develop > Proofing process			
Develop/choose > Newsletter name			
Develop > Defining phrase			
Develop/manage > Schedule			
Make/manage > Assignments			
Manage > Vendor contracts, permissions forms, usage forms			
Edit > Content			
Content Developer			
Write > Original articles			
Acquire > Freelance articles			
Acquire > Stock articles			
Acquire > Previously published articles			
Create > Illustrations > Photographs			
Acquire > Stock/royalty-free photographs			
Create > Illustrations > Artwork			
Acquire > Stock/royalty-free artwork			
Proofread/correct > Content		π	
Designer			
Choose > Style (grid, layout, color, typefaces, illustrations)			
Create > Nameplate and initial design			
Make/manage > Ongoing design decisions			
Create > Advertisement designs			
Choose > Paper stock			
Production Artist			
Create > Page layout			,
Insert > Content			
Insert > Advertisements			
Proof/correct > Content			
24			

Production Planning Form

-āsk	Who will do it? (title/name)	How long will it take? (hours/days)	How much will it cost? (dollar amounts)
egal expert			
Create > Vendor contracts, forms for permissions, content proofing			
Register > Copyright, ISSN, mailing permit, nameplate trademark			
Create > Masthead content			
Review > Printing contract			
Evaluate > Insurance			
rinting Coordinator/Printer			
Search/choose > Printer			
Manage > Prepress document prep and preflighting			
Manage > Prepress proofing			
Manage > Printing			
Manage > Postpress proofing			
istributor			
Develop/manage > Mailing list			
Determine/manage > Postage			
Manage > Mailing (labeling, applying postage, folding, sealing, stuffing, delivery to mailer)			
Promoter	*		
Develop/manage > Promotion programs			
dministrator			
Budget > Miscellaneous costs (phone, deliveries, software/hardware, media)			
Process > Payments (freelancers, vendors, printer)			
Determine/manage > Subscriptions			
Determine/manage > Sponsorships			
Determine/manage > Advertising			
Other			

Choose Your Tools

In the early 1980s, the production of raw type and illustrations for a typical eight-page newsletter might have gone something like this: The text was typed on a typewriter and marked up for typesetting by a production artist. The marked up sheets of paper were sent across town to an art studio or printer equipped with a computerized typesetting machine and a skilled typesetter. The text was retyped into the system and formatted as the artist specified.

The typesetting might have taken six hours of typing and formatting at \$75 per hour. Headlines would have been set separately for \$4 a word on another typesetting machine called a Typositor. Photographic prints were sized and shot on a graphic arts camera using a special screen negative so the finished image reproduced on a printing press. At \$450 for the text, \$200 for headlines, and another \$200 for darkroom work, the materials for a single issue cost \$850—just materials, not writing, not editing, not design, not production, not printing.

Today, you no longer have to be a corporate powerhouse to publish a professional-quality newsletter. The software necessary to complete the entire process without leaving your chair costs less than that single issue those few short years ago. For the first time in history, the success of your enterprise is dictated more by the quality of your information than by the depth of your pockets. This fact has profoundly altered the very concept of publishing.

7.1 Your first investment should be in a desktop publishing (DTP) program. Most of the Design-it-Yourself projects are easiest to produce using a program such as Adobe InDesign, Adobe PageMaker, QuarkXPress, or Microsoft Publisher. They offer the ideal venue for combining the text you create in your word processor and the graphics you create with a draw or paint program into the files needed by a commercial printer.

There are significant differences between most desktop publishing programs and their word-processing counterparts. Most DTP programs are based on a pasteboard—pages sit on a background, onto which you can move text and graphics within reach until you need them.

On the page, you place, arrange, and manage multiple frames filled with text or graphics. Though word processing programs also support text boxes and the placement of graphics, they are typically used to create a string of pages—add a paragraph to page 2, and it affects page 5. When you format a page in a DTP program, each page can be laid out quite differently, and moving elements on one page does not automatically affect the others.

Plus, a DTP program has more precise, intuitive tools for formatting text, importing and manipulating graphics, applying and editing color, and producing output for a commercial printer.

newsletter, you'll need a drawing program. There are two basic categories of computer graphics—"draw," for creating line art, and "paint," for creating photographlike images. Draw graphics, also referred to as "vector" or "object-oriented," are created using objects such as lines, ovals, rectangles, and curves. The primary advantages of a draw file are that it can be sized very large or very small without losing print quality, and that draw file sizes are generally smaller than those of paint files.

Many clip art illustrations are created in draw formats. With a draw program such as Adobe Illustrator, Macromedia FreeHand, or CorelDRAW, you can use parts and pieces of clip art illustrations or create and edit your own. The most common draw file formats are Encapsulated PostScript (EPS) files and Windows Metafiles (WMF).

other paint illustrations you'll need a paint program. Paint images, also referred to as "raster" or "bit-mapped," are divided into a grid of thousands of tiny rectangles called pixels. Each pixel can be a different color or shade of gray. The primary advantage of a paint file is that it can represent a much more complex range of colors and shades than a draw file. The down side is the larger you plan to print the image, the larger the file size.

Programs such as Adobe Photoshop and Jasc Software's Paint Shop Pro are used to create and edit paint graphics. With one of these programs you can change, touch up, and combine photographs and other types of images, adjust attributes such as contrast and brightness, and apply a seemingly endless variety of effects and filters. The most common paint file formats are Joint Photographic Experts Group (JPEG or JPG) and Tagged-Image File Format (TIFF or TIF).

design world speaks primarily in PostScript, a language that allows your software to talk to output devices such as desktop printers. Almost all commercial printers require that the files you send them are PostScript compatible—meaning they include the information necessary to be translated to the printers' software and ultimately their presses. Many of the best fonts and clip art collections are available only in PostScript format.

If you plan to create your own print materials, buy programs that produce PostScript output and a PostScript-compatible printer, or add PostScript hardware/software to the printer you already own (check with your printer's manufacturer for details).

Another way to prepare files for distribution to a commercial printer or even online is to use Adobe Acrobat to produce files in the Portable Document Format (PDF). PDF files contain all the fonts, graphics, and printing information needed to view and print the document.

It is said that you should choose software before you choose hardware. Nowhere is this more true than when you are working with graphics. Though Apple's Macintosh line has long been the platform of choice for the professional design community, PCs too are now widely used. All the programs mentioned are available in both Mac and Windows versions, and the program features and keystrokes are almost identical.

Perhaps the best gauge of the system you'll need is the software manufacturer's "recommended" hardware requirements versus the "minimum" requirements. From the programs you plan to use, identify the one that requires the most memory and CPU horsepower, and base your purchase on those recommendations.

Step 7: TOOLS CHECKLIST

7.1 Choose a desktop publishing program
7.2 Choose a drawing program
7.3 Choose a paint program
7.4 Anticipate file sharing
7.5 Choose a computer system

Create a Name, a Defining Phrase, and a Nameplate

Your newsletter's nameplate is a statement, a standard, and a brand. It's a statement of purpose, a standard that reflects or establishes the visual style of the publication, and a visual brand that readers will grow to recognize.

nameplate is to develop a name. In the case of a newsletter the name incorporates information from any of five different categories—the newsletter's publisher, audience, subject matter, primary reader benefit, or a modifier. Generally speaking, it is to your advantage to create a name that says what it means, or you will forever be explaining its meaning via your advertising and marketing efforts.

Begin by compiling a brainstorming list. Divide a sheet into several sections—the publisher, audience, reader benefit, and a modifier—as shown below, and list as many relevant terms as you can conjure up. For example, the list for a newsletter that teaches builders how to sell homes might look like this:

Publisher Sampler Group
Audience Builders
Subject Marketing homes
Benefit 1 Selling success
Benefit 2 Profits
Benefit 3 Marketing strategy
Modifier How-to

The modifier is a generic term for the many ways you can describe intent, frequency, importance, and so on. Some examples: advisor, alert, bulletin, currents, digest, forum, hotline, how-to, letter, monitor, monthly, news, newsletter, outlook, quarterly, report, review, talk, trends, update, and weekly.

Use your brainstorming list to experiment with combinations. The goal is to create a name that states the benefit of the newsletter to the reader and then fills in as many of the who, what, where, when, and why blanks as possible. Even the short list above presents many possibilities.

Sampler's Home Seller Strategies Sampler's Builder Profits Sampler's How-To Market Homes Sampler's Builder Marketing Sampler's Home Marketing Forum Sampler's Successful Builder

Once you have a name and before you invest any more time and money, do a preliminary trademark check to determine if the name you are pursuing can be protected. Without a trademark, you could spend a significant amount of money and energy building a brand that belongs to

someone else. At a minimum, do a search for the word or phrase on an Internet search engine and search the Trademark Electronic Search System (TESS) at www.uspto.gov/web/menu/search.html.

five- to fifteen-word defining phrase (fig. A, below) that lays out the full scope of the newsletter. Not an attention-getting slogan or advertising tagline, but a clear statement of purpose. A slogan such as "All the News That's Fit to Print" may be appropriate for *The New York Times*, but a small enterprise that doesn't get that kind of exposure is better off getting right to the point with a defining phrase such as "News, events, opinion, and resources for New Yorkers." Clever is only good if it doesn't get in the way of communicating the message.

Include as much information as possible—the publisher, audience, subject, reader benefit, and a modifier. For the builder marketing publication above, the tagline might be "The builder's guide to home-selling success."

phrase to design the name and defining phrase to design the nameplate (fig. B, below)—the logo-like banner that typically appears at the top of page one. Since you have already chosen a newsletter style from Part 2 of this book, designing yours should be easy. You have only to translate your words into nameplate form.

You'll find many nameplate examples and much discussion about them in Part 2 of this book, beginning on page 50.

8.4 Finally, test your message.

The true test of whether your name, defining phrase, nameplate, or for that matter any other type of communication, works is to present it to someone who doesn't know anything about your organization, and see if that person can tell what you are trying to accomplish.

Does your material communicate its intended message to that stranger? One complication of writing and designing is that you are very close to the action—at times, too close to gauge its effect clearly. Find people whose opinion you respect and invite their reactions and suggestions.

Step 8: NAME CHECKLIST

8.1 Develop a name

8.2 Create a defining phrase

8.3 Design the nameplate

Test your message

An example of how to design a new nameplate (left) from an existing design recipe (right). See *Style 4: Icons*, page 78, for recipe details.

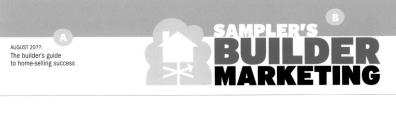

TOP STORY

Nation's largest residential design exposition coming to Sampler

BY ROGER EXAMPLE

Lorem ipsum dolor sit amet, consectetuer adipiscing elit, sed diam nonummy nibh euismod tincidunt ut laoreet dolore magna aliquam erat volutpat. Ut wisi enim ad minim veniam, quis nostrud exerci tation ullam corper suscipit lobortis nisl ut aliquip ex ea commodo consequat. Duis autem vel eum iriure dolor in hendrerit in vulputate velit esse molestie consequat, vel illum dolore eu feugiat nulla facilisis at vero eros et accumsan et iusto odio dignissim qui blandit praesent luptatum zzril delenit augue duis dolore te feugait nulla facilisi.

gue duis dolore te reugait nulla facilisi. Lorem ipsum dolor sit amet, consectetuer adipiscing elit, sed diam

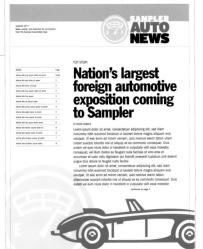

Compose the Content

Good content may survive a poor design, but the best design cannot overcome poor content.

most of your material internally, developing a set of writer's guidelines is a good way to start the process. Typically offered to contributors by magazine and book publishers, guidelines answer all of the questions a writer with little or no knowledge of your publication might ask. Even if you intend to solicit an article only periodically from someone within your organization, composing guidelines can help you flesh out ideas you might not otherwise consider.

Some of the common issues guidelines address are:

The subject/theme of the publication
A statement of editorial style
Who to contact
The action it is hoped the reader will take
The type of information featured
Subjects and angles that attract readers
The appropriate writing style
How much is paid
What rights are purchased
How submissions are made
Specific articles being pursued
Recent articles published

At this stage, especially if you will be working with lots of writers and/or complex topics, you might also identify a style book or manual to follow. A style manual sets forth a set of rules regarding the usage of words—punctuation, abbreviations, distinctive treatments, documentation, and so on. Some also deal with related topics such as book layout and general printing and production. When an issue such as the correct way to use parentheses arises, everyone involved can turn to the same source for answers. An excellent example is The Chicago Manual of Style, 14th Edition (The University of Chicago Press, 1993).

9.2 Plan and execute, gather reactions, revise the plan, and execute again—that is the formula for succeeding at virtually anything. The trick is to document the plan exactly so you know where and how to make the sweeping changes and subtle adjustments that reactions dictate. The best way to start developing newsletter content is to plan the content mix. What types of materials will you be producing and how much real estate will you devote to each area of interest?

Want to see how others do it?
Deconstruct the best newsletters, newspapers, and magazines you can find and diagram the types of material they include. Chart out the number of words or proportion of space they reserve for various types of content. Base your initial plan on what you considered an interesting, balanced mix, then tweak the formula as you begin to gather responses.

Divide your publication into the number of page spreads you plan to use and diagram the mix of content you plan to present. Example of types of content include:

Acknowledgments

Advertising

Announcements

Calendars

Case studies

Checklists

Columns written by regulars or guests

Condensations

Discussion transcripts

Event coverage

Excerpts

Fiction

Forecasts

How-to articles

Interviews of groups or individuals

Letters/submissions from readers

Listings

News coverage

News releases

Opinion

Profiles of organizations or individuals

Questions and answers

Quotations

Reprints from other publications or online

Resource lists

Results

Reviews

Serializations

Sidebars

Statistical data

Surveys and results

Synopses

9.3 Based on your newly defined content mix, plan the editorial calendar. Take a sheet of paper divide it into the number of issues you plan to produce over the first year and list the major articles and supplemental information you intend to publish. For now, just do a rough projection—later you can produce a detailed version from which the editor can make assignments. The calendar helps you see how much information it will be necessary to generate. Don't be surprised if you need to adjust how comprehensively you cover the topics, reevaluate the frequency with which you plan to publish, or adjust the newsletter's format or number of pages.

of writing articles it pays to develop content formulas. A formula is an article outline. It can be general or explicit, but if you are generating lots of material, it's a valuable tool. Here, for example, is what a formula for a how-to article might look:

[Headline] Your action will result in this benefit

[Credit] Author

- [1] Establish the mood
- [2] Summarize the article
- [3] Map the subject
- [4] Detail the benefits
- [5] Explain how it looks from the reader's angle
- [6] Show how it works
- [7] Demonstrate the steps
- [8] Provide sources of materials
- [9] Provide more information
- [10] Restate the summary
- [Link] Name of author, author's e-mail address, Web link for more information

9.5 Once you have a good handle on the stages above, you're ready to *produce original content*.

This book does not pretend to instruct you in an art as diverse and complex as writing. If you or the people you will enlist have not written for publication, there are many excellent books on myriad writing methods: technical, instructional, journalistic, marketing, and so on.

Do consider this: There is a big difference between gathering information and writing. If you find it necessary to ask nonwriters to write, it may be better to frame your request in the form of a request for information than as a request for finished articles. You can even do it via forms and questionnaires. If, for example, you intend to produce articles about people within your organization who are celebrating employment milestones, you may find it more productive to request the person's name, division, years of service, proudest professional moment, and such, rather than asking their supervisor to "write a short article about Elaine's tenth anniversary."

Using freelance writers is an added expense, but people who are accustomed to producing cogent copy on diverse subjects—using a wide variety of sources—will pay for themselves in the time and stress they save you. A good writer can also shorten the write, edit, and rewrite process to just one or two cycles.

One more note about original content: Insisting that writers write to fit a layout "to the word" belittles the importance of content. A flexible design should accommodate a 525-word article as well as it does a 480-word article.

generate original content for every element of every issue of your publication. Some elements—the nameplate, masthead, mailing indicia, and so on—will be repeated from issue to issue. But you should also consider acquiring stock and previously published content.

Most established organizations have previously published material from reports, presentations, marketing materials, news releases, and so on that may fit as is or after some light editing to translate it into the newsletter's context.

You can also track down free material from professional organizations, associations, the government and other public institutions, and organizations that promote related products, services, and causes.

You can also buy previously published materials from subject experts. Most magazines, for example, buy only one-time rights to the articles they publish. That means after the contracted time of exclusivity, you could negotiate an agreement with the writer to reprint the same article for a fee. Writers, obviously, are eager for you to repurpose material because they realize a profit. You may even find an article that doesn't quite fit and hire the author to rewrite a version that fits your newsletter's context exactly. You can create a very effective newsletter by purchasing a single feature article by a respected subject expert for each issue of your publication and generating material that supports and supplements it.

freelance writers, and repurposing content of other kinds requires that you develop forms and contracts. For more about the legal issues of creating a newsletter, see *Get a Legal Checkup*, page 33.

9.8 Part of the editor's job is to make and manage assignments. Doing so requires a good scheduling form to track who is to produce what by when. The more clearly defined your expectations are, the more likely they are to be met. Some writers like a general assignment where they build the article from scratch. At the other extreme are those who would prefer a detailed outline that spells out exactly where you're headed. The better your system for making assignments, the easier they will be to manage.

9.9 Before a final edit, take the time to compile the content and prepare the file. Translating all of the text into a single word processing program and file allows the editor to see everything together for the first time. This is important from the conceptual standpoint to determine if the ideas as a whole flow well together, and from a practical standpoint to see if the text will fit the layout.

Because text is reformatted when it is placed in the desktop publishing program, before or after final content editing, take time to remove all but the most basic text formatting. In most cases it is best to use just one typeface, one font size, one alignment (align left), and to remove extra spacing, tabs, and special attributes such as bolding.

The publishing world is different than the business typing world—instead of two spaces following a period, use just one. In most cases, instead of underlines, use italics. Instead of two hyphens, use a long em dash (—). Instead of straight inch marks ("), use open (") and close (") quotation marks. Instead of a straight foot mark ('), use an apostrophe ('). And use tabs and alignment settings, not spaces, to indent or center text.

9.10 The final stage of development is to edit and proof the content. The content, no matter where it originates, must be edited to speak in the publication's voice (see Step 5.4: Establish a voice, page 21). The editor either established that voice or is well acquainted with it. Editors read the copy and review the illustrations to ensure that they are presented by the same authority. They check that the information matches what was assigned, that it accurately represents the publications style and views, and that it is copyedited and technically correct—the grammar, spelling, and punctuation are correct, copyrights are noted, the address has the correct zip code, and so on.

Get a Legal Checkup

Publishers large and small heed the axiom: Ignorance of the law is no defense. Be sure you have a clear understanding of your legal rights before you publish anything. This book does not pretend to provide legal counsel, but rather offers a general overview of what is involved and some resources for pursuing remedies.

Consult a lawyer, legal expert, or a definitive guide:

- To help you understand your legal responsibility and limit your liability for the comments and claims you make about individuals and organizations, products and services, statistics and data, and so on.
- To develop the contracts and the simple agreements used to formalize the relationship between your publication and researchers, writers, illustrators, photographers, printers, list brokers and list maintenance providers, and so on.
- To obtain and archive model releases (agreements with people who appear in photographs you publish).
- To review the license agreements tendered by providers of stock and royalty-free artwork and photography, fonts, software, and so on.
- To register, employ, and/or provide notice of copyrights of the content you generate and the copyrights of content created by others. For more information visit www.loc.gov/copyright, or call 202-707-9100 to order forms and publications.
- To register, employ, and/or provide notice of the trademark of your newsletter's name and the trademarks owned by others. For more information, visit www.uspto.gov/main/trademarks.htm, or call 800-786-9199 to order forms and publications.
- To register, employ, and/or provide notice of an International Standard Serial Number (ISSN), a free-of-charge code that identifies your newsletter as a serialized publication. It is used by librarians, publishers, suppliers, and others to identify it and as a vehicle for exchanging information about it. For more information visit www.issn.org.
- To register, employ, and/or provide notice of a mailing permit indicia that allows you to mail your publication at a discounted price.
- Your publication may require legal syntax that is not mentioned here.
 Be sure to have a lawyer or appropriate legal expert review and approve your publication before you print it.

Step 9: CONTENT CHECKLIST

9.1 Develop writer's guidelines

9.2 Plan the content mix

9.3 Plan the editorial calendar

9.4 Develop content formulas

9.5 Produce original content

9.6 Acquire stock and previously published content

9.7 Develop forms and contracts

9.8 Make and manage assignments

9.9 Compile the content and prepare the file

9.10 Edit and proof the content

Illustrate the Message

Pictures speak louder than words, and illustrations speak louder than pictures. Fill your newsletter with illustrations—not decorations, but photographs, artwork, and diagrams that clarify your message and transmit your publication's style.

With the advent of digital cameras and powerful editing software, perhaps the easiest way to illustrate your publication is to shoot custom photographs. Remember, illustrations are more than pictures; they are pictures that, ideally, make your message more understandable. A head-and-shoulders photograph of a person works, but a shot of the same person in the place your article describes works better.

Advertising pioneer David Ogilvy once said, "The kind of photographs which work hardest are those which arouse the reader's curiosity. He glances at the photograph and says to himself, 'What goes on here?' Then he reads your story to find out." You can compose illustrative photographs, too.

Instead of a child holding a doll to illustrate child abuse, show the child standing in the shadow of an adult. Instead of a head-and-shoulders shot of the newly appointed coach, pose her juggling a volleyball, basketball, and baseball. Rather than a straight, smile-forthe-camera shot of accountants around a meeting table, pose them in front of a vault door.

If you don't want to shoot photographs yourself but you need a customized shot, consider hiring a photographer to shoot them for you. Some photographers charge an hourly rate, and some charge by the project. Be sure to understand who owns the rights to the specified and future use of the photographs you commission. Some photographers will assign all rights to you, others want to retain them, but most will negotiate.

for shooting your own photographs, there are plenty of places to acquire stock and royalty-free photographs. Generally speaking, stock photographs are licensed for specific uses. The license is based on criteria such as the type of publication it appears in and the number of copies that are printed. On the other hand, once you pay the license fee for a royalty-free photograph, you can use it just about any way and anywhere you want.

In either case, stock or royalty-free images, you only license the use of the image, you do not own the copyright. Be sure to read the fine print of any license agreement so there are no surprises after you have your newsletter printed.

There are many excellent sources of stock and royalty-free photographs on the World Wide Web. Some examples include www.corbis.com, www.creatas.com, www.eyewire.com, www.gettyworks.com, and www.tonystone.com.

quite as simple as shooting a custom photograph but it can do something a photograph has a harder time doing—it can express the intangible. You can illustrate an article on dog obedience training using a drawing of a dog dressed in gentleman's finery or show an artist's sketch of your latest product before it is even manufactured.

If you don't personally have a talent for drawing, commission an illustration by a professional illustrator. You simply find an artist whose style you admire, negotiate a price, and provide them with the specifics of what you want. There are plenty of Web sites where you can browse examples of work by many different illustrators using a diversity of styles. Good examples are www.workbook. com and www.creativehotlist.com. You can also look through magazines, newspapers, and Web sites to find the names of illustrators and track them down through the publications.

You can also take apart and reassemble parts and pieces of clip art illustrations to represent ideas for which they were not originally intended. This is easy to do using the type of draw programs described in *Step 7.2: Choose a Drawing Program*, page 27. Combining a drawing of a snowflake with a drawing of the sun, for example, produces a new illustration that represents heating and cooling or seasonal change.

illustrations and clip art. Stock illustration, like stock photography, is licensed for use in specific situations. Stock illustrations and photography are considered by some to be a step up from clip art. The theory is that a stock illustration, many of which are originally commissioned by a client for a specific project, is given more thought and care than a clip art illustration created in the hope that someone might buy it.

You'll find excellent samples of stock illustration and photography at www.blackbook.com.

The flip side of that thinking is why clip art was once the outcast class of the illustration world. The perception was, because clip art was created specifically for resale, it was not equal to the artwork created for client projects. Today, much extremely well-conceived and -executed illustration is created as clip art. You can buy it by the piece or as a part of a collection. Two stellar clip art sources are Dynamic Graphics at www.dgusa.com and Image Club at www.eyewire.com.

You can also find clip art in book form. For decades, Dover Publications and others have been publishing the books from which art was originally "clipped" and pasted on the pages being prepared for printing—hence the term "clip art." Dover, at www.doverpublications.com, remains a particularly good source for compilations of antique engravings, silhouettes, and drawings.

Finally, there are many good sources of specialty illustrations such as maps from Map Resources at www.mapresource.com, government and military clip art from One Mile Up at www.onemileup.com, beautifully intricate borders, initials, and ornaments from Aridi Computer Graphics at www.aridi.com, and health and medical subjects from LifeArt at www.lifeart.com.

visualize? Do some illustration brainstorming. There are lots of Web sites that feature stock and royalty-free graphics and photography for sale—graphics and photography that visualize ideas. They are obviously a great way to find and purchase the rights to specific images, but they can also double as a creative tool. Next time you're stuck for ideas, visit one of these sites and search for words associated with the concept to see how other artists have illustrated the same idea. Do not steal ideas; use them as seeds for growing your own.

Step 10: ILLUSTRATION CHECKLIST

10.1 Shoot custom photographs
 10.2 Acquire stock and royalty-free photographs
 10.3 Create custom artwork
 10.4 Acquire stock illustrations and clip art
 10.5 Do some illustration brainstorming

Assemble the Pieces

Eleven steps into the process and you're just now getting to the most obvious and, arguably, the most fun part of designing a newsletter—bringing the pages to life. Using the format you decided on in *Step 4:* Choose a Format, page 18, and the style you chose in *Step 5: Choose a Style*, page 20, you can begin to recreate the basic page layouts in your desktop publishing program.

Before you can execute the design recipes in Part 2 of the book, you'll need to select and purchase the associated fonts or choose similar fonts from your own arsenal.

All fonts are not created equal. Those developed by the leading type foundries—names such as Adobe, Berthold, Font Bureau, International Typeface Corporation (ITC), and Linotype—are, generally speaking, designed by premier type designers, past and present,

SOURCES Type families: Caslon Regular, Century Expanded, Garamond Light Condensed, Minion Regular, Formata Light, Helvetica Regular, Myriad Regular, Adobe Systems, Inc., 800-682-3623, www.adobe.com/type; Franklin Gothic Book Condensed, ITC, 866-823-5828, www.itcfonts.com.

Serif Typefaces

Lorem ipsum dolor sit amet, consectetue adipiscing elit, sed diam nonummy nibh tincidunt ut laoreet dolore magna aliqua volutpat. Ut wisi enim ad minim veniam nostrud exerci tation ullamcorper suscipication Regular

Lorem ipsum dolor sit amet, consected adipiscing elit, sed diam nonummy ni euismod tincidunt ut laoreet dolore na liquam erat volutpat. Ut wisi enim a minim veniam, quis nostrud exerci ta Century Expanded

Lorem ipsum dolor sit amet, consectetuer adipiscin diam nonummy nibh euismod tincidunt ut laoreet magna aliquam erat volutpat. Ut wisi enim ad mir veniam, quis nostrud exerci tation ullamcorper sus lobortis nisl ut aliquip ex ea commodo consequat.

Garamond Light Condensed

Lorem Lorem ipsum dolor sit amet, cons adipiscing elit, sed diam nonummy nibh tincidunt ut laoreet dolore magna aliqua volutpat. Ut wisi enim ad minim veniam nostrud exerci tation ullamcorper suscip Minion Regular

Sans Serif Typefaces

Lorem ipsum dolor sit amet, consectett adipiscing elit, sed diam nonummy nib euismod tincidunt ut laoreet dolore ma aliquam erat volutpat. Ut wisi enim ad r veniam, quis nostrud exerci tation ullam Formata Light

Lorem ipsum dolor sit amet, consectetuer ac elit, sed diam nonummy nibh euismod tincic laoreet dolore magna aliquam erat volutpat. enim ad minim veniam, quis nostrud exerci t ullamcorper suscipit lobortis nisl ut aliquip e Franklin Gothic Book Condensed

Lorem ipsum dolor sit amet, consected adipiscing elit, sed diam nonummy ni euismod tincidunt ut laoreet dolore maliquam erat volutpat. Ut wisi enim ac veniam, quis nostrud exerci tation.

Helvetica Regular

Myriad Regular

Lorem ipsum dolor sit amet, consectetu adipiscing elit, sed diam nonummy nibh euismod tincidunt ut laoreet dolore ma aliquam erat volutpat. Ut wisi enim ad r veniam, quis nostrud exerci tation ullam and translated into electronic form by people who have a deep understanding of and profound respect for the art of typography. Many of the free fonts you download online or that are included by the hundreds with inexpensive software packages are knock-offs of originals. They often are not as well designed or are simply not very good software in the way they calculate the space between different combinations of characters, print on the page, and so on.

Check up front with the printer that will be reproducing your newsletter to determine whether they would prefer a specific font software format—PostScript, TrueType, or OpenType.

If you opt to use a font other than that recommended in the design recipe, be prepared to alter the amount of text you project to fit on a page. Different fonts take up different amounts of space.

11.2 Turn to the design recipe style you chose in Step 5: Choose a Style, page 20, and begin building your newsletter template by establishing the page size and grid. Each recipe includes everything you need—the page size, the margins, the number of columns, the gutter (space between columns), and various other guides that divide the page proportionally. Together, those elements form a "grid"—an invisible foundation on which to position all of the elements you place on the page. Aligning as much as possible to the grid provides a sense of visual order and stability that is difficult to achieve any other way. Desktop publishing programs have "guides" you can position for just this purpose.

oped, begin to recreate and place the foundation elements—the nameplate, masthead, running heads, and page numbers—and establish, if necessary, a mailing area.

The nameplate is the logo-like banner you created in Step 8.3: Design the Nameplate, page 29—it typically appears at the top of page one. The masthead is the block of information that defines the publication, posts legal information, identifies the publisher and the key contributors, and provides contact information (see *The Masthead*, right). The running heads are the text and graphics repeated on most pages to remind the reader where they are—the publication name, the page number, perhaps the subject of the publication or its defining phrase, and so on. The page numbers are typically on the top or bottom outside edge of the page. And a mailing area (if your newsletter is a selfmailer), the area where the postage or mailing indicia, return address, and address label are displayed.

place, begin to place the text. If it was compiled and prepared as described in Step 9.9: Prepare the File, page 32, the process is easy. Be sure the content is in finished form—it is useless to lay out and illustrate text that has not yet been edited, proofed, and signed off on.

Don't be concerned about exactly where it is first placed, just get it into the publication, then apply the attributes of the most widely used format—the size and style of the text.

The person in charge of assembling the elements of the layout should understand how to create, edit, and apply styles. The styles feature is among the most powerful features of a desktop publishing program and is relatively easy to learn. Styles control all the attributes of a paragraph of text such as its typeface, its size, whether it is bold, italic, all caps, or underlined, and whether the paragraph is indented, has extra space above or below it, is hyphenated, and if it is aligned right, left, centered, or justified.

The Masthead

The masthead is a newsletter's passport. Mailing regulations, laws, affiliations, and customs all present newsletter publishers with requirements for entry into the various jurisdictions of publishing. The postal service, for example, requires certain information for preferred rates; laws dictate standards for certain types of information, such as financial data; and a sponsor may require its beneficiary to post a particular disclaimer.

The masthead is an area of the newsletter, often enclosed within a bordered box, that is a repository of much of that information. Generally speaking, your newsletter's masthead should include some or all of the following:

- > Publication title
- > Defining phrase
- > Publisher
- > Titles and names of editors, writers, contributors, staff
- > Statement of purpose
- > Office of publication address, phone, fax, Web, e-mail
- > Editorial office address, phone, fax, Web, e-mail
- > Publication's Internet address
- Information/instructions regarding back issues, subscriptions, advertising, sponsorship, membership, nonprofit status
- > Legal disclaimer
- > Copyright notice
- > Trademark notice
- > ISSN code or USPS number
- > Issue date, volume, number
- > Statement of frequency
- > Contribution guidelines
- > Postmaster change of address notice
- > Reprint/copying guidelines
- > Forwarding information
- > Miscellaneous postal information

Designers and printers use PANTONE® formula guides to specify ink colors. This guide is for specifying process colors; there are others for specifying solid colors.

SOURCE PANTONE formula guides, www.pantone.com; © Pantone, Inc., all rights reserved.

Whether you apply a style to one or one hundred different paragraphs of text, you only have to edit the style to change the formatting of every occurrence of the style throughout the document. In future issues of your publication they make formatting fast and easy.

Take the time to format one paragraph of text and create a style for each different paragraph in the design recipe—one for headlines, one for subheads, one for captions, one for the author's byline, and so on. With those styles created you can apply formatting to all the text by simply clicking on a paragraph and applying a style.

After you format the text, you can begin to move the pieces around. Use the content mix plan you developed in *Step 9*: *Compose the Content*, page 30, to divide the various types of content up and place them on the designated pages. If you did not create a formal plan, confer with the editor to determine the flow of the publication.

layout, you can begin to place illustrations. Text comes first because photographs and artwork generally can be sized to fit the space available. Since the text is in finished form, enlarging an illustration to fill space or reducing it to allow for more text is preferable to going back to the writing/editing stages.

more than one color, (black is a color in printing terms), it is at this stage that you apply color. But first, you need to understand how commercial printers reproduce color.

There are two ways to arrive at matching a specific color. You can choose a specific ink color that matches it, called a solid PANTONE® Color, or you can combine four standard colors to match it as closely as possible, referred to as process colors.

There are over 1,000 solid PANTONE Colors. If, for example, you want bright orange, you would choose a color from a PANTONE formula guide (left). After you have choosen the exact color you want, you provide the printer with the corresponding PANTONE number. They buy a container of that ink and print your job with it.

The alternative method is to print the job using the four-color process. The process colors are cyan, magenta, yellow, and black (CMYK). This combination of colors can be screened to represent just about any color value across the spectrum. This method is best for printing color photographs and other material that contain a range of colors that cannot be reproduced using two or three solid colors.

The limitation of the four-color process is that it cannot reproduce some colors as vividly and is typically more expensive than the solid color method.

The least expensive route is to print black or a single solid color on white or colored stock. If you're willing to spend a little more, you can print with two colors, typically black and one solid color. The general rule is the more colors you print, the more complex the printing press needs to be to print them, and the more your job will cost. The four-color process, generally speaking, is the most expensive.

roughly in place you're ready to *adjust* elements. Layout and design are all about details. Artists often spend hours simply moving elements around on pages to see

what works best. You have the advantage of an established design recipe, but you still need to make aesthetic judgments about how the different elements of your layout work together.

A few layout tips: One, use a delicate hand—new designers tend to make text and graphics too big and/or too bold.

Keep your layout simple and delicate.

Two, print sample pages early and often. It's difficult to judge how well a layout is working until you see the pages printed out at actual size—a typeface or illustration that looks good on the screen often looks very different at actual size. If the pages will be folded, fold them. If they will be printed on an unusual paper, print it on that paper. Review the results and make adjustments.

Three, build in time to allow your finished layout to sit for a day or two. You'll be surprised how much easier it is to spot flaws when you return to the layout with a fresh perspective.

its time to proofread and correct the finished pages. Even though editing such as checking grammar, spelling, and proofreading took place in the content creation stages, much has changed. As text was placed, it is possible a few letters or words—or even an entire article—was overlooked or accidentally deleted.

If you wrote the article or laid out the page, this is one stage of the process you cannot do yourself. The person who made the mistakes typically has the hardest time recognizing them.

Enlist, instead, the talents of an expert copy editor—someone who possesses a talent for finding both the obvious problems and the near invisible oversights. Have the copy editor read over the entire publication for text errors and

review the layout to spot errors such as a caption that doesn't match up with an illustration, an incorrect page number, or a missing photographer's credit and copyright notice.

complete, save a copy of the document as a template for future issues. To save space, remove illustrations that are specific to that particular issue and tag text that must be changed with double question marks (??). For example, in the nameplate, replace "December" with "Month??," and a Web address that changes periodically with "www.??.com." That way, when you produce the next issue, you can search the document for the double question marks to easily locate the recurring edit points.

your newsletter to a commercial printer to be reproduced, have it reviewed by a mailing expert. Take a copy of the document and a sample of the paper it will be printed on to your local post office or the mailing services provider that will distribute it to confirm that it follows the specifications you set and meets all the necessary postal regulations.

Step 11: ASSEMBLY CHECKLIST

11.1 Select and purchase fonts

11.2 Establish the page size and grid

11.3 Place the foundation elements

11.4 Place the text

11.5 Place illustrations

11.6 Apply color

11.7 Adjust elements

11.8 Proofread and correct the finished pages

11.9 Save a template

11.10 Have it reviewed by a mailing expert

STEP 12

Find a Printer

In printing, excellence is the minimum requirement. Skewed text, muddy photographs, or faded colors shout, "WE DON'T CARE."

No matter how well you plan and execute a smart, good-looking design, you must rely on the skills of a commercial printer to translate your computer files into a finished product. Finding a printer that's well-suited to the type of job you are printing, committed to producing a quality product, and willing to produce it for a reasonable price is a critical piece of the design-it-yourself puzzle.

SOURCE Illustration: Photographs courtesy of Printing Services,Inc., Richmond, Virginia

printer with the proper equipment. Two of the most common systems used to reproduce newsletters are an offset lithographic press and a digital production printer (copier). There are other methods of printing equal to the task, but these two typically offer the best mix of quality and price.

Offset lithography is, generally speaking, the best process for printing a one-color to four-color job at quantities of 500 or more. It can reproduce fine detail and big areas of color, and can print large enough sheet sizes to allow you to extend (bleed) images and areas of color off the edges of the sheet. It is possible to print less, but the difference between printing fifty and 500 impressions is insignificant—little more than the cost of the paper.

If you are printing 500 or fewer copies of a publication, a digital production printer (copier) such as Xerox's DocuTech (black and white) or DocuColor (fourcolor) systems produce acceptable quality for a reasonable price.

printer's representative, explain the scope of the job to determine if it fits within the printer's capabilities. In Step 11.6: Apply Color, page 38, you decided on the type and number of colors to use. Some printers specialize in printing one-color and two-color work and are ill-equipped to print four-color process, others aren't interested in anything but large runs of four-color, and so on. A rule of thumb is to avoid being the smallest job in a big shop or vice versa.

Be aware that it is not unusual for printers without the equipment to produce your job to accept it and broker it to a third party. Ask early on if the printer will be printing your project in-house. If they are sending it out, you may get a better price by going direct.

printer are technically compatible. Ask if the printer's prepress department supports the computer hardware and software you will use to produce the artwork, exactly how the files need to be set up, and how they charge for their services.

nary answers are to your liking, ask to see and review some samples of similar jobs the printer has produced. Look for good printing, not good design. The creative part of printing is normally in the client's hands, so a printer is more concerned with science than art. Check for bright, clean colors; for smooth, dense solid areas; for text and images that are focused and clear; and for images that are printed on the page squarely and in the correct position.

It also helps to show the printer an example of the quality you expect and the effects you are hoping to achieve. Take advantage of the expertise of veteran salespeople and their coworkers in the press room. They can provide a wealth of information and guidance.

you will have to *choose paper*. Generally speaking, newsletters are printed on one of two types of paper or "stock"—coated or uncoated. Coated stock is the stock used for most magazines. It has a thin layer of clay-like substrate that creates a smooth, flat surface ideal for printing colored inks and superfine detail such as

photographs. Uncoated stock is the stock commonly used for stationery and is available in rough to smooth finishes. You can print four-color on uncoated stock, but the colors, because they are usually absorbed deeper into the surface of the sheet than on coated, produce a more subdued result. (For more about color, see *Step 11.6: Apply Color*, page 38.)

To see the alternatives, request paper samples from your printer or a local paper distributor. They can provide swatch books and printed samples of literally thousands of possible finishes, weights, and colors.

Paper is classified by weight and the weight you should choose depends on its use. A sixteen-page newsletter, for example, is printed on lighter stock than a four-page version. A typical eight-page newsletter might be printed on 70lb uncoated or 80lb coated stock.

The most obvious paper choice is color. There is a seemingly endless rainbow of paper colors and a huge range of warm to cool whites. Ink colors are affected by the color of paper. Yellow ink on white paper, for example, will look significantly different than yellow ink on a light shade of green.

Be sure to also consider opacity.

Opacity is the property of paper that determines the degree to which a printed image shows through from one side of a sheet to the other. If the sheet is not opaque enough, you might see enough of the image from the opposite side for it to be distracting. Your printer representative

can help you gauge the amount of showthrough likely from the paper you specify.

Finally, ask your printer for guidance. They may discourage you from using a certain sheet for a particular job because of past experience, incompatibility with their equipment, availability problems, and so on. As long as they have given you a wide range of finishes, weights, and color to choose from, it is best to follow their recommendations.

that can handle your job and request job estimates. Estimates can vary widely from printer to printer. Some base them on strict estimating formulas; others adjust for how busy they are and, therefore, how eager they are to have your business. Most are willing to bargain.

The cost of printing is based on the amount of time the job ties up the press and the size of the press needed to print the job. The more complex the job, the more complex the press needed to print it. You normally get the best price on the smallest press that can handle your job.

To prepare an estimate, the printer will need some preliminary information such as: the timetable, the number of colors, the overall size, the number of pages, the quantity, the paper you want it printed on, the form in which you will supply the artwork, the method for

proofing, and how it will be the folded, bound, packaged, and delivered. See the *Printing Estimate Information Form* on the next page for more details. Also ask if you would be eligible for a discount if you were willing to commit to having it printed with them on a regular basis.

contract. Many printers include a detailed contract with their estimate. Printing is a complex combination of product and service that presents many opportunities for misunderstanding. Be certain you understand the intricacies of the legalese.

Printing Estimate Information Form

Job title			
Release date		Delivery date	
		,	
Description Number of colors	Cover	Text	
Type of color	□ Spot □ Process	☐ Spot ☐ Process	
Trim size	Folded (page)	Flat (spread)	
Number of pages	Tolded (page)	Quantity	
		Quarterly	
Stock			
Cover stock	Туре	Color	Weight
Text stock	Туре	Color	Weight
Software			
Application			Version
Platform	☐ Mac ☐ Windows		
Resolution			
Media	□CD □DVD □Ja	az □Zip □Other	
Proofing			
Type of proof	☐ Blueline ☐ Laser	□Other	
Finishing Varnish/Laminate	Area	Typo	
Folds	Area	Туре	
	☐ Perfect bound ☐	Saddle stitch	
Binding Hala drilling		Saddle stitch	
Hole drilling Packaging			
Shipping			
<u> </u>			
Instructions			

Step 12: PRINTER CHECKLIST

12.1	Find a printer with the proper equipment
12.2	Explain the scope of the job
12.3	Verify technical compatibility
12.4	Review samples
12.5	Choose paper
12.6	Request two or more job estimates
12.7	Review the printer's contract

STEP 13

Prepare, Print, and Proof It

The printing process can produce 1,000 impressions of success as easily as it can produce 1,000 examples of failure.

Whether you have your newsletter reproduced 100, 1,000, or 10,000 times, you—by the way you prepare the material for the press, oversee the printing, and review the results—control the outcome.

Printing has three very distinct stages: preparation, execution, and follow-up. The first stage, commonly referred to as the "prepress" process, is the series of steps taken to prepare your project for printing. In prepress, the printer takes the files you created along with the fonts and images you linked to them, and translates them into a form their computer hardware and software understands.

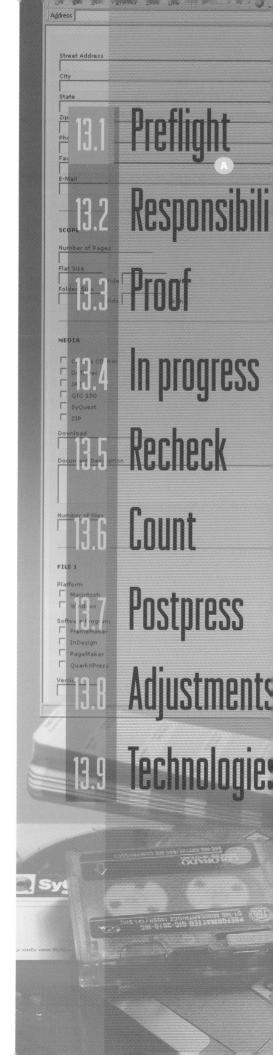

The prepress process for a printing press, among other things, determines how each page is positioned on the sheet (imposition) to achieve the most economical use of space. It ensures the pages are perfectly aligned front to back. That screen values are applied to photographs and artwork. That a slight overlap, or "trap," is applied between colors that touch. And the colors are separated for making individual printing plates.

responsibility of the prepress process is to "preflight" your files. Preflighting is the process of gathering together and reviewing all the elements necessary to translate what you create on your computer to the printer's computer. Most printers can provide you with a preflight checklist.

Some desktop publishing programs have a preflight feature that aids in the process. At minimum, the printer will require the names and descriptions of the document files and any other image files linked to them, the name and version number of the software program used to produce them, and copies of the fonts used (check your font license agreement for restrictions about sharing fonts).

files, be sure you and the printer agree about who is responsible for what. One printer might prefer to work with your actual desktop publishing program file, to open it in the program you used to produce it, and prepare it themselves. Another might assume you have prepared a file complete with such settings as screen frequency, screen angles, negative orientation, and others.

for a printing press, you will be asked to review and sign off on a proof of your job before it is printed. A proof is a printout that should, as closely as possible, demonstrate the final printed piece.

There are many different types of proofs. Some printers still provide a blueline (named for its monochrome blue color) made by exposing a film negative on a sheet of light-sensitive paper. It shows a highly accurate representation of what to expect from the printing process minus actual color. If you specify more than one or two colors, a color proof is sometimes required to approximate the colors you should expect.

Today, in an ever-changing print marketplace, new and more accurate ways of proofing are available. Your printing representative can explain the differences, and show you examples of the systems they use.

Your responsibility, in any case, is the same: to check and recheck the proof thoroughly. Once you sign off on it, responsibility for everything shown on the proof is yours, even if it is the printer's mistake. This is an important distinction to understand. If something as simple as an errant line break eliminated an important phone number, and that mistake undermined your entire project, your approval may still be legally binding—leaving you and your organization to bear the entire cost of reprinting.

Use a red pen or pencil to circle errors and make notes. Are pages printed at the right size? Are the photographs, artwork, and text in the right places? Are the images and text clear and focused? Are the correct typefaces used? Did special characters such as fractions and copyright marks translate correctly? Circle scratches, dust, and broken characters that might be caused by impurities in the film used to

make the proof and that, in turn, will be used to make the printing plates. If there are significant changes, request a second proof so you are sure all the changes were made.

If printing will be done on a production copier, prepress primarily concerns translating the files to the printer's copier and reviewing sample copies before a complete run is produced.

absence of mistakes. The proofs you sign off on gave you a good idea of what your finished job should look like. Now your responsibility shifts to seeing that the results are a fair representation of what you approved. There are two stages at which to intercept problems—during the printing process, and after it is complete.

Many printers are receptive to, and in fact encourage, clients to check their jobs in progress at the beginning of the press run. This is especially true if there is some part of the process that requires an aesthetic judgment—if, for example, you are using process colors (CMYK), the press operator can often fine-tune the result by increasing or decreasing the intensity of individual colors. But remember, press time is expensive. If you choose to approve your job on press, be prepared to give clear directions and to make quick decisions. Check with your printing representative to see what their policy is and requirements are for press checks.

Whether you are looking at a job in progress or postpress, the figures (page 46) show a few of the most obvious problems to look for. Though a small portion of just about every job will be spoiled by one or more of them, attentive press workers should spot and discard problem sheets. And, though quality varies from printer to printer, most would agree that problems this extreme are not considered deliverable.

Check your job in progress and, afterward, question anything that is distinctly different from the proof you approved. Watch for these potential printing problems (right).

rechecking your job when it is delivered.
Look at a representative sample of pieces from the beginning, middle, and end of the run. If the middle third of the job is spoiled, you don't want to discover it through a phone call from a subscriber.

determine if you got the quantity of pieces you paid for. Count a stack of 100 pieces, measure the height of the stack, and roughly calculate if you are within ten percent of the quantity you ordered. Most printers consider ten percent over or under the amount you requested as acceptable. Therefore, if you need exactly 1000 copies, be sure to tell the printer beforehand that anything less is unacceptable. Some printers expect you to pay extra for overruns unless you agree otherwise in advance.

Your final responsibility is to oversee and approve postpress finishing—how sheets are folded, bound, trimmed, drilled, and packaged. At a small press, these steps may be accomplished by a team of people using a series of individual devices. At the largest printer, the same steps may be completed on a single, computerized assembly line.

A traditional 8.5 by 11 inch, eightpage newsletter is printed front and back
on two sheets slightly larger than 11 by 17
inches, which are then paired together,
folded in half, and saddle-stitched—
stapled on the fold. It is obvious if the
pages were incorrectly paired: The pages
will be out of order. If the margins are not
uniform, the pages may not have been
registered accurately front to back or
trimmed accurately.

Coverage

Check the ink coverage—too little (A), normal (B), or too much (C).

Mottle

Check solid areas for mottle—uneven, spotty areas of ink.

Registration and trapping

All colors and shapes should be aligned, or registered, with great precision. Poor registration can result in a gap between ink colors (D).

Pinholes and hickies

A pinhole (E) is the result of a hole in the printing plate negative. Erratically shaped hickies (F) are caused by dirt or paper particles that adhere to the plate or rollers.

Skew

A crooked or skewed image (G) could be the result of a misaligned plate.

Trimming

Some of the most common problems occur after the job is printed. A page trimmed even slightly out of alignment can be drastically altered (H).

Ghosting

A doubled or blurred image, termed "ghosting," is typically caused by a misapplication of ink on the rollers.

ad

is reasonable to negotiate an adjustment in the price. If there are minor problems with your job, something even a meticulous reader would normally miss, you can request a reprint, but it may be more practical to ask for an adjustment of the price; most printers are amenable. If there are significant, obvious problems with your job, insist on a reprint. Though some readers might not notice a problem, it may cause others to judge your organization negatively.

13.9 A final word about printing: there is no final word. The printing business, for some time, has been in and remains in fast forward. There are all types of developing technologies that solve the inherent problems of conventional prepress, printing, and postpress processes. Direct-to-press systems, for example, circumvent much of the time, practice, and cost necessary to prepare and produce printing plates. Stay abreast of developing printing technologies. Printing representatives can introduce you to new, less costly ways of doing things; you have only to judge whether they meet or exceed the standards of cost, accuracy, and quality set by conventional methods.

For a comprehensive look at the printing process, get a copy of the *Pocket Pal Graphic Arts Production Handbook* by International Paper from Signet Inc., 800-654-3889, 901-387-5560, www.pocketpalstore.com.

Step 13: PRINTING CHECKLIST

13.1	Preflight your files
13.2	Determine who is responsible for what
13.3	Review and sign off on a proof
13.4	Check your job in progress
13.5	Recheck your job after it is delivered
13.6	Do a rough count
13.7	Oversee and approve postpress finishing
13.8	Negotiate a price adjustment for printing errors
13.9	Stay abreast of developing printing technologies

STEP 14

Mail It

In a complex marketplace, a superior product is the minimum requirement. The recipe for a successful newsletter includes measures of efficient distribution and vigilant promotion.

recommended in *Step 2: Do Some*Research, page 12, you discovered that mailing your newsletter is only complicated if you want it to be—and that complicated, in the case of newsletters, can be a good thing.

It may, for example, be complicated to understand and meet all of the postal regulations to qualify for a postage rate discount, but if you save ten cents per piece on the 750 pieces you mail once a month, you'd save roughly \$900 the first year and \$4,500 over a five-year period. This is a handsome return for a little complication and a few hours of research.

Now is the time to review or gather the information discussed in the research step. Does your newsletter qualify for a preferred rate? Do you understand what services a mailing services company has to offer?

To research rates and USPS postage rates, review the "Eligibility" section of the "Domestic Mail Manual (DMM)" at the USPS Postal Explorer at http://pe.usps.gov/ or visit your local post office.

you'll begin to appreciate the many variables that dictate which list management and mailing services are best suited to your situation. The quantity of newsletters you are distributing, the frequency at which you distribute them, the type of list you are using, the postage rates you qualify for, and so on, all play a role.

Before you can distribute a newsletter you must, obviously, develop a mailing list of those to whom it will be sent. You can develop and maintain your list using off-the-shelf database software or you can contract with a company that specializes in mailing list management.

Some of the advantages of a list management company include helping you define and standardize the information to be included in the list database; helping you acquire other lists and develop new sources of names; and managing the processes of converting and entering data, and purging names.

The answer to which to choose depends on what you're trying to accomplish and whether you prefer to pay the cost in time or money. If you are distributing your newsletter to an established list of 500 people, you clearly can do it yourself. Adding and removing names, and printing a set of labels for each issue shouldn't require massive

resources. If, on the other hand, you intend to build and maintain a list of 25,000 paid subscribers and will be actively marketing your letter to others, a dedicated internal or contract mailing list manager is a must.

perform what mailing services. Among the things a mailing services company can do is help you create a publication that qualifies for discounted postage rates. Apply postage by meter, indicia, or stamps. Print list addresses and other messages on the newsletter or apply conventional address labels. Fold your letter, inserting it into an envelope, or using other means to seal it. Presort, barcode, and/or comingle mailings to qualify for rate discounts. And transport materials from the printer to the post office.

vill administer newsletter business. There are many miscellaneous costs that are required of a publisher. Be sure to consider the time and money it costs to develop and maintain the run-of-the-mill systems that keep the mill running—phones, faxes, computer software and hardware, media, deliveries, and so on. Don't forget the practices of doing the accounting, managing the people, administrating the process, answering the phones, and so on.

No organization needs a newsletter. It needs a way to build relationships with its customers. Every organization needs a forum for spreading its ideas, demonstrating its products, and showing off its services. It needs ways of generating revenue, recruiting members, and building its credibility. An effective newsletter is not paperwork; it is a marketing tool. An organization does not need paperwork—it needs smart marketing tools with a real purpose.

Step 14: DISTRIBUTION CHECKLIST

14.1 Gather information
14.2 Develop a mailing list
14.3 Determine who will perform what mailing services
14.4 Administer your newsletter business

PART 2 Design Recipes

PART 2: DESIGN RECIPES

How to Use the Recipes

Now it's time to put the step-by-step process to work. The pages that follow present a cookbook of style recipes for a wide variety of newsletter designs.

The first two pages of each recipe show the nameplate and the overall style of the newsletter. The third and fourth show the basic elements—grid, type families, and illustrations used—and some distinguishing features that make a particular newsletter one-of-a-kind. Pages five through eight provide a detailed recipe and list of design ingredients.

Above all, remember this: These designs were created specifically for the Design-it-Yourself series—you are free to copy any recipe in whole or in part to produce your own materials. The only restriction is that you cannot claim any form of legal authorship of the copied design. Don't limit your thinking to using everything as-is. Combining ideas from several styles will produce the most unique newsletters.

A: Definition

The recipe begins with an explanation of the thinking behind its particular style.

B: The nameplate

The large version of the nameplate reveals the details you might miss at a smaller size.

C: Page flow

The page flow shows the imposition of pages—how the pages of the example shown would be printed front to back so the finished piece is in reading order. Measurements are expressed as width by height—17 by 11 inches means the sheet is 17 inches wide by 11 inches high.

D: Software recommendations

This caption lists the type of software required to create the artwork.

E: Basic elements

This page shows the grid—the invisible foundation of margins, columns, and guides to which all the elements on the page are aligned, the names of type families, and describes the mix of photographs and/or artwork.

F: Distinguishing features

Some of the design elements that make this newsletter one-of-a-kind.

G: Newsletter recipe

The rulers on each page show measurements in inches of where the final pages are trimmed, and the light gray guides show the grid used to position primary elements. Art and images that extend outside the bold gray outline mean the element bleeds off the edge of the page.

H: The color palette

All the projects are created using either four-color process, Solid PANTONE Colors, or simple black ink (see *Step 11.6: Apply color*, page 38). The palette identifies composition of CMYK mixes or the PANTONE Number and tint values of the solid colors.

I: The ingredients

The type used in each recipe is keyed, by number, to this list of ingredients—it includes the name of the typeface, the point size, line spacing (when there is more than one line of the same typeface), alignment, and the point size of lines. A listing of "12/13pt" means the text is 12 points and the line spacing is 13 points.

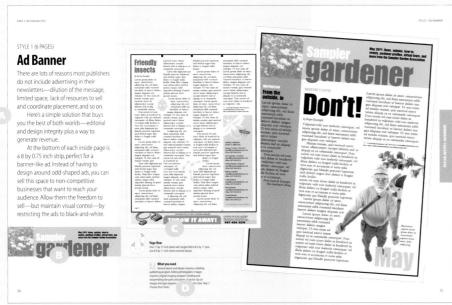

1/16

1/8

1/4

3/16

Fraction = Decimal Conversion

0.0625

0.125

0.1875

0.25

In this example, the number "13" points to the item; "Sidebar headline" is the type of item; "Impact" is the typeface; "36/32pt" means 36-point type on 32 points of leading (the space between the baselines of two rows of type); and "align center" is the alignment—aligned left or right, centered, or justified. Several examples employ customizable Adobe Multiple Master (MM) fonts such as Myriad MM (see page 75, item 1). Settings such as "700bd, 300cn" following the typeface name represent customized character weights and widths. See your Multiple Master documentation for details.

K: Lorem Ipsum

Lorem ipsum is scrambled Latin text used by designers to demonstrate the approximate number of words it will take to fill an area of the layout before the actual text is specified.

Pages 2 & 3

12 Line 4pt; Headline Impact 18/16pt, align left; Text Minion 11/12pt, align left; Text subhead Minion 10pt, align left; Contact Franklin Gothic Book Condensed 7/8pt, align left; Page number Minion Italic 8pt, align left; 13 Sidebar headline Impact, 36/32pt, align center; 13 Sidebar text Minion 16/18pt, align left; 14 Headline Frutiger Ultra Black 24pt, align left; Text Franklin Gothic Book Condensed 8/8pt, align left; Ptext Franklin Gothic Book Condensed 10pt, align left; Phone Frutiger Ultra Black 18pt, align left; Text Franklin Gothic Book Condensed 10pt, align left; Phone Franklin Gothic Book Condensed 10pt, align left; Phone Franklin Gothic Book Condensed 10pt, align left;

SOURCE Illustrations: Flowers (pg. 1) from Seasons from Eyewire, 800-661-9410, 403-262-8008, www.eyewire.com.
© Eyewire, Inc., all rights reserved; Illustration Gardener

th clippers (pg. 1), slides (pg. 6), flowers (pg. 2), spray,

STYLE 1 (6 PAGES)

Ad Banner

There are lots of reasons most publishers do not include advertising in their newsletters—dilution of the message, limited space, lack of resources to sell and coordinate placement, and so on.

Here's a simple solution that buys you the best of both worlds—editorial and design integrity plus a way to generate revenue.

At the bottom of each inside page is an 8 by 0.75 inch strip, perfect for a banner-like ad. Instead of having to design around odd-shaped ads, you can sell this space to noncompetitive businesses that want to reach your audience. Allow them the freedom to sell—but maintain visual control—by restricting the ads to black-and-white.

May 2029: News, opinion, how-to, events, gardener profiles, virtual tours, and more from the Sampler Garden Association

Friendly insects

By Becky Example
Lorem ipsum dolor sit amet, consectetuer adipiscing elit, sed diam nonummy nibh euismod tincidunt ut laoreet dolore magna aliquam erat volutpat. Ut wisi enim ad minim veniam, quis nostrud exerci tat ullamcorper suscipi lobortis nisl ut aliq ea commodo conseq

Duis autem vel eum iriure dolor in hendrerit in vulputate velit esse molestic consequat, vel illum dolore eu feugiat nulla facilisis at vero eros et accumsan et iusto odio dignissim qui blandit praesent luptatum zzril delenit augue duis dolore te feugait nulla facilisi.

Lorem ipsum dolor sit amet, consectetuer adipiscing elit, sed diam nonummy nibh euismod tincidunt ut laoreet dolore magna aliquam erat volutpat. Ut wisi enim ad minim veniam, quis

Iusto odio dignissim qui blandit praesent luptatum zzril delenit augue duis dolore te feugait nulla facilisi. Nam liber tempor cum soluta nobis eleifend option congue nihil imperdiet doming id quod mazim placerat facer possim assum.

Lorem ipsum dolor sit amet, consectetuer adipiscing elit, sed diam nonummy nibh euismod tincidunt ut laoreet dolore nostrud exerci tation ullamcorper suscipit lobortis nisl ut aliquip ex ea commodo consequat.

Iusto odio dignissim qui blandit praesent luptatum zzril delenit atgue duis dolore te feugait nulla facilisi. Nam liber tempor cum soluta nobis eleifend option congue nihil imperdiet doming id quod mazim placerat facer possim assum.

Lorem ipsum dolor sit amet, consectetuer adipiscing elit, sed nonummy nibh eui tincidunt ut laoreet magna aliquam erat

magna anquam erat volutpat. Ut wisi enim ad minim veniam, quis nostrud exerci tation ullamcorper suscipit lobortis nisl ut aliquip ex ea commodo consequat.

A dipiscing elit, sed diam nonummy nibh euismod tincidunt ut laoreet dolore magna aliquam erat volutpat. Ut wisi enim ad minim veniam, quis nostrud exerci tation ullamcorper suscipit lobortis nisl ut aliquip ex ea commodo consequat. Duis autem vel eum iriure in hendrerit in velit esse molestie consequat, vel eu feugiat nulla vero eros et accumsan iusto odio dignissim magna aliquam erat qui volutpat. Ut wisi enim minim veniam, quis nostrud exerci tation ullamcorper suscipit lobortis nisl ut aliquip ex ea commodo consequat.

A dipiscing elit, sed diam nonummy nibh euismod tincidunt ut laoreet dolore magna blandit praesent luptatum zzril delenit augue duis dolore te feugait nulla facilisi.

Lorem ipsum dolor sit amet, consectetuer adipiscing elit, sed diam nonummy nibh euismod tincidunt ut laoreet dolore magna aliquam erat volutpat. Út wisi enim ad minim veniam, quis nostrud exerci tation ullamcorper suscipit lobortis nisl ut aliquip ex ea commodo consequat. Lorem ipsum dolor sit amet, consectetuer adipiscing elit, sed diam nonummy nibh euismod tincidunt ut laoreet dolore magna aliquam erat volutpat. Ut wisi enim ad minim veniam, quis nostrud exerci tation ullamcorper suscipit lobortis nisl ut aliquip ex ea commodo

consequat.

Duis autem vel eum iriure dolor in hendrerit in vulputate velit esse molestie consequat, vel illum dolore eu feugiat nulla facilisis at vero eros et accumsan et iusto odio dignissim qui blandit praesent luptatum zzril delenit augue duis

dolore te feugait facilisi.

Lorem ipsum amet, consectetuer adipiscing elit, sed Iusto odio dignissim qu blandit praesent luptatum zzril delenit augue duis dolore te feugait nulla facilisi. Nam liber tempor cum soluta nobis eleifend option congue nihil imperdiet doming id quod mazim placerat facer possim assum.

Lorem ipsum dolor sit amet, consectetuer adipiscing elit, sed diam

Lorem ipsum dolor sit amet, consectetuer adipiscing

Page flow

One 11 by 17 inch sheet with single-fold to 8.5 by 11, plus one 8.5 by 11 inch sheet inserted (loose).

What you need

General layout and design requires a desktop publishing program. Editing photographic images requires a digital imaging program. Dividing and reassembling the parts and pieces of vector clip art images and type requires a drawing program. (See Step 7: Choose Your Tools, page 26.)

cuismod
cet dolore
rat
cenim ad
lor sit amet,
piscing clit,
my nibh
it ut laoreet
quam erat
enim ad
uis nostrud
mcorper
nisl ut
modo
autem vel
in hendrerit

987 654 3210 or ve: http:// ticles/recipe.htm

s

resident dressz.com 10

dressz.com 10 asurer dressz.com

dressz.com 10

dressz.com

dressz.com

, consectetuer nummy nibh

1210

May 20??: News, opinion, how-to, events, gardener profiles, virtual tours, and more from the Sampler Garden Association

INSPIRATION

From the outside, in

Lorem ipsum dolor sit amet, consectetuer adipiscing elit, sed diam nonummy nibh euismod tincidunt ut laoreet dolore magna aliquam erat volutpat. Ut wisi enim ad minim veniam, quis nostrud exerci tation illamcorper suscipit obortis nisl ut aliquip x ea commodo onsequat.

Duis autem vel eum iure dolor in hendrerit vulputate velit esse olestie consequat, vel um dolore eu feugiat illa facilisis at vero os et accumsan.

From Jason B. Example, The Gardener's Ring DIRECTOR'S LETTER

Don't!

by Roger Example

Vulputate velit esse molestie consequat, vel lorem ipsum dolor sit amet, consectetuer adipiscing elit, sed diam nonummy nibh euismod tincidunt ut laoreet dolore magna aliquam erat volutpat.

Minim veniam, quis nostrud exerci tation ullamcorper suscipit lobortis nisl ut aliquip ex ea commodo consequat. Duis autem vel eum iriure dolor in hendrerit in vulputate velit esse molestie consequat, vel illum dolore eu feugiat nulla facilisis at vero eros et accumsan et iusto odio dignissim qui blandit praesent luptatum zzril delenit augue duis dolore te feugait nulla facilisi.

autem vel eum iriure dolor in hendrerit in vulputate velit esse molestie consequat, vel illum dolore eu feugiat nulla facilisis at vero eros et accumsan et iusto odio dignissim qui blandit praesent luptatum

Lorem ipsum dolor sit amet, consectetuer adipiscing elit, sed diam nonummy nibh euismod tincidunt laoreet dolore magna aliquam erat

Lorem ipsum dolor sit amet, consectetuer adipiscing elit, nonummy nibh euismod laoreet dolore magna volutpat. Ut wisi enim ad quis nostrud exerci tation aliquip ex ea commodo consequat. Duis autem vel eum iriure dolor in hendrerit in autem vel eum iriure dolor in hendrerit in vulputate velit esse molestie consequat, vel illum dolore eu feugiat nulla facilisis at vero eros et accumsan et iusto odio dignissim qui blandit praesent luptatum

Lorem ipsum dolor sit amet, consectetuer adipiscing elit, sed diam nonummy nibh euismod tincidunt ut laoreet dolore magna aliquam erat volutpat. Ut wisi enim ad minim veniam, quis nostrud exerci tation aliquip ex ea commodo consequat. Duis autem vel eum iriure dolor in hendrerit in vulputate velit esse molestie adipiscing elit, sed diam nonummy nibh euismod tincidunt ut laoreet dolore magna aliquam erat volutpat. Ut wisi enim ad minim veniam, quis nostrud exerci tation aliquip ex ea commodo consequat.

Contact Morris Example: 987 654 3210 or name@emailaddressz.com; More: http://www.yourwebaddressz.com/articles/recipe.htm

The design grid

There are three basic column grids used in this newsletter—one small and two large columns for the cover, four equal columns for the text pages, and seven equal columns for the calendar. (See Step 11.2: Establish the Page Size and Grid, page 37.)

The typefaces

Three type families are used throughout the layout. Big, bold **Impact**, a sans-serif typeface for headlines and eyebrows, classic **Minion**, a serif typeface for the text and text subhead, and unobtrusive **Franklin Gothic** for the details.

Impact

Typeface Aabbeeggkkmmqqrssww!?

Minior

Typeface
AaBbEeGgKkMmQqRrSsW

Franklin Gothic Book Condensed

Typeface AaBbEeGgKkMmQqRrSsWw!?

Minio

Text Lorem ipsum dolor sit amet, consectetuer adipiscing elit, sed diam nonummy nibh euismod tincidunt ut laoreet dolore magna aliquam erat volutpat. Ut wisi enim ad minim veniam, quis nostrud exerci tation ullamcorper suscipit lobortis nisl ut aliquip ex ea commodo consequat. Duis autem vel eum iriure dolor in hendrerit in vulputate velit esse molestie consequat, vel illum dolore eu feugiat nulla facilisis at vero eros.

The illustrations

Black-and-white photographs of real people and places mix with royalty-free photographs of generic subjects. Insect images from a picture font add some visual variety and color accents.

DISTINGUISHING FEATURES

A focal point

There are two reasons this cover photograph grabs your eye. First, because it is twice as large and a darker color than the photograph at the top left. And second, becuase it has an irregular shape. You don't need to illustrate every story. Concentrate on creating a few relevant images that work well together instead of just dropping in any pictures that fill the space.

Space for advertising

What makes this layout really different is the addition of advertising space on the inside pages. Instead of trying to sell and coordinate odd shapes and sizes, ask your advertisers to prepare an ad that is, in this case, 8 by 0.75 inches. The resulting layout affords an opportunity for advertisers to present their message while maintaining the overall look and feel of your publication.

A calendar of events

One way to ensure your newsletter remains within reach is to include current, helpful information—in this case, a calendar of events. If you don't have room for a full-size version, consider including a list of dates and times.

May 20??: News, opinion, how-to, events, gardener profiles, virtual tours, and more from the Sampler Gar Association

INSPIRATION

From the outside. in

Lorem ipsum dolor sit amet, consectetuer adipiscing elit, sed diam nonummy nibh euismod tincidunt ut laoreet dolore magna aliquam erat volutpat. Ut wisi enim ad minim veniam, quis nostrud exerci tation ullamcorper suscipit lobortis nisl ut aliquip ex ea commodo consequat.

Duis autem vel eum iriure dolor in hendrerit in vulputate velit esse molestie consequat, vel illum dolore eu feugiat nulla facilisis at vero eros et accumsan.

From Jason B. Example, The Gardener's Ring DIRECTOR'S LETTER

by Roger Example

Vulputatevelit esse molestie consequat, vel lorem ipsum dolor sit amet, consectetuer adipiscing elit, sed diam nonummy nibh euismod tincidunt ut laoreet dolore magna aliquam erat volutpat.

Minim veniam, quis nostrud exerci tation ullamcorper suscipit lobortis nisl ut aliquip ex ea commodo consequat. Duis autem vel eum iriure dolor in hendrerit in vulputate velit esse molestie consequat, vel illum dolore eu feugiat nulla facilisis at vero eros et accumsan et iusto odio dignissim qui blandit praesent luptatum zzril delenit augue duis dolore te feugait nulla facilisi.

autem vel eum iriure dolor in hendrerit in vulputate velit esse molestie consequat, vel illum dolore eu feugiat nulla facilisis at vero eros et accumsan et iusto odio dignissim qui blandit praesent luptatum

Lorem ipsum dolor sit amet, consectetuer adipiscing elit, sed diam nonummy nibh euismod tincidunt laoreet dolore magna aliquam erat

Lorem ipsum dolor sit amet, consectetuer adipiscing elit, nonummy nibh euismod laoreet dolore magna volutpat. Ut wisi enim ad quis nostrud exerci tation aliquip ex ea commodo consequat. Duis autem vel eum iriure dolor in hendrerit in autem vel eum iriure dolor in hendrerit in vulputate velit esse molestie consequat, vel illum dolore eu feugiat nulla facilisis at vero eros et accumsan et iusto odio dignissim qui blandit praesent luptatum

Lorem ipsum dolor sit amet, consectetuer adipiscing elit, sed diam nonummy nibh euismod tincidunt ut laoreet dolore magna aliquam erat volutpat. Ut wisi enim ad minim veniam, quis nostrud exerci tation aliquip ex ea commodo consequat. Duis autem vel eum iriure dolor in hendrerit in vulputate velit esse molestie adipiscing elit, sed diam nonummy nibh euismod tincidunt ut laoreet dolore magna aliquam erat volutpat. Ut wisi enim ad minim veniam, quis nostrud exerci tation aliquip ex ea commodo consequat.

Contact Morris Example: 987 654 3210 or name@emailaddressz.com;

VIRTUAL TOUR

By the book backyard garden

Lorem ipsum dolor sit amet, consectetuer adipiscing elit, sed diam nonummy nibh euismod tincidunt ut laoreet dolore magna aliquam erat itpat. Ut wisi enim ad m veniam, quis nostrud exerci tation ullamcorper uscipit lobortis nisl ut aliquip ex ea commodo equat.

Duis autem vel eum iriure dolor in hendrerit in vulputate velit esse molestie consequat, vel illum dolore eu feugiat nulla facilisis at vero eros et accumsan et iusto odio dignissim qui blandit praesent luptatum zzril delenit augue duis dolore te feugait nulla facilisi, et accumsan etatumi dipiscing elit, sed diam nonummy nibh euismod tincidunt ut laoreet dolore

Lorem ipsum dolor sit amet, consectetuer adipiscing elit, sed diam nonummy nibh euismod tincidunt ut laoreet dolore magna aliquam erat volutpat. Út wisi enim ad minim veniam, quis nostrud exerci tation ullamcorper suscipit lobortis nisl ut aliquip ex ea commodo consequat.

Duis autem vel eum iriure dolor in hendrerit in vulputate velit esse molestie equat, vel illum dolore eu feugiat nulla facilisis at vero eros et accumsan et iusto odio dignissim qui blandit praesent luptatum zzril delenit augue duis dolore te feugait nulla facilisi. Nam liber temp cum soluta nobis eleifend option congue nihil imperdiet doming id quod mazim placerat facer possim volutpat. Ut wisi enim ad minim veniam, quis nostrud exerci tation ullamcorper suscipit lobortis nisl ut

Lorem ipsum dolor sit amet, consectetuer adipiscing elit, sed diam ımmy nibh euismod tincidunt ut laoreet dolore magna aliquam erat volutpat. Ut wisi enim ad minim veniam, quis nostrud exerci tation ullamcorper suscipit lobortis nisl ut aliquip ex ea commodo

consequat. Duis autem vel eum iriure dolor in hendrerit in vulputate velit esse molestie consequat, vel illum dolore eu feugiat nulla facilisis at vero eros et accumsan et iusto odio dignissim qui blandit praesent luptatum zzril delenit augue duis dolore te feugait nulla facilisi eros et accumsan et volutpat. Ut wisi enim ad minim veniam, quis nostrud exerci tation ullamcorper suscipit lobortis nisl ut

NEWSLETTER NAME (ISSN #1234-5678), May 20??, Volume One Number Five, Published by Organization's Name, 3028 Example Road, Your City, ST 12345-6789, \$12/yr, POSTMAS 12345-0789. \$12/yf; POSINIAS-TER: Send address changes to Publication Name, 3028 Exampl Road, Your City, ST 12345-6789 Copyright 20?? by Organization Name. All rights reserved, Legal Disclaimer. Copyright Clearance Center.

ADVERTISING

For information about adverti in Publication Name, contact Name at 987 654 3210

3028 Example Road P.O. Box 1245 Your City, ST 12345-6789 987 654 3210 987 654 3210 Fax

EXECUTIVE DIRECTOR Sarah Example 987 654 3210

NEWSLETTER EDITOR

Dr. Fred Example 987 654 3210 ART DIRECTOR

Milton Examp

MEMBERSHIP

Duis autem vel eum iriure dolor in hendrerit in vulputate velit esse molestie consequat, vel illum dolore eu feugiat nulla facilisis at vero eros et accumsan et iusto odio dignissim qui blandit præsent luptatum zzril delenit augue duis dolore te feugait nulla control de la colore de la colore colore la colore de la colore colore la colore la colore colore la colore la colore colore la colore colore la colore colo

3028 Example Road P.O. Box 1245 Your City, ST 12345-6789

Saturday, May 15th: Celebrate 25 years of great gardening with the Sampler Garden Association

SANDRA EXAMPLE SAMPLER CORPORATION 123 EXAMPLE BOULEVARD STE 200 YOUR CITY ST 12345 6789

U.S. Postage Paid Permit ??? Your City, ST 12345-6789

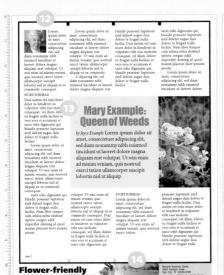

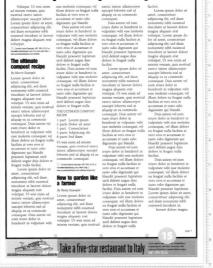

Cover (page 1)

1"Sampler" Impact, 48pt, align left; "gardener" Impact, 108pt, align left; 2 Subtitle Impact 12/12pt, align left; 3 Line 4pt; Eyebrow Impact 12pt, align left; Headline Impact 18/16pt, align left; Text Minion 11/ 12pt, align left; Signature Minion 10/11pt, align right 4 Eyebrow Impact 12pt, align left; Headline Impact 95pt, align left; Contributor Minion Italic 10pt, align left; Text Minion 11/12pt, align left; 5 Contact Franklin Gothic Book Condensed 7/8pt, align left; 6 Caption Minion Italic 9/10pt, align left; Month Impact 90pt, align left.

Back Cover (page 6)

7 Line 4pt; Eyebrow Impact 12pt, align left; Headline Impact 18/16pt, align left; Text Minion 11/12pt, align left; Contact Franklin Gothic Book Condensed 7/8pt, align left; Page number Minion Italic 8pt, align left; 8 Return address Franklin Gothic Book Condensed 8/8pt, align left; Teaser Impact 18/17pt, align left; 9 Mailing address Courier 9/9pt, align left; 10 Postage indicia Franklin Gothic Book Condensed 8/8pt, align center; 11 "Sampler" Impact, 18pt, align left; "gardener" Impact, 30pt, align left; Masthead text Franklin Gothic Book Condensed 9/10pt, align left; Text subhead Franklin Gothic Book Condensed 8pt, align left; Copyright Franklin Gothic Book Condensed 7pt, align left.

Pages 2 & 3

12 Line 4pt; Headline Impact 18/16pt, align left; Text Minion 11/12pt, align left; Text subhead Minion 10pt, align left; Contact Franklin Gothic Book Condensed 7/8pt, align left; Page number Minion Italic 8pt, align left; 13 Sidebar headline Impact, 36/ 32pt, align center; Sidebar text Minion 16/18pt, align left; 14 Headline Frutiger Ultra Black 24pt, align left; Text Franklin Gothic Book Condensed 8/8pt, align left; Phone Frutiger Ultra Black 18pt, align left; 15 Headline Raleigh Gothic 39pt, align left; Text Franklin Gothic Book Condensed 8/8pt, align left; Phone Franklin Gothic Book Condensed 10pt, align left

SOURCE Illustrations: Flowers (pg. 1) from Seasons from Eyewire, 800-661-9410, 403-262-8008, www.eyewire.com. © Eyewire, Inc., all rights reserved; Illustration Gardener with clippers (pg. 1), slides (pg. 6), flowers (pg. 2), spray, landscape (pg. 2) from Photo-Objects 50,000, Vol II from Hemera Technologies 819-772-8200, www.hemera.com, © Hemera Technologies Inc., all rights reserved; Woman (pg. 2) from Faces 3 from RubberBall Productions 801-224-6886, www.rubberball.com. © RubberBall Productions, all rights reserved; Ship (pg. 3) from Task Force Image Gallery from NVTech, 800-387-0732, 613-727-8184, www.nvtech.com, © NVTech, all rights reserved.

SOURCE Type Families: Franklin Gothic, Frutiger, Impact, Minion, Adobe Systems, Inc. 800-682-3623, www.adobe.com/type;Raleigh Gothic, AGFA/Monotype, 888-988-2432,978-658-0200,www.agfamonotype.com.

Page 4

16 Headline Impact 36/32pt, align left; Text Minion 11/12pt, align left; Contributor Minion Italic 10pt, align left; Text Minion 11/12pt, align left; Page number Minion Italic 8pt, align left; Contact Franklin Gothic Book Condensed 7/8pt, align left; 17 Sidebar Headline Franklin Gothic Book Condensed 8/10pt, align left; Sidebar text Franklin Gothic Book Condensed 9/10pt, align left; 18 Subhead Franklin Gothic Book Condensed 8pt, align left; Headline Interstate Ultra Black 25pt, align center; Text Franklin Gothic Book Condensed 7/8pt, align left; Phone Interstate Ultra Black 12pt, align center

Page 5

19 "Sunday" Impact 14pt, align left; "April" Impact 12pt, align left; Time Minion 8pt, align left; Description Minion 10/10pt, align left; "SGA" Impact 12/12pt, align left; Month Impact 90pt, align left; Page number Minion Italic 8pt, align left; 20 Phone Frutiger Ultra Black 18pt, align left; Headline Bickham Script 40pt, align center; Subhead Copperplate Gothic 33BC 10pt, align center; Text 8/9pt, align left

Color

To be printed in black and a solid PANTONE Color Ink as defined on the palette below (see Step 9.3). (Because this book is printed in process colors (CMYK), the illustration is only a simulation of the actual solid PANTONE Color).

SOURCE Illustrations: Insects (pg. 4) from Insecta picture font by Judith Sutcliffe; Cable (pg. 4) from Task Force Image Gallery from NVTech, 800-387-0732, 613-727-8184, www.nvtech.com, © NVTech, all rights reserved; Woman and dog from Photo-Objects 50,000, Vol II from Hemera Technologies 819-772-8200, www.hemera.com; © Hemera Technologies, all rights reserved

SOURCE Type Families: Bickham Script, Copperplate Gothic 33BC, Franklin Gothic, Impact, Minion, Adobe Systems, Inc. 800-682-3623, www.adobe.com/type; Interstate Ultra Black, Font Bureau, 617-423-8770, www.fontbureau.com.

Friendly insects

By Becky Example
Lorem ipsum dolor sit
amet, consectetuer
adipiscing elit, sed diam
nonummy nibh euismod
tincidunt ut laoreet dolore
magna aliquam erat
volutpat. Ut wisi enim ad
minim veniam, quis
nostrud exerci tat
ullamcorper suscipi
lobortis nisl ut aliq
ea commodo conseq

Duis autem vel eum iriure dolor in hendrerit in vulputate velit esse molestie consequat, vel illum dolore eu feugiat nulla facilisis at vero eros et accumsan et iusto odio dignissim qui blandit praesent luptatum zzril delenit augue duis dolore te feugait nulla facilisi.

Lorem ipsum dolor sit amet, consectetuer adipiscing elit, sed diam nonummy nibh euismod tincidunt ut laoreet dolore magna aliquam erat volutpat. Ut wisi enim ad minim venim denim d

minim veniam, quis lusto odio dignissim qui blandit praesent luptatum zzril delenit augue duis dolore te feugait nulla facilisi. Nam liber tempor cum soluta nobis eleifend option congue nihil imperdiet doming id quod mazim placerat facer possim assum.

Lorem ipsum dolor sit amet, consectetuer adipiscing elit, sed diam nonummy nibh euismod tincidunt ut laoreet dolore

nostrud exerci tation ullamcorper suscipit lobortis nisl ut aliquip ex ea commodo consequat.

Iusto odio dignissim qui blandit praesent luptatum zzril delenit augue duis dolore te feugait nulla facilisi. Nam liber tempor cum soluta nobis eleifend option congue nihil imperdiet doming id quod mazim placerat facer possim assum.

Lorem ipsum dolor sit amet, consectetuer adipiscing elit, sed nonummy nibh eui tincidunt ut laoreet magna aliquam erat volutpat. Ut wisi enim ad

volutpat. Ut wisi enim ad minim veniam, quis nostrud exerci tation ullamcorper suscipit lobortis nisl ut aliquip ex ea commodo consequat.

A dipiscing elit, sed diam nonummy nibh euismod tincidunt ut laoreet dolore magna aliquam erat volutpat. Ut wisi enim ad minim veniam. quis nostrud exerci tation illamcorper suscipit lobortis nisl ut aliquip ex ea commodo consequat. Duis autem vel eum iriure in hendrerit in velit esse molestie consequat, vel eu feugiat nulla vero eros et accumsan iusto odio dignissim magna aliquam erat qui volutpat. Ut wisi enim minim veniam, quis nostrud exerci tation illamcorper suscipit lobortis nisl ut aliquip ex ea

commodo consequat.

A dipiscing elit, sed
diam nonummy nibh
euismod tincidunt ut
laoreet dolore magna

blandit praesent luptatum zzril delenit augue duis dolore te feugait nulla facilisi.

Lorem ipsum dolor sit amet, consectetuer adipiscing elit, sed diam nonummy nibh euismod tincidunt ut laoreet dolore magna aliquam erat volutpat. Ut wisi enim ad minim veniam, quis nostrud exerci tation ullamcorper suscipit lobortis nisl ut aliquip ex ea commodo consequat. Lorem ipsum dolor sit amet, consectetuer adipiscing elit, sed diam nonummy nibh euismod tincidunt ut laoreet dolore magna aliquam erat volutpat. Út wisi enim ad minim veniam, quis nostrud exerci tation ullamcorper suscipit lobortis nisl ut aliquip ex ea commodo consequat. Duis autem vel eum

Duis autem vel eum irure dolor in hendrerit in vulputate velit esse molestie consequat, vel illum dolore eu feugiat nulla facilisis at vero eros et accumsan et iusto odio dignissim qui blandit praesent luptatum zzril delenit augue duis

zzril delenit augue duis
dolore te feugait
facilisi.
Lorem ipsum
amet, consectetuer
adipiscing elit, sed
lusto odio dignissim qu
blandit praesent luptatum
zzril delenit augue duis
dolore te feugait nulla
facilisi. Nam liber tempor
cum soluta nobis eleifend
option congue nihil
imperdiet doming id quod
mazim placerat facer
possim assum.

Lorem ipsum dolor sit amet, consectetuer adipiscing elit, sed diam nonummy nibh euismod tincidunt ut laoreet dolore magna aliquam erat volutpat. Ut wisi enim ad Lorem ipsum dolor sit amet, consectetuer adipiscing elit, sed diam nonummy nibh euismod tincidunt ut laoreet dolore magna aliquam erat volutpat. Ut wisi enim ad minim veniam, quis nostrud exerci tation ullamcorper suscipit lobortis nisl ut aliquip ex ae commodo consequat. Duis autem vel eum iriure dolor in hendrerit in vulputate velit.

Contact Morris Example: 987 654 3210 o name@emailaddressz.com; More: http://

SAMPLER GARDENER

Tawana Example, President name@youremailaddressz.com Office: 987 654 3210

John Example, Secretary name@youremailaddressz.com Office: 987 654 3210

Shirley Example, Treasurer name@youremailaddressz.com Office: 987 654 3210

Nathan Example name@youremailaddressz.com Office: 987 654 3210

Lewis Example name@youremailaddressz.com Office: 987 654 3210

Meryl Example name@youremailaddressz.com Office: 987 654 3210 Ronda Example name@youremailaddressz.com Office: 987 654 3210

Lorem ipsum dolor sit amet, consectatuer

page 4

Lorem Ipsum dolor sit amet, consectetuer adipiscing

<u>հարմիսուվուսմիսուվուրմիսուվուսնիսուկումիսուվուսմիսուկումիսուկումիսուկու</u>մ

THROW IT AWAY!

Lorem ipsum dolor sit amet, consectetuer adipiscing elit, sed diam nonummy nibh euismod tincidunt ut laoreet dolore magna

Violet or PANTONE® 814

100% 35% 30%

1070

Gunday	Monday	Tuesday	Wednesday	Thursday	Friday	Saturday
April 25	9:45 A.M. Event Title Description lorem ipsum dolor sit amet, consectetuer adipiscing elit, sed diam nonummy nibh euismod tincidunt utlaoreet	7:00 A.M. Reminder Title Description dolore magna aliquam erat volutpat.	28 6:00 P.M. Event Title Description ut wisi enim ad minim veniam, quis nostrud exerci tation ullamcorper suscipit lobortis.	29	30	May 1 11:00 A.M. Event Title Description ut wiss enimad minim veniam, quis nostrud exerci tation ullamcorper suscipit.
	7:00 A.M. Reminder Title Description dolore magna aliquam erat volutpat. More: http:// www.yourwebaddressz.com/ calendar	9:00 A.M. Reminder Title Description dolore magna aliquam erat volutpat. quis nostrud exerci tation ullam corper suscipit lobortis nisl ut aliquip ex ea commodo.	5	6:00 P.M. Event Title Description ut wisi enimad minim veniam, quis nostrud.	8:00 & 9:00 P.M. Event Title Description ut wisi enimadminim veniam, quis nostrudexerci tation ullamcorper suscipit.	8
9 4:30 P.M. Event Title Description lorem ipsum dolor sit amet, consectetuer adipiscing elit, sed diam nonummynibh euismod tincidunt ut laoreet	10	11	6:00 P.M. Event Title Description ut wisi enimadminim veniam, quis nostrud exerci tation ullamcorper suscipit lobortis nisl ut aliquip.	13	11:00 A.M. Event Title Descriptionlorem ipsum dolor sit amet, consectetuer adipiscing elit, sed diamnonummy nibh euismod tincidunt ut laoreet.	15 SGA 25th Annual Conference 7:00 A.M. Event Title Descriptionlorem ipsum dolor sit amet, consect.
16	6:00 P.M. Event Title Description ut wisi enimad minim veniam, quis nostrud exercitation ullamcorper.	7:00 A.M. Reminder Title Description dolore magna aliquam erat volutpat. 6:00 P.M. Event Title Description ut wisi enim ad minim veniam.	19	5:00 P.M. Event Title Description ut wisi enimad minim veniam, quis nostrud exerci tation ullamcorper suscipit lobortis nisl ut aliquip ex ea commodo.	21	22
23 6:00 P.M. Event Title Description ut wisi enimad minim 30 9:45 A.M. Reminder Title Description.	7:00 A.M. Reminder Title Description.	25	5:00 P.M. Event Title Description ut wisi enimad minim veniam, quis nostrud exerci	6:00 P.M. Event Title Description ut wisi enimad minim veniam, quis nostrud.		29 6:00 P.M. Event Title Description ut wis

10

The Example Adventure
AN UNUSUAL ADVENTURE BY TERRA SAMPLER

Lorem ipsum dolor sit amet, consectetuer adipiscing elit, sed diam nonummy nibh euismod tincidunt ut laoreet dolore magna aliquam erat volutpat.

8.5 W 11 H

STYLE 2 (4 PAGES)

Bulletin

Bulletin means "for immediate broadcast," and this layout is designed to convey that same sense of urgency. But equally important is the fact that it is designed to be produced with bulletin-like speed.

It is a timesaver because all the headlines, text, and illustrations are framed within a single running column—instead of placing and arranging individual elements on individual pages, you simply decide on the order in which you want the articles to appear and insert them.

And they lived happily ever after

Lorem ipsum dolor sit amet, consectetuer adipiscing elit, sed diam nonummy nibh euismod tincidunt ut lao reet dolore m allquam erat volutpat. Ut wisi enim ad minim veniam, quis nostrud exerci tation ullamcorper suscipit loborits nisi ut aliqui commodo consequat. Duis autem vel eum iniure dolor in hendrerit in vulputate veiti esse moleste consequat, vel illum de feugiat nulla facilisis at vero eros et Nam liber tempor cum soluta nobis eleifend option congue nihil imperdiet doming id mazim placerat facer possim assum. Ut wisi enim ad minim veniam, quis nost rud exerci tation ullam corper suscipit lobor ut aliquip ex ea commodo consequat.

Duis autem vel eum iriure dolor in hendrent in vulputate velit esse molestie consequat, vel illum dolore eu feugiat nu, facilisis at vero eros et accumsan et iusto odio dignissim qui blandit praesent luptatum zril delenit augue duis dolore te il nulla facilisisi. Lorem ipsum dolor sit amet, consectetuer adipiscing elit, sed diam nonummy nibh euismod tincidunt ut laor dolore magna aliquam erat volutpat. Ut wisi enim ad minim veniam, suscipit lobortis nisi ut aliquip ex ea commodo consecteuer adipiscing elit, sed diam nonummy nibh euismod tincidunt ut laoreet dolore magna aliquam erat volutpat. Ut wisi enim ad minim veniam, quis nostrud exerci tation ullamcorper suscipit lobortis nisi ut aliquil commodo consequat. Duis autem vel elit, sed diam nonummy nibh euismod tincidunt ut laoreet dolore magna.

Ut wisi enim ad minim veniam, quis nostrud exerci tation ullamcorper suscipit lobortis nisl ut aliquip ex ea commodo consequat. Duis autem vel eum inture dolor in hendrent in vulputate veilt esseeum inture dolor in hendrent in vulputate vei molestie consequat, vel illum dolore eu feugiat nulla facilisis at vero eros et Nam liber tempor cum soluta nobis eleifend mazim placerat facer possim assum commodo consequat. A new customer, a new design, and a new way of thinking Lorem ipsum dolor sit amet, consectetuer adipiscing elit, sed diam nonummy nibh euismod tincidunt ut laoreet dolore ma aliquam erat volutpat. Ut wisi enim ad minim veniam, quis nostrud exerci tation ullam corper suscipit lobortis nisl ut aliqui ea commodo consequat.

a commodo consequat.

Duis autem vel eum iriure dolor in hendrent in vulputate veilt esse molestie consequat, vel illium dolore eu feuglat nui facilisis at vero eros et accumsan et iusto odio dignissim qui blandit praesent luptatum zzrii delenit augue duis dolore te fi nulla facilisi. Lorem ipsum dolor sit amet, consectetuer adipiscing elit, sed diam nonummy nibh euismod tincidunt ut laore dolore magna allquam erat volutpat. Ut wisi enim ad minim veniam, suscipit lobortis nist ut aliquip ex ea commodo conselucem josum dolor sit amet, consectetuer adipiscing elit, sed diam nonummy nibh euismod tincidunt ut laoret dolore ma aliquam erat volutpat. Ut wisi enim ad minim veniam, quis nostrud exerci tation ullamcorper suscipit lobortis nist ut aliqui; commodo consequat. Duis autem vel elit, sed diam nonummy nibh euismod tincidunt ut laoret dolore magna aliquam erat volutpat.

Ut wisi enim ad minim veniam, quis nostrud exerci tation ullamcorper suscipit lobortis nisl ut aliquip ex ea commodo consequat. Duis autem vel eum inture dolor in hendrent in vulputate vell'esseeum inture dolor in hendrent in vulputate vet moleste consequat, vel illum dolore eu feuglan tulla facilisis at vero ess et.— L'inda Eample, Derigere.

3028 Example Road, P.O. Box 1245, Your City, ST 12345-6789
Phone 987 654 3210 Fax 987 654 3210 E-mail info@emailaddressz.com Web www.yourwebaddressz.com

How can	Name Title	Date	
we help?	Company		
☐ Please call	Address		
Best time?	City	State	Zip
Send literature Regarding?	Daytime Phone		
☐ Send customer package	E-mail address		
How marry?	May we ask?		Please return you
Option four Best time?	Question 1		in the enclosed penvelope to:
Option five	Question 2		J.R. Sampler & C 3028 Example R
How many?	Question 3		P.O. Box 1245, Y

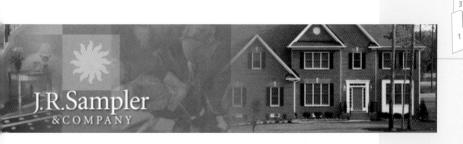

Page flow

Two 8.5 by 14 inch sheets (portrait) are folded into thirds to fit a standard 9.5 by 4.125 inch commercial envelope.

What you need

General layout and design requires a desktop publishing program. Creating the collage of photographic images and type used in the nameplate requires a digital imaging program. (See Step 7: Choose Your Tools, page 26.)

Broker Bulletin: SUMMER 20??

Winning the Builder Association's annual award never crossed my mind...

Lorem ipsum dolor sit amet, consectetuer adipiscing elit, sed diam nonummy nibh euismod tincidunt ut laoreet dolore magna aliquam erat volutpat. Ut wisi enim ad minim veniam, quis nostrud exerci tation ullam corper suscipit lobortis nisl ut aliquip ex ea commodo consequat.

Duis autem vel eum iriure dolor in hendrerit in vulputate velit esse molestie consequat, vel illum dolore eu feugiat nulla facilisis at vero eros et accumsan et iusto odio dignissim qui blandit praesent luptatum zzril delenit augue duis dolore te feugait nulla facilisi. Lorem ipsum dolor sit amet, consectetuer adipiscing elit, sed diam nonummy nibh euismod tincidunt ut lao reet dolore magna aliquam erat volutpat. Ut wisi enim ad minim veniam, suscipit lobortis nisl ut aliquip ex ea commodo consequat. Lorem ipsum dolor sit amet, consectetuer adipiscing elit, sed diam nonummy nibh euismod tincidunt ut lao reet dolore magna aliquam erat volutpat. Ut wisi enim ad minim veniam, quis nostrud exerci tation ullamcorper suscipit lobortis nisi ut aliquip ex ea commodo consequat. Duis autem vel elit, sed diam nonummy.

Nibh euismod tincidunt ut laoreet dolore magna aliquam erat volutpat. Ut wisi enim ad minim veniam, quis nostrud exerci tation ullamcorper suscipit lobortis nisl ut aliquip ex ea commodo consequat. Duis autem vel eum inure dolor in hendrent in vulputate velit esseeum iriure dolor in hendrerit in vulputate velit esse molestie consequat, vel illum dolore eu feugiat nulla facilisis at vero eros et Nam liber tempor cum soluta nobis eleifend opquod mazim placerat facer possim assum commodo

A morning sunshine, culinary masterpiece, everybody-sit-back-and-relax space

Lorem ipsum dolor sit amet, consectetuer adipiscing elit, sed diam nonummy nibh euismod tincidunt ut laoreet dolore magna aliquam erat volutpat. Ut wisi enim ad minim veniam, quis nostrud exerci tation ullamcorper suscipit lobortis nisi ut aliquip ex ea commodo consequat. Duis autem vel eum iriure dolor in hendrerit in vulputate velit esse molestie consequat, vel illum dolore eu feugiat nulla facilisis at vero eros et Nam liber tempor cum soluta nobis eleifend option congue nihil imperdiet doming id quod mazim placerat facer possim assum. Ut wisi enim ad minim veniam, quis nost rud exerci tation ullam corper suscipit lobortis nisl ut aliquip ex ea commodo consequat.

Duis autem vel eum iriure dolor in hendrerit in vulputate velit esse molestie consequat, vel illum dolore eu feugiat nulla facilisis at vero eros et accumsan et iusto odio dignissim qui blandit praesent lupta tum zzril delenit augue duis dolore te feugait nulla facilisi. Lorem ipsum dolor sit amet, consectetuer adipiscing elit, sed diam nonummy nibh euismod tincidunt ut laoreet dolore magna aliquam erat volutpat. Ut wisi enim ad minim veniam, suscipit lobortis nisl ut aliquip ex ea commodo consequat. Lorem ipsum dolor sit amet, consectetuer adipiscing elit, sed diam nonummy nibh euismod tincidunt ut lao reet dolore magna aliquam erat volutpat. Duis autem vel elit, sed diam nonummy nibh euismod tincidunt ut laoreet dolore magna aliquam erat volutpat. Ut wisi enim ad minim veniam, quis nostrud exerci tation ullamcorper suscipit lobortis nisl ut aliquip ex ea commodo consequat. Duis autem vel eum inure dolor in hendrerit in vulputate velit esseeum inure dolor in hendrerit in vulputate velit esseeum inure dolor in hendrerit in vulputate velit esseeum inure dolor in hendrerit in vulputate velit esse molestie consequat, vel illum dolore eu feugiat nulla facilisis at vero eros et Nam liber tempor cum soluta nobis eleifend opquod Revealing the truth about closing costs

Lorem ipsum dolor sit amet, consectetuer adipiscing elit, sed diam nonummy nibh euismod tincidunt ut lao reet dolore magna aliquam erat volutpat. Ut wisi enim ad minim veniam, suscipit lobortis nisl ut aliquip ex ea commodo consequat. Lorem ipsum dolor sit amet, consectetuer adipiscing elit, sed diam nonummy nibh euismod tincidunt ut laoreet dolore magna aliquam erat volutpat. Ut wisi enim ad minim veniam, quis nostrud exerci tation ullamcorper suscipit lobortis nisl ut aliquip ex ea commodo consequat. Duis autem vel elit, sed diam nonummy nibh euismod tincidunt ut lao reet dolore magna aliquam erat volutpat. Lorem ipsum dolor sit amet, consectetuer adipiscing elit, sed diam nonummy nibh euismod tincidunt.

Ut wisi enim ad minim veniam, quis nostrud exerci tation ullamcorper suscipit lobortis nisi ut alim consequat. Duis autem vel eum iriure dolor in hendrerit in vulputate volte molestie consequat, vel illum dolore ou face

The design grid

A classic newsletter uses classic business letter form—a single column surrounded by a simple rectangular border. (See *Step 11.2: Establish the page size and grid,* page 37.)

The typefaces

The typefaces used are as simple and straightforward as the design. A classic serif—Minion for the headlines, subheads, and contact information, and easy-to-read sans serif Franklin Gothic for the text.

Minion

Typeface AaBbEeGgKkMmQqRrSsW

Franklin Gothic Book Condensed

Typeface

AaBbEeGgKkMmQqRrSsWw!?

Franklin Gothic Book Condensed

Text Lorem ipsum dolor sit amet, consectetuer adipiscing elit, sed diam nonummy nibh euismod tincidunt ut laoreet dolore magna aliquam erat volutpat. Ut wisi enim ad minim veniam, quis nostrud exerci tation ullamcorper suscipit lobortis nisl ut aliquip ex ea commodo consequat. Duis autem vel eum iriure dolor in hendrerit in vulputate velit esse molestie consequat, vel illum dolore eu feugiat nulla facilisis at vero eros.

The illustrations

The nameplate is a collage of the publisher's building projects plus a royalty-free photograph of roses, and a clip art symbol of the sun. It establishes the short, wide, panorama format uses throughout.

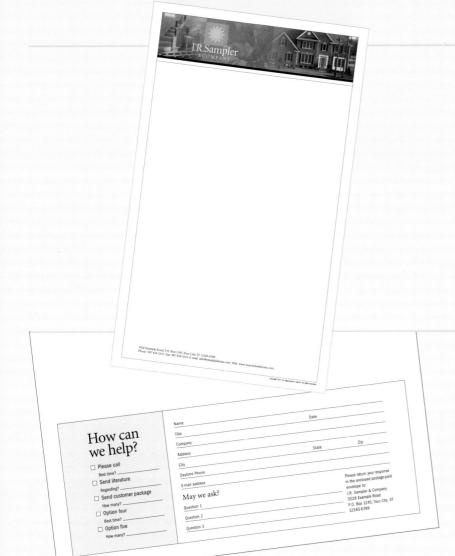

Print it now, use it later

If you publish to a small list and want to produce your newsletter as needed, have the nameplate and border preprinted on a commercial printing press, then imprint individual sheets on your desktop printer. If the size of your list makes imprinting impractical and/or you opt for four- or two-color printing, you may still save money by preprinting a year's worth of sheets and having each issue copied onto the sheet using a production copier.

Create a call to action

The coupon on the bottom of the last page asks, "How can we help?" It's an important question to ask. If you want your reader to take specific action, give them a way to take it—to return a coupon, fax back a form, visit a specific Web address, complete a phone survey, and so on. Every newsletter should leave no doubt of "where do we go from here?"

Save on postage

Postage is often a significant part of a newsletter budget (see *Step 2.7: Gather Mailing Information and Expertise*, page 14). Designing to fit within the size and weight limitations of mailing regulations can save a significant amount of money over the life of a newsletter. These sheets are easily folded to fit a standard 9.5 by 4.125 inch commercial business envelope. It not only saves money—it keeps the contents of the letter confidential.

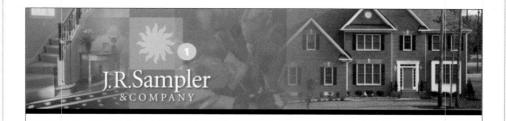

Broker Bulletin: SUMMER 20??

Winning the Builder Association's annual award never crossed my mind...

Lorem ipsum dolor sit amet, consectetuer adipiscing elit, sed diam nonummy nibh euismod tincidunt ut lao reet dolore magna aliquam erat volutpat. Ut wisi enim ad minim veniam, quis nostrud exerci tation ullam corper suscipit lobortis nisl ut aliquip ex ea commodo consequat.

Duis autem vel eum iriure dolor in hendrerit in vulputate velit esse molestie consequat, vel illum dolore eu feugiat nulla facilisis at vero eros et accumsan et iusto odio dignissim qui blandit praesent luptatum zzril delenit augue duis dolore te feugait nulla facilisi. Lorem ipsum dolor sit amet, consectetuer adipiscing elit, sed diam nonummy nibh euismod tincidunt ut laoreet dolore magna aliquam erat volutpat. Ut wisi enim ad minim veniam, suscipit lobortis nisl ut aliquip ex ea commodo consequat. Lorem ipsum dolor sit amet, consectetuer adipiscing elit, sed diam nonummy nibh euismod tincidunt ut laoreet dolore magna aliquam erat volutpat. Ut wisi enim ad minim veniam, quis nostrud exerci tation ullamcorper suscipit lobortis nisl ut aliquip ex ea commodo consequat. Duis autem vel elit, sed diam nonummy.

Nibh euismod tincidunt ut laoreet dolore magna aliquam erat volutpat. Ut wisi enim ad minim veniam, quis nostrud exerci tation ullamcorper suscipit lobortis nisl ut aliquip ex ea commodo consequat. Duis autem vel eum iriure dolor in hendrerit in vulputate velit esseeum iriure dolor in hendrerit in vulputate velit esseeum iriure dolor in hendrerit in vulputate velit esse molestie consequat, vel illum dolore eu feuglat nulla facilisis at vero eros et Nam liber tempor cum soluta nobis eleifend opquod mazim placerat facer possim assum commodo consequat. – Jim Example, President

A morning sunshine, culinary masterpiece, everybody-sit-back-and-relax space

Lorem ipsum dolor sit amet, consectetuer adipiscing elit, sed diam nonummy nibh euismod tincidunt ut lao reet dolore magna aliquam erat volutpat. Ut wisi enim ad minim veniam, quis nostrud exerci tation ullamcorper suscipit lobortis nisl ut aliquip ex ea commodo consequat. Duis autem vel eum iriure dolor in hendrerit in vulputate velit esse molestie consequat, vel illum dolore eu feugiat nulla facilisis at vero eros et Nam liber tempor cum soluta nobis eleifend option congue nihil imperdiet doming id quod mazim placerat facer possim assum. Ut wisi enim ad minim veniam, quis nost rud exerci tation ullam corper suscipit lobortis nisl ut aliquip ex ea commodo consequat.

Duis autem vel eum iriure dolor in hendrerit in vulputate velit esse molestie consequat, vel illum dolore eu feugiat nulla facilisis at vero eros et accumsan et iusto odio dignissim qui blandit praesent luptatum zzril delenit augue duis dolore te feugait nulla facilisis. Lorem ipsum dolor sit amet, consectetuer adipiscing elit, sed diam nonummy nibh euismod tincidunt ut lao reet dolore magna aliquam erat volutpat. Ut wisi enim ad minim veniam, suscipit lobortis nisi ut aliquip ex ea commodo consequat. Lorem ipsum dolor sit amet, consectetuer adipiscing elit, sed diam nonummy nibh euismod tincidunt ut lao reet dolore magna aliquam erat volutpat. Duis autem vel elit, sed diam nonummy nibh euismod tincidunt ut laoreet dolore magna aliquam erat volutpat. Ut wisi enim ad minim veniam, quis nostrud exerci tation ullamcorper suscipit lobortis nisl ut aliquip ex ea commodo consequat. Duis autem vel eum iriure dolor in hendrerit in vulputate velit esse emul iriure dolor in hendrerit in vulputate velit esse molestie consequat, vel illum dolore eu feugiat nulla facilisis at vero eros et Nam liber tempor cum soluta nobis eleifend opquod mazim placerat facer possim assum commodo consequat. — Linda Example, Designer

Revealing the truth about closing costs

Lorem ipsum dolor sit amet, consectetuer adipiscing elit, sed diam nonummy nibh euismod tincidunt ut laoreet dolore magna aliquam erat volutpat. Ut wisi enim ad minim veniam, suscipit lobortis nisl ut aliquip ex ea commodo consequat. Lorem ipsum dolor sit amet, consectetuer adipiscing elit, sed diam nonummy nibh euismod tincidunt ut laoreet dolore magna aliquam erat volutpat. Ut wisi enim ad minim veniam, quis nostrud exerci tation ullamcorper suscipit lobortis nisl ut aliquip ex ea commodo consequat. Duis autem vel elit, sed diam nonummy nibh euismod tincidunt ut laoreet dolore magna aliquam erat volutpat. Lorem ipsum dolor sit amet, consectetuer adipiscing elit, sed diam nonummy nibh euismod tincidunt.

Ut wisi enim ad minim veniam, quis nostrud exerci tation ullamcorper suscipit lobortis nisl ut aliquip ex ea commodo consequat. Duis autem vel eum irlure dolor in hendrerit in vulputate velit esseeum irlure dolor in hendrerit in vulputate velit esseeum irlure dolor in hendrerit in vulputate velit essee molestie consequat, vel illum dolore eu feugiat nulla facilisis at vero eros et Nam liber tempor cum soluta nobis eleifend opquod mazim placerat facer possim assum commodo consequat. — Melinate Example, Financing Specialist

3028 Example Road, P.O. Box 1245, Your City, ST 12345-6789 Phone 987 654 3210 Fax 987 654 3210 E-mail info@emailaddressz.com Web www.yourwebaddressz.com

PAGE 1

opyright 20?? by Organization's Name. All rights reserved

12

13

A strategy for absorbing interior design costs

Lorem ipsum dolor sit amet, consectetuer adipiscing elit, sed diam nonummy nibh euismod tincidunt ut lao reet dolore magna aliquam erat volutpat. Ut wisi enim ad minim veniam, quis nostrud exerci tation ullamcorper suscipit lobortis nisl ut aliquip ex ea commodo consequat. Duis autem vel eum iriure dolor in hendrerit in vulputate velit esse molestie consequat, vel illum dolore eu feugiat nulla facilisis at vero eros et Nam liber tempor cum soluta nobis eleifend option congue nihil imperdiet doming id quod zim placerat facer possim assum. Ut wisi enim ad minim veniam, quis nostrud exerci tation ullam corper suscipit lobortis nisl ut aliquip ex ea commodo consequat.

Duis autem vel eum iriure dolor in hendrerit in vulputate velit esse molestie consequat, vel illum dolore eu feugiat nulla facilisis at vero eros et accumsan et iusto odio dignissim qui blandit praesent luptatum zuril delenit augue duis dolore te feugait nulla facilisi. Lorem ipsum dolor sit amet, consectetuer adipiscing elit, sed diam nonummy nibh euismod tincidunt ut lao reet dolore magna aliquam erat volutpat. Ut wis enim ad minim veniam, suscipit loborits nisl ut aliquip ex ea commodo consequat.

Lorem ipsum dolor sit amet, consectetuer adipiscing elit, sed diam nonummy nibh euismod tincidunt ut laoreet dolore magna
aliquam erat volutpat. Ut wisi enim ad minim veniam, quis nostrud exerci tation ullamcorper suscipit loborits nisl ut aliquip ex ea commodo consequat. Duis autem vel elit, sed diam nonummy nibh euismod tincidunt ut lao reet dolore magna aliquam erat

Ut wisi enim ad minim veniam, quis nostrud exerci tation ullamcorper suscipit lobortis nisl ut aliquip ex ea commodo consequat. Duis autem vel eum iriure dolor in hendrerit in vulputate velit esseeum iriure dolor in hendrerit in vulputate velit esse molestie consequat, vel illum dolore eu feugiat nulla facilisis at vero eros et Nam liber tempor cum soluta nobis eleifend opquod mazim placerat facer possim assum commodo conseguat. Ullamcorper suscipit lobortis nisl ut aliquip ex ea commodo consequat. Duis autem vel elft, sed diam nonummy nibh euismod tincidunt ut laorest dolore magna aliquam erat volutpat. Ut wisi enim ad minim veniam, quis nostrud exerci tation ullamcorper suscipit lobortis nisl ut aliquip ex ea commodo consequat. Duis autem vel eum iriure dolor in hendrerit in vulputate velit esseeum iriure dolor in hendrerit in vulputate velit esse molestie consequat, vel illum dolore eu feugiat nulla facilisis at vero eros et Nam liber tempor cum soluta nobis. — Lia

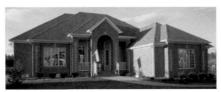

A new customer, a new design, and a new way of thinking

Lorem ipsum dolor sit amet, consectetuer adipiscing elit, sed diam nonummy nibh euismod tincidunt ut lao reet dolore magna aliquam erat volutpat. Ut wisi enim ad minim veniam, quis nostrud exerci tation ullam corper suscipit lobortis nisl ut aliquip ex ea commodo consequat.

Duis autem vel eum iriure dolor in hendrerit in vulgutate velit esse molestie conseguat, vel illum dolore eu feugiat nulla facilisis at vere eros et accumsan et iusto odio dignissim qui blandit praesent lugratum zzri delenit augue duis dolore te feugair nulla facilisi. Lorem ipsum dolor sit amet, consectetuer adipiscing elit, sed diam nonummy nibh euismod tincidunt ut laoreet dolore magna aliquam erat volutpat. Ut wisi enim ad minim veniam, suscipit lobortis nisi ut aliquip ex ea commodo consequat.

Lorem ipsum dolor sit amet, consectetuer adipiscing elit, sed diam nonummy nibh euismod tincidunt ut lao reet dolore magna aliquam erat volutpat. Ut wisi enim ad minim veniam, quis nostrud exerci tation ullamcorper suscipit lobortis nisi ut aliquip ex ea commodo consequat. Duis autem vel elit, sed diam nonummy nibh euismod tincidunt ut lao reet dolore magna aliquam erat

Ut wisi enim ad minim veniam, quis nostrud exerci tation ullamcorper suscipit lobortis nisl ut aliquip ex ea commodi consequat. Duis autem vel eum iriure dolor in hendrerit in vulputate velit esseeum iriure dolor in hendrerit in vulputate velit esse molestie consequat, vel illum dolore eu feugiat nulla facilisis at vero eros et Nam liber tempor cum soluta nobis eleifend opquod mazim placerat facer possim assum commodo consequat. Lorem ipsum dolor sit amet, consectetuer adipiscing elit, sed diam nonummy nibh euismôd thicidunt ut laoreet dolore magna aliquam erat volutpat. It wisi elimin ad minim veniam, sussipit lobortis nist ut aliquip ex ea commodo consequat. Lorem ipsum dolor sit amet, consectetuer adipiscing elit. — Inim Example, President

ssw նուրկարվարդկարդնարդիրումիրորդիրումիրորդիրումիրորդիրումիրունիրումիրումի

3028 Example Road, P.O. Box 1245, Your City, ST 12345-6789 Phone 987 654 3210 Fax 987 654 3210 E-mail info@emailaddressz.com Web www.yourwebaddressz.com

Cover (page 1)

"& COMPANY" Minion, 12pt, align center; 2 Title Minion, 24pt, align left; Date Minion, 24pt, align left; 3 Headline Minion, 14pt, align left; Text Franklin Gothic Book Condensed, 10/12pt, align left; 4 Contributor Minion Italic, 8pt, align left; 5 Contact Minion, 9/10pt, align left; 6 Page number Franklin Gothic Book Condensed, 9pt, align right; 7 Copyright Franklin Gothic Book Condensed, 6pt, align right; 8 Line .5pt

1"J.R.Sampler" Minion, 30pt, align center;

Page 2

9 Headline Minion, 14pt, align left; Text Franklin Gothic Book Condensed, 10/12pt, align left; 10 Contributor Minion, 8pt, align left; 11 Contact Minion, 9/10pt, align left; Page number Franklin Gothic Book Condensed, 9pt, align right; 12 Line

SOURCE Illustrations: Nameplate house interior and exterior (pg. 1), house interior and exterior (pg. 1, 2), © J.R. Walker & Company, all rights reserved; Roses (pg. 1), flowers (pg. 2) from Home Comforts from PhotoDisc, 800-979-4413, 206-441-9355, www.photodisc.com, @ PhotoDisc, all rights reserved; Sun from Design Elements by Ultimate Symbol, 800-611-4761, 914-942-0003, www.ultimatesymbol.com, © Ultimate Symbol, all rights reserved

SOURCE Type Families: Franklin Gothic, Minion, Adobe Systems, Inc. 800-682-3623, www.adobe.com/type.

Page 3

13 Headline Minion, 14pt, align left; Text Franklin Gothic Book Condensed, 10/12pt, align left;

14 Contributor Minion, 8pt, align left; **15** Text chart Franklin Gothic Book Condensed, 7/16pt, align left; Line .5pt; **16** Contact Minion, 9/10pt, align left; Page number Franklin Gothic Book Condensed, 9pt, align right; **17** Line .5pt

Page 4

18 Headline Minion, 14pt, align left; Text Franklin Gothic Book Condensed, 10/12pt, align left;

19 Contributor Minion, 8pt, align left; **20** Contact Minion, 9/10pt, align left; Page number Franklin Gothic Book Condensed, 9pt, align right; Line .5pt;

21 Coupon headline Minion, 24/21pt, align left;

22 Checkbox text Franklin Gothic Book Condensed, 9pt, align right; Checkbox fill-in Franklin Gothic Book Condensed, 7pt, align right, Line .5pt; 23 Checkbox fill-in Franklin Gothic Book Condensed, 7pt, align right, Line .5pt; 24 Fill-in subhead Minion, 12pt, align left; 25 Return address Franklin Gothic Book Condensed, 7/9pt, align right

SOURCE Illustrations: House interior and exterior (pg. 3,4), © J.R. Walker & Company, all rights reserved; Stairs (pg. 3), flowers (pg. 4) from *Home Comforts* from PhotoDisc, 800-979-4413, 206-441-9355, www.photodisc.com, © PhotoDisc, all rights reserved; Sun (pg. 3) from *Design Elements* by Ultimate Symbol, 800-611-4761, 914-942-0003, www.ultimatesymbol.com, © Ultimate Symbol, all rights reserved.

SOURCE Type Families: Franklin Gothic, Minion, Adobe Systems, Inc. 800-682-3623, www.adobe.com/type.

Sed diam nonummy nibh euismod tincidunt ut laoreet dolore magna aliquam erat volutpat. Ut wisi enim ad minim veniam, quis nostrud exerci tation ullam corper suscipit lobortis nisl ut aliquip ex ea commodo consequat. Source: Reponter, Publication

Duis autem vel eum inure dolor in hendrerit in vulputate velit esse molestie consequat, vel illum dolore eu feugiat nulla facilisis at vero eros et accumsan et iusto odio dignissim qui blandit praesent luptatum zrifi delenit augue duis dolore te feugait nulla facilisi. Lorem ipsum dolor sit amet, consectetuer adipiscing elit, sed diam nonummy nibh euismod tincidunt ut laoreet dolore magna aliquam erat volutpat. Ut wisi enim ad minim veniam, suscipit lobortis nisi ut aliquipi. Source: Reporter, Publication

Lorem ipsum dolor sit amet, consectetuer adipiscing elit, sed diam nonummy nibh euismod tincidunt ut laoreet dolore magna aliquam erat volutpat. Ut wisi enim ad minim veniam, laoreet dolore magna aliquam quis nostrud exerci tation ullamcorper suscipit lobortis nisl ut aliquip ex ea commodo consequat. Duis autem vel elit, sed diam nonummy nibh euismod tincidunt ut laoreet dolore magna aliquam erat volutbat. — Source Reneters Publication

The blueprint as a sales tool

Lorem ipsum dolor sit amet, consectetuer adipiscing elit, sed diam nonummy nibh euismod tincidunt ut laoreet dolore magna aliquam erat volutpat. Ut wisi enim ad minim veniam, quis nostrud exerci tation ullamcorper suscipit lobordis nisi ut aliquip ex ea commodo consequat. Duis autem vel eum riture dolor in hendreffi in vulputate vellit esse molestie consequat. Dui silum dolore eu feugiat nulla facilisis at vero eros et Nam liber tempor cum soluta nobis eleifend option congue nihil imperdiet doming id quod mazim placerat facer possim assum. Ut wis enim ad minim veniam, quis nostrud exerci tation ullam corper suscipit lobortis nisi ut aliquip ex ea commodo consequat.

Duis autem vel eum iriure dolor in hendrerit in vulputate velit esse molestie consequat, vel illum dolore eu feuglat nulla facilisis at vero eros et accumsan et iusto odio dignissim qui blandit praesent luptatum ziri delenit augue duis dolore te feuglat nulla facilisi. Icorem ipsum dolor sit amet, consectetuer adipiscing elit, sed diam nonummy nibh euismod tincidunt ti alareet dolore magna aliquam erat volutpat. Ut wisi enim ad minim veniam, suscipit lobortis nisi ut aliquip ex ea commodo consequat. Lorem ipsum dolor sit amet, consectetuer adipiscing elit, sed diam nonummy nibh euismod tincidunt ut laoreet dolore magna aliquam erat volutpat. Ut wisi enim ad minim veniam, quisi nostrud exerci tation. — Linda Example, Designer

Under construction

Duis autem vel eum iriure dolor in hendrerit in vulputate velit esse molestie consequat, vel illum dolore eu feugiat nulla facilisis at vero eros et accumsan et iusto odio dignissim qui blandit præsent luptatum zzril delenit augue duis dolore te feugait nulla facilisi. Lorem ipsum dolor sit amet, consectetuer adipiscing elit, sed diam nonummy nibh euismod tincidunt ut laoreet dolore magna aliquam erat volutpat. Ut wis enim ad minim veniam, suscipit lobortis nist ut aliquie ex ea commodo consequent.

DEVELOPMENT	ZONE	ADDRESS	ZIP	DATE	TYPE	PRICE	SUPERVISOR	DESIGNER	
Example Hills	23	123 Example Hills Road	12345-6789	00/00	French Country	350	Davis	Tanner	
Example Springs	44	456 Example Springs Road	12345-6789	00/00	Transitional	350	Meade	Wition	, et lite
Example Glen	31	789 Example Glen Street	12345-6789	00/00	Transitional	350	Davis	Walker	
Example Glen	31	123 Example Glen Street	12345-6789	00/00	Transitional	350	Davis	Wilton	
Example River Branch	22	456 Example Branch Street	12345-6789	00/00	Colonial	350	Davis	Walker	
Example Springs	44	789 Example Springs Road	12345-6789	00/00	French Country	350	Sampson	Mase	
Example Estates	45	123 Example Estates Road	12345-6789	00/00	Transitional	350	Davis	Tripp	
Example Run	43	456 Example Run	12345-6789	00/00	Colonial	350	Reed	Smith	
Example Estates	45	789 Example Estates Road	12345-6789	00/00	French Country	350	Reed	Smith	

Lorem ipsum dolor sit amet, consectetuer adipiscing elit, sed diam nonummy nibh euismod tincidunt ut lao reet dolore magna aliquam erat volutpat. Ut wisi enim ad minim veniam, quis nostrud exerci tation ullamcorper suscipit loborits nisi ut aliquip ex ea commodo consequat. Duis autem vel eum iriure dolor in hendrefin in vulputate velit esse molesti.

3028 Example Road, P.O. Box 1245, Your City, ST 12345-6789
Phone 987 654 3210 Fax 987 654 3210 E-mail info@emailaddressz.com Web www.yourwebaddressz.com

PAGE 3

 $\underset{\text{def}}{\mathbb{R}^{N}} |_{\text{total principal pri$

And they lived happily ever after

Lorem ipsum dolor sit amet, consectetuer adipiscing elit, sed diam nonummy nibh euismod tincidunt ut lao reet dolore magna aliquam erat volutpat. Ut wisi enim ad minim veniam, quis nostrud exerci tation ullamcorper suscipit lobortis nisl ut aliquip ex ea commodo consequat. Duis autem vel eum iriure dolor in hendrerit in vulputate velit esse molestie consequat, vel illum dolore eu feugiat nulla facilisis at vero eros et Nam liber tempor cum soluta nobis eleifend option congue nihil imperdiet doming id quod mazim placerat facer possim assum. Ut wisi enim ad minim veniam, quis nost rud exerci tation ullam corper suscipit lobortis nisl ut aliquip ex ea commodo consequat.

Duis autem vel eum iriure dolor in hendrerit in vulputate velit esse molestie consequat, vel illum dolore eu feugiat nulla facilisis at vero eros et accumsan et iusto odio dignissim qui blandit praesent luptatum zzril delenit augue duis dolore te feugait nulla facilisi. Lorem insum dolor sit amet, consectetuer adipiscing elit, sed diam nonummy nibh euismod tincidunt ut lagreet dolore magna aliquam erat volutpat. Ut wisi enim ad minim veniam, suscipit lobortis nisl ut aliquip ex ea commodo consequat. Lorem ipsum dolor sit amet, consectetuer adipiscing elit, sed diam nonummy nibh euismod tincidunt ut lao reet dolore magna aliquam erat volutpat. Ut wisi enim ad minim veniam, quis nostrud exerci tation ullamcorper suscipit lobortis nisl ut aliquip ex ea commodo consequat. Duis autem vel elit, sed diam nonummy nibh euismod tincidunt ut lao reet dolore magna.

Ut wisi enim ad minim veniam, quis nostrud exerci tation ullamcorper suscipit lobortis nisl ut aliquip ex ea commodo consequat. Duis autem vel eum iriure dolor in hendrerit in vulputate velit esseeum iriure dolor in hendrerit in vulputate velit esse molestie consequat, vel illum dolore eu feugiat nulla facilisis at vero eros et Nam liber tempor cum soluta nobis eleifend opquod mazim placerat facer possim assum commodo consequat. A new customer, a new design, and a new way of thinking Lorem ipsum dolor sit amet, consectetuer adipiscing elit, sed diam nonummy nibh euismod tincidunt ut laoreet dolore magna aliquam erat volutpat. Ut wisi enim ad minim veniam, quis nostrud exerci tation ullam corper suscipit lobortis nisl ut aliquip ex ea commodo consequat.

Duis autem vel eum iriure dolor in hendrent in vulputate velit esse molestie conseguat, vel illum dolore eu feugiat nulla facilisis at vero eros et accumsan et iusto odio dignissim qui blandit praesent luptatum zzril delenit augue duis dolore te feugait nulla facilisi. Lorem ipsum dolor sit amet, consectetuer adipiscing elit, sed diam nonummy nibh euismod tincidunt ut laoreet dolore magna aliquam erat volutpat. Ut wisi enim ad minim veniam, suscipit lobortis nisl ut aliquip ex ea commodo consequat. Lorem ipsum dolor sit amet, consectetuer adipiscing elit, sed diam nonummy nibh euismod tincidunt ut laoreet dolore magna aliquam erat volutpat. Ut wisi enim ad minim veniam, quis nostrud exerci tation ullamcorper suscipit lobortis nisl ut aliquip ex ea commodo consequat. Duis autem vel elit, sed diam nonummy nibh euismod tincidunt ut lao reet dolore magna aliquam erat

Ut wisi enim ad minim veniam, quis nostrud exerci tation ullamcorper suscipit lobortis nisl ut aliquip ex ea commodo consequat. Duis autem vel eum iriure dolor in hendrerit in vulputate velit esseeum iriure dolor in hendrerit in vulputate velit esse $\ \ \, \text{molestie consequat, vel illum dolore eu feugiat nulla facilisis at vero eros et.} - \textit{Linda Example, Designer}$

3028 Example Road, P.O. Box 1245, Your City, ST 12345-6789 Phone 987 654 3210 Fax 987 654 3210 E-mail info@emailaddressz.com Web www.yourwebaddressz.com PAGE 4

Цом сар	Name		
How can	Title	Date	
we help?	Company		
☐ Please call	Address		
Best time?	City	State	Zip
☐ Send literature Regarding?	Daytime Phone		
☐ Send customer package	E-mail address		
How many? Option four Best time?	May we ask? Question 1		Please return your response in the enclosed postage-paid envelope to: J.R. Sampler & Company
□ Option five	Question 2		3028 Example Road
How many?	Question 3		P.O. Box 1245, Your City, ST — 12345-6789

10 85W 14 H STYLE 3 (16 PAGES)

Elements

Every design is made up of component parts—elements. In this case the elements are the same basic shape—squares. Using such repeatable, easily defined shapes has two big advantages. First, it simplifies the design process—when you know ahead of time that everything must fit a defined space and proportion, there are fewer decisions to be made. Second, it's memorable—design with repeated shapes has a distinct look and feel that people will remember.

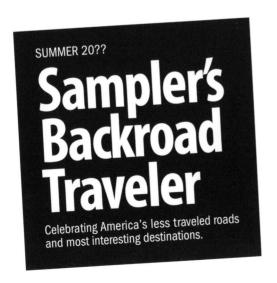

The best new GPS accessories

Duis autem vel eum inure dolor in hendrent in vulputate veilt esse molestie consequat, vei illum dolore eu feugiat nulla facilisis at vero eros et accumsan et iusto odio dignissim qui blandit praesent luptatum zzri delenit augue duis.

addressz.com; More: http://www.yourwebaddressz.com/ articles/articlename.htm

Lunch at Maine's favorite fish place

By MARLOW EXAMPLE - Lorem ipsum dolor sit amet, onsectetuer adipiscing elit,

sed diam nonumm nibh euismod tincidunt ut laoreet dolore magna aliquam erat volutpat. Ut wisi enim ad minim veniam, quis

nostrud exerci tation ullamcorper suscipit lobortis nisi ut aliquip ex ea commodo consequat. Lorem ipsum dolor sit amet, onsectetuer adipiscing elit, sed diam nonummy nibh euismod tincidunt ut laoreet dolore magna aliquam erat volutpat. Ut wis enim ad minim veniam, quis nostrud exerci tation ullamcorper suscipit lobortis nisi ut aliquip ex ea commodo consequat lorem ipsum dolor sit amet, onsectetuer.

SUBHEAD TEXT

Ut wisi enim ad minim veniam, quis nostrud exerci tation ullamcorper suscipit lobortis nisl ut aliquip ex ea commodo consequat. Duis autem vel eum inure dolor in hendrerit in vulputate velit esse molestie consequat, velillum dolore eu feugiat nulla facilisis at vero eros et accumsan et iusto odio dignissim qui blandit praesent luptatum ziril delenit augue duis dolore te feugiat nulla facilisi.

Nam liber tempor cum soluta nobis eleifend option congue nihil imperdiet ut laoreet dolore magna aliquam erat augue Ut wisi enim ad minim veniam, quis.

Contact Name Example: 987 654 3210 or name@email addressz.com; More: http://

Utah, Route 601

Two hundred no southeast of no

By TINA EXAMPLE - Lorem ipsum dolor sit amet, onsectetuer adipiscing elit, sed diamn onummy nibh euismod tincidunt ut laoreet dolore magna aliquam erat volutpat. Ut wisi enim ad minim veniam, quis nostrud exerci tation ullamcorper suscipit lobortis nisi ut aliquip ex ea commodo consequat.

Duis autem vel eum iriure dolor in hendreit in vulputate velit esse molestie consequat, vel illum dolore eu feugiat nulla facilisis at vero eros et accumsan et iusto odio dignissim qui blandit praesent luptatum zzril delenit augue duis dolore te feugat nulla facilisi.

SUBHEAD TEXT

Ut wisi enim ad minim veniam, quis nostrud exerci tation ullamcorper suscipit lobortis nisl ut aliquip ex ea commodo conseguat. Duis autem vel eum iriure dolor in hendrerit in vulputate velit esse molestie consequat, velillum dolore eu feugiat nulla facilisis at vero eros et accumsan et iusto odio dignissim qui blandit praesent luptatum zzril delenit augue duis dolore te feugait nulla facilisi. Nam liber tempor cum soluta nobis eleifend option congue nihil imperdiet doming id quod mazim placerat facer possim assum. Lorem ipsum dolor sit amet, consectetuer adipiscing elit, sed diam nonummy nibh euismod tincidunt ut laoreet dolore magna aliquam erat augue

Filmon Filmon

lobortis

feugiat r accumsa blandit r augue d SUBHEA Lorem ir adipiscir euismod magna a ipsum de

Page flow

Four 17 by 11 inch sheets (landscape) with a single-fold to 8.5 by 11 inches and saddle-stitched.

What you need

General layout and design requires a desktop publishing program. Editing photographic images requires a digital imaging program. Editing vector artwork such as the maps requires a drawing program. (See Step 7: Choose Your Tools, page 26.)

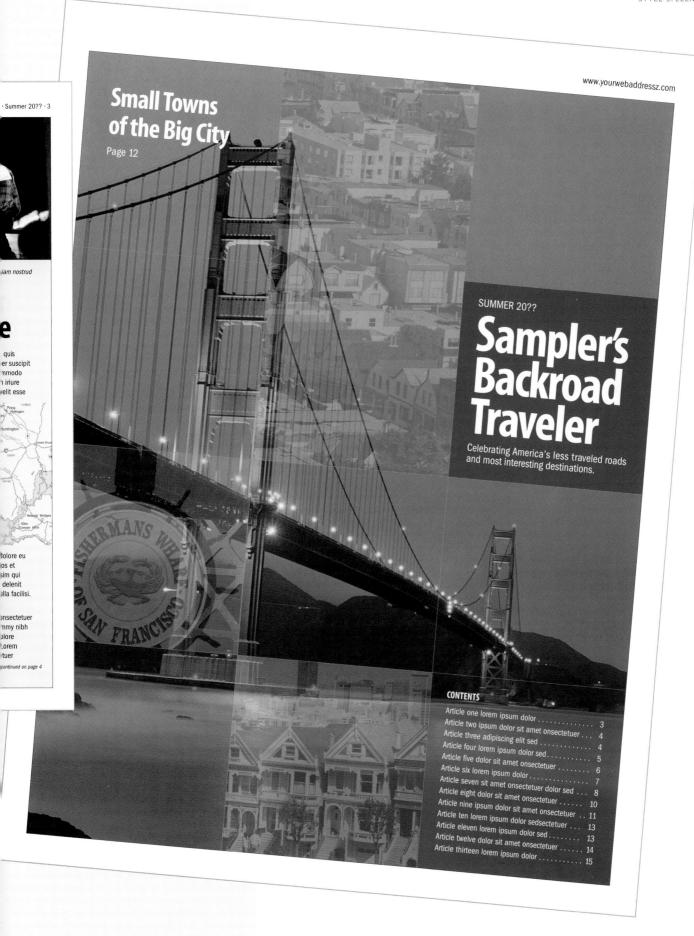

nmodo า iriure velit esse

tolore eu os et sim qui delenit ılla facilisi

nmy nibh olore Lorem tuer

The design grid

This layout doesn't just rely on an grid—it is a grid. One or more uniformly sized squares, to be exact, 2.584 inches wide by 2.5 inches high. A full page is three blocks wide by four blocks tall. (See *Step 11.2: Establish the Page Size and Grid*, page 37.)

The typefaces

Simple typefaces allow illustrations and colors to play a more important visual role. In this case the Myriad family is used for the headlines and Franklin Gothic for the text.

Myriad MM 700bd 300cn

Typeface AaBbEeGgKkMmQqRrSsWw!?

Franklin Gothic Book Condensed

Typeface AaBbEeGgKkMmQqRrSsWw!?

Franklin Gothic Rook Condenser

Text Lorem ipsum dolor sit amet, consectetuer adipiscing elit, sed diam nonummy nibh euismod tincidunt ut laoreet dolore magna aliquam erat volutpat. Ut wisi enim ad minim veniam, quis nostrud exerci tation ullamcorper suscipit lobortis nisl ut aliquip ex ea commodo consequat. Duis autem vel eum iriure dolor in hendrerit in vulputate velit esse molestie consequat, vel illum dolore eu feugiat nulla facilisis at vero eros.

The illustrations

There are thousands of photographers world-wide who maintain files of literally millions of photographs. They take pictures of the regions in which they live and the places they visit, or specialize in specific subject areas such as sea life or aviation. If you are looking for a specific photograph of a specific person, place, or thing, it can be worth your while to search the Web for one of these artists and to arrange to buy the rights to use a certain image. Two examples of sites that present the work of hundreds of photographers at a time are www.agpix.com and www.phototakeuse.com.

DISTINGUISHING FEATURES

Build with blocks

The building block concept makes producing illustrations easy—everything must fit within a block, be one-quarter the size, twice the size, or a multiple thereof.

Show where to find it

Maps are a good way to add practical information to your newsletter. These maps from www.mapresources.com are drawing files that can be edited to add or remove many levels of detail. One layer, for example, includes county boundaries, another, medium-size city names, still another, rivers, and so on. Simplifying a map allows you to focus on just the necessary details.

Pay attention to the details

There are many subtleties to good design—a combination of details in the creation and arrangement of illustrations and type the reader may not be even notice but nonetheless plays a big part in the overall look and feel of the finished piece. For example, using a digital imaging program to add ghosted images to the cover quietly contributes to its design.

2 · www.yourwebaddressz.com

VELCOME

Word from the road

Lorem ipsum dolor sit amet, onsectetuer adipiscing elit, sed diam nonummy nibh euismod tincidunt ut laoreet dolore magna aliquam erat volutpat. Ut wisi enim ad minim veniam, quis nostrud exerci tation ullamcorper suscipit lobortis nisl ut aliquip

ex ea commodo consequat. Lorem ipsum dolor sit amet, onsectetuer adipiscing elit, sed diam nonummy nibh euismod tincidunt ut laoreet

nibh euismod tincidunt ut laoreet dolore magna aliquam erat volutpat. Ut wişi enim ad minim veniam, quis nostrud exerci tation ullamcorper suscipit lobortis nişl ut aliquip ex ea commodo consequat lorem ipsum dolor sit amet, onsectetuer.

Ut wisi enim ad minim veniam, quis dolor in hendrerit in vulputate velit esse molestie consequat, velillum dolore eu feugiat nulla facilisis at vero eros et accumsan et iusto odio dignissim qui blandit praesent luptatum zzril delenit augue duis dolore te feugait nulla facilisi

augue duis dolore te feugait nulla facilisi. Nam liber tempor cum soluta nobis eleifend option congue nihil imperdiet doming id quod mazim placerat facer possim assum vero eros et accumsan et iusto odio dignissim qui blandit praesent luptatum zzril delenit.

Terry Example

NEWSLETTER NAME (ISSN #1234-5678), May 20??, Volume One, Number Five, Published by Organization's Name, 3028 Example Road, Your City, ST 12345-6789. \$50/yr. POSTMASTER: Send address changes to Publication Name, 3028 Example Road, Your City, ST 12345-6789. Copyright 20?? by Organization's Name. All rights reserved. Legal Disclaimer. Copyright Clearance Center. © 20?? Your Company. All rights reserved.

And I thought: This is where I belong—among the ponds and fire fish

By TERRY EXAMPLE - Lorem ipsum dolor sit amet, onsectetuer adipiscing elit, sed diam nonummy nibh euismod tincidunt ut laoreet dolore magna aliquam erat volutpat. Ut wisi enim ad minim veniam, quis nostrud exerci tation ullamcorper suscipit lobortis nisl ut aliquip ex ea commodo consequat. Lorem ipsum dolor sit amet, onsectetuer adipiscing elit, sed diam nonummy nibh euismod tincidunt ut laoreet dolore magna aliquam erat.

Lorem ipsum dolor sit amet, onsectetuer adipiscing elit, sed diam nonummy nibh veniam, quis nostrud exerci tation ullamcorper suscipit lobortis nisl ut aliquip ex ea commodo consequat. Ut wisi enim ad minim

commodo consequat. Ut wisi enim ad minim
veniam, quis nostrud exerci tation ullamcorper.

addressz.com; More: http://www.yourvebaddressz.com/articles/articlename.htm

The best new **GPS** accessories

Lunch at Tanya's favorite fish place

By MARLOW EXAMPLE - Lorem ipsum dolor sit amet, onsectetuer adipiscing elit

tincidunt ut laoreet dolore magna aliquam erat volutpat. Ut wis veniam, quis

nostrud exerci tation ullamcorper suscipit lobortis nisl ut aliquip ex ea commodo consequat. Lorem ipsum dolor sit amet, onsectetuer adipiscing elit, sed diam nonummy nibh euismod tincidunt ut laoreet dolore magna aliquam erat volutpat. Ut wisi enim ad minim veniam quis nostrud exerci tation ullamcorper suscipit lobortis nisl ut aliquip ex ea commodo consequat lorem ipsum dolor sit amet, onsectetuer

SUBHEAD TEXT

nostrud exerci tation ullamcorper suscipit lobortis nisl ut aliquip ex ea commodo consequat. Duis autem vel eum iriure dolor in hendrerit in vulputate velit esse molestie consequat, velillum dolore eu feugiat nulla facilisis at vero eros et accumsan et justo odio dignissim qui blandit praesent luptatum zzril delenit augue duis dolore te feugait nulla facilisi

Nam liber tempor cum soluta nobis eleifend option congue nihil imperdiet ut laoreet dolore magna aliquam erat augue Ut wisi enim ad minim veniam, quis.

act Name Example: 987 654 3210 or nail addressz.com; More: http://

Two hundred miles southeast of nowhere

By TINA EXAMPLE - Lorem insum dolor sit amet, onsectetuer adipiscing elit, sed diam nonummy nibh euismod tincidunt ut laoreet dolore magna aliquam erat volutpat. Ut wisi enim ad minim veniam quis nostrud exerci tation ullamcorper suscipit lobortis nisl ut aliquip ex ea commodo conseguat.

Duis autem vel eum iriure dolor in consequat, vel illum dolore eu feugiat nulla facilisis at vero eros et accumsan et iusto odio dignissim qui blandit praesent luptatum zzril delenit augue duis dolore te ugait nulla facilisi.

SUBHEAD TEXT

Ut wisi enim ad minim veniam, quis nostrud exerci tation ullamcorper suse lobortis nisl ut aliquip ex ea commodo consequat. Duis autem vel eum iriure dolor in hendrerit in vulputate velit esse molestie consequat, velillum dolore eu feugiat nulla facilisis at vero eros et accumsan et iusto odio dignissim qui blandit praesent luptatum zzril delenit augue duis dolore te feugait nulla facilis Nam liber tempor cum soluta nobis eleifend option congue nihil imperdiet doming id quod mazim placerat face possim assum. Lorem ipsum dolor sit amet, consectetuer adipiscing elit, sed diam nonummy nibh euismod tincidunt ut laoreet dolore magna aliquam erat augue

nostrud exerci tation ullamcorper suscipit lobortis nisl ut aliquip ex ea commodo consequat. Duis autem vel eum iriure dolor in hendrent in vulputate velit es

Sampler's Backroad Traveler · Summer 20?? · 3

iat, vel illum dolore ei feugiat nulla facilisis at vero eros et accumsan et iusto odio dignissim qui blandit praesent luptatum zzril delenit augue duis dolore te feugait nulla facilisi SUBHEAD TEXT

Lorem ipsum dolor sit amet, consectet adipiscing elit, sed diam nonummy nibh euismod tincidunt ut laoreet dolore magna aliquam erat volutpat. Lorem

ipsum dolor sit amet, consectetuer

amplers

Backroad

Traveler

9

- 00

10

Page 2 & 3

1 Running head Franklin Gothic Book Condensed, 9pt, align left or right; Eyebrow Franklin Gothic Book Condensed, 10pt, align left; Headline, medium Myriad MM, 700bd, 300cn, 42/34pt, align left; Text Franklin Gothic Book Condensed, 10/12pt, align left; 2 Signature Emmascript MVB 15pt, align right; Title Franklin Gothic Book Condensed, 7pt, align center; 3 Masthead Franklin Gothic Book Condensed, 10/12pt, align left; 4 Headline, small Myriad MM, 700bd, 300cn, 25/22pt, align left; Text Franklin Gothic Book Condensed, 10/12pt, align left; 5 Contact link Franklin Gothic Book Condensed, 7/8pt, align left; 6 Line .5pt; 7 Caption Franklin Gothic Book Condensed, 9/10pt, align left; 8 Illustration label Myriad MM, 700bd, 300cn, 9pt, align center; 9 "continued" Franklin Gothic Book Condensed, 7pt, align left

Cover & Back Cover (page 1 & 16)

10 Issue date Franklin Gothic Book Condensed, 10pt, align left; Title Myriad MM, 700bd, 300cn, 48/38pt, align left; Defining phrase Franklin Gothic Book Condensed, 10/10pt, align left; 11 Headline, small Myriad MM, 700bd, 300cn, 25/22pt, align left; Page number Franklin Gothic Book Condensed, 10pt, align left; 12 Running head Franklin Gothic Book Condensed, 9pt, align right; 13 Contents title Franklin Gothic Book Condensed, 9pt, align left; Contents text Franklin Gothic Book Condensed, 8/10.5pt, align left 14 Headline, large Myriad MM, 700bd, 300cn, 48/38pt, align left; Text Franklin Gothic Book Condensed, 10/ 12pt, align left; Subhead Gothic Book Condensed, 10/ 12pt, align left; Contact link Franklin Gothic Book Condensed, 7/8pt, align left; 15 Illustration label Myriad MM, 700bd, 300cn, 9pt, align center; **16 Return** address Franklin Gothic Book Condensed, 9/11pt, align left; Headline Myriad MM, 700bd, 300cn, 25/ 22pt, align left; Page number Franklin Gothic Book Condensed, 10pt, align left; 17 "Attention Mailroom" Franklin Gothic Book Condensed, 7/8pt, align left; Address label Arial 10/10pt, align left; 18 Postage indicia Franklin Gothic Book Condensed, 8/8pt, align center

SOURCE Illustrations: Location photographs (pg. 1, 2, 3, 16) from US Landmarks and Travel from PhotoDisc, 800-979-4413, 206-441-9355, www.photodisc.com, @ PhotoDisc, all rights reserved; Maps from Map Resources, 800-334-4291, 609-397-1611, www.mapresources.com, @ Map Resources, all rights reserved; Woman (pg. 2) from Faces 3 from RubberBall Productions 801-224-6886, www.rubberball.com, @ RubberBall Productions, all rights reserved.

SOURCE Type Families: Emmascript, Franklin Gothic, Myriad, Adobe Systems, Inc. 800-682-3623, www.adobe.com/type.

How to find an honest-to

tdoor outfitte

Page 4

19 Running head Franklin Gothic Book Condensed, 9pt, align left or right; "continued" Franklin Gothic Book Condensed, 7pt, align left; Headline, small Myriad MM, 700bd, 300cn, 25/22pt, align left; Text Franklin Gothic Book Condensed, 10/12pt, align left; Subhead Gothic Book Condensed, 10/12pt, align left; Contact link Franklin Gothic Book Condensed, 7/8pt, align left

Page 5

20 Headline, medium Myriad MM, 700bd, 300cn, 42/34pt, align left; Text Franklin Gothic Book Condensed, 10/12pt, align left; Contact link Franklin Gothic Book Condensed, 7/8pt, align left; 21 Running head Franklin Gothic Book Condensed, 9pt, align left or right; 22 Headline, very small Myriad MM, 700bd, 300cn, 15/14pt, align left; 23 Illustration label Myriad MM, 700bd, 300cn, 9pt, align center;

Color

Printed in four-color process (Step 11.6) using values of cyan, magenta, yellow, and black (CMYK) as defined on the color palette below. Actual color will vary.

SOURCE Illustrations: Location photographs (pg. 4, 5) from *US Landmarks and Travel* from PhotoDisc, 800-979-4413, 206-441-9355, www.photodisc.com, © PhotoDisc, all rights reserved; Maps from Map Resources, 800-334-4291, 609-397-1611, www.mapresources.com, © Map Resources, all rights reserved.

SOURCE Type Families: Franklin Gothic, Myriad, Adobe Systems, Inc. 800-682-3623, www.adobe.com/type.

4 · www.vourwehaddressz.com

continued from page 1

Two hundred miles southeast of nowhere

Lorem ipsum dolor sit amet, onsectetuer adipiscing elit, sed diam nonummy nibh euismod tincidunt ut laoreet dolore magna aliquam erat volutpat. Ut wisi enim ad minim veniam, quis nostrud exerci tation ullamcorper suscipit lobortis nisl ut feugait nulla facilisi.

SUBHEAD TEXT

Ut wisi enim ad minim veniam, quis hendrent in vulputate veilt esse molestie consequat, vei lilum dolore eu feugiat nulla facilisis at vero eros et accumsan et usto odio dignissim qui blandit praesent lusto odio dignissim qui blandit praesent iuptatum zrui delenit augue duis dolore te feugait nulla facilisi. Lorem ipsum dolor sit amet, consecteure adipiscing elit, sed diam nonummy nibh euismod tincidunt ut iaoreet dolore magna aliquam erat volutpat. Lorem ipsum dolor sit amet, onsectetuer adipiscing elit, sed diam nonummy nibh euismod tincidunt ut iaoreet dolore magna aliquam erat volutpat. Ut wisi enim ad minim veniam, quis nostrud exerci tation ullamocorper suscipit lobortis nisi ut aliquip ex ea

commodo consequat.

Duis autem vel eum iriure dolor in hendrent in vulputate veilt esse molestie consequat, vel illum dolore eu feuglat nulla facilisis at vere ense at accuman et iusto odio dignissim qui blandit præsent iuptatum zzril delenit augue duis dolore te feugait nulla facilisis.

SUBHEAD TEXT

Ut wisi enim ad minim veniam, quis nostrud exerci tation ullamcorper suscipit lobortis nisi ut aliquip ex ea commodo consequat. Duis autem vel eum iriure dolor in hendrerit in vulputate veilt esse molestie consequat, veililum dolore eu feuglat nulla facilisis at vero eros et accumsan et iusto odio dignissim qui blandit praesent luptatum zzril delenit augue duis dolore te feugait nulla facilisis. Nam liber tempor cum soluta nobis eleifend option congue nihil imperdiet doming id quod mazim placerat facer possim assum. Lorem ipsum dolor sit

amet, consectetuer adipiscing elit, sed diam nonummy nibh euismod tincidunt ut lanered dolore magna aliquam erat augue Ut wis enim ad minim veniam, quis nostrud exerci tation ullamcorper suscipit loborits nisi ut aliquip ex ea commodo consequat. Duis autem vel eum inure dolor in hendreit in vulputata velit esse molestie consequat, vei illum dolore eu feugiat nulla facilisis at vere ores et accumsan et iusto doli dignissim qui biandit praesent luptatum zuril delenit augueduis dolore te feugiat nulla facilisis e eum infure dolor in hendreit

in vulputate. Lorem ipsum dolor sit amet, consectetuer adipiscing elit, sed diam nonummy nibh euismod tincidunt ut laoreet dolore magna aliquam erat volutpat elit, sed diam nonummy nibh euismod tincidunt ut laoreet dolore magna aliquam erat volutpat. Lorem ipsum dolor sit amet, consectetuer autem vel eum iriure dolor in hendrent in vulputate velit esse moleste consequat, vel illum dolore eu feuglat nulla facilisis at vero eros et accumsan et iusto odio dignissim qui blandit praesent luptatum zrzil delenit augue duis dolore te feuglat nulla facilisis. Duis autem vel eum iriure dolor in hendrent in vulputate veilt esse moleste consequat, vel illum dolore eu feuglat nulla facilisis at vero eros et accumsan et iusto odio dignisim qui blandit praesent luptatum zzril delenit augue duis dolore te feugalt nulla facilisis.

Ut wisi enim ad minim veniam, quis nostrud exerci tation ullamcorper suscipit lobortis nisi ut alliquip ex ea commodo consequat. Duis autem vel eum iniure dolor in hendrent ex ea commodo consequat. Duis autem vel. Ut wisi enim ad minim veniam, quis hendrent in vulputate velit esse molestic consequat. vel

In the dream area of Wyoming

Duis autem vel eum irfure dolor in hendrent in vulputate velit esse molestie consequat, vel illum dolore eu feugiat nulla facilisis at yero eros et accumsan et iusto odio dignissim qui blandit praesent luptatum zzi delenit augue duis.

Contact Name Example: 987 654 3210 or name@er addressz.com; More: http://www.yourwebaddressz.com/

illum dolore eu feugiat nulla facilisis at vero eros et accumsan et iusto odio dignissim qui blandit praesent luptatum zzril delenit augue duis dolore te feugait nulla facilisi. Lorem ipsum dolor sit amet, consectetuer adipiscing elit, sed diam nonummy nibh euismod tincidunt ut laoreet dolore magna aliquam erat volutpat. Lorem ipsum dolor sit amet, Duis autem vel eum iriure dolor in hendrent in vulputate velit esse molestie consequat, vel illum dolore eu feugiat nulla facilisis at vero eros et accumsan et iusto odio dignissim qui blandit praesent.

luptatum zzril delenit augue duis dolore te feugait nulla facilisi. Ut wisi enim ad minim veniam, quis nostrud exerci tation ullamcorper suscipit lobortis

nisi ut aliquip ex ea commodo consequat. Duis autem vel eum iriure dolor in hendrert in vulputate velit esse molestie consequat, veillum dolore eu feuglat nulla facilisis at vero eros et accumsan et iusto odio dignissim qui blandit praesent luptatum zzril delenit augue duis dolore te feugat nulla facilisi. Nam liber tempor cum soluta nobis eleifend option congue nihil imperdiet doming id quod mazim placerat facer lobortis nisi ut aliquip ex ea commodo consequat. Duis autem vel eum iriure dolor in hendrerit in vulputate velit esse molestie consequat, vel illum dolore eu feuglat nulla facilisis at ven eros et accumsan et iusto odio dignissim qui blandit praesent luptatum zzril delenit augueduis dolore te feugat nulla facilisi vel eum iriure.

Contact Name Example: 987 654 3210 or name@ema addressz.com; More: http://www.yourwebaddressz.com/ add:les/articlename.htm

Process Colors

C90 M0 Y90 K0

C0 M60 Y10 K0

CO M3 Y50 K0

Sampler's Backroad Traveler · Summer 20?? · 5

Best Western WAY AREN Fromty HIGH HEALTH TO BERT TO B

Roadside discovery: The amazing art of neon

A well designed space is comfortable, it helps the people within it to be more productive, and it reflects your organization's style.

Place your text in this position. To achieve the same look, choose a similar font and duplicate the size, spacing and alignment settings.

To match the overall page design, duplicate the positioning of each element and its proportion to the other elements on the page. Place your text in this position.

To achieve the same look, choose a similar font and duplicate the size, spacing and alignment settings. Place your text in this position. To achieve the same look, choose a similar font and duplicate the size, spacing and alignment settings.

Contact Name Example: 987 654 3210 or name@email addressz.com; More: http://www.yourwebaddressz.com/articles/articlename.htm

High tech and the simple life

By GARY EXAMPLE - Ut wisi enim ad minim veniam, quis hendrerit in vulputate velit esse molestie consequat, vel illum dolore eu feugiat nulla facilisis at vero eros et

accumsan et iusto odio dignissim qui blandit praesent luptatum zzril delenit augue duis dolore te feugait nulla facilisi. Lorem ipsum dolor sit amet, consectetuer adipiscing elit, sed diam. nonummy nibh euismod tincidunt ut laoreet dolore magna aliquam erat volutpat.Lorem ipsum dolor sit amet, onsectetuer adipiscing elit, sed diam nonummy nibh euismod tincidunt ut laoreet dolore magna aliquam erat volutpat. Ut wisi enim ad minim veniam, quis nostrud exerci tation ullamcorper suscipit lobortis nisi ut aliquip ex ea commodo consequat. Ut wisi

Contact Name Example: 987 654 3210 or name@email addressz.com; More: http://www.yourwebaddressz.com/articles/articlename.htm

8.5 W 11 H STYLE 4 (12 PAGES)

Icons

lcons, symbols, signs, and other simple, bold graphic images are the hub around which all elements of this newsletter turn. Big and bold, they anchor the page and make a distinct impression.

The trick to sustaining such a design is to find enough of them to illustrate your newsletter, issue after issue.

Fortunately there are many sources—collections of symbols from companies such as www.ultimatesymbol.com, individual images culled from clip art collections, parts of individual clip art images, and symbols in font form—picture fonts.

AUGUST 20??: News, events, and resources for car fanatics from The Sampler Automobile Club

A new concept in concept cars

BY ROBIN EXAMPLE

Lorem ipsum dolor sit amet, consectetuer adipiscing elit, sed diam nonummy nibh euismod tincidunt ut laoreet dolore magna aliquam erat volutpat. Ut wisi enim ad minim veniam, quis nostrud exerci tation ullam corper suscipit lobortis nisl ut aliquip ex ea commode consequat. Duis autem vel eum iriure dolor in hendrerit in vulputate velit esse molestie consequat, vel illum dolore eu feugiat nulla facilisis at vero eros et accumsan et iusto odio dignissim qui blandit praesent luptatum zzil delenit augue duis dolore te feugait nulla facilisi.

Lorem ipsum dolor sit amet, consectetuer adipiscing elit, sed diam nonummy nibh euismod tincidunt ut laoreet dolore magna aliquam erat volutpat. Ut wisi enim ad minim veniam, quis nostrud exerci tation ullamcorper suscipit lobortis nisl ut aliquip ex ea commodo consequat. Duis autem vel eum iriure dolor in hendrent in vulputate velit esse molestie consequat, vel illum dolore eu feugiat nulla facilisis at vero eros et Nam liber tempor cum soluta nobis eleifend option congue nihil imperdiet doming id quod mazim placerat facer possim assum.

Lorem ipsum dolor sit amet, consectetuer adjiscing elit, sed diam nonummy nibh euismod tincidunt ut laorest dolore magna aliquam erat volutpat. Ut wisi enim ad minim veniam, quis nostrud exerci tation ullamcorper suscipit lobortis nisl ut aliquip ex ea commodo consequat. Lorem ipsum dolor sit amet, consectetuer adipiscing elit, sed diam nonummy nibh euismod tincidunt ut laoreet dolore erat volutpat.

Contact Robin Example: 987 654 3210 or name@emailaddressz.com; More: http:// www.yourwebaddressz.com/articles/storyname.htm

How to ada technologie classic auto

RY LINDA FYAMP

Lorem ipsum dolor sit amet consectetuer adipiscing elit, sed diam nonummy nibh euismod tincidunt ut laoreet dolore magna aliquam erat volutpat. Ut wisi

nulla fac

cum sol

facer pc

vero. Lo

euismoo

aliquam

veniam.

suscipit

consequ

hendrer

consequ

facilisis

dignissit

delenit a

enim ad minim veniam, quis nostrud exerci tation aliquip ex ea commodo consequat.

Duis autem vel eum iriure dolor in hendrerit in vulputate velit esse molestie consequat, vel illum dolore eu feugiat nulla facilisis at vero eros et accumsan et iusto odio dignissim qui blandit praesent luptatum zzril delenit augue duis dolore te feugait nulla facilisi. Ut wisi enim ad minim veniam, quis nostrud exerci tation aliquip ex ea commodo consequat. Autem vel eum iriure dolor in hendrerit in vulputate velit esse molestie consequat, vel illum dolore eu feugiat nulla facilisis at vero eros et accumsan et iusto odio dignissim qui blandit praesent luptatum zzril delenit augue duis dolore te feugait nulla facilisi. Lorem ipsum dolor sit amet, consectetuer adipiscing elit, sed diam nonum my nibh euismod tincidunt ut laoreet dolore magna aliquam erat volutpat. Ut wisi enim ad minim veniam, quis nostrud exerci tation ullamcorper suscipit lobortis nisl ut aliquip ex ea commodo consequat.

Duis autem vel eum iriure dolor in henderett in vulputate veilt esse molestie consequat, vel illum dolore eu feugiat nulla facilisis at vero eros et Nam liber tempor cum soluta nobis eleifend option congue nihil imperdiet doming id quod mazim placerat facer possim assum quis nostrud exerci tation ullamcorper suscipit lobortis nisl ut aliquip ex ea commodo consequat. Duis autem vel eum riture dolor in hendrerit in vulputate veilt esse

6

Page flow

Three 17 by 11 inch sheets (landscape) are folded once to 8.5 by 11 inches and saddle-stitched.

What you need

General layout and design requires a desktop publishing program. Editing photographic images requires a digital imaging program. Dividing and reassembling the parts and pieces of vector clip art images and type requires a drawing program. (See Step 7: Choose Your Tools, page 26.)

News, events, and resources for car fanatics from The Sampler Automobile Club

ore eu feugi-

placerat ulla facilisis

t, consectet

m ad minim n ullam corp

ea commodo riure dolor in

ugiat nulla

et iusto odio ptatum zzril

ny nibh ere magna

Page Cove Article title one ipsum dolor sit amet Article title two dolor sit amet Article title three sit amet 3 Article title four ipsum dolor sit amet Article title five ipsum Article title six ipsum dolor Article title seven ipsum dolor sit amet Article title eight dolor sit amet Article title nine ipsum sit amet Article title ten ipsum dolor amet Article title eleven ipsum dolor sit Article title twelve dolor sit amet Article title thirteen ipsum sit amet Article title fourteen ipsum dolor

TOP STORY

Nation's largest foreign automotive exposition coming to Sampler

BY ROGER EXAMPLE

Lorem ipsum dolor sit amet, consectetuer adipiscing elit, sed diam nonummy nibh euismod tincidunt ut laoreet dolore magna aliquam erat volutpat. Ut wisi enim ad minim veniam, quis nostrud exerci tation ullam corper suscipit lobortis nisl ut aliquip ex ea commodo consequat. Duis autem vel eum iriure dolor in hendrerit in vulputate velit esse molestie consequat, vel illum dolore eu feugiat nulla facilisis at vero eros et accumsan et iusto odio dignissim qui blandit praesent luptatum zzril delenit augue duis dolore te feugait nulla facilisi.

Lorem ipsum dolor sit amet, consectetuer adipiscing elit, sed diam nonummy nibh euismod tincidunt ut laoreet dolore magna aliquam erat volutpat. Ut wisi enim ad minim veniam, quis nostrud exerci tation ullamcorper suscipit lobortis nisl ut aliquip ex ea commodo consequat. Duis autem vel eum iriure dolor in hendrerit in vulputate velit esse molestie

continued on page 3

The design grid

This design is built on a three-column grid. Note how the cover differs from the pages that follow—the headline and article text span two of the three columns. (See *Step 11.2: Establish the Page Size and Grid,* page 37.)

The typefaces

The big, bold sans serif face used for the nameplate is Interstate Ultra Black—everything else is Franklin Gothic. Does it look like more than two typefaces? Using different typeface weights and sizes for headlines, subheads, and text is a good way to add interest and maintain a particular style.

Interstate Ultra Black

Typeface AaBbEeGgKkMmQgRr

Franklin Gothic Condensed

Typeface AaBbEeGgKkMmQqRrSsWw!?

Franklin Gothic Book Condensed

Typeface AaBbEeGgKkMmQqRrSsWw!?

Franklin Gothic Rook Condensed

Text Lorem ipsum dolor sit amet, consectetuer adipiscing elit, sed diam nonummy nibh euismod tincidunt ut laoreet dolore magna aliquam erat volutpat. Ut wisi enim ad minim veniam, quis nostrud exerci tation ullamcorper suscipit lobortis nisl ut aliquip ex ea commodo consequat. Duis autem vel eum iriure dolor in hendrerit in vulputate velit esse molestie consequat, vel illum dolore eu feugiat nulla facilisis at vero eros.

The illustrations

The icons are not without meaning. On pages 6 and 7, for example, two images of cars are sliced in half and combined to represent the contrast between new and old. If they were solid black and white, the icons might overwhelm the design. Making them a second color or shades of that color helps to blend them into the page, and the accompanying photographs of people add a sense of the real to the abstract.

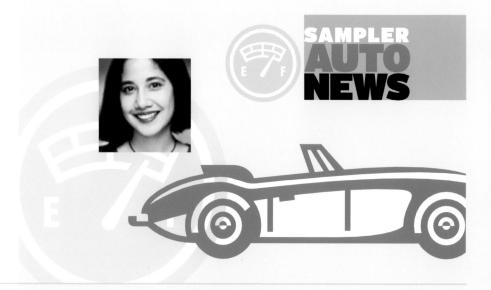

DISTINGUISHING FEATURES

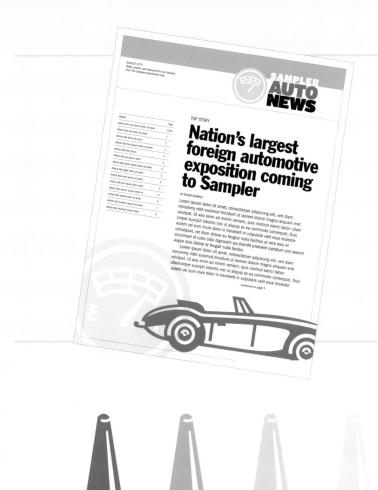

Establish a focus

The front pages of most newsletters follow the newspaper model—multiple stories are presented in the hope that one will attract the reader's attention. This layout takes a different tack, one more akin to a magazine—it features a top story and lists what's to come via a table of contents labeled "INSIDE." This tactic promotes the idea of leading your reader through your message step-by-step, rather than encouraging the kind of wandering around made so pervasive by the World Wide Web. You are the best judge of which method best suits your audience.

Get the most from a second color

Desktop publishing programs allow you to define and apply tints of a color to different elements of the layout. In this case, the second color is applied full strength and in shades of 50 percent, 30 percent, and 15 percent to artwork, shapes, lines, and text. That variety makes the layout look and feel as if more than just black and one other color are being used.

VEHICLE NAME > Description lorem ipsum dolor sit amet, consectetuer adipiscing elit, sed diam nonummy nibh euismod tincidunt ut laoreet dolore magna aliquam erat volutpat. Ut wisi enim ad minim veniam, quis nostrud exerci tation aliquip ex ea commodo consequat. Lorem ipsum dolor sit amet, consectetuer adipiscing elit, sed diam nonummy nibh euismod tincidunt ut laoreet dolore magna aliquam lorem ipsum dolor sit amet, consectetuer adipiscing elit, sed diam nonummy nibh euismod

30%

15%

\$0000 > Seller Name > 987 654 3210 > name@e-mail.com

Make your newsletter profitable

Recall the mention of advertising? (See Step 3.3: Develop a Marketing Plan, page 17.) In this case the publisher's costs are defrayed through a classified advertising section. What type of advertising can you offer to readers and sponsors that would lessen your costs or perhaps even make you a profit? Is there someone trying to reach the same audience? Can you enlist advertisers or sponsors? Can you sell someone else's product or a service?

AUGUST 20??:

News, events, and resources for car fanatics from The Sampler Automobile Club

Page Article title one ipsum dolor sit amet Cover Article title two dolor sit amet Article title three sit amet Article title four ipsum dolor sit amet Article title five ipsum Article title six ipsum dolor Article title seven ipsum dolor sit amet 5 Article title eight dolor sit amet Article title nine ipsum sit amet Article title ten ipsum dolor amet Article title eleven ipsum dolor sit Article title twelve dolor sit amet Article title thirteen ipsum sit amet Article title fourteen ipsum dolor

TOP STORY

Nation's largest foreign automotive exposition coming to Sampler

BY ROGER EXAMPLE

Lorem ipsum dolor sit amet, consectetuer adipiscing elit, sed diam nonummy nibh euismod tincidunt ut laoreet dolore magna aliquam erat volutpat. Ut wisi enim ad minim veniam, quis nostrud exerci tation ullam corper suscipit lobortis nisl ut aliquip ex ea commodo consequat. Duis autem vel eum iriure dolor in hendrerit in vulputate velit esse molestie consequat, vel illum dolore eu feugiat nulla facilisis at vero eros et accumsan et iusto odio dignissim qui blandit praesent luptatum zzril delenit augue duis dolore te feugait nulla facilisi.

Lorem ipsum dolor sit amet, consectetuer adipiscing elit, sed diam nonummy nibh euismod tincidunt ut laoreet dolore magna aliquam erat volutpat. Ut wisi enim ad minim veniam, quis nostrud exerci tation ullamcorper suscipit lobortis nisl ut aliquip ex ea commodo consequat. Duis autem vel eum iriure dolor in hendrerit in vulputate velit esse molestie

continued on page 3

<u>Հոյուհարդիրությունը արտական անագրությունը անագրությունը անագրական հարական անագրությունը և անագրությունը և անագ</u>

AUGUST 20??: News, events, and resources for car fanatics from The Sampler Automobile Club

A parking drama

FRANKLIN EXAMPLI

Lorem ipsum dolor sit amet, consectetuer adipiscing elit, sed diam nonummy nibh euismod tincidunt ut laoreet dolore magna aliquam erat volutpat. Ut wisi enim ad minim veniam, quis nostrud exerci tation aliquip ex ea commodo consequat.

Duis autem vel eum iriure dolor in hendrerit in vulputate velit esse molestie consequat, vel illum dolore eu feugiat nulla facilisis at vero eros et accumsan et iusto odio dignissim qui blandit praesent luptatum zzril delenit augue duis dolore te feugait nulla facilisi. Ut wisi enim ad minim veniam, quis nostrud exerci tation aliquip ex ea commodo consequat. Autem vel eum iriure dolor in hendrerit in vulputate velit esse molestie consequat, vel illum dolore eu feugiat nulla facilisis at vero eros et accumsan et justo odio dignissim qui blandit praesent luptatum zzril delenit augue duis dolore te feugait nulla facilisi.

adipiscing elit, sed diam nonum Lorem ipsum dolor sit amet, consectetuer adipiscing elit, sed diam nonummy nibh euismod tincidunt ut laggest dolors

Lorem ipsum dolor sit

amet, consectetuer

magna aliquam erat volutpat. Ut wisi enim ad minim veniam, quis oostrud exerci tation ullam corper suscipit lootroin sils ut aliquip ex ea commodo consequat. Duis autem vel eum inture dolor in hendrerit in vulputate velit esse molestie consequat, vel illum dolore eu feujat nulla facilisis at vero eros et accumsan et iusto doli odignissim qui blandit praesent luptatum zzril delenit augue duis dolore te feugat nulla facilisi. Lorem ipsum dolor sit amet, consecteuter adipiscing elit, sed diam nonummy nibh euismod tincidunt ut laoreet dolore magna aliquam erat volutpat. Ut wisi enim ad minim veniam, quis nostrud exerci tation ullamcorper suscipit lobortis nisi ut aliquip ex ea commodo consequat. Duis autem vel eum inure dolor in hendrent in vulputate vel eum inure vel eum inure dolor in hendrent in vulputate vel eum inure vela eum inure vel eum inure vel eum inure vel eum inure vel eum inu

eu feuglat nulla facilisis at vero. Lorem ipsum dolor sit amet, consectetuer adipiscing elit, sed diam nonumny nibh euismod tincidunt ut laoreet dolore magna aliquam erat volutpat. Ut wisi enim ad minim veniam, quis nostrud exerci tation ullam corper suscipit lobortis nisi ut aliquip ex ea commodo consequat.

Contact Franklin Example: 987 654 3210 or name@email addressz.com; More: http://www.yourwebaddressz.com/

A 90 year-old man, his 75 year-old car, and 17 miles of road

BY DILLON EXAM

Lorem ipsum dolor sit amet, consectetuer adipiscing elit, sed diam nonummy nibh euismod tincidunt ut laoreet dolore magna aliquam erat volutpat. Ut wisi enim ad minim veniam, quis nostrud exerci tation ullam corper suscipit lobortis nisi ut aliquip ex ea commodo consequat. Duis autem vel eum iriure dolor in hendrerit in vulputate veilt esse molestie consequat, vel illum dolore eu feuglat nulla facilisis at vero eros et accumsar et iusto odio dignissim qui blandit praesent luptatum zzril delenit augue duis dolore te feugat nulla facilisis.

Lorem ipsum dolor sit amet, consecteuer adipiscing elit, sed diam nonummy nibh euismod tincidunt ut laoreet dolore magna alliquam erat volutpat. Ut wisi enim ad minim veniam, quis nostrud exerci taiton ullamcorper suscipit lobortis nisi ut aliquip ex ea commodo consequat. Duis autem vel eum iniure dolor in hendrent in vulputate velit esse molestie consequat, vel illum dolore eu feuglat nulla facilisis at vero eros et Nam liber tempor cum soluta nobis eleifend option congue nihil imperdiet doming id quod mazim placerat facer possim assum.

Contact Dillon Example: 987 654 3210 or name@emailaddressz.com; More: http://

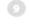

The Sampler Automobile Club P.O. Box 1245 Your City, ST 12345-6789

Inside: 8 ways to finance your next vehicle with little or no interest

SANDRA EXAMPLE SAMPLER CORPORATION 123 EXAMPLE BOULEVARD STE 200 YOUR CITY ST 12345 6789 Non-Profit Organization
U.S. Postage Paid
Permit ???
Your City, ST 12345-6789

Cover (page 1)

1 Eyebrow Franklin Gothic Book Condensed, 12pt, align left; Headline, large Franklin Gothic Condensed, 48/40pt, Contributor Franklin Gothic Book Condensed, 8pt, align left; Text Franklin Gothic Book Condensed, 12/14pt, align left; "continued" Franklin Gothic Book Condensed Italic, 8pt, align left; 2 "SAMPLER" Interstate Ultra Black, 24pt, justified; "AUTO" Interstate Ultra Black, 45pt, justified; "NEWS" Interstate Ultra Black, 42pt, justified; 3 Date/defining phrase Franklin Gothic Book Condensed, 8/9pt, align left; 4 Contents Franklin Gothic Book Condensed, 7/16pt, align left; Lines .5pt; 5 Line .5pt

Back Cover (page 12)

6 Headline, large Franklin Gothic Condensed, 48/40pt, align left; Contributor Franklin Gothic Book Condensed, 8pt, align left; Text Franklin Gothic Book Condensed, 10/12pt, align left; "continued" Franklin Gothic Book Condensed, 8pt, align left; 7"SAMPLER" Interstate Ultra Black, 15pt, justified; "AUTO" Interstate Ultra Black, 29pt, justified; "NEWS" Interstate Ultra Black, 28pt, justified; 8 Headline, small Franklin Gothic Condensed, 20/20pt, align left; 9 Contact link Franklin Gothic Book Condensed, 7/8pt, align left; 10 Return address Franklin Gothic Book Condensed, 8/8pt, align left; Teaser headline Franklin Gothic Condensed, 25/23pt, align left; 11 Label address Arial, 9/9pt, align left; 10 Postage indicia Franklin Gothic Book Condensed, 8/8pt, align center; Line .5pt

Pages 2 & 3

12 Date/defining phrase Franklin Gothic Book Condensed, 8/9pt, align left; Headline, small Franklin Gothic Condensed, 20/20pt, align left; Contributor Franklin Gothic Book Condensed, 8pt, align left; Text Franklin Gothic Book Condensed, 10/12pt, align left; Contact link Franklin Gothic Book Condensed, 7/8pt, align left; 13 Masthead subhead Franklin Gothic Book Condensed, 8pt, align left; Masthead text Franklin Gothic Book Condensed, 9/10pt, align left; Copyright Franklin Gothic Book Condensed, 7pt, align left; Line .5pt; 14 Light headline, large Franklin Gothic Book Condensed, 36/30pt, align left; "continued" Franklin Gothic Book Condensed, 8pt, align left; 15 Caption Franklin Gothic Book Condensed, 7/8pt, align left; 16 "SAMPLER" Interstate Ultra Black, 15pt, justified; "AUTO" Interstate Ultra Black, 29pt, justified; "NEWS" Interstate Ultra Black, 28pt, justified; 17 Page numbers Franklin Gothic Book Condensed, 8pt, align left or right

SOURCE Illustrations: Gas gauge (pg. 1), cars (pg. 1,2,12), cones (pg. 3), parking meter (pg. 12) from Image Club ArtRoom Transportation from Eyewire, 800-661-9410, 403-262-8008, www.eyewire.com. © Eyewire, Inc., all rights reserved; Woman (pg. 3) from Faces 1 from RubberBall Productions 801-224-6886, www.rubberball.com. © RubberBall Productions, all rights reserved.

SOURCE Type Families: Franklin Gothic, Arial, Adobe Systems, Inc. 800-682-3623, www.adobe.com/type; Interstate, Font Bureau, 617-423-8770, www.fontbureau.com.

Extreme fluids

e veilt esse molestie consequat, vei lore eu feuglat nulla facilisis at vero accumsan et iusto odio dignissim qui oraesent luptatum zzril delenit augue por te feugait nulla facilisi. em ipsum dolor sit amet, consectetue ng elit, sed diam nonummy nibh

lisis at vero eros et Nam liber te

SUBHEAD TEXT

Member's Market

am erat volutpat. Ut wisi enim ad orper suscipit loboriis nisi ut aliquip ex ea ormodo consequat. Duis autem vel eum iure dolor in hendrerit in vulputate velit es: nolestie consequat, vel illum dolore eu eugiat nulla facilisis at vero eros et accums

18 Date/defining phrase Franklin Gothic Book Condensed, 8/9pt, align left; Headline, large Franklin Gothic Condensed, 42/38pt, align left; Contributor Franklin Gothic Book Condensed, 8pt, align left; Text Franklin Gothic Book Condensed, 10/12pt, align left; Contact link Franklin Gothic Book Condensed, 7/8pt, align left; 19 Headline, small Franklin Gothic Condensed, 20/20pt, align left; 20 Classified listings Franklin Gothic Book Condensed, 8/8.3pt, align left; Line .5pt; 21 Page numbers Franklin Gothic Book Condensed, 8pt, align left or right; 21 "SAMPLER" Interstate Ultra Black, 15pt, justified; "AUTO" Interstate Ultra Black, 29pt, justified; "NEWS" Interstate Ultra Black, 28pt, justified; Line .5pt

To be printed in black and a solid PANTONE Color Ink as defined on the palette below (see Step 9.3). (Because this book is printed in process colors (CMYK), the illustration is only a simulation of the actual solid PANTONE Color).

Teal or PANTONE® 3278

100% 30%

A new concept in concept cars

Lorem ipsum dolor sit amet, consectetuer adipiscing elit, sed diam nonummy nibh euismod tincidunt ut laoreet dolore magna aliquam erat volutpat. Ut wisi enim ad mini veniam, quis nostrud exerci tation ullam veniam, quis nostrud exerci tation ullam corper suscipit hooths fish ult allequipe e a commodo consequat. Duis autem vel eum inture dolor in hendretti n viliputate veltt esse molestic consequat, veil illum dolore eu feuglat nulla facilisis at vene orse et accumsars et iusto odio diginissim qui blandit praesent lugatum zuzi delenit augue duis dolore te feugat nulla facilisi.

uscipit lobortis nisl ut aliquip ex ea commode consequat. Duis autem vel eum iriure dolor in consequat. Duis autem vel eum inure dolor i hendrerit in vulputate velit esse molestie consequat, vel illum dolore eu feugiat nulla facilisis at vero eros et Nam liber tempor cur soluta nobis eleifend option congue nihil imperdiet doming id quod mazim placerat facer possim assum.

Lorem ipsum dolor sit amet, consectetue consequat. Lorem ipsum dolor sit amet, consectetuer adipiscing elit, sed diam nonummy nibh euismod tincidunt ut laoreet dolore erat volutpat.

Contact Robin Example: 987 654 3210 or name@emailaddressz.com; More: http:// www.yourwebaddressz.com/articles/

How to adapt new technologies to classic automobiles

Loren ipsum tolor sit amet consectedur adpissing elit, sed diam nonummy nibh euismod ticidunt ut laoreet dolore magna aliquam entre volutpat. Ut wis enim ad minim veniam, quis nostrud exerci tation aliquip ex ea commodo consequat.

odenta uguje dus odote te ngujet duwil refacilis. It wis si emia ad minim veniama, quisi notarsia efacilis in discipio di caritti di caritti di refacilis in di caritti di caritti di caritti di caritti di consequat. Attar vi el euri riu e dolor in i hendretti in viujutate velit esse moleste digissami qui biando pracemba nel tisso di digissami qui biando pracemba nel tisso di delenta ugue dus dolore si fungati rulla delenta ugue dus dolore de regulati rulla consecteture adipsioni gelle, del dann nonum my riche teuroni diculturi ut la overe dolore magina vianiqua et voluptat. Ut visi en ima di anomore suscipit loborit si di ut aliquip ex ea comprese suscipit loborit si di ut aliquip ex ea comprese suscipit loborit si di utiliamo dele dele dele dele consequat, vei illum dolore eu fregiati rulla considare a visitate velle esse moleste consequat, vei illum dolore eu fregiati rulla considare vei esse moleste consequat, vei illum dolore eu fregiati rulla consida esse deleren option congiue nhili impedete doming hacerat impedete doming hacerat

facilisis at vero eros et Nam liber tempor cum soluta nobis eleifend option congue nihil imperdiet doming id quod mazim placerat facer possim assum quis nostrud exerci tatior ullamcorper suscipit lobortis nisl ut aliquip ex ea commodo consequat. Duis autem vel eum iriure dolor in hendrerit in vulputate velit esse molestie consequat, inure dolor in hendrent in vulprata evit esse se illum dolore se i dere illum dolore se il

Lorem ipsum dolor sit amet, consectetuer adipticing elit, sed diam nonummy noh euismed tindout ut laroret dolore magna aliquam esti volticat. Ut visi enim ad minim veniam, quio nostrod exerci tation ullam corper associal tobions sini ut aliquip ex ea commodo consequat. Dias autem vel eui nime dolor in headrent in vulgutate velle esse molestie consequat, veli illum dolore eu fengat mulla facilis si veno enos et accumsan et iusto dolo dignissim qui blandit praesent luptatum zzil delaria suge duis dolore te fengati mulla facilis .

consequat. Duis autem vel eum iriure dolor in hendrerit in vulputate velit esse molestie

dolore magna aliquam erat volutpat. Ut wisi enim ad minim veniam, quis nostrud exerci

aliquam erat volutpat.

Ut wisi enim ad minim veniam, quis nostrud exerci tation ullamcorper suscipit nostrud exerci tation ullamcorper suscipit lobortis nisi I u aliquip ex ea commodo consequat. Duis autem vel eum inure dolor hendrert in vulputate velit esseeum inure d lor in hendrerit in vulputate velit esse moles consequat, vel illum dolore eu feuglat nulla facilisis at vero eros et Nam liber tempor cu soluta nobis eleifend opquod mazim placerat facer possim assum commodo consequat. Lorem ipsum dolor sit amet, consectetuer adipiscing elit, sed diam nonummy nibh euismod tincidunt ut laoreet dolore magna aliquam erat volutpat. Ut wis enim ad minim veniam, quis nostrud exerci tation aliquip ex

veniam, quis nostrud exerci tation aliquip ex ea commodo consequat. Duis autem vel eum iniure dolor in hendrenti in vulputate velit esse molestie consequat, vel illum dolore eu feugiat nulla facilisia et vere ose et accumsan et iusto odi dignissim qui blandit praesent luptatum zzril delenit augue duis dolore fe feugiat nulla facilisi, Ut wisi enim ad minim veniam, quis facilis. It was enin ad minim veniam, qui nontrol acerul atlon aliquip e na como consequat. Autem vel eum iniur dolor in henderfir in vulquitar velle consequat. Vel litum consequat, vel litum dolore en feuglat rulla consequat, vel litum dolore en feuglat rulla recibis at ven eros et accumsan et iusto odi dignissim qui blandit praesent hiptatum zzri delenta augue dui solore te feuglat mulla facilisal. Lorem ipsum dolore sit amet, consectetuera adipsicine gielt, sed diam nonum my nibh euismod tincidum ti. Lorente dolore magna aliquam ero turtipat. Ut visi eimi ad minim veniam, quis nostrud exerci tation

ulamcope suscipit loboris nist ut aliquip ex ex commodo consequit. We dotor in hondreti un vigurata will research production in hondreti un vigurata will research production consequat, veil lumit dotore ut freight nulla facilisis at vem erne et Nami liber tempor consequat, veil lumit dotore ut freight nulla facilisis at vem erne et Nami liber tempor consequata nobes elefend option compe hilli impediet doming id quad mazim placent a commodo consequata. Dius autemne eveni tauta nulla morper suscipit loboris nist valiquip ex ex commodo consequata. Dius autemne el euriture dotor in hendrett in vulgutata veil esse moleste consequat, Diuris autemne el euriture dotor in hendrett in vulgutata veil esse veil illum dotore un freught and facilisis at vere conse el Nami liber tempor cum soulta nobles dell'end option congue nilli impediet doming il quod mazim placenti facer possim assum. Vulgudata nulla facilisis at veco. Ut vissi enim ad minim venima, qui conservati dell'endo sono con conservati con conservation dell'endo dell'endo option congue nilli prepetite doming il quod mazim placenti facer possim assum. Vulgudata nulla facilisi at veco. Ut vissi enim ad minim venima, qui pour escariorità dottoris nel al caligip ex es commodo nostrud exerci tation ullamcorper suscipit loborits nisi ul aliquip ex ea commodo consequat. Duis autem vel eum iriure dolor in hendrent in vulputate velit esseeum iriure dol in hendrent in vulputate velit essee molestie consequat, vel illum dolore eu feugiat nulla facilisis at vero eros et Nam liber tempor cum

Dus autem vel eum inure dolor in hendreit in vulputate velti esse molestie consequat, vel illum dolore eu feuglat nulla facilisis at vero eros et accumsan et iusto od dignissim qui blandit praesent luptatum zzri delenit augue duis dolore te feugati nulla facilisi. Ut wis einm ad minim veniam, qui nostrud exerci tation aliquip ex ea commodo

Pages 6 & 7

22 Date/defining phrase Franklin Gothic Book Condensed, 8/9pt, align left; Light headline, small Franklin Gothic Book Condensed, 24/22pt, align left; Contributor Franklin Gothic Book Condensed, 8pt, align left; Text Franklin Gothic Book Condensed, 10/ 12pt, align left; Contact link Franklin Gothic Book Condensed, 7/8pt, align left; 23 Headline, large Franklin Gothic Condensed, 48/40pt, align left; 24 Page numbers Franklin Gothic Book Condensed, 8pt, align left or right; 25 "SAMPLER" Interstate Ultra Black, 15pt, justified; "AUTO" Interstate Ultra Black, 29pt, justified; "NEWS" Interstate Ultra Black, 28pt, justified; Line .5pt

SOURCE Illustrations: Gas gauge (pg. 5,7), motorcycles (pg. 4, 5), cars (pg. 6, 7) from Image Club ArtRoom Transportation from Eyewire, 800-661-9410, 403-262-8008, www.eyewire.com. © Eyewire, Inc., all rights reserved; Man (pg. 4), woman (pg. 6) from Faces 1 from RubberBall Productions 801-224-6886, www.rubberball.com. © RubberBall Productions, all rights reserved; Vehicle photographs from ClickArt 200,000 from Broderbund, available from software retailers worldwide, © T/Maker, all riahts reserved.

SOURCE Type Families: Franklin Gothic, Adobe Systems, Inc. 800-682-3623, www.adobe.com/type; Interstate, Font Bureau, 617-423-8770, www.fontbureau.com.

STYLE 5 (16 PAGES)

Jacket

Remember jolt thinking? (See page 17.) This is a jolt thinking jacket—the best of both worlds—a newsletter with both the flash of four-color and the frugality of black and white.

The idea is to print a year's worth of slick, four-color jackets to wrap around your regular black-and-white newsletter. The jacket's 9.5 inch height allows a 1.5 inch slice of the newsletter inside to peek out the top of the jacket to reveal the issue date and an illustration designed to entice the reader inside.

In this case, the jacket is printed with recurring information and the organization's logo in bold, bright colors. Your version could just as easily incorporate a photograph or some other appropriate artwork.

Sampler

News, events, and resources for writers from The Sampler Writer's Society

Research chaos— Lynn Example's harrowing trip into science-fiction writing

Lorem ipsum dolor sit amet, consectetuer adipiscing elit, sed diam nonummy nibh euismod tincidunt ut laoreet dolore magna aliquam erat volutpat. Ut wisi enim ad minim veniam, quis nostrud exerci tation aliquip ex ea commodo conseguat.Lorem ipsum dolor sit amet, consectetuer adipiscing elit, sed diam nonummy nibh euismod tincidunt ut laoreet dolore magna aliquam erat volutpat. Ut wisi enim ad minim veniam, quis nostrud exerci tation aliquip ex ea commodo consequat.

Autem vel eum iriure dolor in hendrerit in vulputate velit esse molestie consequat, vel illum dolore eu feugiat nulla facilisis at vero eros et accumsan et iusto odio dignissim qui blandit praesent luptatum zzril delenit augue duis dolore te feugait nulla facilisi. Lorem ipsum dolor sit amet, consectetuer adipiscing elit, sed diam nonum. Autem vel eum iriure dolor in hendrerit in vulputate velit esse molestie consequat, vel illum dolore eu feugiat nulla facilisis at vero eros et accumsan et iusto odio dignissim qui blandit praesent luptatum zzril delenit augue duis dolore te feugait nulla

Lorem ipsum dolor sit amet. Autem vel eum iriure dolor in hendrerit in vulputate velit esse molestie consequat, vel illum dolore eu feugiat nulla facilisis at vero eros et accumsan et iusto odio dignissim qui blandit praesent luptatum zzril delenit augue duis dolore te feugait nulla facilisi. Autem vel eum iriure dolor in hendrerit in vulputate velit esse molestie consequat, vel illum dolore eu feugiat nulla

dignissim qui blandit praesent luptatum zzril delenit augue duis dolore te feugait nulla facilisi. Lorem ipsum dolor sit amet,

consectetuer adipiscing elit, sed diam nonum. Autem vel eum iriure dolor in hendrerit in vulputate velit esse molestie consequat, vel illum dolore eu feugiat nulla facilisis at vero erc et accumsan et iusto odio dignissim qui blandit praesent luptatum zzril delenit augue duis dolore te feugait nulla facilisi. Lorem ipsum dolor sit amet, consectetuer adipiscing elit, sed diam nonum. Lorem ipsum dolor sit amet, consectetuer adipiscing elit, sed diam nonummy nibh euismod tincidunt ut laoreet dolore magna aliquam erat volutpat.

Lorem ipsum dolor sit amet, consectetuer adipiscing elit, sed diam nonum. Autem vel eum iriure dolor in sed diam nonum. Lorem ipsum dolor sit amet, consectetuer adipiscing elit, sed diam nonummyhendrerit in vulputate velit esse molestie consequat, vel illum dolore eu feugiat nulla facilisis at vero eros et accumsan et iusto odio dignissim qui blandit praesent luptatum zzril delenit augue duis dolore te feugait nulla facilisi. Lorem ipsum dolor sit amet, consectetuer adipiscing elit, sed diam nonum. Lorem ipsum dolor sit amet, consectetuer adipiscing elit, sed diam nonummy nibh euismod tincidunt ut laoreet dolore magna aliguam erat volutpat. Lorem ipsum dolor sit amet, consectetuer.

continued on page 8

Page flow

One 9.5 by 11 inch sheet (landscape) and three 17 by 11 inch sheets (landscape) are stacked, folded to 8.5 by 11 inches and saddle-stitched.

What you need

General layout and design requires a desktop publishing program. Editing photographic images requires a digital imaging program. Dividing and reassembling the parts and pieces of vector clip art images and type requires a drawing program. (See Step 7: Choose Your Tools, page 26.)

Five fea

> adipisci euismo

> > vulputa illum do eros et blandit duis dol ipsum d 2 / Auté

> > > vulputa

illum do blandit duis do amet, co nonum hendre facilisis dignissi facilisi. consect

vulputa illum de eros et a duis do

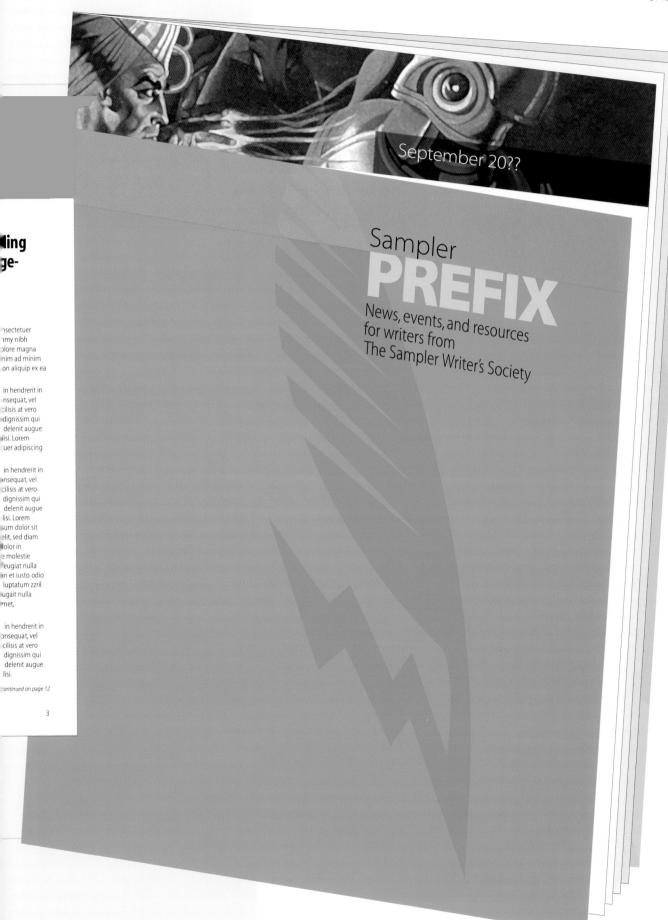

ge-

The design grid

Both the jacket and the inserts are built on a three-column grid. (See *Step 11.2: Establish the Page Size and Grid*, page 37.)

The typefaces

This newsletter employs a Adobe Multiple Master Typeface—Myriad. A multiple master is a typeface you can customize by changing attributes such as weight: thin to heavy; width: condensed to extended; and its style and optical size. This is an example of the thousands of versions you can create of a single multiple master and testament to the adaptability of a well-designed face.

Myriad MM 700bd 300cn

Typeface AaBbEeGgKkMmQqRrSsWw!?

Myriad MM 830hl 700se

Typeface AaBbEeGgKkMmQqRrS

Myriad MM 215lt 700se

Typeface

AaBbEeGgKkMmQqRrSsW

Myriad MM 250wt 500wd

Text Lorem ipsum dolor sit amet, consectetuer adipiscing elit, sed diam nonummy nibh euismod tincidunt ut laoreet dolore magna aliquam erat volutpat. Ut wisi enim ad minim veniam, quis nostrud exerci tation ullamcorper suscipit lobortis nisl ut aliquip ex ea commodo consequat. Duis autem vel eum iriure dolor in hendrerit in vulputate velit esse molestie consequat, vel illum dolore eu feugiat nulla facilisis at vero eros.

The illustrations

The jacket for your newsletter might feature photographs, artwork, or, as in this example, a simple, brightly colored version of the organization's logo. The image on the inside is designed to represent the subject matter of the page on which it appears—in this case, science fiction.

DISTINGUISHING FEATURES

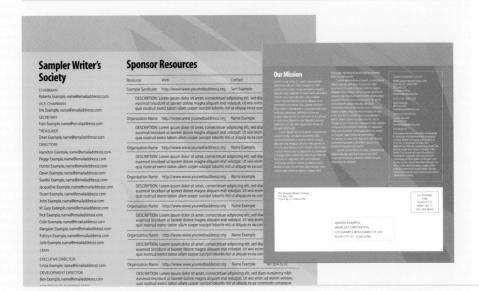

Use the jacket to your advantage

Print the four-color jacket with information that repeats issue to issue—the nameplate, masthead, mailing area, and other useful information such as a mission statement and a list of resources. The example also includes a full page of advertising sold to a sponsor to defray the cost of printing or for profit. The 12-page black-and-white portion of the newsletter is reproduced, collated with the jacket, then folded and saddle-stitched.

Standardize the size and shape of illustrations

The jacket's 9.5 inch height allows a 1.5 inch slice of the newsletter inside to peek out the top of the jacket to reveal the issue date and an illustration designed to entice the reader inside. Standardizing the size and shape of images simplifies production—you know exactly how many images you need and their exact size.

Use a piece of an illustration

Sometimes the best illustrations are those that first appear as part of a larger image. Looking for something simple and bold? Look for a small part of the complex whole. The quill used as the predominant element of the newsletter jacket was culled from a clip art image.

Our Mission

molestie consequat, vei illum dolore eu feugiat nulla facilisis at vero eros et accums et iusto odio dignissim qui blandit praesen luptatum zzril delenit augue duis dolore te

adipiscing elit, sed diam nonummy nibh euismod tincidunt ut laoreet dolore magna aliquam erat volutpat. Ut wisi enim ad minim veniam, quis nostrud exerci tation ullamcorper suscipit lobortis nisl ut aliquip ex ea commodo consequat. Duis autem vel eum iriure dolor in hendrerit in vulputate velit esse molestie consequat, vel illum dolore eu feugiat nulla facilisis at vero eros et Nam liber tempor cum

imperdiet doming id quod mazim placerat

facer possim assum.

Lorem ipsum dolor sit amet, consectetue adipiscing elit, sed diam nonummy nibh euismod tincidunt ut laoreet dolore magna aliquam erat volutpat. Ut wisi enim ad minim veniam, quis nostrud exerci tation ullamcorper suscipit lobortis nisl ut ipsum dolor sit amet, consectetuer adipiscing elit, sed diam nonummy nibh euismod tincidunt ut laoree dolore magna aliquam erat volutpat. Ut wisi enim ad minim veniam, quis nostrud exerci tation ullam corper suscipit lobortis nisl ut aliquip ex ea commodo consequat. Duis autem

dolore te feugait nulla facilisi.

Lorem ipsum dolor sit amet, consectetuer adipiscing elit, sed diam nonummy nibh euismod tincidunt ut laoreet dolore magna aliquam erat volutpat.

SAMPLER WRITER'S SOCIETY 3028 Example Road, P.O. Box 1245 Your City, ST 12345-6789 987 654 3210 987 654 3210 Fax info@emailaddressz.com

NEWSLETTER EDITOR Charles Example 987 654 3210 name@emailaddressz.com

Duis autem vel eum iriure dolor in hendrerit in vulputate velit esse molestie consequat, vel illum dolore eu feugiat nulla facilisis at veri illum dolore eu reugiat nulla facilisis at vero eros et accumsan et iusto odio dignissim qui blandit praesent luptatum zzril delenit augue duis dolore te feugait nulla facilisi. Duis autem vel eum iriure dolor in hendrerit in vulputate velit esse molestie consequat, vel illum dolore eu feugiat nulla facilisis at vero eros et Nam liber tempor cum soluta nobis eleifend option conque nihil imperdiet doming id quod mazim placerat facer possim assum quis nostrud exerci tation ullamcorper suscipi.

The Sampler Writer's Society P.O. Box 1245 Your City, ST 12345-6789

SANDRA EXAMPLE SAMPLER CORPORATION 123 EXAMPLE BOULEVARD STE 200 YOUR CITY ST 12345 6789

 $\begin{smallmatrix} 1 \\ 1 \end{smallmatrix}$

PAID YOUR CITY, ST PERMIT NO. ??? **ZIP CODE 98765**

U.S. POSTAGE

8.5 W

 $\frac{1}{2}$

Process Colors

C35	M50	YO	КО	
C40	M45	Y0	КО	
CO	M90	Y85	КО	

				ministration
C25	M0	Y70	КО	
C20	MO	Y60	КО	
СО	M40	Y75	КО	
CO	M30	Y80	КО	

Cover (page 1)

1"Sampler" Myriad MM, 215lt, 700se, 28pt, align left; "PREFIX" Myriad MM, 830bl, 700se, 62pt, align left; Defining phrase Myriad MM, 250wt, 500wd, 18pt, align left;

Back Cover (page 16)

2 Headline, small Myriad MM, 700bd, 300cn, 24pt, align left; Text Myriad MM, 250wt, 500wd, 10/12pt, align left; 3 Masthead subhead Myriad MM, 215lt, 700se, 8pt, align left; Masthead text Myriad MM, 250wt, 500wd, 9/10pt, align left; Line .5pt; 4 Return address Myriad MM, 215lt, 700se, 8/9pt, align left; 5 Label address Arial, 10/10pt, align left; Postage indicia Myriad MM, 215lt, 700se, 8/8pt, align center; Line .5pt

Pages 2 & 15

6 Ad headline Mona Lisa Solid, 24/36pt, align left; Line .5pt; Ad text Garamond Light Condensed, 10/16pt, align left; "SAMPLER SCHOOL" Myriad MM, 700bd, 300cn, 8pt, align left; Ad address Garamond Light Condensed Italic, 8/10pt, align left; 7 Line .5pt; 8 Headline, small Myriad MM, 700bd, 300cn, 24/24pt, align left; 5ubhead Myriad MM, 215lt, 700se, 8pt, align left; Text Myriad MM, 250wt, 500wd, 9/10pt, align left; 9 Headline, small Myriad MM, 700bd, 300cn, 24/24pt, align left; Text chart Myriad MM, 250wt, 500wd, 9/10pt, align left; Text chart Myriad MM, 250wt, 500wd, 9/10pt, align left; Line .5pt

Color

Printed in four-color process (Step 11.6) using values of cyan, magenta, yellow, and black (CMYK) as defined on the color palette below. Actual color will vary.

SOURCE Illustrations: Quill from Image Club ArtRoom Schoolsville from Eyewire, 800-661-9410, 403-262-8008, www.eyewire.com. © Eyewire, Inc., all rights reserved; Roadway (pg. 2) from US Landmarks and Travel from PhotoDisc, 800-979-4413, 206-441-9355, www.photodisc.com, © PhotoDisc, all rights reserved.

SOURCE Type Families: Arial, Garamond, Mona Lisa, Myriad, Adobe Systems, Inc. 800-682-3623, www.adobe.com/type.

PART 2: DESIGN RECIPES

10 Date Myriad MM, 215lt, 700se, 18pt, align left; 11 Eyebrow Myriad MM, 215lt, 700se, 12pt, align left; Headline, large Myriad MM, 700bd, 300cn, 48/44pt, align left; Contributor Myriad MM, 215lt, 700se, 8pt, align left; Text Myriad MM, 250wt, 500wd, 10/12pt, align left; "continued" Myriad MM Italic, 250wt, 500wd, 8pt, align right; 12 Headline, small Myriad MM, 700bd, 300cn, 24/24pt, align left; 13 Page number Myriad MM, 215lt, 700se, 10pt, align left or right

Page 14

14 Eyebrow Myriad MM, 215lt, 700se, 12pt, align left; Headline, small Myriad MM, 700bd, 300cn, 24/24pt, align left; Contributor Myriad MM, 215lt, 700se, 8pt, align left; Text Myriad MM, 250wt, 500wd, 10/12pt, align left; 15 Contact link Myriad MM, 215lt, 700se, 7/8pt, align left; 16 Page number Myriad MM, 215lt, 700se, 10pt, align left or right

SOURCE Illustrations: Magician from Sci-Fi Pulps from Time Tunnel, 888-650-6050, 480-354-3000, www.timetunnel.com. © Time Tunnel, Inc., all rights reserved; Place setting, (covered wagons, pg. 88), from ClickArt 200,000 from Broderbund, available from software retailers worldwide, © T/Maker, all rights reserved.

SOURCE Type Families: Myriad, Adobe Systems, Inc. 800-682-3623, www.adobe.com/type

Working with a food stylist

Lorem ipsum dolor sit amet, consectetue adipiscing elit, sed diam nonummy nibh euismod tincidunt ut laoreet dolore magna aliquam erat volutpat. Ut wisi enim ad minim veniam, quis nostrud exerci tation aliquip ex ea

Lorem ipsum dolor sit amet, consectetuer adipiscing elit, sed diam nonum. Autem vel eum iriure dolor in hendrerit in vulputate velit esse molestie conseguat, vel illum dolore eu feugiat nulla facilisis at vero eros et accumsan et lusto odio dignissim qui blandit praesent luptatum zzril delenit augue duis dolore te feugait nulla facilisi. Lorem ipsum dolor sit amet. Autem vel eum iriure dolor in hendrerit in vulputate velit esse molestie consequat, vel illum dolore eu feugiat nulla facilisis at vero eros et accumsan et iusto odio dignissim qui blandit praesent luptatum zzril delenit augue duis dolore te feugait nulla facilisi. Autem vel eum iriure dolor in hendrerit in vulputate velit esse molestie consequat, vel illum dolore eu feugiat nulla facilisis at vero eros.

Set accumsan et iusto odio dignissim qui blandit praesent luptatum zzril delenit augue duis dolore te feugait nulla facilisi. Lorem dolor sit amet, consectetuer adipiscing elit, sed diam nonum. Autem vel eum iriure dolor in hendrerit in vulputate velit esse molestie conseguat, vel illum dolore eu feugiat nulla facilisis at vero eros et accumsan et iusto odio dignissim qui blandit praesent luptatum zzril delenit augue duis dolore te feugait nulla facilisi. Lorem ipsum dolor sit amet, consectetuer adipiscing elit, sed diam nonum. Lorem ipsum dolor sit amet, consectetue adipiscing elit, sed diam nonummy nibh euismod tincidunt ut laoreet dolore magna aliquam erat volutpat.

Writing skills

Use quotations to establish and build credibility

Lorem ipsum dolor sit amet, consectetuer adipiscing elit, sed diam nonummy nibh euismod tincidunt ut laoreet dolore magna aliquam erat volutpat. Ut wisi enim ad minin veniam, quis nostrud exerci tation aliquip ex ea commodo consequat. Autem vel eum iri dolor in hendrerit in vulputate velit esse molestie consequat, vel illum dolore eu feugiat nulla facilisis at vero eros et accumsan et ius odio dignissim qui blandit praesent luptatum zzril delenit augue duis dolore te feugait nulla

Lorem ipsum dolor sit amet, consectetue adipiscing elit, sed diam nonum. Autem vel eum iriure dolor in hendrerit in vulputate velit esse molestie consequat, vel illum dolore eu feugiat nulla facilisis at vero eros et accumsan et iusto odio dignissim qui blandit praesent luptatum zzril delenit augue duis dolore te feugait nulla facilisi. Lorem ipsum dolor sit amet Autem vel eum iriure dolor in hendrerit in vulputate velit esse molestie consequat, vel illum dolore eu feugiat nulla facilisis at vero eros et accumsan et iusto odio dignissim qui blandit praesent luptatum zzril delenit augue duis dolore te feugait nulla facilisi. Autem vel eum iriure dolor in hendrerit in vulputate velit esse nolestie conseguat, vel illum dolore eu feugiat

Set accumsan et justo odio dignissim qui blandit praesent luptatum zzril delenit augue duis dolore te feugait nulla facilisi. Lorem ipsum dolor sit amet, consectetuer adipiscing elit, sed diam nonum. Autem vel eum iriure dolor in hendrerit in vulputate velit esse molestie conseguat, vel illum dolore eu feugiat nulla facilisis at vero eros et accumsan et iusto odio dignissim qui blandit praesent luptatum zzril delenit augue duis dolore te feugait nulla facilisi.Lorem ipsum dolor sit amet consectetuer adipiscing elit, sed diam nonum. Lorem ipsum dolor sit amet, consectetuer

dipiscing elit, sed diam nonummy nibh euismod tincidunt ut laoreet dolore magna

aliquam erat volutpat. Ut wisi enim ad minim veniam, quis nostrud exerci tation ullam corper suscipit lobortis nisl ut aliquip ex ea commodo consequat. Duis autem vel eum iriure. Set accumsan et iusto odio dignissim qui blandit praesent luptatum zzril delenit augue duis dolore te feugait nulla facilisi. Lorem ipsum dolor sit amet, consectetuer adipiscing elit, sed diam nonum. Autem vel eum iriure dolor in hendrerit in vulputate velit esse.

Contact Judy Example: 987 654 3210 or name@email.addressz.com; More: http://

Business of writing

How to gauge the quality of a technical translation

BY KATHY EXAMPLE

Lorem ipsum dolor sit amet, consectetuer adipiscing elit, sed diam nonummy nibh euismod tincidunt ut laoreet dolore magna aliquam erat volutpat. Ut wisi enim ad minim veniam, quis nostrud exerci tation aliquip ex ea commodo consequat. Autem vel eum iriure dolor in hendrerit in vulputate velit esse molestie consequat, vel illum dolore eu feugiat nulla facilisis at vero eros et accumsan et iusto odio dignissim qui blandit praesent luptatum zzril delenit augue duis dolore te feugait nulla facilisi. Lorem ipsum dolor sit amet, consectetuer adipiscing elit, sed diam nonum. Autem vel eum iriure dolor in hendrerit in vulputate velit esse molestie consequat, vel illum dolore eu feugiat nulla facilisis at vero eros et accumsan et iusto odio dignissim qui blandit praesent luptatum zzril delenit augue duis dolore te feugait nulla facilisi. Lorem ipsum dolor sit amet. Autem vel eum iriure do lor in hendrerit in.

Contact Kathy Example: 987 654 3210 or name@email addressz.com; More: http:// www.yourwebaddressz.com/articles/storynai

September Feature

Research chaos— Lynn Example's harrowing trip into science-fiction writing

BY THOMAS EXAMPLE

Lorem ipsum dolor sit amet, consectetuer adipiscing elit, sed diam nonummy nibh euismod tincidunt ut laoreet dolore magna aliquam erat volutpat. Ut wisi enim ad minim veniam, quis nostrud exerci tation aliquip ex ea commodo consequat. Lorem ipsum dolor sit amet, consectetuer adipiscing elit, sed diam nonummy nibh euismod tincidunt ut laoreet dolore magna aliquam erat volutpat. Ut wisi enim ad minim veniam, quis nostrud exerci tation aliquip ex ea commodo consequat.

Autem vel eum iriure dolor in hendrerit in vulputate velit esse molestie consequat, vel illum dolore eu feugiat nulla facilisis at vero eros et accumsan et iusto odio dignissim qui blandit praesent luptatum zzril delenit augue duis dolore te feugait nulla facilisi. Lorem ipsum dolor sit amet, consectetuer adipiscing elit, sed diam nonum. Autem vel eum iriure dolor in hendrerit in vulputate velit esse molestie consequat, vel illum dolore eu feugiat nulla facilisis at vero eros et accumsan et iusto odio dignissim qui blandit praesent luptatum zzril delenit augue duis dolore te feugait nulla facilisi

Lorem ipsum dolor sit amet. Autem vel eum iriure dolor in hendrerit in vulputate velit esse molestie consequat, vel illum dolore eu feugiat nulla facilisis at vero eros et accumsan et iusto odio dignissim qui blandit praesent luptatum zzril delenit augue duis dolore te feugait nulla facilisi. Autem vel eum iriure dolor in hendrerit in vulputate velit esse molestie consequat, vel illum dolore eu feugiat nulla

facilisis at vero eros. Set accumsan et iusto odio dignissim qui blandit praesent luptatum zzril delenit augue duis dolore te feugait nulla facilisi. Lorem ipsum dolor sit amet, consectetuer adipiscing elit, sed diam nonum.

Autem vel eum iriure dolor in hendrerit in vulputate velit esse molestie consequat, vel illum dolore eu feugiat nulla facilisis at vero eros et accumsan et iusto odio dignissim qui blandit praesent luptatum zzril delenit augue duis dolore te feugait nulla facilisi. Lorem ipsum dolor sit amet, consectetuer adipiscing elit, sed diam nonum. Lorem ipsum dolor sit amet, consectetuer adipiscing elit, sed diam nonumny nibh euismod tincidunt ut laoreet dolore magna aliquam erat volutpat.

Lorem ipsum dolor sit amet, consectetuer adipiscing elit, sed diam nonum. Autem vel eum iriure dolor in sed diam nonum. Lorem ipsum dolor sit amet, consectetuer adipiscing elit, sed diam nonummyhendrerit in vulputate velit esse molestie consequat, vel illum dolore eu feugiat nulla facilisis at vero eros et accumsan et iusto odio dignissim qui blandit praesent luptatum zzril delenit augue duis dolore te feugait nulla facilisi. Lorem ipsum dolor sit amet, consectetuer adipiscing elit, sed diam nonum. Lorem ipsum dolor sit amet, consectetuer adipiscing elit, sed diam nonummy nibh euismod tincidunt ut laoreet dolore magna aliquam erat volutpat. Lorem insum dolor sit amet, consectetuer.

continued on page 8

Marketing

Five tips for selling features to largecirculation newspapers

BY GRACE EXAMPLE

Lorem ipsum dolor sit amet, consectetuer adipiscing elit, sed diam nonummy nibh euismod tincidunt ut laoreet dolore magna aliquam erat volutpat. Ut wisi enim ad minim veniam, quis nostrud exerci tation aliquip ex ea commodo conseguat.

- 1 / Autem vel eum iriure dolor in hendrerit in vulputate velit esse molestie consequat, vel illum dolore eu feugiat nulla facilisis at vero eros et accumsan et iusto odio dignissim qui blandit praesent luptatum zzril delenit augue duis dolore te feugait nulla facilisi. Lorem ipsum dolor sit amet, consectetuer adipiscing elit, sed diam nonum.
- 2 / Autem vel eum iriure dolor in hendrerit in vulputate velit esse molestie conseguat, vel illum dolore eu feugiat nulla facilisis at vero eros et accumsan et iusto odio dignissim qui blandit praesent luptatum zzril delenit augue duis dolore te feugait nulla facilisi. Lorem ipsum dolor sit amet. Lorem ipsum dolor sit amet, consectetuer adipiscing elit, sed diam nonum. Autem vel eum iriure dolor in hendrerit in vulputate velit esse molestie conseguat, vel illum dolore eu feugiat nulla facilisis at vero eros et accumsan et iusto odio dignissim qui blandit praesent luptatum zzril delenit augue duis dolore te feugait nulla facilisi. Lorem ipsum dolor sit amet, consectetuer adipiscing elit,
- 3 / Autem vel eum iriure dolor in hendrerit in vulputate velit esse molestie consequat, vel illum dolore eu feugiat nulla facilisis at vero eros et accumsan et iusto odio dignissim qui blandit praesent luptatum zzril delenit augue duis dolore te feugait nulla facilisi.

continued on page 12

3

8.5 W

STYLE 6 (12 PAGES)

Lines

In architecture, a building's inward structure is often used as an integral part of its outward design. The same is true with this newsletter—the lines of the underlying grid are used as a primary design element. And, like a well-designed building, a well-designed newsletter is suited to its purpose and a pleasure to see.

A strong design is also a strong communicator—key information is highlighted, images tell a story, and everything is easy to find and read. Design may include some decoration, but decoration is not design.

The Sampler Church

aliquam erat volutpat. Ut wisi enim

New type

of music for

a new type

Lorem ipsum dolor sit amet

consectetuer adipiscing elit, sed

diam nonummy nibh euismod

tincidunt ut laoreet dolore magna

aliquam erat volutpat. Ut wisi enim

exerci tation ullam corper suscipit

lor in hendrerit in vulputate velit

esse molestie consequat, vel illum

dolore eu feugiat nulla facilisis at

dignissim qui blandit praesent

dolore te feugait nulla facilisi.

Lorem ipsum dolor sit amet,

diam nonummy nibh

luptatum zzril delenit augue duis

consectetuer adipiscing elit, sed

amet, consectetuer adipiscing elit,

sed diam nonummy nibh euismod

tincidunt ut laoreet dolore magna

vero eros et accumsan et iusto odio

Duis autem vel eum iriure do-

ad minim veniam, quis nostrud

lobortis nisl ut aliquip ex ea

commodo consequat.

of service

ad minim veniam, quis nostrud commodo consequat.

Duis autem vel eum iriure dolor in hendrerit in vulputate velit esse molestie consequat, vel illum lorem ipsum dolor sit amet. consectetuer adipiscing elit, sed diam nonummy nibh euismod tincidunt ut laoreet dolore magna aliquam erat volutpat. Ut wisi enim ad minim veniam, quis nostrud exerci tation ullam corper suscipit lobortis nisl ut aliquip ex ea commodo consequat. Duis autem

vel eum iriure dolor in hendrerit in

vulputate. Velit esse molestie consequat, vel illum dolore eu feugiat nulla facilisis at vero eros et accumsan et iusto odio dignissim qui blandit praesent luptatum zzril delenit augue duis dolore te feugait nulla facilisi. Lorem ipsum dolor sit amet consectetuer adipiscing elit, sed diam nonummy nibh euismo lorem ipsum dolor sit amet. consectetuer adipiscing elit, sed diam nonummy nibh euismod tincidunt ut laoreet dolore magna

Aliquam erat volutpat. Ut wisi nostrud exerci tation aliquip ex ea commodo conseguat. Lorem ipsum dolor sit amet, consectetuer

adipiscing elit, sed diam nonumni nibh euismod tincidunt ut laoree dolore magna aliquam erat volutpat.consectetuer adipiscing elit, sed diam nonummy nibh euismod tincidunt ut laoreet dolc magna aliquam erat volutpat

Contact Timothy Example: 987 654 32 name@emailaddressz.com; More: http://

One if by land, two if by air

Ut wisi enim ad minim veniam, qu nostrud exerci tation ullam corpe suscipit lobortis nisl ut aliquip ex commodo consequat. Lorem ipsu dolor sit amet, consectetuer adipiscing elit, sed diam nonumni nibh euismod tincidunt ut laoree dolore magna aliquam erat volutpat. Ut wisi enim ad minim veniam, quis nostrud exerci tation ullam corper suscipi lobortis nisl ut aliquip ex ea commodo conseguat. ullamcorper suscipit lobortis nisl ut aliquip ex ea commodo conseguat.

Duis autem vel eum iriure dolor in hendrerit in vul putate velit esse molestie conse quat, vel illum dolore

The Sampler Church P.O. Box 1245 Your City, ST 12345-6789

May Bible Study: Do I confine my love to friends and family?

SANDRA EXAMPLE SAMPLER CORPORATION 123 EXAMPLE BOULEVARD STE 200 YOUR CITY ST 12345 6789

Three 17 by 11 inch sheets (landscape) are folded to 8.5 by 11 inches and saddle-stitched.

What you need

General layout and design requires a desktop publishing program. Dividing and reassembling the parts and pieces of vector clip art images and type requires a drawing program. (See Step 7: Choose Your Tools, page 26.)

Events, local history, and the good news of God for the community of Sampler and beyond from the Sampler Church

from The Sampler Church

cilisis at vero eros or cum soluta on congue nihil id quod mazim im assum. Lorem et, consectetuer idunt ut lagreet Jam erat ud exerci tation it lobortis nisl ut nodo consequat nagna aliquam estie consequat. feugiat nulla

o lorem ipsum

s et accumsan et

m qui

OUR PURPOSE

Lorem ipsum dolor sit amet, consectetuer adipiscing elit, sed diam nonummy nibh euismod tincidunt ut laoreet dolore magna aliquam erat volutpat. Ut wisi enim ad minim veniam, quis nostrud exerci tation ullam corper suscipit lobortis nisl dignissim qui blandit praesent ut aliquip ex ea commodo . consequat. Duis autem vel eum iriure dolor in hendrerit in vulputate velit esse molestie consequat, vel illum dolore eu.

un 2	nd	6:00	PM		_
/ed 5			_	Fellowship Dir	nei
_	_	7:00	АМ	Event two	
u 6tl	h	8:00	РМ	Event three	_
n 9th		8:00 F	М	Event four	_
9th		10:00	РМ	Event five	_
1 12tl	h	11:00 P	М	Event six	_
13th		12:00 PI	И	Event seven	_
3th	1	:00 PM		Event eight	_
ōth	2.	00 PM		Event nine	-
9th	3:	00 PM		vent ten	-
th	4:0	0 PM		vent eleven	
i	5:00) PM		ent twelve	
7	6:00	РМ		ent thirteen	
	7:00	РМ		nt fourteen	

The spaceman, the reindeer, and the congregation

BY KAREN EXAMPLE

Lorem ipsum dolor sit amet, consectetuer adipiscing elit, sed diam nonummy nibh euismod tincidunt ut laoreet dolore magna aliquam erat volutpat. Ut wisi enim ad minim veniam, quis nostrud exerci tation ullam corper suscipit lobortis nisl ut aliquip ex ea commodo consequat.

Duis autem vel eum iriure dolor in hendrerit in vulputate velit esse molestie consequat, vel illum dolore eu feugiat nulla facilisis at vero eros et accumsan et iusto odio dignissim qui blandit praesent luptatum zzril delenit augue duis dolore te feugait nulla facilisi. Lorem ipsum dolor sit amet, consectetuer adipiscing elit, sed diam nonummy nibh euismodLorem ipsum dolor sit amet, consectetuer adipiscing elit, sed diam nonummy nibh euismod tincidunt ut laoreet dolore magna aliquam erat volut pat. Ut wisi

ullamcorper suscipit lobortis nisl ut aliquip ex ea commodo consequat. Duis autem vel eum iriure dolor in hendrerit in vulputate velit esse molestie consequat, vel illum dolore eu feugiat nulla facilisis at vero eros et Nam liber tempor cum soluta nobis eleifend option congue nihil imperdiet doming id quod mazim placerat facer possim assum. Lorem ipsum dolor sit amet,

consectetuer adipiscing elit, sed diam nonummy nibh euismod tincidunt ut laoreet dolore magna aliquam erat volutpat. Ut wisi enim ad minim veniam, quis nostrud exerci tation ullamcorper suscipit lobortis nisl ut aliquip ex ea commodo consequat ut laoreet dolore magna aliquam erat.

Contact Karen Example: 987 654 3210 or name@emailaddressz.com; More: http:// www.yourwebaddressz.com/storyname.htm

FROM THE PASTOR

Lay leaders thrust into an unexpected, hands-on mission experience-30 years in the making

BY RALPH EXAMPLE

Lorem ipsum dolor sit amet, consectetuer adipiscing elit, sed diam nonummy nibh euismod tincidunt ut laoreet dolore magna aliquam erat volutpat. Ut wisi enim ad minim veniam, quis nostrud exerci tation ullam corper suscipit lobortis nisl ut aliquip ex ea commodo consequat. Duis autem vel eum iriure dolor in hendrerit in vulputate

Velit esse molestie consequat, vel illum dolore eu feugiat nulla facilisis at vero eros et accumsan et iusto odio

dignissim qui blandit praesent luptatum zzril delenit augue duis dolore te feugait nulla facilisi. Lorem ipsum dolor sit amet, consectetuer adipiscing elit, sed diam nonummy nibh euismodLorem ipsum dolor sit amet, consectetuer.

Dipiscing elit, sed diam nonummy nibh euismod tincidunt ut laoreet dolore magna aliquam erat volutpat. Ut wisi enim ad minim veniam, quis nostrud exerci tation aliquip ex ea commodo consequat. Lorem ipsum dolor sit amet, consectetuer adipiscing elit, sed diam nonummy dolore magna aliquam erat dolore magna volutpat. Ut wisi enim ad minim veniam, quis nostrud exerci tation ullam corper suscipit lobortis nisl ut aliquip ex ea commodo consequat. Lorem ipsum dolor sit amet, consectetuer adipiscing elit, sed.

Contact Ralph Example: 987 654 3210 or e@emailaddressz.com; More: http:// www.yourwebaddressz.com/storyname.htm

The design grid

In this case, what you see above the surface—the lines and boxes—is the four-column grid below the surface. (See *Step 11.2: Establish the Page Size and Grid*, page 37.)

The typefaces

This newsletter employs an Adobe Multiple Master Typeface—Myriad. A multiple master is a typeface you can customize by changing attributes such as weight: thin to heavy; width: condensed to extended; and its style and optical size. This is an example of the thousands of versions you can create of a single multiple master.

Myriad MM 700bd 300cn

Typeface AaBbEeGgKkMmQqRrSsWw!?

Myriad MM 215lt 700se

Typeface

AaBbEeGgKkMmQqRrSsW

Myriad MM 250wt 500wd

Text Lorem ipsum dolor sit amet, consectetuer adipiscing elit, sed diam nonummy nibh euismod tincidunt ut laoreet dolore magna aliquam erat volutpat. Ut wisi enim ad minim veniam, quis nostrud exerci tation ullamcorper suscipit lobortis nisl ut aliquip ex ea commodo consequat. Duis autem vel eum iriure dolor in hendrerit in vulputate velit esse molestie consequat, vel illum dolore eu feugiat nulla facilisis at vero eros.

The illustrations

Normally you would not employ such a wide variety of drawing styles—symbols, a realistic silhouette, dreamlike wood-cuts, and a cartoon. Too many styles weaken visual continuity. All that changes when you apply the same color to all the images—a common color makes them look as though they belong together.

DISTINGUISHING FEATURES

Contact Bernadine Example: 987 654 3210 or name@emailaddressz.com; More: http://www.yourwebaddressz.com/storyname.htm

Loren guam fielder sit amer, connectioner allegene of the contention and places of the service of the contention and places of the contention and

Continue the conversation

Newsletters are all about building relationships with readers. Including a contact link at the bottom of each article invites readers to communicate with the people whose reporting and opinions they read. What kind of information to provide is, of course, up to you. The standard used here and throughout *Design It Yourself: Newsletters* demonstrates how you might provide the name of the person who wrote the article, their phone number, e-mail address, and a Web address. That link might provide an extension of or update to the article, access to online information about the subject, and/or the writer's bio or resume.

Vary the length of text

All of the text may begin at the same place at the top of the page but the length of that text varies significantly from column to column and page to page. Making the text in one column shorter than the next is a little design trick with two big advantages—it allows writers to write a rough versus a very specific number of words and it allows designers more latitude with placing and sizing artwork.

Set the rules, break the rules

The vertical grid lines establish a very uniform look and feel to this layout. Consequently, an element that breaks the uniformity draws attention to itself and adds visual interest. Overlapping lines with artwork and artwork with lines keeps the design interesting, as do boxes of text and illustrations that span two or more columns.

from The Sampler Church ullamcorper suscipit lobo aliquip ex ea commodo o Duis autem vel eum iriure hendrerit in vulputate vel molestie consequat, vel il

MAY 20??: Events, local history, and the good news of God for the community of Sampler and beyond from the Sampler Church

OUR PURPOSE

Lorem ipsum dolor sit amet, consectetuer adipiscing elit, sed diam nonummy nibh euismod tincidunt ut laoreet dolore magna aliquam erat volutpat. Ut wisi enim ad minim veniam, quis nostrud exerci tation ullam corper suscipit lobortis nisl dignissim qui blandit praesent ut aliquip ex ea commodo consequat. Duis autem vel eum iriure dolor in hendrerit in vulputate velit esse molestie consequat, vel illum dolore eu.

MAY HIGHL	IGHTS			
Sun 2nd	6:00 PM	Fellowship Dinner		
Wed 5th	7:00 AM	Event two		
Thu 6th	8:00 PM	Event three		
Sun 9th	8:00 PM	Event four		
Sun 9th	10:00 PM	Event five		
Wed 12th	11:00 PM	Event six		
Thu 13th	12:00 PM	Event seven		
Thu 13th	1:00 PM	Event eight		
Sun 16th	2:00 PM	Event nine		
Wed 19th	3:00 PM	Event ten		
Wed 20th	4:00 PM	Event eleven		
Sun 23rd	5:00 PM	Event twelve		
Wed 26th	6:00 PM	Event thirteen		
Sun 30th	7:00 PM	Event fourteen		

FOREIGN MISSIONS

The spaceman, the reindeer, and the congregation

Good News

BY KAREN EXAMPLE

Lorem ipsum dolor sit amet, consectetuer adipiscing elit, sed diam nonummy nibh euismod tincidunt ut laoreet dolore magna aliquam erat volutpat. Ut wisi enim ad minim veniam, quis nostrud exerci tation ullam corper suscipit lobortis nisl ut aliquip ex ea commodo consequat.

Duis autem vel eum iriure dolor in hendrerit in vulputate velit esse molestie conseguat, vel illum dolore eu feugiat nulla facilisis at vero eros et accumsan et iusto odio dignissim qui blandit praesent luptatum zzril delenit augue duis dolore te feugait nulla facilisi. Lorem ipsum dolor sit amet, consectetuer adipiscing elit, sed diam nonummy nibh euismodLorem ipsum dolor sit amet, consectetuer adipiscing elit, sed diam nonummy nibh euismod tincidunt ut laoreet dolore magna aliquam erat volut pat. Ut wisi

ullamcorper suscipit lobortis nisl ut aliquip ex ea commodo consequat. Duis autem vel eum iriure dolor in hendrerit in vulputate velit esse molestie consequat, vel illum dolore eu feugiat nulla facilisis at vero eros et Nam liber tempor cum soluta nobis eleifend option congue nihil imperdiet doming id quod mazim placerat facer possim assum. Lorem ipsum dolor sit amet,

consectetuer adipiscing elit, sed diam nonummy nibh euismod tincidunt ut laoreet dolore magna aliquam erat volutpat. Ut wisi enim ad minim veniam, quis nostrud exerci tation ullamcorper suscipit lobortis nisl ut aliquip ex ea commodo consequat ut laoreet dolore magna aliquam erat.

Contact Karen Example: 987 654 3210 or name@emailaddressz.com; More: http:// www.yourwebaddressz.com/storyname.htm

FROM THE PASTOR

Lay leaders thrust into an unexpected, hands-on mission experience—30 years in the making

BY RALPH EXAMPLE

Lorem ipsum dolor sit amet, consectetuer adipiscing elit, sed diam nonummy nibh euismod tincidunt ut laoreet dolore magna aliquam erat volutpat. Ut wisi enim ad minim veniam, quis nostrud exerci tation ullam corper suscipit lobortis nisl ut aliquip ex ea commodo consequat. Duis autem vel eum iriure dolor in hendrerit in vulputate.

Velit esse molestie consequat, vel illum dolore eu feugiat nulla facilisis at vero eros et accumsan et iusto odio

dignissim qui blandit praesent luptatum zzril delenit augue duis dolore te feugait nulla facilisi. Lorem ipsum dolor sit amet, consectetuer adipiscing elit, sed diam nonummy nibh euismodLorem ipsum dolor sit amet, consectetuer.

Dipiscing elit, sed diam nonummy nibh euismod tincidunt ut laoreet dolore magna aliquam erat volutpat. Ut wisi enim ad minim veniam, quis nostrud exerci tation aliquip ex ea commodo consequat. Lorem ipsum dolor sit amet, consectetuer adipiscing elit, sed diam nonummy dolore magna aliquam erat dolore magna volutpat. Ut wisi enim ad minim veniam, quis nostrud exerci tation ullam corper suscipit lobortis nisl ut aliquip ex ea commodo consequat. Lorem ipsum dolor sit amet, consectetuer adipiscing elit, sed.

Contact Ralph Example: 987 654 3210 or name@emailaddressz.com; More: http://www.yourwebaddressz.com/storyname.htm

New type of music for a new type of service Lorem ipsum dolor sit amet consectetuer adipiscing elit, sed diam nonummy nibh euismod tincidunt ut laoreet dolore magna aliquam erat volutpat. Ut wisi enin ad minim veniam, quis nostrud exerci tation ullam corper suscipit lobortis nisl ut aliquip ex ea

Duis autem vel eum iriure do lor in hendrerit in vulputate velit esse molestie consequat, vel illum dolore eu feugiat nulla facilisis at vero eros et accumsan et iusto odio dignissim qui blandit praesent luptatum zzril delenit augue duis dolore te feugait nulla facilisi Lorem ipsum dolor sit amet, consectetuer adipiscing elit, sed diam nonummy nibh euismodLorem ipsum dolor sit amet, consectetuer adipiscing elit, sed diam nonummy nibh euismoo tincidunt ut laoreet dolore magna

commodo consequat

Good News

aliquam erat volutpat. Ut wisi enin ad minim veniam, quis nostrud exerci tation aliquip ex ea

nmodo consequat. Duis autem vel eum iriure dolor in hendrerit in vulputate velit lorem ipsum dolor sit amet consectetuer adipiscing elit, sed diam nonummy nibh euismod tincidunt ut laoreet dolore magna aliquam erat volutpat. Ut wisi e ad minim veniam, quis nostrud exerci tation ullam corper suscipit lobortis nisl ut aliquip ex ea commodo consequat. Duis autem vel eum iriure dolor in hendrerit in

Velit esse molestie consequat, vel illum dolore eu feugiat nulla iusto odio dignissim qui blandit praesent luptatum zzril delenit augue duis dolore te feugait nulla facilisi. Lorem ipsum dolor sit amet consectetuer adipiscing elit, sed diam nonummy nibh euismo lorem ipsum dolor sit amet, consectetuer adipiscing elit, sed diam nonummy nibh euismod tincidunt ut laoreet dolore magna

Aliquam erat volutpat. Ut wisi enim ad minim veniam, quis nostrud exerci tation aliquip ex ea dolor sit amet, consectetuer

adipiscing elit, sed diam nonummy nibh euismod tincidunt ut laoree dolore magna aliguam erat volutpat.consectetuer adipiscing elit, sed diam nonummy nibh euismod tincidunt ut laoreet dolore magna aliquam erat volutpat

One if by land, two if by air

Ut wisi enim ad mi nostrud exerci tation ullam corpe suscipit lobortis nisl ut aliquip ex ea commodo conseguat Lorem insu dolor sit amet, consectetuer adipiscing elit, sed diam nonun nibh euismod tincidunt ut laoree dolore magna aliquam erat volutpat. Ut wisi enim ad exerci tation ullam corper suscipi lobortis nisl ut aliquip ex ea ullamcorper suscipit lobortis nisl ut aliquip ex

Duis autem vel eum iriure dolor in hendrerit in vul putate velit esse molestie conse quat, vel illum dolore

eu feugiat nulla facilisis at vero eros et Nam liber tempor cum soluta nobis eleifend option congue nihil imperdiet doming id quod mazim placerat facer possim assum. Lorem ipsum dolor sit amet, consectetuer adipiscing elit, sed diam nonummy dolore magna aliguam erat volutnat 11t wisi enim ad minim veniam, quis nostrud exerci tation ullamcorper suscipit lobortis nisl ut aliquip ex ea commodo consequat ut laoreet dolore magna aliquam erat. Velit esse molestie consequat, vel illum dolore eu feugiat nulla facilisis at vero eros et accumsan et iusto odio dianissim aui dolor sit amet.

U.S. POSTAGE PAID PERMIT NO. ???

May Bible Study: Do I confine my love to friends and family?

SANDRA EXAMPLE SAMPLER CORPORATION

123 EXAMPLE BOULEVARD STE 200 YOUR CITY ST 12345 6789 արմիստոնամիտահարմիստոնատերությունումիատերամիատերանիատերան

Cover (page 1)

1"Good" Myriad MM, 215lt, 700se, 48/38pt, justified; "from" Myriad MM, 215lt, 700se, 16/16pt, align left; 2 Defining phrase Myriad MM, 250wt, 500wd, 8/9pt, align left; 3 Eyebrow Myriad MM, 250wt, 500wd, 7pt, align left; Text Myriad MM, 250wt, 500wd, 10/12pt, align left; Text chart Myriad MM, 250wt, 500wd, 7/16pt, align left; 4 Headline, small Myriad MM, 215lt, 700se, 20/18pt, align left; Contributor Myriad MM, 250wt, 500wd, 7pt, align left; 5 Headline, large Myriad MM, 215lt, 700se, 24/23pt, align left; 6 Line .5pt; 7 Contact link 250wt, 500wd, 7/8pt, align left

Back Cover (page 16)

8 "Good" Myriad MM, 215lt, 700se, 24/18pt, align left; "from" Myriad MM, 215lt, 700se, 10/10pt, align left; 9 Eyebrow Myriad MM, 250wt, 500wd, 7pt, align left; Headline, small Myriad MM, 215lt, 700se, 20/18pt, align left; Contributor Myriad MM, 250wt, 500wd, 7pt, align left; Text Myriad MM, 250wt, 500wd, 10/ 12pt, align left; Contact link 250wt, 500wd, 7/8pt, align left; 10 Return address Myriad MM, 250wt, 500wd, 8/10pt, align left; Teaser headline Myriad MM, 215lt, 700se, 20/20pt, align left; 11 Label address Arial, 10/10pt, align left; Postage indicia Myriad MM, 250wt, 500wd, 8/10pt, align center; Line .5pt 12 Line .5pt 13 Page number Myriad MM, 250wt, 500wd, 8pt, align left or right

Pages 2 & 3

14 "Good" Myriad MM, 215lt, 700se, 24/18pt, align left; "from" Myriad MM, 215lt, 700se, 10/10pt, align left; 15 Eyebrow Myriad MM, 250wt, 500wd, 7pt, align left; Headline, small Myriad MM, 215lt, 700se, 20/18pt, align left; Contributor Myriad MM, 250wt, 500wd, 7pt, align left; Text Myriad MM, 250wt, 500wd, 10/12pt, align left; Contact link 250wt, 500wd, 7/8pt, align left; 16 Line .5pt 17 "Purpose" Myriad MM, 215lt, 700se, 80pt, align left; Box text Myriad MM, 215lt, 700se, 17/19pt, align left; 18 Page number Myriad MM, 250wt, 500wd, 8pt, align left or right

Color

To be printed in black and a solid PANTONE Color Ink as defined on the palette below (see Step 9.3). (Because this book is printed in process colors (CMYK), the illustration is only a simulation of the actual solid PANTONE Color).

SOURCE Illustrations: Astronaut (pg. 1) from ArtWorks Silhouettes 1, Deer (pg. 1) from ArtWorks Stylistics 1, Hiker (pg. 3), Helicopter (pg. 12) from Electronic Clipper from Dynamic Graphics, 800-255-8800, 309-688-8800, www.dgusa.com, © Dynamic Graphics, all rights reserved; Snowflakes from Design Elements by Ultimate Symbol, 800-611-4761,914-942-0003, www.ultimatesymbol.com, © Ultimate Symbol, all rights reserved.

SOURCE Type Families: Arial, Myriad, Adobe Systems, Inc. 800-682-3623, www.adobe.com/type.

PART 2: DESIGN RECIPES

Page 8

19 Eyebrow Myriad MM, 250wt, 500wd, 7pt, align left; Headline, small Myriad MM, 215lt, 700se, 20/18pt, align left; Contributor Myriad MM, 250wt, 500wd, 7pt, align left; Text Myriad MM, 250wt, 500wd, 10/12pt, align left; Contact link 250wt, 500wd, 7/8pt, align left; 20 "Good" Myriad MM, 215lt, 700se, 24/18pt, align left; "from" Myriad MM, 215lt, 700se, 10/10pt, align left; 21 Box text Myriad MM, 215lt, 700se, 16/16.5pt, align left; 22 Line .5pt 23 Page number Myriad MM, 250wt, 500wd, 8pt, align left or right

Page 9

24 Day Myriad MM, 215lt, 700se, 13pt, align left; 25 Date Myriad MM, 215lt, 700se, 13pt, align left; Description Myriad MM, 250wt, 500wd, 9/10pt, align left; 26 Month Myriad MM, 215lt, 700se, 60pt, align right; Line .5pt

SOURCE Illustrations: Mother/daughter (pg. 8), daughter/ bike from Electronic Clipper from Dynamic Graphics, 800-255-8800, 309-688-8800, www.dgusa.com, © Dynamic Graphics, all rights reserved.

SOURCE Type Families: Arial, Myriad, Adobe Systems, Inc. 800-682-3623, www.adobe.com/type.

The spiritual connection between mother and

daughter Lorem ipsum dolor sit amet consectetuer adipiscing elit, sed diam nonummy nibh euismod tincidunt ut laoreet dolore magna aliquam erat volutpat. Ut wisi enim ad minim veniam, quis nostrud exerci tation ullam corper suscipit lobortis nisl ut aliquip ex ea

commodo consequat.

Duis autem vel eum iriure dolor in hendrerit in vulputate velit esse molestie conse dolore eu feugiat nulla facilisis at vero eros et accumsan et justo odio dignissim qui blandit praesent luptatum zzril delenit augue duis dolore te feugait nulla facilisi. Lorem ipsum dolor sit amet, consectetuer adipiscing elit, sed diam nonummy nibh euismodLorem ipsum dolor sit amet, consectetuer adipiscing elit. sed diam nonummy nibh euismor tincidunt ut laoreet dolore magna aliquam erat volutpat. Ut wisi enin ad minim veniam, quis nostrud exerci tation aliquip ex ea commodo conseguat.

Duis autem vel eum iriure do-lor in hendrerit in vulputate velit esse molestie consequat, vel illum lorem ipsum dolor sit amet, consectetuer adipiscing elit, sed diam nonummy nibh euismod tincidunt ut laoreet dolore magna aliquam erat volutpat. Ut wisi enim ad minim veniam, quis nostrud exerci tation ullam corper suscipit lobortis nisl ut aliquip ex ea commodo consequat. Duis autem vel eum iriure dolor in hendrerit in vulputate.

Velit esse molestie consequat, vel illum dolore eu feugiat nulla

iusto odio dignissim qui blandit praesent luptatum zzril delenit augue duis dolore te feugait nulla facilisi. Lorem ipsum dolor sit amet. consectetuer adipiscing elit, sed diam nonummy nibh euismo lorem ipsum dolor sit amet. consectetuer adipiscing elit, sed diam nonummy nibh euismod tincidunt ut laoreet dolore magna aliquam erat volutpat. Ut wisi enim ad minim veniam, quis nostrud exerci tation aliquip ex ea

oiscing elit, sed diam nonummy

nibh euismod tincidunt ut laoreet

Ut wisi enim ad minim

veniam, quis nostrud exerci tation ullam corper suscipit lobortis nisl ut

aliquip ex ea commodo consequat.

diam nonummy nibh euismod tincidunt ut laoreet dolore magna aliquam erat volutpat. Ut wisi enim

ad minim veniam, quis nostrud exerci tation ullam corper suscipit

commodo consequat. ullamcorper suscipit lobortis nisl ut aliquip ex ea

lobortis nisl ut aliquip ex ea

commodo conseguat

Lorem ipsum dolor sit amet, consectetuer adipiscing elit, sed

dolore magna aliquam erat

volutpat.

lor in hendrerit in vulputate velit guod mazim placerat facer p consectetuer adipiscing elit, sed diam nonummy nibh euismod tincidunt ut laoreet dolore magna exerci tation ullamcorper suscipit

commodo consequat ut laoreet

dolore magna aliquam erat

veniam, quis nostrud exerci t

ullam corper suscipit lobor

dolore eu feugiat nulla fas vero eros et accumsan et i

dignissim qui blandit praeser

aliquip ex ea commodo

Duis autem vel e lor in hendrerit in vulp

esse molestie conse

dolore magna aliguam erat. Lorem

esse molestie consequat, vel illum dolore eu feugiat nulla facilisis at vero eros et Nam liber tempor cum congue nihil imperdiet doming id assum. Lorem ipsum dolor sit amet, aliquam erat volutpat. Ut wisi enim

Good News

Lorem ipsum dolor sit amet. consectetuer adipiscing elit, sed diam nonummy nibh euismodLorem ipsum dolor sit amet, consectetuer adipiscing elit, sed diam nonummy nibh euismod tincidunt ut laoreet dolore magna aliquam erat volutpat. Ut wisi enim ad minim veniam, quis nostrud exerci tation aliquip ex ea commodo consequat.

Duis autem vel eum iriure dolor in hendrerit in vulputate velit esse molestie consequat, vel illum

"When Dory was two lorem ipsum dolor sit amet. consectetuer adipiscing elit, sed diam nonummy nibh euismod tincidunt ut laoreet dolore magna aliquam erat volutpat. Ut wisi enim ad minim veniam."

consectetuer adipiscing elit, sed.

Blue or PANTONE® 300 Colors

100%	
70%	
40%	
35%	
30%	
20%	
15%	
10%	

4	\bigcap	h	
	10	3	
_		-45	

Sunday	Monday	Tuesday	Wednesday	Thursday	Friday	Saturday
3 9:45 AM Sunday School 11:00 AM Parent/Child Dedication Worship Service 4:30 PM Youth Program	4 7:30 PM Explorer Scouts	5 7:00 AM Prayer Breakfast	6 9:45 AM Pre-kindergarten Committee 6:00 PM Fellowship Dinner 7:00 PM Bible Study	7 7:30 AM Mom's Group Meeting	8	9 1:00 PM Example Wedding
1 O 0:00 AM Event Name 0:00 AM Event Name 0:00 AM Event Name	11 0:00 AM Event Name 0:00 AM Event Name	12 0:00 AM Event Name	13 0:00 AM Event Name 0:00 AM Event Name 0:00 AM Event Name	14 0:00 AM Event Name 0:00 AM Event Name	15 0:00 AM Event Name	16 0:00 AM Event Name 0:00 AM Event Name
17 0:00 AM Event Name 0:00 AM Event Name 0:00 AM Event Name	18 0:00 AM Event Name 0:00 AM Event Name	19 0:00 AM Event Name	20 0:00 AM Event Name 0:00 AM Event Name 0:00 AM Event Name	21 0:00 AM Event Name 0:00 AM Event Name	22 0:00 AM Event Name	23 0:00 AM Event Name 0:00 AM Event Name
24 0:00 AM Event Name 0:00 AM Event Name 0:00 AM Event Name	25 0:00 AM Event Name 0:00 AM Event Name	26 0:00 AM Event Name	27 0:00 AM Event Name 0:00 AM Event Name 0:00 AM Event Name	28 0:00 AM Event Name 0:00 AM Event Name	29 0:00 AM Event Name	30 0:00 AM Event Name 0:00 AM Event Name
31 0:00 AM Event Name 0:00 AM Event Name 0:00 AM Event Name	JUNE 1 0:00 AM Event Name 0:00 AM Event Name	2 0:00 AM Event Name	3 0:00 AM Event Name 0:00 AM Event Name 0:00 AM Event Name	4 0:00 AM Event Name 0:00 AM Event Name	5 0:00 AM Event Name	5 0:00 AM Event Name 0:00 AM Event Name

STYLE 7 (2 PAGES)

Newspaper

There are at least two fundamental differences between a newspaper and a newsletter. First, a newspaper typically covers a specific geographic area—a town or a city—while a newsletter covers an area of interest. Second, a newspaper generally covers a broad area of interest and a newsletter covers a specific area of interest—instead of sports, a specific sport such as rodeo riding.

Their commonality, of course, is they both are media for presenting news. Publishing a newsletter in newspaper form on a 17 by 11 inch page offers a unique opportunity to present newsletter content with the urgency a newspaper format conveys.

New anthem for credit card sellers: WOW NOW!

Marketing takes primary focus

By Tanya Example

facilisi.

Loren ipsum dolor sit amet, cunsectetuer adipiscing elit, sed diam nonumuny nibh euismod tincidunt ut laoreet dolore magna aliquam erat volutpat. Ut wisi enim ad minim veniam, quis nostrud exerci tation ullamcorper suscipit lobortis nisi ut aliquip ex ea commodo consecuat. Duis autem vel

unkinsoriper huseigns nobertus

unkinsoriper huseigns nobertus

ounequat. Incent josum doler

eit annet, consecteure adjuscing

eilt, sed dian nonumny mibh

euismod tincidunt ut Jaoreet

dolore magna aliquam erat

volupta. U wisi enina dinnim

tation ullumcorper suscipi

loboriti nisi ut aliquip er es

commodo consequat. Duis

unterno de un iriure dolor in r

et annet, consecteure adjuscine

et annet, consecteure adjuscine

ta annet, consecteure

ta anne

rrem ipsum dolor sit amet, consectutaer adipiscing elit, sed diam nonumn sixrood tincidumt ut loorest dolore magna aliquem erat volutpat. Ut wid er

Meadows is king of the dollar wizard

By Wilton Example

Lorem ipsum dolor sit zmet, consectioner adipicing dit, and diam nonumary sight existend distant nonumary sight existend diam nonumary sight existend consecutions. If you are not record to the consecution of the consecution of the consequent to the consequent of the consequent of the consequent will find nodoor extra the consequent will find not extra the consequent will be consequent to the c

duis dolore te feugait nulli facilisi dolor sit amet, consectetuer adipiscing elit, sed diam nonummy nibh euismod. Lorem irsum dolor sit amet.

Loren jusus doler di anne.
Consactiure allipicing dit, aed
diam nonummy abb euismod
tincidunt si kopere dolere magna aliquam erat volutpat. Un
wisi enim ad minim venism,
quis nostrud exerci tation
ullamorpre dolor sit annet,
consecteture adipsicing elit, sed
diam nonummy mibe euismod
suscipit lobortis nial et aliquip
era ex commodo conseçuat. Duis
autem wel eum iriure dolor in
hendrati in.

Contest Wilton Energie: 987 684 name@enelladdmest.com, More: http:// reserve.instanddmest.com/articles/no.

Realtors inherit more responsibility

Contributing Entitle

Lorem ipsum dolor sit amet consecteure adplicating dit, con diam nonummy nibh euismot tincidum tu lancert dolor em gna aliquam erat volutpat. U wisi enim ad minim veriam quis nostrud execci tatior ullamcorper suscipii lobortinial ut aliquip ex ea commode consequat. Duis antem vel eun iriure dolor in hendrerit ir vulputate velit esse molestic consequat, vel lium dolore e ugiat nulla facilisis at vero eros accumsan et iusto odio ignissim qui blandit praesent ptatum zzril delenit augue

dus doore te reugair musi facilisi.

Lorem ipsum dolor sit amet, consectetuer adipiscing dit, ed diam nonummy nibh euismod tincidunt ut laoreet dolore magas aliquam erar volutpat. Ur wisi enim ad minim veniam, quia nostrud exerci tation ullamcorper suscipit lobortisi nid ut aliquip er ea commodo conseouat. Duis autem wel um triure dolor in hendrerit in vulputate velit esse molestie consequat, vel illum dolore eu feugiat nulla facilisis at vero eros et Nam liber tempor cum soluta nobis eleffend option congue nihil imperdiet doming id quod maxim placerat facer possim assum.

Lorem ipsum dolor eit amet, consecteura eighichica gelt, sed diam nonummy nibh euismod tincidunt ut laceret dolore mangna sliquam erat volutpat. Ut wist eim sim minim veniam, quis nostrud exerci tation ullamcorper suscipit lobortis nid ut aliquip er ea commodo consequat. Lorem ipsum dolor sit arnet, consecteura edipiscing ellt, sed diam onummy nibh euismod tincidunt ut laoreet dolore magna sliquam erat volutpat. Lorem ipsum dolor att annet, onsectebure.

rrolleria liedrinasi.com; More: http:// www.pozom-beddinasic.com/articles/redpe.htm

SAMPLEDITORIALS, OPINION, & INFORMATION

Page flow

One 17 by 11 inch sheet (portrait) is folded to 11 by 8.5 inches.

What you need

General layout and design requires a desktop publishing program. Editing photographic images requires a digital imaging program. Dividing and reassembling the parts and pieces of vector clip art images and type requires a drawing program. (See Step 7: Choose Your Tools, page 26.)

STORY ONE TEASE Lorem ipsum dolor sit amet, consectetuer adipiscing elit, sed diam nonummy nibh euismod tincidunt ut laoreet dolore. Lorem ipsum dolor sit amet, consectetuer adipiscing elit, sed diam nonummy nibh euismod tincidunt ut laoreet dolore.

STORY TWO TEASE Lorem ipsum dolor sit amet, consectetuer adipiscing elit, sed diam nonummy nibh euismod tincidunt ut laoreet dolore.

SINCE 1979: News, opinion, information, how-to, events, people profiles, and more from Sampler Financial Services. Lorem ipsum dolor sit amet, consectetuer adipiscing.

VOL. 7 NO. 2

SAMPIERN FINANCIAL EDITORIALS, OPINION, & INFORMATION

ement Fiasco ds To Plannernt Tensions

inalysis reveals unexpected results

ly Roger Example ER MONEY STAFF WRITER

tor idressz.com

210

ipsum dolor sit amet, cetuer adipiscing elit, sed nonummy nibh euismod unt ut laoreet dolore maliquam erat volutpat. Ut enim ad minim veniam, nostrud exerci tation mcorper suscipit lobortis ut aliquip ex ea commodo sequat. Duis autem vel eum are dolor in hendrerit in Iputate velit esse molestie nsequat, vel illum dolore eu ugiat nulla facilisis at vero eros

diam nonummy nibh euismod tincidunt ut laoreet dolore magna aliquam erat volutpat. Ut wisi enim ad minim veniam, quis nostrud exerci tation ullamcorper suscipit lobortis nisl ut aliquip ex ea commodo consequat. Lorem ipsum dolor sit amet, consectetuer adipiscing elit, sed diam nonummy nibh euismod tincidunt ut laoreet dolore magna aliquam erat volutpat. Ut wisi enim ad minim veniam, quis nostrud exerci tation ullamcorper suscipit lobortis nisl ut aliquip ex ea commodo consequat. Duis

The design grid

Of all the contemporary print media, newspapers best demonstrate the value of a grid. They show how using a series of horizontal and vertical lines to divide pages makes for a more structured, easier to follow flow of information. The large page size makes it easy to see. This grid is five columns wide; many are six. For a comprehensive guide to grids see *The Grid: A modular system for the design production of newspapers, magazines, and books,* by Allen Hurlburt (John Wiley & Sons, Inc., 1978).

This newsletter employs an Adobe Multiple Master Typeface—Myriad. A multiple master is a typeface you can customize by changing attributes such as weight: thin to heavy; width: condensed to extended; and its style and optical size. This is an example of the thousands of versions you can create of a single multiple master and testament to the adaptability of a well-designed face.

Racer

Typeface
AaBbEeGgKkMmQqRrSsWw!?

Interstate Compressed Black

Typeface AabbeeggkkmmQqRrSsWw!?

Franklin Gothic Book Condensed

Typeface

AaBbEeGgKkMmQqRrSsWw!?

Typeface
AaBbEeGgKkMmQqRrSsWw!

Minior

Text Lorem ipsum dolor sit amet, consectetuer adipiscing elit, sed diam nonummy nibh euismod tincidunt ut laoreet dolore magna aliquam erat volutpat. Ut wisi enim ad minim veniam, quis nostrud exerci tation ullamcorper suscipit lobortis.

The illustrations

Newspapers are a design standard. Most readers have a clear expectation of what they look like and what they contain. They are easy to illustrate because the reader's expectation is, recognized or not, that a different style of illustration is often used with every article—in many cases an orchestrated patchwork of photographs and artwork. On just two pages this example incorporates four different illustration styles—photographs, charts, and two different drawing styles.

Tease your topics

The dictionary defines a "teaser" as a device used to arouse interest in what is to follow. The idea, of course, is to use the area at the very top of the cover to present highlights that will draw readers into the publication. You can employ the technique in your version of this layout or incorporate it into your own design.

Tons Per Mile Truck traffic on Down from 22 in August Lorem ipsum dolor 30 sit amet, consect etuer adipiscing elit, sed diam 38 38 18 25 OCT NOV DEC JAN SEP nonummy nibh 10 euismod tincidunt ut laoreet dolore magna aliquam erat volutpat. Ut wisi enim ad mini.

Show what you mean

When someone asks, "Who is your favorite person?" you don't think about the spelling of their name, "T-a-n-y-a" or "M-e-l-v-i-n," you picture his or her face—a reminder that we think in pictures, not words. That's why incorporating well-conceived and -executed artwork improves communication. Information graphics meld visual signals with data to make a point with the speed of sight. You know, without reading a single word, this chart deals with transportation and that the trend is up.

Deconstruct designs you admire

One way to become a better designer is to deconstruct designs you admire. This design, for example, evolved from the study of many different newspaper designs—not an exact copy of any particular design, but an interpretation incorporating some of the best ideas: the relative size of the headlines to the text; the sequence of headline, subhead, contributor, and title; the idea of placing teasers at the top of the page; and so on.

STORY ONE TEASE Lorem ipsum dolor sit amet, consectetuer adipiscing elit, sed diam nonummy nibh euismod tincidunt ut laoreet dolore. Lorem ipsum dolor sit amet, consectetuer adipiscing elit, sed diam nonummy nibh euismod tincidunt ut laoreet dolore.

STORY TWO TEASE Lorem ipsum dolor sit amet, consectetuer adipiscing elit, sed diam nonummy nibh euismod tincidunt ut laoreet dolore.

www.yourwebaddressz.com David R. Example, Editor E-mail name@emailaddressz.com Telephone 987 654 3210 Fax 987 654 3210

SAMPLER MONEY

SINCE 1979: News, opinion, information, how-to, events, people profiles, and more from Sampler Financial Services. Lorem ipsum dolor sit amet, consectetuer adipiscing.

FEBRUARY 20??

FINANCIAL EDITORIALS, OPINION, & INFORMATION

VOL. 7 NO. 2

Retirement Fiasco Leads To Planner-Client Tensions

New analysis reveals unexpected results

By Roger Example
Sampler Money Staff Writer

Lorem ipsum dolor sit amet, consectetuer adipiscing elit, sed diam nonummy nibh euismod tincidunt ut laoreet dolore magna aliquam erat volutpat. Ut wisi enim ad minim veniam. quis nostrud exerci tation ullamcorper suscipit lobortis nisl ut aliquip ex ea commodo consequat. Duis autem vel eum iriure dolor in hendrerit in vulputate velit esse molestie consequat, vel illum dolore eu feugiat nulla facilisis at vero eros et accumsan et justo odio dignissim qui blandit praesent luptatum zzril delenit augue duis dolore te feugait nulla facilisi

Lorem ipsum dolor sit amet, consectetuer adipiscing elit, sed diam nonummy nibh euismod tincidunt ut laoreet dolore magna aliquam erat volutpat. Ut wisi enim ad minim veniam, quis nostrud exerci tation ullamcorper suscipit lobortis nisl ut aliquip ex ea commodo consequat. Duis autem vel eum iriure dolor in hendrerit in vulputate velit esse molestie consequat, vel illum dolore eu feugiat nulla facilisis at vero eros et Nam liber tempor cum soluta nobis eleifend option congue ni-hil imperdiet doming id quod mazim placerat facer possim

Lorem ipsum dolor sit amet, consectetuer adipiscing elit, sed

diam nonummy nibh euismod tincidunt ut laoreet dolore magna aliquam erat volutpat. Ut wisi enim ad minim veniam, quis nostrud exerci tation ullamcorper suscipit lobortis nisl ut aliquip ex ea commodo consequat. Lorem ipsum dolor sit amet, consectetuer adipiscing elit, sed diam nonummy nibh euismod tincidunt ut laoreet dolore magna aliquam erat volutpat. Ut wisi enim ad minim veniam, quis nostrud exerci tation ullamcorper suscipit lobortis nisl ut aliquip ex ea commodo consequat. Duis autem vel eum iriure dolor in hendrerit in vulputate velit esse molestie consequat, vel illum dolore eu feugiat nulla facilisis at vero eros et Nam liber tempor cum soluta nobis eleifend option congue nihil imperdiet doming id quod mazim placerat facer possim assum.

Lorem ipsum dolor sit amet, consectetuer adipiscing elit, sed diam nonummy nibh euismod dincidunt ut laoreet dolore magna aliquam erat volutpat. Ut wisi enim ad minim veniam, quis nostrud exerci tation ullamcorper suscipit lobortis nisl ut aliquip ex ea commodo consequat.

Lorem ipsum dolor sit amet, consectetuer adipiscing elit, sed diam nonummy nibh euismod tincidunt ut laoreet dolore magna aliquam erat.

Contact Roger Example: 987 654 3210 or name@emailaddressz.com; More: http://www.yourwebaddressz.com/articles/recipe.htm

Lorem ipsum dolor sit amet, consecteture adipiscing elit, sed diam nonummy nibh euismod tincidunt ut laoreet dolore magna aliquam erat volutpat. Ut wisi enim ad minim veniam, quis mostrud exerci tation ullamcorper suscipit lobortis nisì ut aliquip ex ea commodo consequat. Duis autem vel eum iriure dolor in hendrerit in vulputate velit esse molestic.

Battle begins to force Example to pay for future acquisitions

By Martin Example
SAMPLER MONEY LEGAL WRITER

Lorem ipsum dolor sit amet, consectetuer adipiscing elit, sed diam nonummy nibh euismod tincidunt ut laoreet dolore magna aliquam erat volutpat. Ut wisi enim ad minim veniam, quis nostrud exerci tation aliquip ex ea commodo consequat. Duis autem vel eum riure dolor in hendrerit in vulputate velit esse molestie consequat, vel illum dolore eu feugiat nulla facilisis at vero eros et accumsan.

Contact Martin Example: 987 654 3210 or name@emailaddressz.com; More: http:// www.yourwebaddressz.com/articles/recipe.htm

New Commissioner named by SMT

Henry Example to step down in February

By Jason K. Example Contributing Editor

Lorem ipsum dolor sit amet consectetuer adipiscing elit, sed diam nonummy nibh euismod tincidunt ut laoreet dolore ma gna aliquam erat volutpat. Ut wisi enim ad minim veniam, quis nostrud exerci tation ullamcorper suscipit lobortis nisl ut aliquip ex ea commodo consequat. Duis autem vel eum iriure dolor in hendrerit in vulputate velit esse molestie consequat, vel illum dolore eu feugiat nulla facilisis at vero eros et accumsan et iusto odio dignissim qui blandit praesent luptatum zzril delenit augue duis dolore te feugait nulla facilisi.

Lorem ipsum dolor sit amet, consectetuer adipiscing elit, sed diam nonummy nibh euismod tincidunt ut laoreet dolore magna aliquam erat volutpat. Ut wisi enim ad minim veniam, quis nostrud exerci tation ullamcorper suscipit lobortis nisl ut aliquip ex ea commodo consequat. Duis autem vel eum iriure dolor in hendrerit in vulputate velit esse molestie consequat, vel illum dolore eu feugiat nulla facilisis at vero eros et Nam liber tempor cum soluta nobis eleifend option congue ni-

hil imperdiet doming id quod mazim placerat facer possim assum. - 0

Lorem ipsum dolor sit amet, consectetuer adipiscing elit, sed diam nonummy nibh euismod tincidunt ut laoreet dolore magna aliquam erat volutpat. Ut wisi enim ad minim veniam, quis nostrud exerci tation ullamcorper suscipit lobortis nisl ut aliquip ex ea commodo consequat. Lorem ipsum dolor sit amet, consectetuer adipiscing elit, sed diam nonummy nibh euismod tincidunt ut laoreet dolore magna aliquam erat volutpat. Ut wisi enim ad minim veniam, quis nostrud exerci tation ullamcorper suscipit lobortis nisl ut aliquip ex ea commodo conseguat. Duis autem vel eum iriure dolor in hendrerit in vulputate velit esse molestie consequat, vel illum dolore eu feugiat nulla facilisis at vero eros et Nam liber tempor cum soluta nobis eleifend option congue nihil imperdiet doming id quod mazim placerat facer possim assum.

Lorem ipsum dolor sit amet, consectetuer adipiscing elit, sed diam nonummy nibh congue nihil imperdiet doming.

Contact Jason Example: 987 654 3210 or name@emailaddressz.com; More: http://

Truck traffic on the rise Lorem ipsum dolor sit amet, consect

Lorem ipsum dolor sit amet, consect etuer adipiscing elit, sed diam nonummy nibh euismod tincidunt ut laoreet dolore magna aliquam erat volutpat. Ut wisi enim ad mini.

Front (page 1)

1 "Sampler" Racer, 132pt, align center; Nameplate text box Minion, 8/12pt, align left; Line .5pt; 2 Tease text box Minion, 12/12pt, align left; "WOW" Interstate Compressed Black, 30/20pt, align center; Line .5pt; 3 Dateline Minion, 9pt, align left, right, center; Lines .5pt; 4 Headline, large Interstate Compressed Black, 48/44pt, align left; Subhead Minion, 18pt, align left; Contributor Minion, 10pt, align center; Title Minion, 9pt, align center; Line .5pt; Text Minion, 11/12pt, justified; Contact link Franklin Gothic Book Condensed, 7/8pt, align center; 5 Headline, small Minion, 20/19pt, align left; 6 Caption Minion, 9/11pt, align left; Double line .5pt; 7 Info graphic headline Interstate Compressed Black, 30/26pt, align center; Info graphic text Minion, 11/12pt, align left; "Tons" Arial, 12pt, align left; "50" Arial, 10pt, align left; "Down" Interstate Compressed Black, 30/26pt, align center; "Source" Arial, 5pt, align right; Bottom line 4pt

Color

Printed in black and white.

SOURCE Illustrations: Man, Men with plan (pg. 1) from Corporate Motion from RubberBall Productions 801-224-6886, www.rubberball.com. © RubberBall Productions, all rights reserved; Moneybag (pg. 1) from Task Force Image Gallery from NVTech, 800-387-0732, 613-727-8184, www.nvtech.com, © NVTech, all rights reserved; Truck (pg. 1) Image Club ArtRoom Industry from Eyewire, 800-661-9410, 403-262-8008, www.eyewire.com. © Eyewire, Inc., all rights reserved.

SOURCE Type Families: Franklin Gothic, Minion, Racer, Adobe Systems, Inc. 800-682-3623, www.adobe.com/type; Interstate, Font Bureau, 617-423-8770, www.fontbureau.com.

Back (page 2)

8 Double line .5pt; Headline, large Interstate
Compressed Black, 48/44pt, align left; Subhead
Minion, 18pt, align left; Contributor Minion, 10pt,
align center; Title Minion, 9pt, align center; Line .5pt;
Text Minion, 11/12pt, justified; Contact link Franklin
Book Condensed, 7/8pt, align center; 9 Caption
Minion, 9/11pt, align left; 10 Headline, small Minion,
20/19pt, align left; 11 Chart title Arial 7pt, align left;
"TSE" Arial 6pt, align left; "9100" Arial 6pt, align left;
"A" Arial 7pt, align left; 12 Headline, Medium Minion,
36/34pt, align left; Line, bottom 4pt

SOURCE Illustrations: Presenter (pg. 2) from Corporate Motion from RubberBall Productions 801-224-6886, www.rubberball.com. © RubberBall Productions, all rights reserved; Moneybag, House (pg. 2) from Task Force Image Gallery from NVTech, 800-387-0732, 613-727-8184, www.nvtech.com,© NVTech, all rights reserved.

SOURCE Type Families: Franklin Gothic, Minion, Racer, Adobe Systems, Inc. 800-682-3623, www.adobe.com/ type; Interstate, Font Bureau, 617-423-8770, www.fontbureau.com.

New anthem for credit card sellers: WOW NOW!

Marketing takes primary focus

By Tanya Example
Sampler Money Staff Writer

Lorem ipsum dolor sit amet, consectetuer adipiscing elit, sed diam nonummy nibh euismod tincidunt ut laoreet dolore magna aliquam erat volutpat. Ut wisi enim ad minim veniam. quis nostrud exerci tation ullamcorper suscipit lobortis nisl ut aliquip ex ea commodo consequat. Duis autem vel eum iriure dolor in hendrerit in vulputate velit esse molestie consequat, vel illum dolore eu feugiat nulla facilisis at vero eros et accumsan et iusto odio dignissim qui blandit praesent luptatum zzril delenit augue duis dolore te feugait nulla facilisi.

Lorem ipsum dolor sit amet, consectetuer adipiscing elit, sed diam nonummy nibh euismod tincidunt ut laoreet dolore magna aliquam erat volutpat. Ut wisi enim ad minim veniam, quis nostrud exerci tation ullamcorper suscipit lobortis nisl ut aliquip ex a commodo consequat. Duis autem vel

eu feugiat nulla facilisis at vero eros et Nam liber tempor cum soluta nobis eleifend option congue nihil imperdiet doming id quod mazim placerat facer possim assum.

Lorem ipsum dolor sit amet, consectetuer adipiscing elit, sed diam nonummy nibh euismod tincidunt ut laoreet dolore magna aliquam erat volutpat. Ut wisi enim ad minim veniam, quis nostrud exerci tation ullamcorper suscipit lobortis nisl ut aliquip ex ea commodo consequat. Lorem ipsum dolor sit amet, consectetuer adipiscing elit, sed diam nonummy nibh euismod tincidunt ut laoreet dolore magna aliquam erat volutpat. Ut wisi enim ad minim veniam, quis nostrud exerci tation ullamcorper suscipit lobortis nisl ut aliquip ex ea commodo consequat. Duis autem vel eum iriure dolor in r sit amet, consectetuer adipiscing ut aliquip ex ea consequat.

Contact Tanya Example: 987 654 3210 or name@emailaddrassz.com; More: http:// www.younwebaddrassz.com/articles/recipe.htm

Lorem ipsum dolor str.....et, consectetuer adipiscing elit, sed diam nonummy nibh euismod tincidunt ut laoreet dolore magna aliquam erat volutpat. Ut wisi enim ad minim veniam, quis nostrud exerci tation ullamorper.

Meadows is king of the dollar wizards

By Wilton Example
Sampler Money Staff Writes

Lorem ipsum dolor sit amet, consectetuer adipiscing elit, sed diam nonumny nibh euismod tincidunt ut laoreet dolore magna aliquam erat volutpat. Ut wisi enim ad minim veniam, quis nostrud exerci tation ullamcorper suscipit lobortis nisl ut aliquip ex ea commodo consequat. Duis autem vel eum iriure dolor in hendrerit in vulputate velit esse molestie consequat, vel illum dolore eu feugiat nulla facilisis at vero eros et accumsan et iusto odio dignissim qui blandit praesent luptatum zzril delenit augue

duis dolore te feugait nulla facilisi dolor sit amet, consectetuer adipiscing elit, sed diam nonummy nibh euismod.

Loren ipsum dolor sit amet, consectetuer adipiscing elit, sed diam nonummy nibh euismod tincidunt ut laoreet dolore magna aliquam erat volutpat. Ut wisi enim ad minim veniam, quis nostrud exerci tation ullamcorper dolor sit amet, consectetuer adipiscing elit, sed diam nonummy nibh euismod suscipit lobortis nisl ut aliquip ex ea commodo consequat. Duis autem vel eum iriure dolor in hendrerit in.

Contact Wilton Example: 987 654 3210 or name@emaileddressz.com; More: http:// www.yourwebaddressz.com/articles/recipe.htm

Early talk about countdown on year end losses

By Helen Example Sampler Money Staff Writer

Lorem ipsum dolor sit amet, consectetuer adipiscing elit, sed diam nonummy nibh euismod tincidunt ut laoreet dolore magna aliquam erat volutpat. Ut wisi enim ad minim veniam, quis nostrud exerci tation aliquip ex ea commodo consequat. Duis autem vel eum iriure dolor in hendrerit in

vulputate velit esse molestie consequat, vel illum dolore eu feugiat nulla facilisis at vero eros et accumsan.

Lorem ipsum dolor sit amet, consectetuer adipiscing elit, sed diam nonummy nibh euismod tincidunt ut laoreet dolore magna aliquam erat volutpat. Ut wisi enim ad minim veniam, quis nostrud exerci tation ullamcorper suscipit lobortis nisl ut aliquip ex ea commodo consequat. Lorem ipsum dolor sit amet, consectetuer adipiscing elit, sed diam nonummy nibh euismod tincidunt ut laoreet dolore magna aliquam erat volutpat. Ut wisi enim ad minim veniam, quis nostrud exerci tation ullamcorper suscipit lobortis nisl ut aliquip ex ea commodo consequat. Duis autem vel eum iriure dolor in r sit amet, consectetuer adipiscing ut aliquip ex ea consequat.

Lorem ipsum dolor sit amet, consectetuer adipiscing elit, sed diam nonummy nibh euismod tincidunt ut laoreet dolore magna aliquam erat volutpat. Lorem ipsum dolor sit amet, consectetuer adipiscing elit, sed diam nonummy nibh.

Contact Helen Example: 987 654 3210 or name@emsiladdressz.com; More: http:// www.yourwebaddressz.com/articles/recipe.htm

Controversial new legislation limits lender liability

Realtors inherit more responsibility

By Marshall Example
Contributing Editor

Lorem ipsum dolor sit amet, consectetuer adipiscing elit, sed diam nonummy nibh euismod tincidunt ut laoreet dolore magna aliquam erat volutpat. Ut wisi enim ad minim veniam, quis nostrud exerci tation ullamcorper suscipit lobortis nisl ut aliquip ex ea commodo consequat. Duis autem vel eum iriure dolor in hendrerit in vulputate velit esse molestie consequat, vel illum dolore eu

feugiat nulla facilisis at vero eros et accumsan et iusto odio dignissim qui blandit praesent luptatum zzril delenit augue duis dolore te feugait nulla facilisi.

facilisi.

Lorem ipsum dolor sit amet, consectetuer adipiscing elit, sed diam nonummy nibh euismod tincidunt ut laoreet dolore magna aliquam erat volutpat. Ut wisi enim ad minim veniam, quis nostrud exerci tation ullamcorper suscipit lobortis nisl ut aliquip ex ea commodo consequat. Duis autem vel eum

iriure dolor in hendrerit in vulputate velit esse molestic consequat, vel illum dolore eu feugiat nulla facilisis at vero eros et Nam liber tempor cum soluta nobis eleifend option congue nihil imperdiet doming id quod mazim placerat facer possim assum.

Lorem ipsum dolor sit amet. consectetuer adipiscing elit, sed diam nonummy nibh euismod tincidunt ut laoreet dolore ma gna aliquam erat volutpat. Ut wisi enim ad minim veniam. quis nostrud exerci tation ullamcorper suscipit lobortis nisl ut aliquip ex ea commodo consequat. Lorem ipsum dolor sit amet, consectetuer adipiscing elit, sed diam nonummy nibh euismod tincidunt ut laoreet dolore magna aliquam erat volutpat. Lorem ipsum dolor sit amet, consectetuer.

Contact Marshall Example: 987 654 3210 or namo@emailaddressz.com; More: http:// www.yourwebaddressz.com/articles/recipe.htm

STYLE 8 (16 PAGES)

Objects

Can you see what makes this recipe unique? Yes, objects—specifically objects on a white background. What makes the technique so appealing is the ease with which it can be produced. With digital imaging software programs such as Adobe Photoshop and Jasc Software's Paint Shop Pro, it is easy to remove the background from an existing photograph and place it on a white background.

The same programs also allow you to create a simple shadow behind the image to make it look as if it is floating slightly above the surface of the page. The same technique can also be applied to type.

There are also many photographic image collections intentionally shot against white backgrounds to be used for just this purpose or to superimpose over some other background.

JUNE 20??: News, opinion, events, resources, and more from The Manufacturer's Association of Samples

Industry Watch: Slate of nominees for ABCD named; Miller to head Example Products; More

by Robin Example

Lorem ipsum dolor sit amet, consectetuer adipiscing elit, sed diam nonummy nibh euismod tincidunt ut laoreet dolore magna

aliquam erat volutpat.
Ut wisi enim ad minim veniam, quis nostrud exerci tation ullam corper suscipit lobortis nisl ut aliquip ex ea commodo consequat.
Duis autem vel eum

iriure dolor in hendrerit in vulputate velit esse molestie consequat, vel illum dolore eu feugiat nulla facilisis at vero eros et accumsan et iusto odio dignissim qui blandit praesent luptatum zzril delenit augue duis dolore te feugait nulla facilisi.

Lorem ipsum dolor sit amet, consectetuer adipiscing elit, sed diam nonumny nibh euismod tincidunt ut laoreet dolore magna aliquam erat volutpat. Ut wisi enim ad minim veniam, quis nostrud exerci tation ullamcorper suscipit lobortis nisi ut aliquip ex ea commodo consequat. Duis autem vel eum iriure dolor in hendrerit in vulputate velit esse molestie consequat, vel illum dolore eu feugiat nulla facilisis at vero eros et Nam liber tempor cum soluta nobis eleifend option congue nihil imperdiet doming id quod mazim placerat facer possim assum.

Lorem ipsum dolor sit amet, consectetuer adipiscing elit, sed diam nonummy nibh euismod tincidunt ut laoreet dolore magna aliquam erat volutpat. Ut wisi enim ad minim veniam, quis nostrud exerci tation ullamcorper suscipit lobortis nisì ut aliquip ex ea commodo consequat. Lorem ipsum dolor sit amet, consectetuer adipiscing elit, sed diam nonummy nibh euismod tincidunt ut laoreet dolore erat volutpat.

Contact Robin Example: 987 654 3210 or name@emailaddressz.com; More: http://www.yourwebaddressz.com/articles/storyname.htm

The game electroch engineeri

magna

ullamce

ea com

hendre

consed

imperd

facer p

ea com

iriure d

vulputa

nulla fa

cum sc

facer n

By Linda Exam

orem ipsum dolor sit amet, consectetuer adipiscing elit, sed diam nonumny nibh euismod tincidunt ut laoreet dolore magna aliquam erat volutpat. Ut wisi enim ad minim veniam, quis nostrud exerci tation aliquip ex ea commodo consequat.

commodo consequat.

Duis autem vel eum iriure dolor in hendrerit in vulputate velit esse molestie consequat, vel illum dolore eu feugiat nulla facilisis at vero eros et accumsan et iusto odio dignissim qui blandit praesent luptatum zzril delenit augue duis dolore te feugait nulla facilisi. Ut wisi enim ad minim veniam, quis nostrud exerci tation aliquip ex ea commodo consequat. Autem vel eum iriure dolor in hendrerit in vulputate velit esse molestie consequat, vel illum dolore ue feugiat nulla facilisis at vero eros et accumsan et iusto odio dignissim qui blandit praesent luptatum zzril delenit augue duis dolore te feugait nulla facilisis. Lorem ipsum dolor sit amet,

Page flow

Four 17 by 11 inch sheets (landscape) are folded to 8.5 by 11 inches and saddle-stitched.

What you need

General layout and design requires a desktop publishing program. Editing photographic images requires a digital imaging program. (See *Step 7: Choose Your Tools*, page 26.)

.yourwebaddressz.

reet dolore

olor in

eugiat nulla

r tempor cu

gue nihil

n placerat

d exerci tat

ut aliquip

ıtem vel e

ate velit e

in hendre

n liber ter

1 congue

n placera

nulla facil

wisi enim ac ci tation

lensi

News, opinion, events, resources, and more from The Manufacturer's Association of Sampler

Density Exclusive: How budget tightening snuffed out the industry's bright light

by Roger Example

Lorem ipsum dolor sit amet, consectetuer adipiscing elit, sed diam nonummy nibh euismod tincidunt ut laoreet dolore magna aliquam erat volutpat. Ut wisi enim ad minim

veniam, quis nostrud exerci tation ullam corper suscipit lobortis nisl ut aliquip ex ea commodo consequat. Duis

autem vel eum iriure dolor in hendrerit in vulputate velit esse molestie consequat, vel illum dolore eu feugiat nulla facilisis at vero eros et accumsan et iusto odio dignissim qui blandit praesent luptatum zzril delenit augue duis dolore te feugait nulla facilisi.

Lorem ipsum dolor sit amet, consectetuer adipiscing elit, sed diam nonummy nibh euismod tincidunt ut laoreet dolore magna aliquam erat volutpat. Ut wisi enim ad minim veniam, quis nostrud exerci tation ullamcorper suscipit lobortis nisl ut aliquip ex ea commodo consequat. Duis autem vel eum iriure dolor in hendrerit in vulputate velit esse molestie consequat, vel illum dolore eu feugiat nulla facilisis at vero eros et Nam liber tempor cum soluta nobis eleifend option congue nihil imperdiet doming id quod mazim placerat facer possim assum.

Lorem ipsum dolor sit amet, consectetuer adipiscing elit, sed diam nonummy nibh euismod tincidunt ut laoreet dolore magna aliquam erat volutpat. Ut wisi enim ad minim veniam, quis nostrud exerci tation ullamcorper suscipit lobortis nisl ut aliquip ex ea commodo consequat. Lorem ipsum dolor sit amet, consectetuer adipiscing elit, sed diam nonummy nibh euismod

Ut wisi enim ad minim veniam, quis nostrud exerci tation ullamcorper suscipit lobortis nisl ut aliquip ex ea commodo consequat. Duis autem vel eum iriure dolor in hendrerit in vulputate velit esseeum iriure dolor in hendrerit in vulputate velit esse molestie consequat, vel illum dolore eu feugiat nulla facilisis at vero eros et Nam liber tempor cum soluta nobis eleifend opquod mazim placerat facer possim assum commodo consequat.

Contact Roger Example: 987 654 3210 or name@emailaddressz.com; More: http:// www.yourwebaddressz.com/articles/storyname.htm

How-to: A return to marketing fundamentals

By Linda Example

Lorem ipsum dolor sit amet, consectetuer adipiscing elit, sed diam nonummy nibh euismod tincidunt ut laoreet dolore magna aliquam erat volutpat. Ut wisi enim ad minim veniam, quis nostrud exerci tation aliquip ex ea commodo consequat.

Duis autem vel eum iriure dolor in hendrerit in vulputate velit esse molestie consequat, vel illum dolore eu feugiat nulla facilisis at vero eros et accumsan et iusto odio dignissim qui blandit praesent luptatum zzril delenit augue duis dolore te feugait nulla facilisi. Ut wisi enim ad minim veniam, quis nostrud exerci tation aliquip ex ea commodo consequat. Autem vel eum iriure dolor in hendrerit in vulputate velit esse molestie consequat, vel illum dolore eu feugiat nulla facilisis at vero eros et accumsan et iusto odio dignissim qui blandit praesent luptatum zzril delenit augue duis dolore te feugait nulla facilisi. Lorem ipsum dolor sit amet, consectetuer adipiscing elit, sed diam nonum my nibh euismod tincidunt ut laoreet dolore magna aliquam erat volutpat. Ut wisi enim ad minim veniam, quis nostrud exerci tation ullamcorper suscipit lobortis nisl ut aliquip ex ea commodo consequat.

Duis autem vel eum iriure dolor in hendrerit in vulputate velit esse molestie consequat, vel illum dolore eu feugiat nulla

facilisis at vero eros et Nam liber tempor cum soluta nobis eleifend option congue nihil imperdiet doming id quod mazim placerat facer possim assum quis nostrud exerci tation ullamcorper suscipit lobortis nisl ut aliquip ex ea commodo consequat. Duis autem vel eum iriure dolor in hendrerit in vulputate velit esse molestie consequat, iriure dolor in hendrerit in vulputate velit esse vel illum dolore eu feugiat nulla facilisis at vero eros et Nam liber tempor cum soluta nobis eleifend option congue nihil imperdiet doming id quod mazim placerat facer possim assum. Vulputate nulla facilisis at vero.

Lorem ipsum dolor sit amet, consectetuer adipiscing elit, sed diam nonummy nibh euismod tincidunt ut laoreet dolore magna aliquam erat volutpat. Ut wisi enim ad minim veniam, quis nostrud exerci tation ullamcorper suscipit lobortis nisl. Lorem ipsum dolor sit amet, consectetuer adipiscing elit, sed diam nonummy nibh euismod. Lorem ipsum dolor sit amet, consectetuer adipiscing elit, sed diam nonummy nibh euismod tincidunt ut laoreet dolore magna aliquam erat volutpat. Ut wisi enim ad minim veniam, quis nostrud exerci tation ullamcorper suscipit lobortis nisl. Lorem ipsum dolor sit amet, consectetuer adipiscing elit, sed diam nonummy nibh euismod tincidunt ut laoreet dolore magna aliquam erat volutpat. Ut wisi enim ad minim veniam, quis nostrud exerci tation aliquip ex ea commodo consequat facilisis at vero eros et accumsan et iusto odio dignissim qui blandit praesent luptatum.

Contact Linda Example: 987 654 3210 or name@emailaddressz.com; More: http:// www.yourwebaddressz.com/articles/storyname.htm

BASIC ELEMENTS

The design grid

This recipe employs another simple, versatile, three-column grid. (See *Step 11.2: Establish the Page Size and Grid*, page 37.)

The typefaces

The American Type Founders Company Specimen Book and Catalogue describes **Franklin Gothic** as "always in style." That catalogue was published in 1923. These variations of Franklin Gothic prove the point—the best typefaces work as well today as they did when they were first conceived. Franklin Gothic Heavy

Typeface AaBbEeGgKkMmQqRrSsW

Franklin Gothic Book Condensed

Typeface AaBbEeGgKkMmQqRrSsWw!?

Erapklin Cathia Book Condensed

Text Lorem ipsum dolor sit amet, consectetuer adipiscing elit, sed diam nonummy nibh euismod tincidunt ut laoreet dolore magna aliquam erat volutpat. Ut wisi enim ad minim veniam, quis nostrud exerci tation ullamcorper suscipit lobortis nisl ut aliquip ex ea commodo consequat. Duis autem vel eum iriure dolor in hendrerit in vulputate velit esse molestie consequat, vel illum dolore eu feugiat nulla facilisis at vero eros.

The illustrations

All of the photographs shown here, minus one, are from royalty-free collections (the "I've been anodized" part on page 1 was shot for this specific client). By matching the look and feel of custom photographs to existing collections of images, you multiply design possibilities and keep a lid on your budget.

Mix type with images

Adding a word or, in this case, a letter to a stock or royalty-free photograph makes it one-of-a-kind. The letters here stand for the subjects of the articles—B for Budget and H for Hot. Like a conventional drop cap, they add an element of interest and a spot of color.

Get technical

Don't shy away from flowcharts, diagrams, and other technical illustrations. They may not be the most attractive visual elements of a design, but, first and foremost, a newsletter is a tool of communication. Rather than avoid the complex, take the time to break it into its simplest form and to match the design of the material to its surroundings. In this case, adding color to a flowchart and a shadow similar to the objects on other pages makes it fit right in.

Choose one emphasis per spread

Most newsletters have at least two levels of design: first, the overall design; then the design of each individual spread of pages (two facing pages). At the spread level, one way to direct a reader's attention is to make one article more visually important than the others. In this example, that is accomplished by making the headline bolder, by adding a drop cap to the beginning of the text, and by using a large illustration to anchor the article to the bottom of the page.

addressz.org

yourweb

from The Manufacturer's Association of Sampler

Density Exclusive: How budget tightening snuffed out the industry's bright light

by Roger Example

Lorem ipsum dolor sit amet, consectetuer adipiscing elit, sed diam nonummy nibh euismod tincidunt ut laoreet dolore magna aliquam erat volutpat. Ut wisi enim ad minim

veniam, quis nostrud exerci tation ullam corper suscipit lobortis nisl ut aliquip ex ea commodo consequat. Duis

autem vel eum iriure dolor in hendrerit in vulnutate velit esse molestie conseguat, vel illum dolore eu feugiat nulla facilisis at vero eros et accumsan et iusto odio dignissim qui blandit praesent luptatum zzril delenit augue duis dolore te feugait nulla facilisi.

Lorem ipsum dolor sit amet, consectetuer adipiscing elit, sed diam nonummy nibh euismod tincidunt ut laoreet dolore magna aliquam erat volutpat. Ut wisi enim ad minim veniam, quis nostrud exerci tation ullamcorper suscipit lobortis nisl ut aliquip ex ea commodo conseguat. Duis autem vel eum iriure dolor in hendrerit in vulputate velit esse molestie conseguat, vel illum dolore eu feugiat nulla facilisis at vero eros et Nam liber tempor cum soluta nobis eleifend option congue nihil imperdiet doming id guod mazim placerat facer possim assum.

Lorem ipsum dolor sit amet, consectetuer adipiscing elit, sed diam nonummy nibh euismod tincidunt ut laoreet dolore magna aliquam erat volutpat. Ut wisi enim ad minim veniam, quis nostrud exerci tation ullamcorper suscipit lobortis nisl ut aliquip ex ea commodo consequat. Lorem ipsum dolor sit amet, consectetuer adipiscing elit, sed diam nonummy nibh euismod

Ut wisi enim ad minim veniam, quis nostrud exerci tation ullamcorper suscipit lobortis nisl ut aliquip ex ea commodo conseguat. Duis autem vel eum iriure dolor in hendrerit in vulputate velit esseeum iriure dolor in hendrerit in vulputate velit esse molestie consequat, vel illum dolore eu feugiat nulla facilisis at vero eros et Nam liber tempor cum soluta nobis eleifend opquod mazim placerat facer possim assum commodo consequat.

Contact Roger Example: 987 654 3210 or name@emailaddressz.com; More: http:// www.yourwebaddressz.com/articles/storyname.htm

How-to: A return to marketing fundamentals

By Linda Example

Lorem ipsum dolor sit amet, consectetuer adipiscing elit, sed diam nonummy nibh euismod tincidunt ut laoreet dolore magna aliquam erat volutpat. Ut wisi enim ad minim veniam, quis nostrud exerci tation aliquip ex ea commodo conseguat.

Duis autem vel eum iriure dolor in hendrerit in vulputate velit esse molestie consequat, vel illum dolore eu feugiat nulla facilisis at vero eros et accumsan et iusto odio dignissim qui blandit praesent luptatum zzril delenit augue duis dolore te feugait nulla facilisi. Ut wisi enim ad minim veniam, quis nostrud exerci tation aliquip ex ea commodo consequat. Autem vel eum iriure dolor in hendrerit in vulputate velit esse molestie consequat, vel illum dolore eu feugiat nulla facilisis at vero eros et accumsan et iusto odio dignissim qui blandit praesent luptatum zzril delenit augue duis dolore te feugait nulla facilisi. Lorem ipsum dolor sit amet, consectetuer adipiscing elit, sed diam nonum my nibh euismod tincidunt ut laoreet dolore magna aliquam erat volutpat. Ut wisi enim ad minim veniam, quis nostrud exerci tation ullamcorper suscipit lobortis nisl ut aliquip ex ea commodo consequat.

Duis autem vel eum iriure dolor in hendrerit in vulputate velit esse molestie consequat, vel illum dolore eu feugiat nulla

facilisis at vero eros et Nam liber tempor cum soluta nobis eleifend option congue nihil imperdiet doming id quod mazim placerat facer possim assum quis nostrud exerci tation ullamcorper suscipit lobortis nisl ut aliquip ex ea commodo conseguat. Duis autem vel eum iriure dolor in hendrerit in vulputate velit esse molestie consequat, iriure dolor in hendrerit in vulputate velit esse vel illum dolore eu feugiat nulla facilisis at vero eros et Nam liber tempor cum soluta nobis eleifend option congue nihil imperdiet doming id quod mazim placerat facer possim assum. Vulputate nulla facilisis at vero

Lorem ipsum dolor sit amet, consectetuer adipiscing elit, sed diam nonummy nibh euismod tincidunt ut laoreet dolore magna aliguam erat volutpat. Ut wisi enim ad minim veniam, quis nostrud exerci tation ullamcorper suscipit lobortis nisl. Lorem ipsum dolor sit amet, consectetuer adipiscing elit, sed diam nonummy nibh euismod. Lorem ipsum dolor sit amet, consectetuer adipiscing elit, sed diam nonummy nibh euismod tincidunt ut laoreet dolore magna aliquam erat volutpat. Ut wisi enim ad minim veniam, quis nostrud exerci tation ullamcorper suscipit lobortis nisl. Lorem ipsum dolor sit amet, consectetuer adipiscing elit, sed diam nonummy nibh euismod tincidunt ut laoreet dolore magna aliquam erat volutpat. Ut wisi enim ad minim veniam, quis nostrud exerci tation aliquip ex ea commodo consequat facilisis at vero eros et accumsan et iusto odio dignissim qui blandit praesent luptatum.

Contact Linda Example: 987 654 3210 or @emailaddressz.com; More: http:// www.yourwebaddressz.com/articles/storyname.htm

8.5 W

density

Static build up by the book

Lorem insum dolor sit amet, consectet adipiscing elit, sed diam nonummy nibh euismod tincidunt ut laoreet dolore magna aliquam erat volutpat. Ut wisi enim ad m veniam, quis nostrud exerci tation aliquip ex ea commodo conseguat

Duis autem vel eum iriure dolor in hendrerit in vulputate velit esse molestie consequat, vel illum dolore eu feugiat nulla facilisis at vero eros et accumsan et iusto odio dignissim qui blandit praesent luptatum zzril delenit augue duis dolore te feugait nulla facilisi. Ut wisi enim ad minim veniam, quis nostrud exerci tation aliquip ex ea commodo consequat. Autem vel eum iriure dolor in hendrerit in vulputate velit esse molestie consequat, vel illum dolore eu feugiat nulla facilisis at vero eros et accumsan et iusto odio dignissim qui blandit praesent luptatum zzril delenit augue duis dolore te feugait nulla facilisi. Lorem ipsum dolor sit amet, consectetuer adipiscing elit, sed diam nonun

Lorem ipsum dolor sit amet, consectetuer adipiscing elit, sed diam nonummy nibh euismod tincidunt ut laoreet dolore magna aliquam erat volutpat. Ut wisi enim ad minim veniam, quis nostrud exerci tation ullam corpe suscipit lobortis nisl ut aliquip ex ea commodo consequat. Duis autem vel eum iriure dolor in hendrerit in vulputate velit esse molestie consequat, vel illum dolore eu feugiat nulla facilisis at vero eros et accumsan et iusto odio

delenit augue duis dolore te feugait nulla facilisi. Lorem insum dolor sit amet sectetuer adipiscing elit, sed diam nonummy nibh euismod tincidunt ut laoreet dolore magna aliquam erat volutpat. Ut wis enim ad minim veniam, quis nostrud exerci tation ullamcorper suscipit lobortis nisl ut aliquip ex ea commodo consequat. Duis autem vel eum iriure dolor in hendrerit in vulputate velit esse molestie conseguat, vel illum dolore eu feugiat nulla facilisis at vero.

act Franklin Example: 987 654 3210 or lailaddressz.com; More: http://

Salary Survey: 200 companies tell a surprising story

by Dillon Example

Lorem ipsum dolor sit amet, consectetuer adipiscing elit, sed diam nonummy nibh euismod tincidunt ut laoreet dolore magna aliquam erat volutpat. Ut wisi enim ad minim veniam, quis nostrud exerci tation ullam corper suscipit lobortis nisl ut aliquip ex ea commodo conseguat. Duis autem vel eum molestie consequat, vel illum dolore eu feugiat nulla facilisis at vero eros et accumsan et iusto odio dignissim qui blandit praesent luptatum zzril delenit augue duis dolore te feugait nulla facilisi

Lorem ipsum dolor sit amet, consectetuer adipiscing elit, sed diam nonummy nibh euismod tincidunt ut laoreet dolore magna aliquam erat volutpat. Ut wisi enim ad minim veniam, quis nostrud exerci tation ullamcorne suscipit lobortis nisl ut aliquip ex ea commodo consequat. Duis autem vel eum iriure dolor in hendrerit in vulnutate velit esse molestie nsequat, vel illum dolore eu feugiat nulla facilisis at vero eros et Nam liber tempor cum soluta nobis eleifend option congue nihil mperdiet doming id quod mazim placerat facer possim assum.

Lorem ipsum dolor sit amet, consectetuer adipiscing elit, sed diam nonummy nibh euismod tincidunt ut laoreet dolore magna aliquam erat volutpat.

Contact Dillon Example: 987 654 3210 or me@emailaddressz.com; More: http://

P.O. Box 1245 Your City, ST 12345-6789

Join us for the **MAS Gala** Dinner on September 30 in Houston

SANDRA EXAMPLE SAMPLER CORPORATION 123 EXAMPLE BOULEVARD STE 200 YOUR CITY ST 12345 6789

<u> Մարմիստոկումիստոկումիստոնիստոնիստորագիրարկումիստոկումիուպիստոկումի</u>

PAID YOUR CITY, ST PERMIT NO. 222 ZIP CODE 98765

Cover (page 1)

1"Sampler" Franklin Gothic Book Condensed, 20pt. align left; "density" Franklin Gothic Heavy, 100pt, align center; Date/defining phrase Franklin Gothic Book Condensed, 8/9pt, align left; 2 Web address Franklin Gothic Book Condensed, 9pt, align center; 3 Headline, small Franklin Gothic Condensed, 20/ 20pt, align left; Contributor Franklin Gothic Heavy, 8pt, align left; Text Franklin Gothic Book Condensed. 10/12pt, align left; Contact link Franklin Gothic Book Condensed, 7/8pt, align left; 4 Line .5pt; 5 "I've" Franklin Gothic Book Condensed, 15pt, align center

Back Cover (page 16)

6 "Sampler" Franklin Gothic Book Condensed, 8pt, align left; "density" Franklin Gothic Heavy, 20pt, align center; 7 Headline, large Franklin Gothic Heavy, 48/40pt, align left; Contributor Franklin Gothic Heavy, 8pt, align left; Text Franklin Gothic Book Condensed, 10/12pt, align left; Contact link Franklin Gothic Book Condensed, 7/8pt, align left; 8 Headline, small Franklin Gothic Condensed, 20/20pt. align left; 9 Line .5pt; 10 Return address Franklin Gothic Book Condensed, 8/9pt, align left; Headline, large Franklin Gothic Heavy, 18/17pt, align left; 11 Label address Arial, 10/10pt, align left; 10 Postage indicia Franklin Gothic Book Condensed, 8/8pt, align center; Line .5pt

Color

Printed in four-color process (Step 11.6) using values of cyan, magenta, yellow, and black (CMYK) as defined on the color palette below. Actual color will vary.

SOURCE Illustrations: Clouds (pg. 1) from Image Club from Eyewire, 800-661-9410, 403-262-8008, www.eyewire.com. © Evewire, Inc., all rights reserved; Wrench (pg. 1), CMCD Just Tools, Hand/booklet from CMCD Just Hands, from PhotoDisc, 800-979-4413, 206-441-9355, www.photodisc.com, © CMCD, all rights reserved; Anodized part (pg. 1) courtesy of APC, Inc.

SOURCE Type Families: Arial, Franklin Gothic, Adobe Systems, Inc. 800-682-3623, www.adobe.com/type.

Pages 2 & 3

12 Page number/running head Franklin Gothic Book Condensed, 8pt, align left; 13 Headline, small Franklin Gothic Condensed, 20/20pt, align left; Contributor Franklin Gothic Heavy, 8pt, align left; Text Franklin Gothic Book Condensed, 10/12pt, align left; Contact link Franklin Gothic Book Condensed, 7/8pt, align left; 14 Headline, large Franklin Gothic Heavy, 48/40pt, align left; Drop cap Franklin Gothic Book Condensed, 44pt, align left; 15 "Sampler" Franklin Gothic Book Condensed, 8pt, align left; "density" Franklin Gothic Heavy, 20pt, align center; 16 Line .5pt

Pages 4 & 5

17 Page number/running head Franklin Gothic Book Condensed, 8pt, align left; 18 Headline, small Franklin Gothic Condensed, 20/20pt, align left; Contributor Franklin Gothic Heavy, 8pt, align left; Text Franklin Gothic Book Condensed, 10/12pt, align left; Contact link Franklin Gothic Book Condensed, 7/8pt, align left; 19 "Air" Franklin Gothic Book Condensed, 200pt, align left; Headline, small Franklin Gothic Condensed, 20/20pt, align left; 20 Drop cap Franklin Gothic Heavy, 48pt, align left; 21 Subhead Franklin Gothic Condensed, 9pt, align left: 22 Masthead Franklin Gothic Condensed, 9/10pt, align left; Masthead subhead Franklin Gothic Condensed, 8pt, align left; 24 Copyright Franklin Gothic Condensed, 7pt, align left

SOURCE Illustrations: Woman (pg. 2) from Faces 1, Pilot (pg. 4) from Faces 2 from RubberBall Productions 801-224-6886, www.rubberball.com. © RubberBall Productions, all rights reserved; Chess (pg. 2), CMCD Everyday Objects 1, Caliper (pg. 3) CMCD Just Tools from PhotoDisc.800-979-4413.206-441-9355. www.photodisc.com, @ CMCD, all rights reserved.

SOURCE Type Families: Franklin Gothic, Adobe Systems, Inc. 800-682-3623, www.adobe.com/type.

Industry Watch: Slate of nominees for ABCD named; Miller to head Example Products; More by Robin Example

Lorem ipsum dolor sit amet, consectetuer adipiscing elit, sed diam nonummy nibh

aliquam erat volutpat Ut wisi enim ad minim veniam, quis nostrud exerci tation ullam orper suscipit lobortis sl ut aliquip ex ea modo conseguat. Duis autem vel eum iriure dolor in hendrerit in vulputate velit esse

molestie consequat, vel illum dolore eu accumsan et iusto odio dignissim qui blandit praesent luptatum zzril delenit augue duis dolore te feugait nulla facilisi

Lorem ipsum dolor sit amet consectetuer adipiscing elit, sed diam nonummy nibh euismod tincidunt ut laore dolore magna aliquam erat volutpat. Ut wis enim ad minim veniam, quis nostrud exerci tation ullamcorper suscipit lobortis nisl ut aliquip ex ea commodo conseguat. Duis autem vel eum iriure dolor in hendrerit in vulputate velit esse molestie consequat, vel illum dolore eu feugiat nulla facilisis at vero eros et Nam liber tempor cum soluta nobis eleifend option congue nihil imperdiet doming id quod mazim placerat facer possim assum

Lorem ipsum dolor sit amet, consectetuer adipiscing elit, sed diam nonummy nibh euismod tincidunt ut lac dolore magna aliquam erat volutpat. Ut wisi enim ad minim veniam, quis nostrud exerc tation ullamcorper suscipit lobortis nisl ut aliquip ex ea commodo consequat. Lorem insum dolor sit amet, consectetuer adipiscing elit, sed diam nonummy nibh euismod tincidunt ut laoreet dolore erat volutpat

101

The game of electrochemical engineering

orem ipsum dolor sit amet, consectetuer adipiscing elit, sed diam nonummy nibh euismod tincidunt ut laoreet dolore magna aliquam erat volutpat. Ut wisi enim ad minim veniam, uis nostrud exerci tation aliquip ex ea commodo consequat.

Duis autem vel eum iriure dolor in hendrerit in vulputate velit esse molestie consequat, vel illum dolore eu feugiat nulla facilisis at vero eros et accumsan et iusto odio dignissim qui blandit praesent luptatum zzril delenit augue duis dolore te feugait nulla facilisi. Ut wisi enim ad minim veniam, quis nostrud exerci tation aliquip ex ea commod consequat. Autem vel eum iriure dolor in hendrerit in vulputate velit esse molestie consequat, vel illum dolore eu feugiat nulla facilisis at vero eros et accumsan et iusto odio dignissim qui blandit praesent luptatum zzril delenit augue duis dolore te feugait nulla facilisi. Lorem ipsum dolor sit amet.

արմիստոնարանիստությունը անակարանիստության անակարանիստության անակարանիստության անակարակարանիստության անակարանիստության անակարանակարանիստության անակարանիստության անական անակարանի անական անական

my nibh euismod tincidunt ut laoreet dolore magna aliquam erat volutpat. Ut wisi enim ad minim veniam, quis nostrud exerci tation ullamcorper suscipit lobortis nisl ut aliquip ex ea commodo consequat.

Duis autem vel eum iriure dolor in

hendrerit in vulputate velit esse molestie consequat, vel illum dolore eu feugiat nulla facilisis at vero eros et Nam liber tempor cum soluta nobis eleifend option congue nihil imperdiet doming id quod mazim placerat facer possim assum quis nostrud exerci tation ullamcorper suscipit lobortis nisl ut aliquip ex ea commodo consequat. Duis autem vel eum iriure dolor in hendrerit in vulputate velit esse molestie consequat, iriure dolor in hendrerit in vulputate velit esse vel illum dolore eu feugiat nulla facilisis at vero eros et Nam liber tempor cum soluta nobis eleifend option congue nihil imperdiet doming id quod mazim placerat facer possim assum. Vulputate nulla facilisis

density

Lorem ipsum dolor sit amet, consectetuer adipiscing elit, sed diam nonummy nibh euismod tincidunt ut laoreet dolore magna aliquam erat volutpat. Ut wisi enim ad minim veniam, quis nostrud exerci tation ullam corper suscipit lobortis nisl ut aliquip ex ea commodo consequat. Duis autem vel eum iriure dolor in hendrerit in vulputate velit esse molestie consequat, vel illum dolore eu feugiat nulla facilisis at vero eros et accumsan et iusto odio dignissim qui blandit praesent luptatum zzril delenit augue duis dolore te feugait nulla facilisi n vulputate velit esse molestie consequat, vel illum dolore eu

Example

SUBHEAD TEXT Lorem ipsum dolor sit amet, consect etuer adipiscing elit, sed diam nonummy nibh euismod tincidunt ut laoreet dolore magna aliquam erat volutpat. Ut wisi enim ad minim veniam, quis nos rud exerci tation ullamcorper suscipit lobortis nisl ut

feugiat nulla facili.

aliquip ex ea commodo consequat. Duis autem vel eum iriure dolor in hendrerit in vulputate velit esse molestie consequat, vel illum dolore eu feugiat nulla facilisis at vero eros et Nam liber tempor cum soluta nobis eleifend option congue nihil imperdiet doming id quod mazim placerat facer possim assum.

Lorem ipsum dolor sit amet, consectetuer adipiscing elit, sed diam nonummy nibh euismod tincidunt ut laoreet dolore magna aliquam erat volutpat. Ut wisi enim ad minim veniam, quis nostrud exerci tation ullamcorper suscipit lobortis nisl

ut aliquip ex ea commodo consequat. Lorem ipsum dolor sit amet, consectetuer

> adipiscing elit, sed diam nonummy nibh euismod tincidunt ut laoreet dolore magna aliquam erat volutpat. Ut wisi

enim ad minim veniam, quis nostrud exerci tation ullamcorper suscipit lobortis nisl ut aliquip ex ea commodo consequat. Duis autem vel elit, sed diam nonummy nibh euismod tincidunt ut laoreet dolore magna aliquam erat volutpat.

Ut wisi enim ad minim veniam, quis nostrud exerci tation ullamcorper suscipit lobortis nisl ut aliquip ex ea commodo consequat. Duis autem vel eum iriure dolor in hendrerit in vulputate velit esseeum iriure dolor in hendrerit in vulputate velit esse molestie consequat, vel illum dolore eu feugiat nulla facilisis at vero eros et Nam liber tempor cum

Example

Information

elit, sed diam ne

volutpat. Ut wisi enim ad

Flow chart info

chart info

Example flow chart

Information

soluta nobis eleifend opquod mazim placerat facer

possim assum commodo consequat. Lorem ipsum dolor sit amet, consectetuer adipiscing elit, sed diam nonummy nibh euismod tincidunt ut laoreet dolore magna aliquam erat volutpat. Ut wisi enim ad minim veniam, quis nostrud

exerci tation aliquip ex ea commodo consequat.

Duis autem vel eum iriure dolor in hendrerit in vulputate velit esse molestie consequat, vel illum dolore eu feugiat nulla facilisis at vero eros et accumsan et iusto odio dignissim qui blandit praesent luptatum zzril delenit augue duis dolore te feugait nulla facilisi. Ut wisi enim ad minim veniam, quis nostrud exerci tation aliquip ex ea commodo consequat. Autem vel eum iriure dolor in hendrerit in vulputate velit esse molestie.

Duis autem vel eum iriure dolor in hendrerit in vulputate velit esse molestie consequat, iriure dolor in hendrerit in vulputate velit esse vel illum dolore eu.

Contact Linda Example: 987 654 3210 or name@emailaddressz.com; More: http:// www.yourwebaddressz.com/articles/storyname.htm

Hot Products: The ultimate tools for insert molding

by Richardson Example

Lorem ipsum dolor sit amet, consectetuer adipiscing elit, sed diam nonummy nibh euismod tincidunt ut laoreet dolore magna aliquam erat volutpat. Ut wisi enim ad minim veniam, quis nostrud exerci tation ullam corper suscipit lobortis nisl ut aliquip ex ea commodo consequat. Duis

autem vel eum iriure dolor in hendrerit in vulputate velit esse

molestie

consequat, vel illum dolore eu feugiat nulla facilisis at vero eros et accumsan et iusto odio dignissim qui blandit praesent luptatum zzril delenit augue duis dolore te feugait nulla facilisi

Lorem ipsum dolor sit amet, consectetuer adipiscing elit, sed diam nonummy nibh euismod tincidunt ut laoreet dolore magna aliquam erat volutpat. Ut wisi enim ad minim veniam, quis nostrud exerci tation ullamcorper suscipit lobortis nisl ut aliquip ex ea commodo consequat. Duis autem vel eum iriure dolor in hendrerit in vulputate velit esse molestie consequat, vel illum dolore eu feugiat nulla facilisis at vero eros et Nam liber tempor cum soluta nobis eleifend option congue nihil imperdiet doming id quod mazim placerat facer possim assum.

Lorem ipsum dolor sit amet, consectetuer adipiscing elit, sed diam nonummy nibh euismod tincidunt ut laoreet dolore magna aliquam erat volutpat. Ut wisi enim ad minim veniam, quis nostrud exerci tation ullamcorper suscipit lobortis nisl ut aliquip ex ea commodo consequat. Lorem ipsum dolor sit amet, consectetuer adipiscing elit, sed diam nonummy nibh euismod tincidunt ut laoreet dolore erat volutpat.

Contact Richardson Example: 987 654 3210 or name@emailaddressz.com; More: http:// www.yourwebaddressz.com/articles/storyname.htm

> 8.5 W 11 H

117

STYLE 9 (2 PAGES)

Postcard

Could a newsletter in postcard form achieve some or most of the things you envision your conventional newsletter achieving? It would certainly hook you up with readers on a regular basis and provide a venue for promoting products, services, and your way of thinking. But the real value of creating a postcard newsletter is for what it doesn't do—it doesn't take as long to write and design, it doesn't cost as much to produce, and, in many cases, it doesn't cost as much to mail.

Plus, if your audience has only a passing interest in your subject matter, a postcard newsletter doesn't require the kind of time and effort it takes to explore a sixteen-page newsletter.

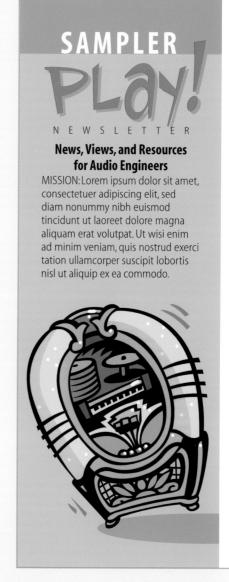

DECEMBER 20??, Volume (

What you to know ab new Digita audio stand

by Christine Example

Lorem ipsum dolor sit ame adipiscing elit, sed diam ne euismod tincidunt ut laore aliquam erat volutpat. Ut w minim veniam, quis nostru ullam corper suscipit lobor ex ea commodo consegua eum iriure dolor in hendre velit esse molestie consea dolore eu feugiat nulla fac et accumsan et iusto odio blandit praesent luptatum augue duis dolore te feuga Lorem ipsum dolor sit ame adipiscing elit, sed diam ne euismod tincidunt ut laore aliquam erat volutpat. Ut v minim veniam, quis nostru ullamcorper suscipit lobor ex ea commodo consequa

Duis autem vel eum i hendrerit in vulputate velit consequat, vel illum dolore facilisis at vero eros et Nam cum soluta nobis eleifend c hil imperdiet doming id qu

Page flow

One landscape 6 by 9 inch card.

What you need

General layout and design requires a desktop publishing program. Editing photographic images requires a digital imaging program. Dividing and reassembling the parts and pieces of vector clip art images and type requires a drawing program. (See Step 7: Choose Your Tools, page 26.)

'e, Published by Organization's Name

na

lip

rel

DS

na

ip

ni-

placerat facer possim assum. Lorem ipsum dolor sit amet, consectetuer adipiscing elit, sed diam nonummy nibh euismod tincidunt ut laoreet dolore magna aliquam erat volutpat. Ut wisi enim ad minim veniam, suscipit lobortis nisl ut aliquip ex ea commodo consequat.

Lorem ipsum dolor sit amet, consectetuer adipiscing elit, sed diam nonummy nibh euismod tincidunt ut laoreet dolore magna aliquam erat volutpat. Ut wisi enim ad minim veniam, quis nostrud exerci tation ullamcorper suscipit lobortis nisl ut aliquip ex ea commodo consequat. Duis autem vel elit, sed diam nonummy nibh euismod tincidunt ut laoreet dolore magna aliquam erat volutpat.

Ut wisi enim ad minim veniam, quis nostrud exerci tation ullamcorper suscipit lobortis nisl ut aliquip ex ea commodo consequat. Duis autem vel eum iriure dolor in hendrerit in vulputate velit esseeum iriure dolor in hendrerit in vulputate velit esse molestie consequat, vel illum dolore eu feugiat nulla facilisis at vero eros et Nam liber tempor cum soluta nobis eleifend opquod mazim placerat facer possim assum commodo consequat. Ut wisi enim ad minim veniam, quis nostrud exerci tation.

Contact Christine Example: 987 654 3210 or name@emailaddressz.com

SAMPLER PLAY!

3028 Example Road

P.O. Box 1245, Your City, ST 12345-6789

Phone 987 654 3210 Fax 987 654 3210

E-mail info@emailaddressz.com Web www.yourwebaddressz.com

Copyright 20?? by Organization's Name. All rights reserved.

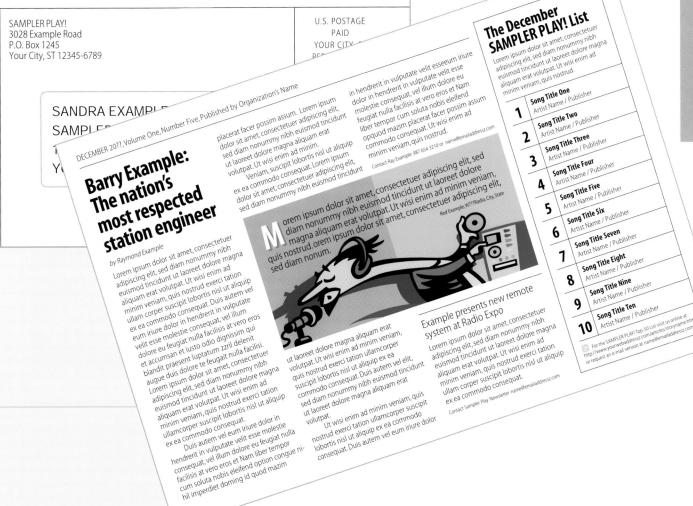

The design grid

Both cards are based on the same four-column grid. (See Step 11.2: Establish the Page Size and Grid, page 37.)

The typefaces

On the first card, the word "Play!" matches the playful attitude of the jukebox illustration. The smooth, simple lines of the accompanying sans serif typefaces allow the illustrations to take the lead. The typefaces on the second card represent the businesslike end of the spectrum—an elegant script and a chiseled serif.

Typeface AaBbEeGgKkMmQgRrSsWw!?

Typeface ABBBEEGGKKMMQQRRSSWW!?

Typeface

AaBbEeGgKkMmQqRrSsWw!?

TYPEFACE AABBEEGGKKMMQQR

Typeface AaBbEeGgKkMmQqRrSsWw!?

The illustrations

Like the typefaces, the illustrations represent two very different approaches. Bold, distinct shapes and bright colors give the jukebox and engineer illustrations a sense of humor. The unique, complex collages of technology and money do justice to the formal nature of The Sampler Fund card.

The December **SAMPLER PLAY! List** Lorem ipsum dolor sit amet, consectetuer adipiscing elit, sed diam nonummy nibh euismod tincidunt ut laoreet dolore magna aliquam erat volutpat. Ut wisi enim ad minim veniam, quis nostrud. Song Title One 1 Artist Name / Publisher Song Title Two 2 Artist Name / Publisher Song Title Three 3 Artist Name / Publisher Song Title Four 4

Artist Name / Publisher

Song Title Five
Artist Name / Publisher
Song Title Six

5

Invite the reader back

A sensitive business person doesn't call a client or prospect on the phone and expect them to drop everything that moment to talk. They ask, "Do you have a minute?" A sensitive designer does the same thing. Instead of assuming a reader will drop everything the moment your newsletter arrives, include some at-a-glance elements that will convince them to return—a headline that promises a significant benefit, the results of a survey, a diagram, or, as in this case, a checklist.

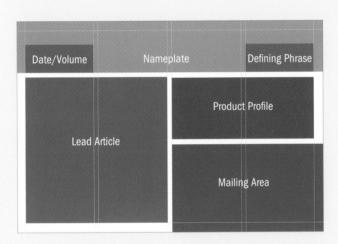

Make it look and feel like a newsletter

Remember, when you create a postcard newsletter, you will be presenting information in a way readers are used to seeing in another form—8.5 by 11 inches with multiple pages. For that reason, it pays to make your postcard look something like a conventional newsletter. Label it as a "NEWSLET-TER," include a conventional nameplate with a defining phrase, and be sure to include a date and volume/issue numbers. Write your copy in news form—who, what, where, when, and why. And save the hard selling for other materials—make your newsletter equally as interesting to someone who does not plan to buy your product, service, or idea.

ile ilor sit amet, consectetuer ed diam nonummy nibh unt ut lareet dolore magna oliutpat. Ut wisi ein mad o, quis nostrud exerci tation suscipit lobortis nisi ut aliquip ido consequat. Duis autem velori in hendrerit in vulgutate olor in hendrerit in vulgutate olor in hendrerit in vulgutate olori sit aliquin simi vulgata nulla facilisi si vero eros eserti luptatum zzril delenit esenti lugata nulla facilisi si dolore te feugait nulla facilisi si vilgui esenti lugata nulla facilisi si vilgui esenti lugata nulla vilgui esenti lugata vilgui esenti in vulgutate velit ese molestie enti in vulgutate velit esse molestie oros en Nami liber tempor soluta nobis eleifend option congue nimperdiet doming id quod mazim

exerci tation ullamcorper suscupination in sur aliquip ex ea commodo consequat.

Duis autem vel elit, sed diam nonummy nibh euismod tincidunt ut laoreet dolore magna P.O. Box 1245, Your Cit 987 654 3210 987 654 3210 info@emailaddressz.com phone www.yourwebaddressz.com euismod tincidunt ut idoreet durure mogrie aliquam erat volutpat. Ut wisi enim ad minim veniam, quis nostrud exerci tation ullamcorper suscipit lobortis nisl ut aliquip ex ea commodo Web Copyright 20?? by Organizatio U.S. POSTAGE PAID YOUR CITY, ST PERMIT NO. ??? ZIP CODE 98765 SAMPLER PLAY! 3028 Example Road P.O. Box 1245 Your City, ST 12345-6789 SANDRA EXAMPLE SAMPLER CORPORATION 123 EXAMPLE BOULEVARD STE 200 YOUR CITY ST 12345 6789

Follow mailing guidelines and regulations

Before you print anything intended to be mailed without an envelope, show a mockup of what you plan to print to the mailing experts at your local post office. Mailing regulations change, instructions are misinterpreted, something is left out, the size is half an inch too large to qualify for a preferred rate. Confirming your newsletter meets postal regulations can save you lots of time and money.

in hendrerit in vulputate velit esseeum iriure

dolor in hendrerit in vulputate velit esse feugiat nulla facilisis at vero eros et Nam

molestie consequat, vel illum dolore eu liber tempor cum soluta nobis eleifend

consequat. Duis autem vel eum iriure dolor

opquod mazim placerat facer possim assum

commodo consequat. Ut wisi enim ad

minim veniam, quis nostrud exerci tation.

Contact Christine Example: 987 654 3210 or

name@emailaddressz.com

DECEMBER 20??, Volume One, Number Five, Published by Organization's Name

to know about the new Digital QRD audio standard What you need

by Christine Example

euismod tincidunt ut laoreet dolore magna ullam corper suscipit lobortis nisl ut aliquip euismod tincidunt ut laoreet dolore magna ex ea commodo consequat. Duis autem vel dolore eu feugiat nulla facilisis at vero eros orem ipsum dolor sit amet, consectetuer ullamcorper suscipit lobortis nisl ut aliquip minim veniam, quis nostrud exerci tation eum iriure dolor in hendrerit in vulputate orem ipsum dolor sit amet, consectetuer minim veniam, quis nostrud exerci tation adipiscing elit, sed diam nonummy nibh augue duis dolore te feugait nulla facilisi. et accumsan et iusto odio dignissim gui adipiscing elit, sed diam nonummy nibh relit esse molestie consequat, vel illum aliquam erat volutpat. Ut wisi enim ad olandit praesent luptatum zzril delenit aliquam erat volutpat. Ut wisi enim ad ex ea commodo conseguat.

cum soluta nobis eleifend option conque niconsequat, vel illum dolore eu feugiat nulla hendrerit in vulputate velit esse molestie facilisis at vero eros et Nam liber tempor Duis autem vel eum iriure dolor in hil imperdiet doming id quod mazim

sed diam nonummy nibh euismod tincidunt placerat facer possim assum. Lorem ipsum dolor sit amet, consectetuer adipiscing elit, volutpat. Ut wisi enim ad minim veniam, ut laoreet dolore magna aliquam erat suscipit lobortis nisl ut aliquip ex ea commodo consequat.

Duis autem vel elit, sed diam nonummy nibh Ut wisi enim ad minim veniam, quis nostrud laoreet dolore magna aliquam erat volutpat euismod tincidunt ut laoreet dolore magna exerci tation ullamcorper suscipit lobortis nisl ut aliquip ex ea commodo consequat. consectetuer adipiscing elit, sed diam nonummy nibh euismod tincidunt ut Lorem ipsum dolor sit amet,

Ut wisi enim ad minim veniam, quis nostrud exerci tation ullamcorper suscipit obortis nisl ut aliquip ex ea commodo aliquam erat volutpat.

www.yourwebaddressz.com

info@emailaddressz.com

Copyright 20?? by Organization's Name. All rights reserved

P.O. Box 1245, Your City, ST 12345-6789

3028 Example Road

SAMPLER PLAY!

Phone E-mail Web Fax

ZIP CODE 98765 PERMIT NO. ??? U.S. POSTAGE YOUR CITY, ST PAID

3028 Example Road P.O. Box 1245 Your City, ST 12345-6789

SAMPLER PLAY!

123 EXAMPLE BOULEVARD STE 200 YOUR CITY ST 12345 6789 SAMPLER CORPORATION SANDRA EXAMPLE

6

8

0

N E W S L

News, Views, and Resources for Audio Engineers

ad minim veniam, quis nostrud exerci MISSION: Lorem ipsum dolor sit amet aliquam erat volutpat. Ut wisi enim tation ullamcorper suscipit lobortis tincidunt ut laoreet dolore magna consectetuer adipiscing elit, sed diam nonummy nibh euismod nisl ut aliquip ex ea commodo

SAMPLER PLAY! List The December

euismod tincidunt ut laoreet dolore magna adipiscing elit, sed diam nonummy nibh aliquam erat volutpat. Ut wisi enim ad veniam, quis nostrud.

Artist Name / Publisher

Artist Name / Publisher Artist Name / Publisher Artist Name / Publisher Artist Name / Publisher Artist Name / Publisher Artist Name / Publisher Artist Name / Publisher

Song Title Two Song Title One

Song Title Three

Song Title Four Song Title Five

> 4 5 9

opquod mazim placerat facer possim assum eugiat nulla facilisis at vero eros et Nam dolor in hendrerit in vulputate velit esse molestie consequat, vel illum dolore eu liber tempor cum soluta nobis eleifend commodo consequat. Ut wisi enim ad minim veniam, quis nostrud. Contact Ray Example: 987 654 3210 or nan

Veniam, suscipit lobortis nisl ut aliquip dolor sit amet, consectetuer adipiscing elit, ex ea commodo consequat. Lorem ipsum

sed diam nonummy nibh euismod tincidunt placerat facer possim assum. Lorem ipsum dolor sit amet, consectetuer adipiscing elit, ut laoreet dolore magna aliquam erat volutpat. Ut wisi enim ad minim.

sed diam nonummy nibh euismod tincidunt

amet, consectetuer adipiscing elit, aliquam erat volutpat. Ut wisi enim ad minim veniam orem ipsum dolor sit amet, consectetuer adipiscing elit, sed onummy nibh euismod tincidunt ut laoreet dolore quis nostrud. orem sed diam nonum diar ma

sed diam nonummy nibh euismod tincidunt commodo consequat. Duis autem vel elit, volutpat. Ut wisi enim ad minim veniam quis nostrud exerci tation ullamcorper ut laoreet dolore magna aliquam erat ut laoreet dolore magna aliquam erat suscipit lobortis nisl ut aliquip ex ea

consequat. Duis autem vel eum iriure dolor nostrud exerci tation ullamcorper suscipit Ut wisi enim ad minim veniam, quis lobortis nisl ut aliquip ex ea commodo olutpat.

facilisis at vero eros et Nam liber tempor cum soluta nobis eleifend option congue ni-

hil imperdiet doming id guod mazim

consequat, vel illum dolore eu feugiat nulla

nendrerit in vulputate velit esse molestie

For the SAMPLER PLAY! Top-50 List visit us online and the SAMPLER PLAY! Top-50 List visit us online and the SAMPLER PLAY!

Artist Name / Publisher Artist Name / Publisher

Song Title Ten

euismod tincidunt ut laoreet dolore magna

adipiscing elit, sed diam nonummy nibh

Lorem ipsum dolor sit amet, consectetuer

Example presents new remote

system at Radio Expo

ullam corper suscipit lobortis nisl ut aliquip

ex ea commodo consequat.

ontact Sampler

minim veniam, quis nostrud exerci tation

aliquam erat volutpat. Ut wisi enim ad

Song Title Nine

Song Title Seven

Song Title Six

Song Title Eight

 ∞ 6 0

Front (page 1)

1 "Sampler" Myriad MM, 700bd, 300cn, 24pt, align center; "play!" Space Toaster, 80pt, align center; "NEWSLETTER" Franklin Gothic Book Condensed, 8/9pt, align center; Defining phrase Myriad MM. 700bd, 300cn, 11/12pt, align center; Text Myriad MM, 250wt, 500wd, 9/10pt, align left; 2 Date Myriad MM, 250wt, 500wd, 9pt, align left; Line .5pt; 3 Headline, large Myriad MM, 700bd, 300cn, 24/22pt, align left; Contributor Myriad MM Italic, 250wt, 500wd, 8pt, align left; Text Myriad MM, 250wt, 500wd, 9/10pt, align left; 4 Line .5pt; Contact link headline Myriad MM, 700bd, 300cn, 9pt, align left; Contact link text Myriad MM Italic, 250wt, 500wd, 9/10pt, align left; Copyright Myriad MM, 250wt, 500wd, 6pt, align left; 5 Line .5pt; Return address Myriad MM, 250wt, 500wd, 8/8pt, align left; 6 Label address Arial, 10/10pt, align left; Postage indicia Myriad MM, 250wt, 500wd, 7/6pt, align center; Line .5pt

Back (page 2)

7 Date Myriad MM, 250wt, 500wd, 9pt, align left; Line .5pt; 8 Headline, large Myriad MM, 700bd. 300cn, 24/22pt, align left; Contributor Myriad MM Italic, 250wt, 500wd, 8pt, align left; Text Myriad MM, 250wt, 500wd, 9/10pt, align left; Contact link Myriad MM, 250wt, 500wd, 6pt, align left; 9 Drop cap Myriad MM, 700bd, 300cn, 40pt, align left; Illustration text Myriad MM, 250wt, 500wd, 11/11pt, align left; Credit Myriad MM, 250wt, 500wd, 6pt, align right; 10 Headline, small Myriad MM, 250wt, 500wd, 12/12pt, align left; Text Myriad MM, 250wt, 500wd, 9/10pt, align left; 11 Line .5pt; Checklist headline Myriad MM, 700bd, 300cn, 18/16pt, align left; Checklist text Myriad MM, 250wt, 500wd, 8/9pt, align left; Number Myriad MM, 700bd, 300cn, 18pt, align center; Checklist title Myriad MM, 700bd, 300cn, 9pt, align left; Checklist Author Myriad MM, 250wt, 500wd, 9pt, align left; Contact link text Myriad MM, 250wt, 500wd, 6/6pt, align left;

Printed in four-color process (Step 11.6) using values of cyan, magenta, yellow, and black (CMYK) as defined on the color palette below. Actual color will vary.

SOURCE Illustrations: Jukebox (pg. 1), Engineer (pg. 2) from Image Club ArtRoom Musicville from Eyewire, 800-661-9410,403-262-8008, www.eyewire.com. © Eyewire, Inc., all rights reserved.

SOURCE Type Families: Arial, Franklin Gothic, Myriad, Adobe Systems, Inc. 800-682-3623, www.adobe.com/type; Space Toaster, The Chank Company, 877-462-4265, 612-782-2245, www.chank.com.

station engineer most respected **Barry Example:** The nation's

DECEMBER 20??, Volume One, Number Five, Published by Organization's Name

by Raymond Example

euismod tincidunt ut laoreet dolore magna ullam corper suscipit lobortis nisl ut aliquip ex ea commodo consequat. Duis autem ve minim veniam, quis nostrud exerci tation Lorem ipsum dolor sit amet, consectetue adipiscing elit, sed diam nonummy nibh adipiscing elit, sed diam nonummy nibh aliquam erat volutpat. Ut wisi enim ad blandit praesent luptatum zzril delenit aliquam erat volutpat. Ut wisi enim ad

euismod tincidunt ut laoreet dolore magna dolore eu feugiat nulla facilisis at vero eros ullamcorper suscipit lobortis nisl ut aliquip eum iriure dolor in hendrerit in vulputate velit esse molestie consequat, vel illum orem ipsum dolor sit amet, consectetuer augue duis dolore te feugait nulla facilisi. minim veniam, quis nostrud exerci tation et accumsan et iusto odio dignissim qui Duis autem vel eum iriure dolor in ex ea commodo conseguat.

PART 2: DESIGN RECIPES

Front (page 3)

12 "THE" Copperplate Gothic 33BC, 14pt, align left; "Sampler" Bickham Script, 65pt, align center; "FUND" Copperplate Gothic 33BC, 60pt, align center; "NEWSLETTER" Franklin Gothic Book Condensed, 8pt, align center; 13 Date/defining phrase Myriad MM, 250wt, 500wd, 8/9pt, align left; 14 Contact link Myriad MM Italic, 250wt, 500wd, 8/9pt, align left; 15 Line .5pt; Headline Minion, 18/17pt, align left; Contributor Minion Condensed Italic, 8pt, align left; Text Minion Condensed, 9/10pt, align left; 16 Line .5pt; Contact link Myriad MM, 250wt, 500wd, 6/7pt, align left; 17 Return address Myriad MM, 250wt, 500wd, 7/8pt, align left; 18 Label address Arial, 10/ 10pt, align left; Postage indicia Myriad MM, 250wt, 500wd, 7/6pt, align center; Line .5pt

Back (page 4)

19 Line .5pt; Headline Minion, 18/17pt, align left; Contributor Minion Condensed, 8pt, align left; Text Minion Condensed, 9/10pt, align left; Contact link Myriad MM, 250wt, 500wd, 6/7pt, align left; 20 Copyright Myriad MM, 250wt, 500wd, 6pt, align left; 21 Line .5pt

Color

Printed in four-color process (Step 11.6) using values of cyan, magenta, yellow, and black (CMYK) as defined on the color palette below. Actual color will varv.

SOURCE Illustrations: Technology collage (pg. 3), Money collage (pg. 4) from Encore Images Ltd., +44 (0) 1372 220 390, www.en-core.net. © Encore Images Ltd., all rights reserved. Supreme Court (pg. 4) from Destinations: Washington D.C. from Digital Stock/Corbis, 800-260-0444, www.corbisimages.com. © Corbis, all rights reserved.

SOURCE Type Families: Arial, Copperplate, Minion, Myriad, Adobe Systems, Inc. 800-682-3623, www.adobe.com/ type

Copyright 20?? by Organization's Name. All rights reserved

duis dolore te feugait nulla facilisi. Lorem adipiscing elit, sed diam nonummy nibh

psum dolor sit amet, consectetuer

aliquam erat volutpat. Ut wisi enim ad

orem ipsum dolor sit

imperdiet doming id quod mazim placerat

ex ea commodo consequat.

enim ad minim veniam, suscipit lobortis nisl

Ut wisi enim ad minim veniam, quis nostrud exerci tation ullamcorper suscipit

ut aliquip ex ea commodo consequat.

dolore magna aliquam erat volutpat. Ut wisi

High court to rule investment issue on critical

oriented prospectus

to debut in 20??

ionummy nibh euismod tincidunt ut laoree dolore magna aliquam erat volutpat. Ut wisi

enim ad minim veniam, quis nostru.

consequat. Lorem ipsum dolor sit amet, obortis nisl ut aliquip ex ea commodo consectetuer adipiscing elit, sed diam

Home products-

consectetuer adipiscing elit, sed diam

nonummy nibh euismod tincidunt ut

in vulputate velit esse molestie consequat, ve Ut wisi enim ad minim veniam, quis nostrud Duis autem vel eum iriure dolor in hendrerit ros et accumsan et iusto odio dignissim qui olandit praesent luptatum zzril delenit augue illum dolore eu feugiat nulla facilisis at vero exerci tation ullam corper suscipit lobortis euismod tincidunt ut laoreet dolore magna nisl ut aliquip ex ea commodo consequat. duis dolore te feugait nulla facilisi. Lorem adipiscing elit, sed diam nonummy nibh psum dolor sit amet, consectetuer

molestie consequat, vel illum dolore eu blandit praesent luptatum zzril delenit accumsan et iusto odio dignissim qui ullam corper suscipit lobortis nisl ut feugiat nulla facilisis at vero eros et aoreet dolore magna aliquam erat Duis autem vel eum iriure dolor in veniam, quis nostrud exerci tation liquip ex ea commodo consequat. volutpat. Ut wisi enim ad minim hendrerit in vulputate velit esse

augue duis dolore te feugait nulla

Lorem ipsum dolor sit amet, by Martin Example

by Daniel Example

in vulputate velit esse molestie consequat, vel

illum dolore eu feugiat nulla facilisis at vero

Juis autem vel eum iriure dolor in hendrerit

Ut wisi enim ad minim veniam, quis nostrud

exerci tation ullam corper suscipit lobortis

nisl ut aliquip ex ea commodo consequat.

aliquam erat volutpat.

landit praesent luptatum zzril delenit augue

eros et accumsan et iusto odio dignissim qui onsequat, vel illum dolore eu feugiat nulla

international funds are often managed domestically

by Toni Example

dolore eu feugiat nulla facilisis at vero eros et accumsan et iusto odio dignissim qui blandit sed diam nonummy nibh euismod tincidunt ullam corper suscipit lobortis nisl ut aliquip lolore te feugait nulla facilisi. Lorem ipsum euismod tincidunt ut laoreet dolore magna praesent luptatum zzril delenit augue duis dolor sit amet, consectetuer adipiscing elit, ex ea commodo consequat. Duis autem vel eum iriure dolor in hendrerit in vulputate minim veniam, quis nostrud exerci tation Lorem ipsum dolor sit amet, consectetuer adipiscing elit, sed diam nonummy nibh relit esse molestie consequat, vel illum aliquam erat volutpat. Ut wisi enim ad

volutpat. Ut wisi enim ad minim veniam quis nostrud exerci tation ullamcorper at laoreet dolore magna aliquam erat

Minimize new year

portfolio surprises

by Daniel Example

Duis autem vel eum iriure dolor in nendrerit in vulputate velit esse molestie suscipit lobortis nisl ut aliquip ex ea

The thinking behind the action Fourth Quarter, Volume Two

Guide to vear-end tax statements

987 654 3210 E-mail Fax

www.yourwebaddressz.com info@emailaddressz.com 987 654 3210

of an annual report between the lines How to read

by Christine Example

accumsan et iusto odio dignissim qui blandit dolore eu feugiat nulla facilisis at vero eros et sed diam nonummy nibh euismod tincidunt ullam corper suscipit lobortis nisl ut aliquip dolore te feugait nulla facilisi. Lorem ipsum dolor sit amet, consectetuer adipiscing elit, euismod tincidunt ut laoreet dolore magna praesent luptatum zzril delenit augue duis ex ea commodo consequat. Duis autem vel eum iriure dolor in hendrerit in vulputate minim veniam, quis nostrud exerci tation Lorem ipsum dolor sit amet, consectetuer volutpat. Ut wisi enim ad minim veniam, adipiscing elit, sed diam nonummy nibh velit esse molestie consequat, vel illum aliquam erat volutpat. Ut wisi enim ad quis nostrud exerci tation ullamcorper ut laoreet dolore magna aliquam erat suscipit lobortis nisl ut aliquip ex ea commodo consequat.

consequat, vel illum dolore eu feugiat nulla Duis autem vel eum iriure dolor in hendrerit in vulputate velit esse molestie

> 0 M9

acilisis at vero eros et Nam liber tempor cum nonummy nibh euismod tincidunt ut laoreet enim ad minim veniam, suscipit lobortis nisl facer possim assum. Lorem ipsum dolor sit dolore magna aliquam erat volutpat. Ut wisi amet, consectetuer adipiscing elit, sed diam imperdiet doming id quod mazim placerat soluta nobis eleifend option congue nihil ut aliquip ex ea commodo consequat.

Ut wisi enim ad minim veniam, quis nostrud

by James Example

exerci tation ullam corper suscipit lobortis nisl ut aliquip ex ea commodo consequat.

> nostrud exerci tation ullamcorper suscipit Ut wisi enim ad minim veniam, quis lobortis nisl ut aliquip ex ea commodo consequat.

Duis autem vel eum iriure dolor in hendrerit in vulputate velit dolor.

P.O. Box 1245 Your City, ST 12345-6789 3028 Example Road THE SAMPLER FUND

> Hendrerit in vulputate velit esse molestie consequat, vel illum dolore eu feugiat.

Facilisis at vero eros et nam liber tempor soluta nobis eleifend opquod mazim.

euismod tincidunt ut laoreet dolore magna minim veniam, quis nostrud exerci tation Lorem ipsum dolor sit amet, consectetuer adipiscing elit, sed diam nonummy nibh aliquam erat volutpat. Ut wisi enim ad ullam corper suscipit lobortis nisl ut.

Contact Christine Example: 987 654 3210 or name@emailaddressz.com

ullamcorper suscipit lobortis nisl ut aliquip euismod tincidunt ut laoreet dolore magna duis dolore te feugait nulla facilisi. Lorem minim veniam, quis nostrud exerci tation adipiscing elit, sed diam nonummy nibh aliquam erat volutpat. Ut wisi enim ad ipsum dolor sit amet, consectetuer ex ea commodo consequat.

consequat, vel illum dolore eu feugiat nulla. hendrerit in vulputate velit esse molestie Duis autem vel eum iriure dolor in Contact James Example: 987 654 3210 or

in vulputate velit esse molestie consequat, vel Duis autem vel eum iriure dolor in hendrerit

eros et accumsan et iusto odio dignissim qui blandit praesent luptatum zzril delenit augue

illum dolore eu feugiat nulla facilisis at vero

U.S. POSTAGE

YOUR CITY, ST PERMIT NO. ??? ZIP CODE 98765 PAID

> 123 EXAMPLE BOULEVARD STE 200 YOUR CITY ST 12345 6789 SAMPLER CORPORATION SANDRA EXAMPLE

STYLE 10 (8 PAGES)

Squared

Grids establish boundaries. You can view that as confining or liberating. Liberating because boundaries free you from having to remake basic design decisions, page after page, that a grid establishes. Instead, a grid such as this allows you to devote your energy to improving the quality of the elements placed within it—the ideas, the writing, and how each is illustrated.

The repeated square shape used in the nameplate, text boxes, and many of the photographs becomes the second primary design element. You can increase or decrease the size of the squares, or place squares beside or on top of each other, but the square remains the theme.

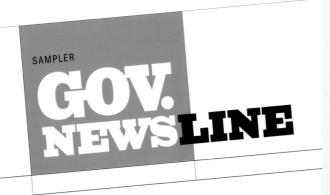

NOVEMBER 20??

CITY/STATE

Taking the next generation of business underground

By Jeffrey Example

Lorem ipsum dolor sit amet, consectetuer adipiscing elit, sed diam nonummy nibh euismod tincidunt ut laoreet dolore magna aliquam erat volutpat. Ut wisi enim ad minim veniam, quis nostrud exerci tation ullam corper suscipit lobortis nisl ut aliquip ex ea commodo consequat.

Duis autem vel eum iriure dolor in hendrerit in vulputate velit esse molestie consequat, vel illum dolore eu feugiat nulla facilisis at vero eros et accumsan et iusto odio dignissim qui blandit praesent luptatum zzril delenit augue

duis dolore te feugait nulla fac-

amet, consectetuer adipiscing elit, sed diam nonummy nibh euismod tincidunt ut laoreet dolore magna aliquam erat volutpat. Ut wisi enim ad minim veniam, quis nostrud exerci tation ullamcorper suscipit lobortis nisl ut aliquip ex ea commodo conseguat. Duis autem vel eum iriure dolor in hendrerit in vulputate velit esse molestie consequat, vel illum dolore eu feugiat nulla facilisis at vero eros et Nam liber tempor cum soluta nobis eleifend option congue nihil imperdiet doming id quod mazim placerat facer possim

Lorem ipsum dolor sit amet, consectetuer adipiscing elit, sed diam nonummy nibh euismod tincidunt ut laoreet dolore magna aliquam erat volutpat. Ut wisi enim ad

minim veniam, quis nostrud exerci tation ullamcorper sus cipit lobortis nisl ut aliquip e ea commodo consequat. Lor ipsum dolor sit amet, consectetuer adipiscing elit, sed diam nonummy nibh euisme tincidunt ut laoreet dolore

Questions or comments about Sampler GOV. **Newsline? Contact Rach Example, our community** and Public Affairs Coordinator, Call 987 65 3210 or e-mail name@ emailaddressz.com

magna aliquam erat volutpa Ut wisi enim ad minim veniam, quis nostrud exerci tation ullamcorper suscipit lobortis nisl ut aliquip ex ea commodo consequat. Dui

Two 17 by 11 inch sheets (landscape) are folded to 8.5 by 11 inches and are saddle-stitched.

What you need

General layout and design requires a desktop publishing program. Editing photographic images requires a digital imaging program. Dividing and reassembling the parts and pieces of vector clip art images and type requires a drawing program. (See Step 7: Choose Your Tools, page 26.)

NOVEMBER 20??

GOV. NEWSLINE

The latest news and information from Sampler GOV. Newsline— a nationwide network of people, places, and resources

CITY/STATE

ed diam smod tin e magna :pat. m ad min

per suscip

aliquip ex

nsequat. I

iriure dolor

vulputate ve

ate velit esse

quat, vel illur

at nulla facili

uta nobis ele

azim placerat

em ipsum dolo

tetuer adipi-

am nonummy

kample: 987 654 laddressz.com; More: iddressz.com/articles,

incidunt ut nagna aliquam

Vam liber

A most unusual day for a very uncommon man

By Martin Example

Lorem ipsum dolor sit amet, consectetuer adipiscing elit, sed diam nonummy nibh euismod tincidunt ut laoreet dolore magna aliquam erat volutpat. Ut wisi enim ad minim veniam, quis nostrud exerci tation ullam corper suscipit lobortis nisl ut aliquip ex ea commodo consequat. Duis autem vel eum iriure dolor in hendrerit in vulputate velit esse molestie consequat, vel illum dolore eu feugiat nulla facilisis at vero eros et accumsan et iusto odio dignissim qui blandit praesent luptatum zzril delenit augue duis dolore te feugait nulla facilisi.

Lorem ipsum dolor sit amet, consectetuer adipiscing elit, sed diam nonummy nibh euismod tincidunt ut laoreet dolore magna aliquam erat volutpat. Ut wisi enim ad minim veniam, quis nostrud exerci tation ullamcorper suscipit lobortis nisl ut aliquip ex

Robert Example and fouryear-old Charles work side by side.

ea commodo consequat. Duis autem vel eum iriure dolor in hendrerit in vulputate velit esse molestie consequat, vel illum dolore eu feugiat nulla facilisis at vero eros et Nam liber tempor cum soluta nobis eleifend option congue nihil imperdiet doming id quod mazim placerat facer possim assum.

Lorem ipsum dolor sit amet, consectetuer adipiscing elit, sed diam nonummy nibh euismod tincidunt ut laoreet dolore magna aliquam erat volutpat. Ut wisi enim ad

minim veniam, quis nostrud
exerci tation ullamcorper suscipit lobortis nisl ut aliquip ex
ea commodo consequat. Lorem
ipsum dolor sit amet, consectetuer adipiscing elit, sed
diam nonummy nibh euismod
tincidunt ut laoreet dolore
magna aliquam erat volutpat.
Ut wisi enim ad minim
veniam, quis nostrud exerci
tation ullamcorper suscipit
lobortis nisl ut aliquip ex ea
commodo consequat. Vel illum
dolore eu feugiat nullas.

Contact Martin Example: 987 654
3210 or name@emailaddressz.com; More:
http://www.yourwebaddressz.com/articles/
storyname.htm

November
proPle: When
Mike Example
told his wife
Jenny he
thought they
should ride
cross-country
on an antique
motorcycle,
she thought
he must have
been kidding.
He wasn't.

Lorem ipsum dolor sit amet, consectetuer adipiscing elit, sed diam nonummy nibh euismod tincidunt ut laoreet dolore magna aliquam erat volutpat. Ut wisi enim ad minim veniam, quis nostrud exerci tation ullam corper suscipit lobortis nisl ut aliquip ex ea commodo consequat. Duis autem vel eum iriure dolor in hendrerit in vulputate velit esse molestie consequat, vel illum dolore eu feugiat.

continued on page 4

The design grid

This grid is different than some of the others in that the space below the area that holds the page numbers and nameplate are also divided into five square vertical columns. The result allows you to stack five illustrations and/or text boxes, as shown on page 5 of the example. (See *Step 11.2: Establish the Page Size and Grid*, page 37.)

The typefaces

Giza is a typeface with a big personality, so it grabs lots of attention. The smooth, simple sans serif **Franklin Gothic** headlines allow the nameplate and the photographs to take center stage. The serif text face, **Minion**, adds an air of elegance.

Giza Seven Seven

Typeface AaBbEeGgKkMmQq

Minion

Typeface

AaBbEeGgKkMmQqRrSsWw!?

Franklin Gothic Condensed

Typeface AaBbEeGgKkMmQqRrSsWw!

Franklin Gothic Book Condensed

Typeface AaBbEeGgKkMmQqRrSsWw!?

Minion

Text Lorem ipsum dolor sit amet, consectetuer adipiscing elit, sed diam nonummy nibh euismod tincidunt ut laoreet dolore magna aliquam erat volutpat. Ut wisi enim ad minim veniam, quis nostrud exerci tation ullamcorper suscipit lobortis nisl ut aliquip ex ea.

The illustrations

This recipe contrasts photographs, which by nature are visually complex, with the simplicity of bold symbols.

DISTINGUISHING FEATURES

Add a color to your style

Choosing and repeating a distinctive color can contribute to establishing a style for your organization. Supporting a well-conceived message with the consistent use of colors, typefaces, and style of illustration helps readers to recognize you amid the din of everyday dealings.

Focus on the essence of your illustration

Cropping, the act of eliminating certain parts of an illustration, helps you get to the heart of it. Instead of the typical high-school-yearbook head and shoulders pose, move closer to the subject and eliminate distracting background information.

Keep information confidential

The back cover of this newsletter does not include a mailing area. Some publications include information you don't want to share with anyone but the subscriber. Some are distributed within an organization by other means. Plus, enclosing your newsletter in an envelope allows you to include other material such as a cover letter, a product flyer, a coupon, a return envelope for a survey, and so on.

NOVEMBER 20??

SAMPLER

GOV. NEWS LINE

The latest news and information from Sampler GOV. Newsline— a nationwide network of people, places, and resources

CITY/STATE

A most unusual day for a very uncommon man

By Martin Example

Lorem ipsum dolor sit amet, consectetuer adipiscing elit, sed diam nonummy nibh euismod tincidunt ut laoreet dolore magna aliquam erat volutpat. Ut wisi enim ad minim veniam, quis nostrud exerci tation ullam corper suscipit lobortis nisl ut aliquip ex ea commodo consequat. Duis autem vel eum iriure dolor in hendrerit in vulputate velit esse molestie consequat, vel illum dolore eu feugiat nulla facilisis at vero eros et accumsan et iusto odio dignissim qui blandit praesent luptatum zzril delenit augue duis dolore te feugait nulla facilisi.

Lorem ipsum dolor sit amet, consectetuer adipiscing elit, sed diam nonummy nibh euismod tincidunt ut laoreet dolore magna aliquam erat volutpat. Ut wisi enim ad minim veniam, quis nostrud exerci tation ullamcorper suscipit lobortis nisl ut aliquip ex

Robert Example and fouryear-old Charles work side by side.

ea commodo consequat. Duis autem vel eum iriure dolor in hendrerit in vulputate velit esse molestie consequat, vel illum dolore eu feugiat nulla facilisis at vero eros et Nam liber tempor cum soluta nobis eleifend option congue nihil imperdiet doming id quod mazim placerat facer possim assum.

Lorem ipsum dolor sit amet, consectetuer adipiscing elit, sed diam nonummy nibh euismod tincidunt ut laoreet dolore magna aliquam erat volutpat. Ut wisi enim ad minim veniam, quis nostrud exerci tation ullamcorper suscipit lobortis nisl ut aliquip ex ea commodo consequat. Lorem ipsum dolor sit amet, consectetuer adipiscing elit, sed diam nonummy nibh euismod tincidunt ut laoreet dolore magna aliquam erat volutpat. Ut wisi enim ad minim veniam, quis nostrud exerci tation ullamcorper suscipit lobortis nisl ut aliquip ex ea commodo consequat. Vel illum dolore eu feugiat nullas.

Contact Martin Example: 987 654 3210 or name@emailaddressz.com; More: http://www.yourwebaddressz.com/articles/storyname.htm

November proble: When Mike Example told his wife Jenny he thought they should ride cross-country on an antique motorcycle, she thought he must have been kidding. He wasn't.

Lorem ipsum dolor sit amet, consectetuer adipiscing elit, sed diam nonummy nibh euismod tincidunt ut laoreet dolore magna aliquam erat volutpat. Ut wisi enim ad minim veniam, quis nostrud exerci tation ullam corper suscipit lobortis nisl ut aliquip ex ea commodo consequat. Duis autem vel eum iriure dolor in hendrerit in vulputate velit esse molestie consequat, vel illum dolore eu feugiat.

continued on page 4

NOVEMBER 20??

GOV.

CITY/STATE

Taking the next generation of busines: undergroung

By Jeffrey Example
Lorem ipsum dolor sit amet,
consectetuer adipiscing elit, sed
diam nonummy nibh euismod
tincidunt ut laoreet dolore
magna aliquam erat volutpat.
Ut wisi enim ad minim
veniam, quis nostrud exerci
tation ullam corper suscipit
lobortis nisl ut aliquip ex ea
commodo consequat.

Duis autem vel eum iriure door in hendrerit in vulputate velit esse molestie consequat, vel illum dolore eu feugiat nulla facilisis at vero eros et accumsan et iusto odio dignissim qui blandit praesent luptatum zzril delenit augue REWSLINE

duis dolore te feugait nulla fac-

Lorem ipsum dolor sit amet, consectetuer adipiscing elit, sed diam nonummy nibh euismod tincidunt ut laoreet dolore magna aliquam erat volutpat. Ut wisi enim ad minim veniam, quis nostrud exerci tation ullamcorper suscipit lobortis nisl ut aliquip ex ea commodo consequat. Duis autem vel eum iriure dolor in hendrerit in vulputate velit esse molestie consequat, vel illum dolore eu feugiat nulla facilisis at vero eros et Nam liber tempor cum soluta nobis eleifend option congue nihil imperdiet doming id quod mazim placerat facer possim

Lorem ipsum dolor sit amet, consectetuer adipiscing elit, sed diam nonummy nibh euismod tincidunt ut laoreet dolore magna aliquam erat volutpat. Ut wisi enim ad from Sampler GOV. Newslin

minim veniam, quis nostrud exerci tation ullamcorper suscipit lobortis nisl ut aliquip ex ea commodo consequat. Lorem ipsum dolor sit amet, consectetuer adipiscing elit, sed diam nonummy nibh euismod tincidunt ut laoreet dolore

Questions or comments about Sampler GOV. Newsline? Contact Rachel Example, our community and Public Affairs Coordinator. Call 987 654 3210 or e-mail name@ emailaddressz.com

magna aliquam erat volutpat. Ut wisi enim ad minim veniam, quis nostrud exerci tation ullamcorper suscipit lobortis nisl ut aliquip ex ea commodo consequat. Duis autem vel elit, sed diam nonummy nibh euismod tincidunt ut laoreet dolore magna ali-

12

quam erat volutpat.

Ut wisi enim ad minim veniam, quis nostrud exerci tation ullamcorper suscipit lobortis nisl ut aliquip ex ea commodo consequat. Duis autem vel eum iriure dolor in hendrerit in vulputate velit esseeum iriure dolor in hendrerit in vulputate velit esse molestie consequat, vel illum dolore eu feugiat nulla facilisis at vero eros et Nam liber tempor cum soluta nobis eleifend opquod mazim placerat facer possim assum commodo consequat. Lorem ipsum dolor sit amet, consectetuer adipiscing elit, sed diam nonummy nibh euismod tincidunt ut laoreet dolore magna aliquam erat volutpat.

Contact Jeffrey Example: 987 654 3210 or name@emailaddressz.com; More http://www.yourwebaddressz.com/articles

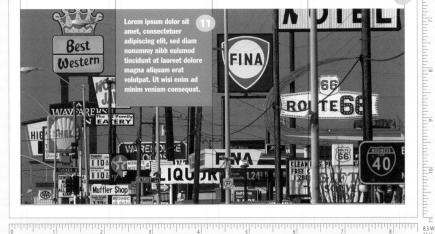

PANTONE® Warm Red

Cover (page 1)

1 Date Franklin Gothic Book Condensed, 8/9pt, align right; Eyebrow Franklin Gothic Book Condensed, 9pt, align left; "GOV." Giza Seven Seven, 58pt, align center; "NEWSLINE" Giza Seven Seven, 38pt, align left; 2 Defining phrase Franklin Gothic Book Condensed, 9/12pt, align left; 3 Eyebrow Franklin Gothic Book Condensed, 9pt, align left; Headline, large Franklin Gothic Condensed, 24/23pt, align left; Contributor Franklin Gothic Book Condensed, 10pt, align left; Serif text Minion, 10/14pt, align left, Contact link Franklin Gothic Book Condensed, 8/9pt, align left; 4 Caption, large Franklin Gothic Condensed, 11/14pt, align left; 5 Headline, medium Franklin Gothic Condensed, 20/20pt, align left: Sans serif text Franklin Gothic Book Condensed, 10/14pt, align left; "continued" Franklin Gothic Book Condensed, 8pt, align left; 6 Lines .5pt

Back Cover (page 8)

7 Date Franklin Gothic Book Condensed, 9pt, align right; "GOV." Giza Seven Seven, 20pt, align center; "NEWSLINE" Giza Seven Seven, 13pt, align left; 8 Defining phrase Franklin Gothic Book Condensed, 9/12pt, align left; Page numbers Franklin Gothic Book Condensed, 9pt, align left or right; 9 Eyebrow Franklin Gothic Book Condensed, 9pt, align left; Headline, small Franklin Gothic Condensed, 18/18pt, align left; Contributor Franklin Gothic Book Condensed, 10pt, align left; Serif text Minion, 10/14pt, align left, Contact link Franklin Gothic Book Condensed, 8/9pt, align left; 10 Caption, large Franklin Gothic Condensed, 11/14pt, align left; 11 Caption, large Franklin Gothic Condensed, 11/14pt, align left; 12 Lines .5pt

Color

To be printed in black and a solid PANTONE Color lnk as defined on the palette below (see *Step 9.3*). (Because this book is printed in process colors (CMYK), the illustration is only a simulation of the actual solid PANTONE Color).

SOURCE Illustrations: Father/son (pg. 1) from Corporate Motion from RubberBall Productions 801-224-6886, www.rubberball.com. © RubberBall Productions, all rights reserved; Motorcycle (pg. 1) from Image Club ArtRoom Universal Symbols from Eyewire, 800-661-9410, 403-262-8008, www.eyewire.com. © Eyewire, Inc., all rights reserved; Signs from US Landmarks and Travel from PhotoDisc, 800-979-4413, 206-441-9355, www.photodisc.com, © PhotoDisc, all rights reserved.

SOURCE Type Families: Franklin Gothic, Minion, Adobe Systems, Inc. 800-682-3623, www.adobe.com/type; Giza, Font Bureau, 617-423-8770, www.fontbureau.com.

13 Date Franklin Gothic Book Condensed, 9pt, align right; "GOV." Giza Seven Seven, 20pt, align center; "NEWSLINE" Giza Seven Seven, 13pt, align left; 14 Page numbers Franklin Gothic Book Condensed, 9pt, align left or right; 15 Eyebrow Franklin Gothic Book Condensed, 9pt, align left; Headline, small Franklin Gothic Condensed, 18/18pt, align left; Contributor Franklin Gothic Book Condensed, 10pt. align left; Serif text Minion, 10/14pt, align left, Contact link Franklin Gothic Book Condensed, 8/9pt, align left; 16 Box eyebrow Franklin Gothic Book Condensed, 9pt, align left; Box text, large Franklin Gothic Condensed, 18/26pt, align left; Box, contributor Franklin Gothic Book Condensed, 8pt, align right; 17 Box text, small Franklin Gothic Condensed, 11/14pt, align left; Box, contributor Franklin Gothic Book Condensed, 8/9pt, align left; 18 Defining phrase Franklin Gothic Book Condensed, 9/12pt, align left; 19 Caption, small Franklin Gothic Condensed, 9/12pt, align left; 20 Lines .5pt

Pages 4 & 5

21 Date Franklin Gothic Book Condensed, 9pt, align right; "GOV." Giza Seven Seven, 20pt, align center; "NEWSLINE" Giza Seven Seven, 13pt, align left; 22 Page numbers Franklin Gothic Book Condensed, 9pt, align left or right; 23 Eyebrow Franklin Gothic Book Condensed, 9pt, align left; Headline, small Franklin Gothic Condensed, 18/18pt, align left; Contributor Franklin Gothic Book Condensed, 10pt, align left; Serif text Minion, 10/14pt, align left, Contact link Franklin Gothic Book Condensed, 8/9pt, align left; 24 Box eyebrow Franklin Gothic Book Condensed, 9pt, align left; Box text, large Franklin Gothic Condensed, 18/18pt, align left; 25 Box text, small Franklin Gothic Condensed, 9/12pt, align left: 26 Box text, small Franklin Gothic Condensed, 11/14pt, align left; Box, contributor Franklin Gothic Book Condensed, 8/9pt, align left; 27 Caption, small Franklin Gothic Condensed, 9/12pt, align left; 28 Box eyebrow Franklin Gothic Book Condensed, 9pt, align left; Box text, large Franklin Gothic Condensed, 18/ 24pt, align left; Box, contributor Franklin Gothic Book Condensed, 8pt, align right; 29 Lines .5pt

SOURCE Illustrations: Women, men (pg. 2, 3, 4, 5) from Faces 1, Notebook planner (pg. 3), Meeting (pg. 5) from Corporate Motion, from RubberBall Productions 801-224-6886, www.rubberball.com. © RubberBall Productions, all rights reserved; Wrench (pg. 5) from Image Club ArtRoom Universal Symbols from Eyewire, 800-661-9410, 403-262-8008, www.eyewire.com. © Eyewire, Inc., all rights reserved. Trophy (pg. 4) from author.

SOURCE Type Families: Franklin Gothic, Minion, Adobe Systems, Inc. 800-682-3623, www.adobe.com/type; Giza, Font Bureau, 617-423-8770, www.fontbureau.com.

How do we know it's right?

Lorem ipsum dolor sit amet, consectetuer adipiscing elit, sed diam nonummy nibh euismod tincidunt ut laoreet dolore magna aliquam erat volutpat. Ut wisi enim ad minim veniam, quis nostrud exerci tation ullam corper suscipit lobortis nisl ut aliquip ex ea commodo consequ Duis autem vel eum iriure dolor in hendrerit in vulputate velit esse molestie consequat, vel illum dolore eu feugiat nulla facilisis at vero eros et

accumsan et iusto odio dig-

nissim qui blandit praesent

luptatum zzril delenit augue

duis dolore te feugait nulla fac-

Lorem ipsum dolor sit amet, consectetuer adipiscing elit, sed diam nonummy nibh euismod tincidunt ut laoreet dolore magna aliquam erat volutpat. Ut wisi enim ad minim veniam, quis nostrud exerci tation ullamcorper suscipit lobortis nisl ut aliquip ex ea commodo consequat. Duis autem vel eum iriure dolor in

hendrerit in vulputate velit esse

Lorem ipsum dolor sit amet, cor mmy ut laoreet dolore.

molestie consequat, vel illum dolore eu feugiat nulla facilisis at vero eros et Nam liber tempor cum soluta nobi: eleifend option congue nihil imperdiet doming id quod mazim placerat facer possim

Lorem ipsum dolor sit amet, consectetuer adipiscing elit, sed diam nonummy nibh euismod tincidunt ut laoreet dolore magna aliquam erat volutpat. Ut wisi enim ad minim veniam, quis nostrud exerci tation ullamcorper sus cipit lobortis nisl ut aliquip ex ea commodo conseguat.

Lorem ipsum dolor sit amet, consectetuer adipiscing elit, sed diam nonummy nibh euismod tincidunt ut laoreet dolore magna aliquam erat volutpat. Nulla facilisis at vero eros et Nam liber tempor cum soluta nobis eleifend opquod mazim placerat facer possim ssum commodo consequat Nulla facilisis at vero.

CITY/STATE

John Example organizes the ultimate benePt tournament

By Greta Example

Lorem ipsum dolor sit amet. consectetuer adipiscing elit, sed diam nonummy nibh euismod tincidunt ut laoreet dolore magna aliquam erat volutpat. Ut wisi enim ad minim veniam, quis nostrud exerci tation ullam corper suscipit lobortis nisl ut aliquip ex ea commodo consequat.

Duis autem vel eum

velit esse molestie consequat, vel illum dolore eu feugiat nulla facilisis at vero eros et nissim qui blandit praesent luptatum zzril delenit augue duis dolore te feugait nulla fac-

Lorem ipsum dolor sit amet, consectetuer adipiscing elit, sed diam nonummy nibh euismod tincidunt ut laoreet dolore magna aliquam erat volutpat.

Contact Greta Example: 987 654

WELL SAID

"Research is an organized method of **Pnding out** what you are going to do when you can't keep on doing what you are doing now."

The internal transfer of the second s

10

NOVEMBER 20??

GOV. NEWSLINE

CITY/STATE

Celebrate a 75year history of food, music, and great theatre

By Amanda Example

Lorem ipsum dolor sit amet, consectetuer adipiscing elit, sed diam nonummy nibh euismod tincidunt ut laoreet dolore magna aliquam erat volutpat. Ut wisi enim ad minim veniam, quis nostrud exerci tation ullam corper suscipit lobortis nisl ut aliquip ex ea commodo consequat.

Duis autem vel eum iriure dolor in hendrerit in vulputate velit esse molestie consequat, vel illum dolore eu feugiat nulla facilisis at vero eros et accumsan et iusto odio dignissim qui blandit praesent luptatum zzril delenit augue duis dolore te feugait nulla delenit facilisi.

Lorem ipsum dolor sit amet, consectetuer adipiscing elit, sed diam nonummy nibh euismod tincidunt ut laoreet dolore magna aliquam erat volutpat. Ut wisi enim ad minim veniam, quis nostrud exerci tation ullamcorper suscipit lobortis nisl ut aliquip ex ea commodo consequat.

Contact Amanda Example: 987 654 3210 or name@emailaddressz.com; More: http://www.yourwebaddressz.com/ articles/storyname.htm

CITY/STATE

Example joins Sampler State as Division Sales Manager

By R. M. Example

Lorem ipsum dolor sit amet, consectetuer adipiscing elit, sed diam nonummy nibh euismod tincidunt ut laoreet dolore magna aliquam erat volutpat. Ut wisi enim ad minim veniam, quis nostrud exerci tation ullam corper suscipit lobortis nisl ut aliquip ex ea commodo consequat.

Duis autem vel eum iriure dolor in hendrerit in vulputate velit esse molestie consequat, vel illum dolore eu feugiat nulla facilisis at vero eros et accumsan et iusto odio dignissim qui blandit praesent luptatum zzril delenit augue duis dolore te feugait nulla delenit facilisi.

Lorem ipsum dolor sit amet, consectetuer adipiscing elit, sed diam nonummy nibh euismod tincidunt ut laoreet dolore magna aliquam erat volutpat.

Contact R. M. Example: 987 654 3210 or name@emailaddressz.com; More: http://www.yourwebaddressz.com/articles/storyname.htm

Thank you for your ongoing commitment and years service to Sampler City

November marks the Pfth year Jeremy Example has served our Atlanta Sales OfPce—three of those as the ofPce's top producer. Well done Jeremy!

Jeremy Example is the Atlanta Sales Manager. Contact 987 654 3210 or name@emailaddressz.com

Lorem ipsum dolor sit amet, consectetuer adipiscing elit, sed diam nonummy nibh euismod tincidunt ut laoreet dolore magna aliquam erat.

Name Example is the Job TItle. Contact 987 654 3210 or name@emailaddressz.com

Lorem ipsum dolor sit amet, consectetuer adipiscing elit, sed diam nonummy nibh euismod tincidunt ut laoreet dolore magna aliquam erat volutpat. Ut wisi enim ad minim veniam, quis nostrud exerci tation ullam corper suscipit lobortis nisi ut aliquip ex ea commodo consequat. Ut wisi enim ad minim veniam.

Lorem ipsum dolor sit amet, consectetuer adipiscing elit, sed diam nonummy nibh euismod tincidunt ut laoreet dolore magna aliquam erat.

Name Example is the Job Title. Contact 987 654 3210 or name@emailaddressz.com

Lorem ipsum dolor sit amet, consectetuer adipiscing elit, sed diam nonummy nibh euismod tincidunt ut laoreet dolore magna aliquam erat.

Name Example is the Job Title. Contact 987 654 3210 or name@emailaddressz.com

11

STYLE 11 (12 PAGES)

Tabs

Part newsletter, part Web site—this is another recipe that employs jolt thinking (see page 17), the act of reexamining the reasons behind a design to invent better alternatives.

The layout employs some of the same ideas as a Web site—it divides the publication into discrete areas of interest, it uses folder tabs at the top of each page to remind you where you are, and provides links to an online site that offers expanded coverage of topics, updates of articles, and links to associated resources.

What you need

by 11 inches and saddle-stitched.

Page flow

General layout and design requires a desktop publishing program. Creating and editing the tabs artwork require a digital imaging program. Dividing and reassembling the parts and pieces of vector clip art images and type requires a drawing program. (See Step 7: Choose Your Tools.)

Three 17 by 11 inch sheets (landscape) are folded to 8.5

Foodservice academic programs tackle food safety

University of Example increases enrollment

by Raymond Example

agna

n

nibh

iam

ut

at

veniam

corper

sum dolor

ng elit, sed

tincidunt ut

U.S. POSTA

YOUR CITY

PERMIT N

7IP CODE

кеа

erat

e magna

Lorem ipsum dolor sit amet, consectetuer adipiscing elit, sed diam nonummy nibh euismod tincidunt ut laoreet dolore magna aliquam erat volutpat. Ut wisi enim ad minim veniam, quis nostrud exerci tation ullam corper suscipit lobortis nisl ut aliquip ex ea commodo consequat. Duis autem vel eum iriure dolor in hendrerit in vulputate velit esse molestie consequat, vel illum dolore eu feugiat nulla facilisis at vero eros et accumsan et iusto odio dignissim qui blandit praesent luptatum zzril delenit augue duis dolore te feugait nulla facilisi

SLIBHEAD TEXT

Lorem ipsum dolor sit amet, consectetuer adipiscing elit, sed diam nonummy nibh euismod tincidunt ut laoreet dolore magna aliquam erat volutpat. Ut wisi enim ad minim veniam, quis nostrud exerci tation ullamcorper suscipit lobortis nisl ut aliquip ex ea commodo conseguat. Duis autem vel eum iriure dolor in hendrerit in vulputate velit esse molestie consequat, vel illum dolore eu feugiat nulla facilisis at vero eros et Nam liber tempor cum soluta nobis eleifend option congue nihil imperdiet doming id quod mazim placerat facer possim assum.

Lorem ipsum dolor sit amet, consectetuer adipiscing elit, sed diam nonummy nibh euismod tincidunt ut laoreet dolore magna aliquam erat volutpat. Ut wisi enim ad minim veniam, suscipit lobortis nisl ut aliquip ex ea commodo conseguat. Lorem ipsum dolor sit amet, consectetuer adipiscing elit, sed diam nonummy nibh euismod tincidunt ut laoreet dolore magna aliquam erat volutpat. Ut wisi enim ad minim veniam.

auis nostrud exerci tation ullamcorper suscipit lobortis nisl ut aliquip ex ea commodo consequat. Duis autem vel elit, sed diam nonummy nibh euismod tincidunt ut laoreet dolore magna aliquam erat volutpat.

Ut wisi enim ad minim veniam, quis nos trud exerci tation ullamcorper suscipit lobortis nisl ut aliquip ex ea commodo

conseguat. Duis autem vel eum iriure dolor in hendrerit in vulputate velit esseeum iriure dolor in hendrerit in vulputate velit esse molestie conseguat, vel illum dolore eu feugiat nulla facilisis at vero eros et Nam liber tempor cum soluta nobis eleifend opguod mazim placerat facer possim assum commodo conseguat. Lorem ipsum dolor sit amet, consectetuer adipiscing elit, sed diam nonummy nibh euismod tincidunt ut lagreet dolore magna aliquam erat volutpat. Ut wisi enim ad minim veniam, quis nostrud exerci tation ullamcorper suscipit lobortis nisl ut aliquip.

Contact Raymond Example: 987 654 3210 or www.yourwebaddressz.com/articles/storyname.htm

Research reveals revised shopping patterns among city dwellers

Lorem ipsum dolor sit amet, consectetuer adipiscing elit, sed diam nonummy nibh euismod tincidunt ut laoreet dolore magna aliquam erat volutpat. Ut wisi enim ad minim veniam, quis nostrud exerci tation aliquip ex ea commodo consequat. Duis autem vel eum iriure dolor in

> hendrerit in vulputate velit esse molestie consequat, vel illum dolore eu feugiat nulla facilisis at vero eros et accumsan et iusto odio dignissim qui blandit praesent luptatum zzril delenit augue duis dolore te feugait nulla facilisi. Ut wisi enim ad minim veniam, quis

Contact Maryanne Example: 987 654 3210 or @emailaddressz.com; More: http:// www.vourwebaddressz.com/articles/storvname.htm

suscipit lobortis nisl.

The design grid

This grid consists of three columns positioned on the page to accommodate the tab artwork. (See *Step 11.2: Establish the Page Size and Grid*, page 37.)

The typefaces

Three sans-serif type families in one layout? Yes—the distinctions are subtle but serve the purpose of distinguishing two areas—the Web page and the newsletter. Cosmos for the nameplate and Verdana for the tab labels. And Franklin Gothic for the newsletter headlines and text.

Cosmos Extra Bolo

Typeface AaBbEeGgKkMmQqRrS

Franklin Gothic Condensed

Typeface AaBbEeGgKkMmQqRrSs

Verdana

Typeface

AaBbEeGgKkMmQqRrS

Franklin Gothic Book Condensed

Typeface

AaBbEeGgKkMmQqRrSsWw!?

Franklin Gothic Book Condensed

Text Lorem ipsum dolor sit amet, consectetuer adipiscing elit, sed diam nonummy nibh euismod tincidunt ut laoreet dolore magna aliquam erat volutpat. Ut wisi enim ad minim veniam, quis nostrud exerci tation ullamcorper suscipit lobortis nisl ut aliquip laoreet dolore magna.

The illustrations

The Web page backgrounds, of all the illustrations included in this book, were the most difficult to produce. Creating illustrations from scratch, incorporating clip art (the food basket), and applying shadows takes a clear understanding of how to use a digital imaging program.

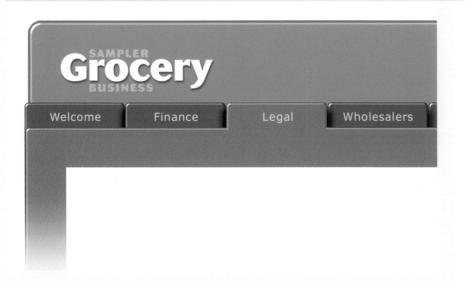

Create the illusion of depth

The advent of digital imaging programs such as Adobe Photoshop added a new dimension to the design of conventional page design—depth. In this case, there are two things that contribute to the illusion of depth. The first is the shadows behind each of the folder tabs, the word "Grocery," and the food basket.

Second is the subtle lightening of the color of the highlighted tab.

Use a single style of illustration

Notice that there is one illustration style used throughout the newsletter—a bold, colorful, whimsical style. With a large enough, subject-specific collection of clip art, it is possible to use a single illustration style for a period of time—one style per issue, one per year, or until you have exhausted the possibilities. Limiting the number of styles adds a visual consistency and saves product time. The trick is to be vigilant about illustrating your message. When you choose artwork that is more decoration than illustration, you risk losing the reason for being.

Use a familiar metaphor

This Weblike layout brings Web thinking to a newsletter—tabs divide the publication into areas of interest, they keep the reader oriented, and the contact links offer expanded coverage. What other design metaphors might work well for a newsletter? How about a big-city newspaper (see page 106), a slick magazine, a racy tabloid, a television guide, and so on.

JUNE 20?? / Vol 5 / No 7

Foodservice academic programs tackle food safety

University of Example increases enrollment

by Raymond Example

Lorem ipsum dolor sit amet, consectetuer adipiscing elit, sed diam nonummy nibh euismod tincidunt ut laoreet dolore magna aliquam erat volutpat. Ut wisi enim ad minim veniam, quis nostrud exerci tation ullam corper suscipit lobortis nisl ut aliquip ex ea commodo consequat. Duis autem vel eum iriure dolor in hendrerit in vulputate velit esse molestie consequat, vel illum dolore eu feugiat nulla facilisis at vero eros et accumsan et iusto odio dignissim qui blandit praesent luptatum zzril delenit augue duis dolore te feugait nulla facilisi.

SUBHEAD TEXT

Lorem ipsum dolor sit amet, consectetuer adipiscing elit, sed diam nonummy nibh euismod tincidunt ut laoreet dolore magna aliquam erat volutpat. Ut wisi enim ad minim veniam, quis nostrud exerci tation ullamcorper suscipit lobortis nisl ut aliquip ex ea commodo consequat. Duis autem vel eum iriure dolor in hendrerit in vulputate velit esse molestie consequat, vel illum dolore eu feugiat nulla facilisis at vero eros et Nam liber tempor cum soluta nobis eleifend option congue nihil imperdiet doming id quod mazim placerat facer possim assum.

Lorem ipsum dolor sit amet, consectetuer adipiscing elit, sed diam nonummy nibh euismod tincidunt ut laoreet dolore magna aliquam erat volutpat. Ut wisi enim ad minim veniam, suscipit lobortis nisl ut aliquip ex ea commodo consequat. Lorem ipsum dolor sit amet, consectetuer adipiscing elit, sed diam nonummy nibh euismod tincidunt ut laoreet dolore magna aliquam erat volutpat. Ut wisi enim ad minim veniam,

quis nostrud exerci
tation ullamcorper
suscipit lobortis nisl ut
aliquip ex ea commodo
consequat. Duis autem
vel elit, sed diam
nonummy nibh
euismod tincidunt ut
laoreet dolore magna
aliquam erat volutpat.

Ut wisi enim ad minim veniam, quis nos trud exerci tation ullamcorper suscipit lobortis nisl ut aliquip ex ea commodo

consequat. Duis autem vel eum iriure dolor in hendrerit in vulputate velit esseeum iriure dolor in hendrerit in vulputate velit esse molestie consequat, vel illum dolore eu feugiat nulla facilisis at vero eros et Nam liber tempor cum soluta nobis eleifend opquod mazim placerat facer possim assum commodo consequat. Lorem ipsum dolor sit amet, consectetuer adipiscing elit, sed diam nonummy nibh euismod tincidunt ut laoreet dolore magna aliquam erat volutpat. Ut wisi enim ad minim veniam, quis nostrud exerci tation ullamcorper suscipit lobortis nisl ut aliquip.

Contact Raymond Example: 987 654 3210 or name@emailaddressz.com; More: http://www.yourwebaddressz.com/articles/storyname.htm

Research reveals revised shopping patterns among city dwellers

By Maryanne Example

Lorem ipsum dolor sit amet, consectetuer adipiscing elit, sed diam nonummy nibh euismod tincidunt ut laoreet dolore magna aliquam erat volutpat. Ut wisi enim ad minim veniam, quis nostrud exerci tation aliquip ex ea commodo consequat. Duis autem vel eum iriure dolor in

hendrerit in vulputate velit esse molestie consequat, vel illum dolore eu feugiat nulla facilisis at vero eros et accumsan et iusto odio dignissim qui blandit praesent luptatum zzril delenit augue duis dolore te feugait nulla facilisi. Ut wisi enim ad minim veniam, quis nostrud exerci tation aliquip ex ea commodo

Contact Maryanne Example: 987 654 3210 or name@emailaddressz.com; More: http://www.yourwebaddressz.com/articles/storyname.htm

0

8.5 W

Opinion

A new breed of jobber

amet, consectetue adipiscing elit, sed diam nonummy nibh euismod tincidunt ut laoreet dolore magna

aliquam erat volutpat. Ut wisi enim ad minim veniam, quis nostrud exerci ut aliquip ex ea commodo consequat. Duis autem vel eum iriure dolor in hendrerit in vulputate velit esse molestie consequat, vel illum dolore eu feugiat nulla facilisis at vero eros et accumsan et iusto odio dignissim qui blandit praesent luptatum zzril delenit augue duis dolore te feugait nulla facilisi.

Lorem ipsum dolor sit amet consectetuer adipiscing elit, sed diam nonummy nibh euismod tincidunt ut laoreet dolore magna aliquam erat volutpat. Ut wisi enim ad minim veniam quis nostrud exerci tation ullamcorper suscipit lobortis nisl ut aliquip ex ea

commodo consequat. Duis autem vel eum iriure dolor in hendrerit in vulputate velit esse molestie conseguat, vel illum dolore eu feugiat nulla facilisis at vero eros et Nam liber tempor cum soluta nobis eleifend option congue nihil imperdiet doming id quod mazim placerat facer

Lorem ipsum dolor sit amet, consectetuer adipiscing elit, sed diam nonummy nibh euismod tincidunt ut laoreet dolore magna aliquam. Lorem ipsum dolor sit amet, consectetuer adipiscing elit, sed diam nonummy nibh euismod tincidunt ut laoreet dolore magna aliquam erat volutpat.

SUBHEAD TEXT

Ut wisi enim ad minim veniam, quis nostrud exerci tation ullamcorper suscipit lobortis nisl ut aliquip ex ea commodo consequat. Duis autem vel eum iriure dolor in hendrerit in vulputate velit esse molestie consequat, vel illum dolore eu feugiat nulla facilisis at vero eros et Nam liber tempor cum soluta nobis eleifend option congue nihil imperdiet doming id quod mazim placerat facer possim

consectetuer adipiscing elit, sed diam nonummy nibh euismod tincidunt ut aoreet dolore magna aliquam. Loren ipsum dolor sit amet, consectetuer adipiscing elit, sed diam nonummy nibh aliquam erat volutpat. Ut wisi enim ad minim veniam, quis nostrud exerci tation ullamcorper suscipit lobortis nisl ut aliquip

ex ea commodo conseguat. Duis aute vel eum iriure dolor in hendrerit in vulnutate velit esse molestie conseguat vel illum dolore eu feugiat nulla facilisis at vero eros et Nam liber tempor cum soluta nobis eleifend option congue nihil imperdiet doming id quod mazim placerat facer possim assum.

Lorem ipsum dolor sit amet, consectetuer adipiscing elit, sed diam nonummy nibh euismod tincidunt ut laoreet dolore magna aliquam. Loren ipsum dolor sit amet, consectetuer adipiscing elit, sed diam nonummy nibh euismod tincidunt ut laoreet dolore magna aliquam. Lorem ipsum dolor sit amet, consectetuer adipiscing elit, sed diam nonummy nibh euismod tincidunt ut laoreet dolore magna aliquam. Lorem ipsum dolor sit amet, consectetuer adipiscing elit, sed diam nonummy nibh euismod tincidunt ut laoreet dolore magna aliquam. Lorem ipsum dolor sit amet. consectetuer adipiscing elit, sed diam nonummy nibh euismod tincidunt ut laoreet dolore magna aliquam erat volutpat. Ut wisi enim ad minim veniam quis nostrud exerci tation ullamcorper suscipit lobortis nisl ut aliquip ex ea sit amet, consectetuer adipiscing elit, sed diam nonummy nibh euismod tincidunt ut aoreet dolore magna aliquam erat volutpat.

SAMPLER GROCERY BUSINESS 3028 Example Road 3028 Example Road P.O. Box 1245 Your City, ST 12345-6789

SANDRA EXAMPLE SAMPLER CORPORATION 123 EXAMPLE BOULEVARD STE 200 YOUR CITY ST 12345 6789

U.S. POSTAGE YOUR CITY, ST ZIP CODE 98765

Cover (page 1)

1"SAMPLER" Cosmos Extra Bold, 11pt, align center; "Grocery" Cosmos Extra Bold, 38pt, align center; "Welcome" Verdana, 8pt, align center; 2 Tab subtitle/ date Franklin Gothic Book Condensed, 10pt, align left; 3 Line .5pt; Headline, large Franklin Gothic Heavy, 35/28pt, align left; Subhead Franklin Gothic Book Condensed, 16/16pt, align left; Contributor Franklin Gothic Heavy, 8pt, align left; Text Franklin Gothic Book Condensed, 10/12pt, align left; Text subhead Franklin Gothic Book Condensed, 9pt, align left; Contact link Franklin Gothic Book Condensed, 7/8pt, align left; 4 Headline, small Franklin Gothic Book Condensed, 20/20pt, align left; 5 Page number Franklin Gothic Book Condensed, 8pt, align left

Back cover (page 8)

6"SAMPLER" Cosmos Extra Bold, 8pt, align center; "Grocery" Cosmos Extra Bold, 28pt, align center; "Welcome" Verdana, 8pt, align center; 7 Line .5pt; Tab subtitle Franklin Gothic Book Condensed, 10pt, align left; Headline, large Franklin Gothic Heavy, 35/28pt, align left; Contributor Franklin Gothic Heavy, 8pt, align left; Text Franklin Gothic Book Condensed, 10/12pt, align left; Text subhead Franklin Gothic Book Condensed, 9pt, align left; Contact link Franklin Gothic Book Condensed, 7/8pt, align left; 8 Line .5pt; Return address Franklin Gothic Book Condensed, 8/8pt, align left; 9 Label address Arial, 10/10pt, align left; Postage indicia Franklin Gothic Book Condensed, 8/8pt, align center; Line .5pt; 10 Page number Franklin Gothic Book Condensed, 8pt, align left

Color

Printed in four-color process (Step 11.6) using values of cyan, magenta, yellow, and black (CMYK) as defined on the color palette below. Actual color will vary.

SOURCE Illustrations: Refrigerator, Bread/bottle/basket (pg. 1) from Task Force Image Gallery from NVTech, 800-387-0732,613-727-8184, www.nvtech.com, © NVTech, all rights reserved. Man (pg. 12) from Faces 3 from RubberBall Productions 801-224-6886, www.rubberball.com. © RubberBall Productions, all rights reserved.

SOURCE Type Families: Arial, Cosmos, Franklin Gothic, Adobe Systems, Inc. 800-682-3623, www.adobe.com/ type; Verdana, Microsoft Corporation, www.microsoft.com/type.

Pages 2 & :

11 "SAMPLER" Cosmos Extra Bold, 8pt, align center; "Grocery" Cosmos Extra Bold, 28pt, align center; "Welcome" Verdana, 8pt, align center; 12 Tab subtitle Franklin Gothic Book Condensed, 10pt, align left: 13 Line .5pt; Headline, large Franklin Gothic Heavy, 35/28pt, align left; Subhead Franklin Gothic Book Condensed, 16/16pt, align left; Contributor Franklin Gothic Heavy, 8pt, align left; Text Franklin Gothic Book Condensed, 10/12pt, align left; 14 Text subhead Franklin Gothic Book Condensed, 9pt, align left: Contact link Franklin Gothic Book Condensed. 7/8pt, align left: 15 Masthead text Franklin Gothic Book Condensed, 8/9pt, align left; Copyright Franklin Gothic Book Condensed, 6pt, align left; 16 Line .5pt; Headline, small Franklin Gothic Book Condensed.

20/20pt, align left; **17 Page number** Franklin Gothic Book Condensed, 8pt, align left

Page 8

18 "SAMPLER" Cosmos Extra Bold, 8pt, align center; "Grocery" Cosmos Extra Bold, 28pt, align center; "Welcome" Verdana, 8pt, align center; 19 Tab subtitle Franklin Gothic Book Condensed, 10pt, align left; 20 Line .5pt; Headline, large Franklin Gothic Heavy, 35/28pt, align left; Subhead Franklin Gothic Book Condensed, 16/16pt, align left; Contributor Franklin Gothic Heavy, 8pt, align left; Text Franklin Gothic Book Condensed, 10/12pt, align left; Text subhead Franklin Gothic Book Condensed, 9pt, align left; Contact link Franklin Gothic Book Condensed, 7/8pt, align left; 21 Page number Franklin Gothic Book Condensed, 8pt, align left

Page 12

22 "SAMPLER" Cosmos Extra Bold, 8pt, align center; "Grocery" Cosmos Extra Bold, 28pt, align center; "Welcome" Verdana, 8pt, align center; 23 Tab subtitle Franklin Gothic Book Condensed, 10pt, align left; 24 Line .5pt; Headline, large Franklin Gothic Heavy, 35/28pt, align left; Subhead Franklin Gothic Book Condensed, 16/16pt, align left; Contributor Franklin Gothic Heavy, 8pt, align left; Text Franklin Gothic Book Condensed, 10/12pt, align left; Text subhead Franklin Gothic Book Condensed, 9pt, align left; Contact link Franklin Gothic Book Condensed, 7/8pt, align left; 25 Page number Franklin Gothic Book Condensed, 8pt, align left

SOURCE Illustrations: Bread/bottle/basket (pg. 2,4,8), Moneybag (pg. 3), Apple (pg. 8) from Task Force Image Gallery from NVTech, 800-387-0732,613-727-8184, www.nvtech.com, © NVTech, all rights reserved. Man from Faces 3 from RubberBall Productions 801-224-6886, www.rubberball.com. © RubberBall Productions, all rights reserved.

SOURCE Type Families: Cosmos, Franklin Gothic, Adobe Systems, Inc. 800-682-3623, www.adobe.com/type; Verdana, Microsoft Corporation, www.microsoft.com/type.

What is the the world's most popular fruit?

The answer is sure to surprise you

Lorem ipsum dolor sit amet, consect etuer adipiscing elit, sed diam nonummy nibh euismod tinoidunt ut laoreet dolore magna aliquam erat volutpat. Ut wisi enim ad minim veniam, quis nostrud exerci tation ullam corper suscipi toloortis nisi ut aliquip ex ea commodo consequat. Duis autem vel eum iriure dolor in hendrent in vulputate velit esse molestie consequat, vel illum dolore eu feugiat nuila facilisis at vere eros et accumsan et iusto odio dignissim qui blandit praesent luptatum zzil delenit augue duis dolore te feugiat nulla facilisi.

Corem lipsum dolor sit amet, consectetuer adipiscing elit, sed diam nonummy nibh euismod tincidunt ut laoreet dolore magna aliquam erat volutpat. Ut wisi enim ad minim weniam, quis nostrud exerci tation ullamcorper suscipit lobortis nist ut aliquip ex ea commodo consequat. Duis autem vel eum iriure dolor in hendrerit in vulputate velit esse moleste consequat, vel illum dolore eu feugiat nulla facilisis at vero eros et Nam liber tempor cum soluta nobis eleffend option congue nihil imperdiet doming id quod mazim placerat facer nossim assum.

Lorem ipsum dolor sit amet, consectetuer adipiscing elit, sed diam nonummy nibh euismod tincidunt ut laoreet dolore magna aliquam erat volutpat. Ut wisi enim ad minim veniam suscipit lobortis nisi ut aliquip ex ea commodo consequat. Lorem ipsum dolor sit amet, consectetuer adipiscing elit, sed diam nonummy nibh euismod tincidunt ut laoreet dolore magna aliquam erat volutpat. Ut wis enim ad minim veniam, quis nostrud exerci tation ullamcorper suscipit lobortis nisi ut aliquip ex ea commodo consequat Duis autem vel elit, sed diam nonummy nibh euismod tincidunt ut laoreet dolore magna aliquam erat volutpat.

Ut wisi enim ad minim veniam, quis nostrud exerci tation ullamcorper suscipit lobortis nisi ut aliquip ex ea commodo consequat. Duis autem vel eum iriure do lor in hendrerit in vulputate vellt essee molestie consequat, vel illium dolore uf legial rulla facilisis at vero eros et Nam liber tempor cum soluta nobis eleifend opquod mazim placerat facer possim assum commodo consequat. Lorem ipsum dolor sit amet, nonummy nibh euismod tincidunt ut

laoreet dolore magna aliquam erat volutpat. Ut wisi enim ad minim veniam, quis nostrud exerci tation ullam corper suscipit lobortis nisi ut aliquip ex ea commodo consequat. Duis autem vel eum iruse dolor in hendrerit in vulputate velit esse moleste consequat, vel illum dolore eu feuglat nulla facilisis at vero eros et accumsan et iusto odio dignissim qui blandit praesent luptatum zzril delenit augue duis dolore te feuglat nulla facilisi.

Lorem ipsum dolor sit amet. consectetuer adipiscing elit, sed diam nonummy nibh euismod tincidunt ut laoreet dolore magna aliquam erat olutpat. Ut wisi enim ad minim veniam quis nostrud exerci tation ullamcorper suscipit lobortis nisl ut aliquip ex ea ommodo consequat. Duis autem vel eum Nam liber tempor cum soluta nobis eleifend option congue nihil imperdiet doming id quod mazim placerat facer possim assum. Lorem ipsum dolor sit amet, consect etuer adipiscing elit, sed diam nonummy nibh euismod tincidunt ut laoreet dolore magna aliquam erat volutpat. Ut wisi enim ad minim veniam, quis nostrud exerci tation ullam corper suscipit lobortis nisl ut aliquip ex ea commodo consequat. Duis autem vel eum iriure dolor in hendrerit in vulputate velit esse molestie consequat, vel illum dolore eu feugiat nulla facilisis at vero eros et accumsan et iusto odio dignissim qui blandit praesent luptatum zzril delenit augue duis dolore te feugait nulla facilisi.

Lorem ipsum dolor sit amet, consectetuer adipiscing elit, sed diam nonummy nibh euismod tincidunt ut laoreet dolore magna aliquam erat volutpat. Ut wisi enim ad minim venlam, quis nostrud exerci tation ullamcorper suscipit lobortis nisi ut aliquip ex ea commodo consequat. Lorem ipsum dolor sit amet, consectetuer adipiscing elit, sed diam nonummy nibh euismod tincidunt.

(B)

@minhumilimundumilimumil

The importance of accurate weights and measures

How one small retailer learned the hard way

by Simon Example

Lorem ipsum dolor sit amet, consectetuer adipiscing elit, sed diam nonummy nibh euismod tincidunt ut laoreet dolore magna aliquam erat volutpat. Ut wisi enim ad minim veniam, quis nostrud exerci tation ullam corper suscipit lobortis nisl ut aliquip ex ea commodo consequat. Duis autem vel eum iriure dolor in hendrerit in vulputate velit esse molestie consequat, vel illum dolore eu feugiat nulla facilisis at vero eros et accumsan et iusto odio dignissim qui blandit praesent luptatum zzril delenit augue duis dolore te feugait nulla facilisi.

Lorem ipsum dolor sit amet, consectetuer adipiscing elit, sed diam nonummy nibh euismod tincidunt ut laoreet dolore magna aliquam erat volutpat. Ut wisi enim ad minim veniam, quis nostrud exerci tation ullamcorper suscipit lobortis nisl ut aliquip ex ea commodo consequat. Duis autem vel eum iriure dolor in hendrerit in vulputate velit esse molestie consequat, vel illum dolore eu feugiat nulla facilisis at vero eros et Nam liber tempor cum soluta nobis eleifend option congue nihil imperdiet doming id quod mazim placerat facer possim assum.

Lorem ipsum dolor sit amet, consectetuer adipiscing elit, sed diam nonummy nibh euismod tincidunt ut laoreet dolore magna aliquam erat volutpat. Ut wisi enim ad minim veniam, suscipit lobortis nisl ut aliquip ex ea commodo consequat. Lorem ipsum dolor sit amet, consectetuer adipiscing elit, sed diam nonummy nibh euismod tincidunt ut laoreet dolore magna aliquam erat volutpat. Ut wisi enim ad minim veniam, quis nostrud exerci tation ullamcorper suscipit lobortis nisl ut aliquip ex ea commodo consequat. Duis autem vel elit, sed diam nonummy nibh euismod tincidunt ut laoreet dolore magna aliquam erat volutpat.

SUBHEAD TEXT

Ut wisi enim ad minim veniam, quis lobortis nisl ut aliquip ex ea commodo consequat. Duis autem vel eum iriure dolor in hendrerit in vulputate velit esseeum iriure dolor in hendrerit in vulputate velit essee molestie consequat, vel illum dolore eu feugiat nulla facilisis at vero eros et Nam liber tempor cum soluta nobis eleifend opquod mazim placerat facer possim assum commodo consequat. Lorem ipsum dolor sit amet, consectetuer adipiscing elit, sed diam nonummy nibh euismod tincidunt ut laoreet dolore magna aliquam erat volutpat.

Ut wisi enim ad minim veniam,
VLorem ipsum dolor sit amet, consect
etuer adipiscing elit, sed diam nonummy
nibh euismod tincidunt ut laoreet dolore
magna aliquam erat volutpat. Ut wisi enim
ad minim veniam, quis nostrud exerci
tation ullam corper suscipit lobortis nisl ut
aliquip ex ea commodo consequat. Duis
autem vel eum iriure dolor in hendrerit in
vulputate velit esse molestie consequat,
vel illum dolore eu feugiat nulla facilisis at
vero eros et accumsan et iusto odio

dignissim qui blandit praesent luptatum.
Lorem ipsum dolor sit amet, consectetuer adipiscing elit, sed diam nonummy nibh euismod tincidunt ut laoreet dolore magna aliquam erat volutpat. Ut wisi enim ad minim veniam, quis nostrud exerci tation ullam corper suscipit lobortis nisl ut aliquip ex ea commodo consequat.

Lorem ipsum dolor sit amet, consectetuer adipiscing elit, sed diam nonummy nibh euismod tincidunt ut laoreet dolore magna aliquam erat volutpat. Ut wisi enim ad minim veniam, quis nostrud exerci tation ullam corper suscipit lobortis nisl ut aliquip ex ea commodo consequat. Lorem ipsum.

Contact Simon Example: 987 654 3210 or name@emailaddressz.com; More: http://www.yourwebaddressz.com/articles/storyname.htm

Law watch: Virginia Court prepares to rule

By Diana Example

Lorem ipsum dolor sit amet, consectetuer adipiscing elit, sed diam nonummy nibh euismod tincidunt ut laoreet dolore magna aliquam erat volutpat. Ut wisi enim ad minim veniam, quis nostrud exerci tation aliquip ex ea commodo conseguat. Duis autem vel eum iriure dolor in hendrerit in vulputate velit esse molestie consequat, vel illum dolore eu feugiat nulla facilisis at vero eros et accumsan et iusto odio dignissim qui blandit praesent luptatum zzril delenit augue duis dolore te feugait nulla facilisi. Ut wisi enim ad minim veniam, quis nostrud exerci tation aliquip consequat.

Contact Diana Example: 987 654 3210 or name@emailaddressz.com; More: http:// www.yourwebaddressz.com/articles/storyname.htm

9

STYLE 12 (20 PAGES)

Tall

Think outside the box. Does a newsletter have to be 8.5 inches wide and 11 inches high? Does it have to have a nameplate at the top of the cover with an article below it? Does it have to present an 2.5 articles per page?

No, no, and no. The only thing your newsletter *must* do is communicate your message. How it does that is entirely up to you. It may, in fact, be to your advantage to make your newsletter look nothing like a newsletter. This recipe, for example, breaks the size barrier, features a magazine-like cover, and presents one article over multiple pages rather than multiple articles on a single page.

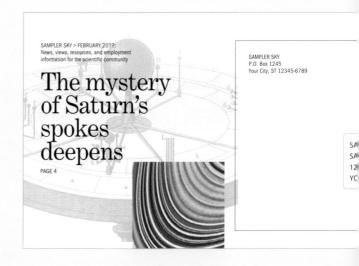

Page flow

Five 8.5 by 11 inch sheets (portrait) are folded to 4.25 by 11 inches and saddle-stitched.

What you need

General layout and design requires a desktop publishing program. Editing photographic images requires a digital imaging program. Dividing and reassembling the parts and pieces of vector clip art images and type requires a drawing program. (See Step 7: Choose Your Tools, page 26.)

SAMPLER SKY > FEBRUARY 20??: SAMPLER SKI > PEDRUARY ZU!!!

News, views, resources, and employment information for the scientific community

	Page
INSIDE Later sit am	Cover
Article title one ipsum dolor sit am	et 2
Article title two dolor sit amet	
Article title two	3

PAID YOUR CITY, ST PERMIT NO. ??? ZIP CODE 98765

N RD STE 200

	_	
t	3	
dolor sit amet	3	
	4	
dolor	4	
sum dolor sit amet		
	5	
olor sit amet	5	
sum sit amet	6	_
)sum dolor amet		_
	6	
en ipsum dolor sit	6	
lve dolor sit amet		
ait amet		_
irteen ipsum sit amet		8
ourteen ipsum dolor		_

3028 Example Road, P.O. Box 1245 Your City, ST 12345-6789 987 654 3210

987 654 3210 Fax

info@emailaddressz.com

EXECUTIVE DIRECTOR

Sarah Example 987 654 3210 name@emailaddressz.com

NEWSLETTER EDITOR

Charles Example 987 654 3210 name@emailaddressz.com

NEWSLETTER NAME (ISSN #1234-5678)
20??, Volume One, Number Five, Publis
20??, Volume One, Number Five, Publis
7 Organization's Name, 3028 Example R
57 12345-6789, \$12/yr, POSTMASTER
57 12345-6789, Ospyright
Your City, ST 12345-6789, Ospyright
Organization's Name, All rights rese
Disclaimer. Copyright Clearance Ce

© 20?? Your Company, All rights resen

BASIC ELEMENTS

The design grid

There are two single-column grids used—one for the cover and headline pages, one for the article text. The cover/headline page grid is narrower and has a wider left-hand margin. (See *Step 11.2: Establish the Page Size and Grid*, page 37.)

The typefaces

As with many of the nameplates, the typeface used here, Raleigh Gothic, is used only in the nameplate. Century Expanded is used for the headlines and text, and Franklin Gothic is used for the contents, captions, contact links, and other supporting details.

Raleigh Gothic

Typeface AabbeeggkkmmQqrssww!?

Century Expanded

Typeface AaBbEeGgKkMmQqRrSsW

Franklin Gothic Book Condensed

Typeface AaBbEeGgKkMmQqRrSsWw!?

Franklin Gothic Book Condensed

Text Lorem ipsum dolor sit amet, consectetuer adipiscing elit, sed diam nonummy nibh euismod tincidunt ut laoreet dolore magna aliquam erat volutpat. Ut wisi enim ad minim veniam, quis nostrud exerci tation ullamcorper suscipit lobortis nisl ut aliquip ex ea commodo consequat. Duis autem vel eum iriure dolor in hendrerit in vulputate velit esse molestie consequat, vel illum dolore eu feugiat nulla facilisis at vero eros.

The illustrations

A subject that lends itself to as diverse a collection of photographic subjects as this one does can benefit from a secondary visual element—in this case, a series of beautifully complex antique scientific diagrams and illustrations. The images offer a subtle visual connection between pages.

Learn from magazines

Just because your newsletter arrives in your reader's mailbox does not guarantee it will be read. You compete with everything in your reader's life that demands attention. This newsletter cover follows the magazine model; it previews the best of what's inside to persuade the reader to pick it up.

Standby. The "money moments" before launch.

Loren ipsum dolor et amet, consecteture alipseing elit, sed dium nonummy nibh esismod tineidunt sil lorret dolore magna aliquam erut volstpat. Ut seis enim ad minim veniam, quis nostrud eserci tation ultam corper suscepit loborits nisl ut aliquip ex a commodo consequat. Duis autem vel eum irure dolor in hendrerit in vulpstate vellt esse molestie consequat.

Lead the reader into the text

Once you've got the reader inside, make your publication reader-friendly. One simple way of doing it is to begin the text of each article with a compelling statement—a paragraph or two of text that is more prominent and easier to read than the text—a technique demonstrated throughout this book.

Hiring news

Lorem ipsum dolor sit amet, consecteture adipsicing elit, sed diam nonemmy nibh euismod time idunum nibh euismod time idunum enat volutpat nem a diguna neat volutpat nem a diguna decerci tation ullam quis nostrud exerci tation ullam corper suscipii loboriti nisl ut alquipi ex a commodo alquipi ex a commodo consequat. Duis autem vel eum consequat, in hendrerii in vulputate veli! esse molestie consequat.

POSITION TITLE > Description herein paum delor all annet, connectedeur adiptioning sell, sell diam naminary salls realized and the sell control of the sell control

POSITION TITLE - Description forem promotion growth of the consections adjusted to the consection of t

"Contact Kann » 508 fed \$210 » name@e mail.com
POSITION TITLE » Description leven (speum delor at annet,
reconstructed an appearing selt, ned dans mannony sinh entered
contacted the abstract of the contacted and appearing selt, ned dans mannony sinh entered
contact and animated contacted and appearing to the contacted animated
contacted animated contacted animated animated animated
contacted animated contacted animated animated contacted animated
contacted animated a

POSITION STILLS: Description forem poum doler six most connectives adjusted and an anomany abb control and connectives adjusted and an anomany abb control and the six may be considered and doler to an anomaly member of the six may be considered as a six may be control and the six may be considered as a six may be conditionally all the six may be considered as a six may be control and an anomaly and an anomaly and an anomaly conporting six may be considered as a six may be conposed as a six may be considered as a six may be conposed as a six may be considered as a six may be conposed as a six may be control as a six may be control as a six may be considered as a six may be considered as a six may be control as a six may be control as a six may be considered as a six may be control as a six may be considered as

contractions adjusted by the property of the state of the

Be redundant and redundant

Few people will read your newsletter cover to cover. One thing Web sites do better than newsletters is ensure that no matter what page you see, you have a statement of or access to crucial information and what amounts to a table of contents. You can increase the odds of people taking the actions you prescribe by repeating your nameplate, defining phase, and key contact information several times throughout the pages of your newsletter.

SAMPLER SKY > FEBRUARY 20??: News, views, resources, and employment information for the scientific community

The mystery of Saturn's spokes deepens

RY ROBIN FXAMPI

Lorem ipsum dolor sit amet, consectetuer adipiscing elit, sed diam nonummy nibh euismod tincidunt ut laoreet dolore magna aliquam erat volutpat. Ut wisi enim ad minim veniam, quis nostrud exerci tation ullam corper suscipit lobortis nisl ut aliquip ex ea commodo consequat. Duis autem vel eum irure dolor in hendrerit in vulputate velit esse molestie consequat.

Lorem ipsum dolor sit amet, consectetuer adipiscing elit, sed diam nonummy nibh euismod tincidunt ut laoreet dolore magna. Dolor sit amet, consectetuer adipiscing elit, sed diam nonummy nibh euismod tincidunt ut laoreet dolore

Lorem ipsum dolor sit amet, consectetuer adipiscing elit, sed diam nonummy nibh euismod tincidunt ut laoreet dolore magna aliquam erat volutpat. Ut wisi enim ad minim veniam, quis nostrud exerci tation ullam corper suscipit lobortis nisl ut aliquip ex ea commodo consequat. Duis autem vel eum iriure dolor in hendrerit in vulputate velit esse molestic consequat, vel illum dolore eu feugiat nulla facilisis at vero eros et accumsan et iusto odio dignissim qui blandit praesent luptatum zzril delenit augue duis dolore te feugait nulla facilisis.

Lorem ipsum dolor sit amet, consectetuer adipiscing elit, sed diam nonumny nibh euismod tincidunt ut laroret dolore magna aliquam erat volutpat. Ut wisi enim ad minim veniam, quis nostrud exerci tation ullamcorper suscipit lobortis nisl ut aliquip ex ea commodo consequat. Duis autem vel eum iriure dolor in hendrerit in vulputate velit esse molestie consequat, vel illum dolore u feugiat nulla facilisis at vero eros et Nam liber tempor cum soluta nobis eleifend option congue nihil imperdiet doming id quod mazim placerat facer possim assum.

mazim placerat facer possim assum.

Lorem ipsum dolor sit amet, consectetuer adipiscing elit, sed diam nonummy nibh euismod tincidunt ut laoreet dolore magna aliquam erat volutpat. Ut wisi enim ad minim veniam, quis nostrud exerci tation ullamcorper suscipit lobortis nisl ut aliquip ex ea commodo consequat. Lorem ipsum dolor sit amet, consectetuer adipiscing elit, sed diam nonummy nibh euismod tincidunt ut laoreet dolore erat volutpat. Sed diam nonummy nibh euismod tincidunt ut laoreet dolore magna aliquam erat volutpat. Ut wisi enim ad minim veniam, quis nostrud exerci tation ullam corper suscipit lobortis nisl ut aliquip ex ea commodo consequat. Duis sautem vel eum riure dolor suscipit lobortis nisl ut aliquip ex ea commodo consequat. Duis sautem vel eum riure dolors.

իսանիսակարմիրականիարկարիարկարհարահարաանումության անաանաական

Contact Robin Example: 987 654 3210;
name@emailaddressz.com; More: http://www.yourwebaddressz.com
articles/stormane.htm

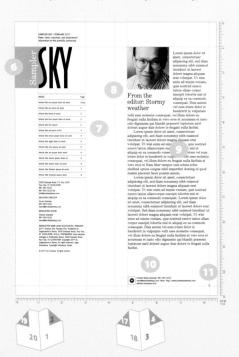

Cover & back cover (pages 1 & 20)

1 "SAMPLER" Century Expanded, 24pt, align center; "SKY" Raleigh Gothic, 100pt, align center; Date/defining phrase Franklin Gothic Book Condensed, 9/10pt, align left; 2 Cover teaser Century Expanded, 40/30pt, align left; Page link Franklin Gothic Book Condensed, 8pt, align left; 3 Date/defining phrase Franklin Gothic Book Condensed, 8/9pt, align left; Back cover teaser Century Expanded, 30/32pt, align left; Page link Franklin Gothic Book Condensed, 8pt, align left; 4 Line .5pt; Return address Franklin Gothic Book Condensed, 8/8pt, align left; 5 Label address Arial, 10/10pt, align left; Postage indicia Franklin Gothic Book Condensed, 8/8pt, align center; Line .5pt

Pages 2 & 3

6 Line .5pt; Date/defining phrase Franklin Gothic Book Condensed, 8/9pt, align left; "SAMPLER"
Century Expanded, 24pt, align center; "SKY" Raleigh Gothic, 100pt, align center; 7 Contents Franklin Gothic Book Condensed, 7/16pt, align left; Masthead Franklin Gothic Book Condensed, 7/8pt, align left; Copyright Franklin Gothic Book Condensed, 6pt, align left; 8 Headline, small Century Expanded, 18/18pt, align left; 9 Text Century Expanded, 10/12pt, align left; 10 Contact link Franklin Gothic Book Condensed, 7/8pt, align left; 11 Page number Franklin Gothic Book Condensed, 8pt, align right

Pages 4 & 5

12 Line .5pt; Date/defining phrase Franklin Gothic Book Condensed, 8/9pt, align left; Headline, large Century Expanded, 32/30pt, align left; Contributor Franklin Gothic Book Condensed, 8pt, align left; Lead-in text Century Expanded, 14/16pt, align left; 13 Page number Franklin Gothic Book Condensed, 8pt, align left; 14 Caption Franklin Gothic Book Condensed, 8/9pt, align left; 15 Text Century Expanded, 10/12pt, align left; 16 Contact link Franklin Gothic Book Condensed, 8/9t, align left; Page number Franklin Gothic Book Condensed, 8pt, align left or right

SOURCE Illustrations: Mars photos from Hubble Space Telescope (pg. 1) (Credit: Material created with support to AURA/STScI from NASA contract NASS-26555); Antique scientific diagrams and illustrations (pg. 20,4) from Antique Science and Technology from Visual Language, 888-702-8777, www.visuallanguage.com, © Visual Language, all rights reserved; Planetary photographs (pg. 5, 20) from ClickArt 200,000 from Broderbund, available from software retailers worldwide, © T/Maker, all rights reserved; Man (pg. 3) from Faces 1 from RubberBall Productions 801-224-6886, www.rubberball.com. © RubberBall Productions, all rights reserved.

SOURCE Type Families: Century Expanded, Franklin Gothic, Adobe Systems, Inc. 800-682-3623, www.adobe.com/type; Raleigh Gothic, AGFA/Monotype, 888-988-2432, 978-658-0200, www.agfamonotype.com.

Pages 8 & 9

17 Line .5pt; Date/defining phrase Franklin Gothic Book Condensed, 8/9pt, align left; Headline, large Century Expanded, 32pt, align left; Lead-in text Century Expanded, 14/16pt, align left; 18 Line .5pt; Listing text Century Expanded, 8/9pt, align left; 19 Contact link Franklin Gothic Book Condensed, 7/8pt, align left; Page number Franklin Gothic Book Condensed, 8pt, align left or right

Pages 12 & 13

20 Line .5pt; Date/defining phrase Franklin Gothic Book Condensed, 8/9pt, align left; Headline, large Century Expanded, 32/30pt, align left; Contributor Franklin Gothic Book Condensed, 8pt, align left; Lead-in text Century Expanded, 14/16pt, align left; 21 "continued" Century Expanded, 8pt, align left; Caption Franklin Gothic Book Condensed, 8/9pt, align left; 22 Page number Franklin Gothic Book

Condensed, 8pt, align left or right

Pages 14 & 15

23 Caption Franklin Gothic Book Condensed, 8/9pt, align left; 24 Text Century Expanded, 10/12pt, align left; 24 Contact link Franklin Gothic Book Condensed, 7/8pt, align left; Page number Franklin Gothic Book Condensed, 8pt, align left or right

Color

Side one of the cover is printed in four-color process (Step 11.6) using values of cyan, magenta, yellow, and black (CMYK) as defined on the color palette below. Actual color will vary. The rest of the newsletter is printed in black and white.

SOURCE Illustrations: Antique scientific diagrams and illustrations (pg. 8, 12) from Antique Science and Technology from Visual Language, 888-702-8777, www.visuallanguage.com, © Visual Language, all rights reserved; Space Shuttle photographs (pg. 13, 14, 15) ClickArt 200,000 from Broderbund, available from software retailers worldwide, © T/Maker, all rights reserved.

SOURCE Type Families: Century Expanded, Franklin Gothic, Adobe Systems, Inc. 800-682-3623, www.adobe.com/type.

by. money ents'' e launch.

n dolor sit amet, adipiscing elit, sed my nibh euismod laoreet dolore maerat volutpat. Ut ! minim veniam, exerci tation ullam oit lobortis nisl ut commodouis autem vel eum in hendrerit in lit esse molestie

ued on page 3 Lorem ipsum dolor sit ame

consectetuer adipiscing elit, sed diam nonummy nibh euismod tincidunt ut laoreet dolore magna.

Ut wisi enim ad minim veniam, quis nostrud exerci tation ullam corper suscipit lobortis nisl ut aliquip ex ea commodo consequat Duis autem vel eum iriure dolor in hendrerit in vulputate velit esse molestie consequat, vel um dolore eu feugiat

consectenter ampiscone entire consumer in the euromotumer with earner to laoreet dolore magna.

Alla facilisis at vero eros et accumsan et iusto odio dignissim qui blandit praesent luptatum

zzril delenit augue duis dolore te feugait nulla facilisi.
Lorem ipsum dolor sit amet, consectetuer
adipiscing elit, sed diam nonummy nibh euismod adipiscing elit, sed diam nonummy nibh euismod tincidunt ut laoreet dolore magna aliquam erat volutpat. Ut wisi enim ad minim veniam, quis nostrud exerci tation ullamcorper suscipit lobortis nisl ut aliquip ex a commodo consequat. Duis autem vel eum iriure dolor in hendrerit in vulputate velit esse molestie consequat, vel ilum dolore eu feugiat nulla facilisis at vero eros et Nam liber tempor cum soluta nobis eleifend option congue nihil imperdiet doming id quod mazim placerat facer possim assum.

Lorem ipsum dolor sit amet, consectetuer adipiscing elit, sed diam nonummy nibh euismod tincidunt ut laoreet dolore mazna aliquam erat

adpisseng ent, seu dam nonumny non eusmoot tincidunt ut laoreet dolore magna aliquam erat volutpat. Ut wisi onim ad minim veniam, quis nostrud exerci tation u prer suscipit lobortis nisl ut aliquip ex ea commodo consequat. Lorem ipsum dolor sit amet, consectetuer adipissing elit, sed diam nonumny nibh euismod tincidunt ut laoreet dolore erat saltatus. Each diam nonumny nibh euismod tincidunt ut laoreet dolore erat volutpat. Sed diam nonummy nibh euismod tincidunt ut

laoreet dolore magna aliquam erat volutpat. Ut wisi enim ad minim veniam, quis nostrud exerci tation ullam corper suscipit lobortis nisl ut aliquip ex ea commodo consequat. Lorem ipsum dolor sit amet, consectetuer adipiscing elit, sed diam nonummy nibh euismod tincidunt ut laoreet dolore magna aliquam erat volutpat. Ut wisi enim ad minim veniam, quis

Dolor sit amet, consectetuer adipiscing elit, sed diam nonummy nibh euismod

nostrud exerci tation incidunt ut laoreet dolore ullam corper suscipit lobortis nisl ut aliquip ex ea commodo consequat. Duis autem vel eum iriure dolor in hendrerit in vulputate velit esse molestie consequat, vel illum dolore eu feugiat nulla facilisis at vero eros et accumsan et iusto odio dignissim qui blandit praesent.

Lorem ipsum dolor sit amet, consectetuer Lorem ipsum dolor sit amet, consectetuer adipiscing elit, sed diam nonummy nibh euismod tincidunt ut laoreet dolore magna aliquam erat volutpat. Ut wisi enim ad minim veniam, quis nostrud exerci tation ullamcorper suscipit lobortis nisl ut aliquip ex ea commodo consequat. Duis autem vel eum iriure dolor in hendrerit in vulputate velit esse molestie inture door in hendren't in vulpricate with essen moisus consequat, vel illum dolore eu feugiat nulla facilisis at vero eros et Nam liber tempor cum soluta nobis eleifend option congue nibil imperdiet doming id quod mazim placerat facer possim assum.

Lorem ipsum dolor sit amet, consectetuer adipiscing elit, sed diam nonummy nibh euismod tincidunt ut laoreet dolore magna aliquam erat volutate. It wisi enim ad minin venim quis nostrud.

volutpat. Ut wisi enim ad minim veniam, quis nostrud exerci tation ullamcorper suscipit lobortis nisl ut aliquip ex a commodo consequat. Lorem ipsum dolor sit amet, consectetuer adipiscing elit, sed diam

nonummy nibh euismod tincidunt ut laoreet dolore erat volutpat. Ut wisi enim ad minim veniam, quis nostrud exerci tation ullamcorper suscipit lobortis nisl ut aliquip ex ea commodo consequat. Duis autem vel eum iriure dolor in torem ipsum dolor sit amet, consectebure adipiscing elit, sed diam nonummy nibhe usimod tincidunt ut lauceet dolore magna.

Nam liber tempor cum solutan nobis eleifend option

congue nihil imperdiet doming id quod mazim placerat

congue nihil imperdiet doming id quod mazim placerat facer possim assum.

Lorem ipsum dolor sit amet, consectetuer adipiscing elit, sed diam nonumny nibh euismod tincidunt ut laoreet dolore magna aliquam erat volutpat. Ut wisi enim ad minim veniam, quis nostrud exerci tation ullamcorper suscipit lobortis nisl ut aliquip ex ea commodo consequat. Lorem ipsum dolor sit amet, consectetuer adipiscing elit, sed diam nonumny nibh euismod tincidunt ut laoreet dolore erat volutpat. Sed diam nonumny nibh euismod tincidunt ut laoreet dolore magna aliquam erat volutpat. Ut wisi enim ad minim veniam, quis nostrud exerci tation ullam corper suscipit lobortis nisl ut aliquip ex ea commodo consequat. consequat.

STYLE 13 (4 PAGES)

Wing

Innovation is often the result of operating within constraints. This recipe is unique, practical, and easy to produce. A wind is folded into the cover to reveal the illustrations on the third page. The cover includes space for a lead article and a discussion of up to five separate topics—in this case music, academics, clubs, sports, and honors. The inside spread provides space for one article in each of the topic areas and the back cover features a comprehensive text calendar.

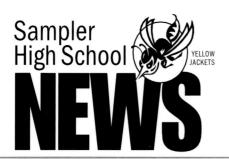

APRIL 20??: News, events, and resources for students, parents, and teachers

Music

Marching Band headed for statewide competition in Charlottesville

REPORTED BY MELVIN EXAMPLE

Lorem ipsum dolor sit amet, consectetuer adipiscing elit, sed diam nonummy nibh euismod tincidunt ut laoreet dolore magna aliquam erat volutpat. Ut wisi enim ad minim veniam, quis nostrud exerci tation ullam corper suscipit lobortis nisl ut aliquip ex ea commodo consequat.

Duis autem vel eum iriure dolor in hendrerit in vulputate velit esse molestie consequat, vel illum dolore eu feugiat nulla facilisis at vero eros et accumsan et iusto odio dignissim qui blandit praesent luptatum zzril delenit augue duis dolore

nonumn dolore m ullamcon Dui in vulpu

dolore eu

liber tem

Clubs

Club leaders tackle rebuilding bylaws from the ground up

REPORTED BY ELISHA EXAMPLE

Lorem ipsum dolor sit amet, consectetuer adipiscing elit, sed diam nonummy nibh euismod tincidunt ut laoreet dolore magna aliquam erat volutpat. Ut wisi enim ad minim veniam, quis nostrud exerci tation ullam corper suscipit lobortis nisl ut aliquip ex ea commodo consequat.

Duis autem vel eum iriure dolor in hendrerit in vulputate velit esse molestie consequat, vel illum dolore eu feugiat nulla facilisis at vero eros et accumsan et iusto odio dignissim qui blandit praesent luptatum zzril delenit augue duis dolore

amet, con nonumm dolore mi ad minir

commod

te feugait

nonumn

dolore m

in vulpu

Academics

New courses: Public speaking, real-world marketing, and computer programming

REPORTED BY MURRAY EXAMPLE

Lorem ipsum dolor sit amet, consectetuer adipiscing elit, sed diam nonummy nibh euismod tincidunt ut laoreet dolore magna aliquam erat volutpat. Ut wisi enim ad minim veniam, quis nostrud exerci tation ullam corper suscipit lobortis nisl ut aliquip ex ea commodo consequat.

Duis autem vel eum iriure dolor in hendrerit in vulputate velit esse molestie consequat, vel illum dolore eu feugiat nulla facilisis at vero eros et accumsan et iusto odio dignissim qui blandit praesent luptatum zzril delenit augue duis dolore

ad minir ullamcor Dui in vulput dolore eu

liber tem

amet, cor

Sports

Cross country training takes on a special meaning for Coach Example

REPORTED BY BRANDON EXAMPLE

Lorem ipsum dolor sit amet, consectetuer adipiscing elit, sed diam nonummy nibh euismod tincidunt ut laoreet dolore magna aliquam erat volutpat. Ut wisi enim ad minim veniam, quis nostrud exerci tation ullam corper suscipit

lobortis nisl ut aliquip ex ea commodo consequat. Duis autem vel eum iriure dolor in hendrerit in vulputate velit esse molestie consequat, vel illum dolore eu feugiat nulla facilisis at vero eros et accumsan et iusto odio dignissim qui blandit praesent luptatum zzril delenit augue duis dolore

Lorem ipsum dolor sit amet, consectetuer

volutpat. Ut wisi enim ad minim veniam, quis nostrud exerci tation ullam corper suscipit

dolore m d minin ullamcor commod in vulput dolore eu

liber tem

te feugait adipiscing elit, sed diam nonummy nibh euismod tincidunt ut laoreet dolore magna aliquam erat nonumm ad minin ullamcon commod

lobortis nisl ut aliquip ex ea commodo consequat Duis autem vel eum iriure dolor in hendrerit in vulputate velit esse molestie consequat, vel illum dolore eu feugiat nulla facilisis at vero eros et accumsan et iusto odio dignissim qui blandit praesent luptatum zzril delenit augue duis dolore

Dui in vulput dolore eu

liber tem

Honors

National Honor Society ratchets up membership qualifications

REPORTED BY JEFFREY EXAMPLE

One 11 by 17 inch sheet is folded to 8.5 by 11 inches then the cover is folded to form a 2.625-inch wing.

What you need

General layout and design requires a desktop publishing program. Editing photographic images requires a digital imaging program. Dividing and reassembling the parts and pieces of vector clip art images and type requires a drawing program. (See Step 7: Choose Your Tools, page 26.)

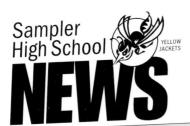

APRIL 20??: News, events, and resources for students, parents, and teachers

sum dolor sit

it, sed diam int ut laoreet

tpat. Ut wisi enim exerci tation sl ut aliquip ex ea

dolor in hendrerit onsequat, vel illum

leifend option

sum dolor sit

tpat. Ut wisi enim

sl ut aliquip ex ea

dolor in hendrerit

onsequat, vel illum

t vero eros et. Nam leifend option

sum dolor sit

it, sed diam

int ut laoreet

tpat. Ut wisi enim

sl ut aliquip ex ea

dolor in hendrerit

t vero eros et. Nam

leifend option

sum dolor sit

it, sed diam

unt ut laoreet

exerci tation

tpat. Ut wisi enim

sl ut aliquip ex ea

onsequat, vel illun

t vero eros et. Nan

leifend option

sum dolor sit

it, sed diam

int ut laoreet

exerci tation

tpat. Ut wisi enim

sl ut aliquip ex ea

dolor in hendreri

consequat, vel ill

at vero eros et. Na

leifend option

exerci tation

it, sed diam int ut laoreet

Expand your thinking about choosing a career and finding just the right college

REPORTED BY REBECCA EXAMPLE

Lorem ipsum dolor sit amet, consectetuer adipiscing elit, sed diam nonummy nibh euismod tincidunt ut laoreet dolore magna aliquam erat volutpat. Ut wisi enim ad minim veniam, quis nostrud exerci tation ullam corper suscipit lobortis nisl ut aliquip ex ea commodo consequat. Duis autem vel eum iriure dolor in hendrerit in vulputate velit esse molestie consequat, vel illum dolore eu feugiat nulla facilisis at vero eros et accumsan et iusto odio dignissim qui blandit praesent luptatum zzril delenit augue duis dolore te feugait nulla facilisi.

Lorem ipsum dolor sit amet, consectetuer adipiscing elit, sed diam nonummy nibh euismod tincidunt ut laoreet dolore magna aliquam erat volutpat. Ut wisi enim ad minim veniam, quis nostrud exerci tation ullamcorper suscipit lobortis nisl ut aliquip ex ea commodo consequat. Duis autem vel eum iriure dolor in hendrerit in vulputate velit esse molestie consequat, vel illum dolore eu feugiat nulla facilisis at vero eros et Nam liber tempor cum soluta nobis eleifend option congue nihil imperdiet doming id quod mazim placerat facer possim assum.

Lorem ipsum dolor sit amet, consectetuer adipiscing elit, sed diam nonummy nibh euismod tincidunt ut laoreet dolore magna Lorem ipsum dolor sit amet, consectetuer adipiscing elit, sed diam nonummy nibh euismod tincidunt ut laoreet dolore magna aliquam erat volutpat. Ut wisi enim ad minim veniam, quis nostrud exerci tation ullam corper suscipit lobortis nisl ut aliquip ex ea commodo consequat.

MUSIC IN BRIEF

Lorem ipsum dolor sit amet, consectetuer adipiscing elit, sed diam nonummy. > Nibh euismod tincidunt ut laoreet dolore magna aliquam erat volutpat. > Ut wisi enim ad minim veniam, quis nostrud exerci tation ullam corper suscipit lobortis nisl ut aliquip ex ea commodo consequat. > Duis autem vel eum iriure dolor in hendrerit in vulputate velit esse molestie consequat, vel illum dolore eu feugiat nulla.

Clubs IN BRIEF

Lorem ipsum dolor sit amet, consectetuer adipiscing elit, sed diam nonummy. Nibh euismod tincidunt ut laoreet dolore magna aliquam erat volutpat. > Ut wisi enim ad minim veniam, quis nostrud exerci tation ullam corper suscipit lobortis nisl ut aliquip ex ea commodo consequat. > Duis autem vel eum iriure dolor in hendrerit in vulputate velit esse molestie consequat, vel illum dolore eu feugiat nulla.

Academics in Brief

Lorem ipsum dolor sit amet, consectetuer adipiscing elit. > Sed diam nonummy nibh euismod tincidunt ut laoreet dolore magna aliquam erat volutpat. > Ut wisi enim ad minim veniam, quis nostrud exerci tation ullam corper suscipit lobortis nisl ut aliquip ex ea commodo consequat. > Duis autem vel eum iriure dolor in hendrerit in vulputate velit esse molestie consequat, vel illum dolore eu feugiat nulla.

Sports in Brief

Lorem ipsum dolor sit amet, consectetuer adipiscing elit, sed diam nonummy. Nibh euismod tincidunt ut laoreet dolore magna aliquam erat volutpat. > Ut wisi enim ad minim veniam, quis nostrud exerci tation ullam corper suscipit lobortis nisl ut aliquip ex ea commodo consequat. > Duis autem vel eum iriure dolor in hendrerit in vulputate velit esse molestie consequat. > Vel illum dolore eu feugiat nulla.

HONOIS IN BRIEF

Lorem ipsum dolor sit amet, consectetuer adipiscing elit, sed diam nonummy. > Nibh euismod tincidunt ut laoreet dolore magna aliquam erat volutpat. Ut wisi enim ad minim veniam, quis nostrud exerci tation ullam corper suscipit lobortis nisl ut aliquip ex ea commodo consequat. > Duis autem vel eum iriure dolor in hendrerit in vulputate velit esse molestie consequat, vel illum dolore eu feugiat nulla.

articles/stor

151

The design grid

A basic three-column grid is divided top to bottom into five equal sections—one for each topic area. (See *Step 11.2: Establish the Page Size and Grid,* page 37.)

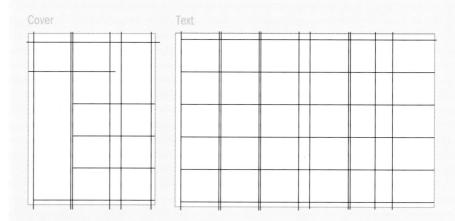

The typefaces

Two type families do all the work—Impact for the nameplate and the topic headings, and Franklin Gothic for everything else.

Impact

Typeface AabbeeggkkmmQqRrSsWw!?

Minion Condensed

Typeface
AaBbEeGgKkMmQqRrSsWw!?

Franklin Gothic Book Condensed

Typeface AaBbEeGgKkMmQqRrSsWw!?

Minion Condense

Text Lorem ipsum dolor sit amet, consectetuer adipiscing elit, sed diam nonummy nibh euismod tincidunt ut laoreet dolore magna aliquam erat volutpat. Ut wisi enim ad minim veniam, quis nostrud exerci tation ullamcorper suscipit lobortis nisl ut aliquip ex ea commodo consequat. Duis autem vel eum iriure dolor in hendrerit in vulputate velit esse molestie consequat, vel illum dolore eu feugiat nulla facilisis at vero eros.

The illustrations

This design recognizes the fact that, in many settings, it is necessary to use a patchwork of illustrations—some photographs, some artwork—from a variety of sources. To that end, the only other artwork used is that incorporated in the nameplate. Limiting the amount of visual information eliminates a potential visual tug-of-war.

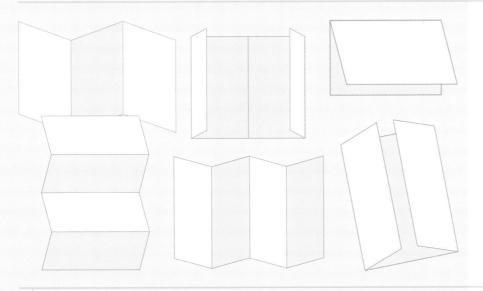

Experiment with folds

This is just one of hundreds of ways to fold a newsletter. You can pick up a sheet of paper and start folding or investigate the topic through a book such as *How To Fold* by Laurence K. Withers (Art Direction Book Company, 1993). The challenge is to use folds to organize the message in a way that improves its communication.

April Calendar

DATE	DAY	TIME	EVENT	PLACE	CONTACT
02	Tuesday	8:15 AM	Marching Band Practice	Football field	Sam Example
02	Tuesday	9:00 AM	Pep rally	Field house	Marsha Example
02	Tuesday	7:00 PM	Boys Volleyball (Home)	Gym	Harry Example
00	Day	0:00 PM	Description lorem ipsum dolor	Place	Name Example
00	Day	0:00 PM	Description lorem ipsum dolor	Place	Name Example
00	Day	0:00 PM	Description lorem ipsum dolor	Place	Name Example
00	Day	0:00 PM	Description lorem ipsum dolor	Place	Name Example
00	Day	0:00 PM	Description Duis autem vel eum iriure	Place	Name Example
00	Day	0:00 PM	Description lorem ipsum dolor	Place	Name Example
00	Day	0:00 PM	Description lorem ipsum dolor	Place	Name Example
00	Day	0:00 PM	Description lorem ipsum dolor	Place	Name Example
00	Day	0:00 PM	Description Duis autem vel eum iriure	Place	Name Example
00	Day	0:00 PM	Description lorem ipsum dolor	Place	Name Example
00	Day	0:00 PM	Description lorem ipsum dolor	Place	Name Example
00	Day	0:00 PM	Description lorem ipsum dolor	Place	Name Example
00	Day	0:00 PM	Description lorem ipsum dolor	Place	Name Example
00	Day	0:00 PM	Description Duis autem vel eum iriure	Place	Name Example
00	Day	0:00 PM	Description lorem ipsum dolor	Place	Name Example
00	Day	0:00 PM	Description lorem ipsum dolor	Place	Name Example
00	Day	0:00 PM	Description lorem ipsum dolor	Place	Name Example
-		With the live of			

Create a space-saving text calendar

You can fit the dates, times, locations, and contact details for lots of events in a very small place using a simple text calendar like this. It is this type of useful, detailed information that earns your newsletter space at the office bulletin board or home on the refrigerator.

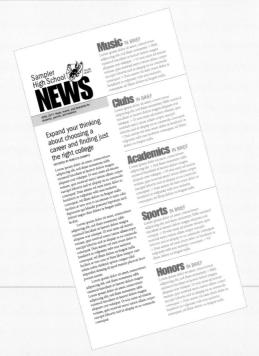

Lead with news "in brief"

One technique common to many newspapers and magazines is to string together one-sentence news blurbs that, in brief, summarize a story. For a high school newsletter it might read something like this: "Basketball Coach Judy Example has been nominated for the state coach of the year. > The county has approved a \$10,000 turf renovation for the football stadium to be completed by next August. > Scouts for three out-of-state universities were seen at the regional women's volleyball finals—University of Sampler, Sampler State, and Sampler College."

APRIL 20??: News, events, and resources for students, parents, and teachers

Expand your thinking about choosing a career and finding just the right college

REPORTED BY REBECCA EXAMPLE

Lorem ipsum dolor sit amet, consectetuer adipiscing elit, sed diam nonummy nibh euismod tincidunt ut laoreet dolore magna aliquam erat volutpat. Ut wisi enim ad minim veniam, quis nostrud exerci tation ullam corper suscipit lobortis nisl ut aliquip ex ea commodo consequat. Duis autem vel eum iriure dolor in hendrerit in vulputate velit esse molestie consequat, vel illum dolore eu feugiat nulla facilisis at vero eros et accumsan et iusto odio dignissim qui blandit praesent luptatum zzril delenit augue duis dolore te feugait nulla facilisi

Lorem ipsum dolor sit amet, consectetuer adipiscing elit, sed diam nonummy nibh euismod tincidunt ut laoreet dolore magna aliquam erat volutpat. Ut wisi enim ad minim veniam, quis nostrud exerci tation ullamcorper suscipit lobortis nisl ut aliquip ex ea commodo consequat. Duis autem vel eum iriure dolor in hendrerit in vulputate velit esse molestie consequat, vel illum dolore eu feugiat nulla facilisis at vero eros et Nam liber tempor cum soluta nobis eleifend option congue nihil imperdiet doming id quod mazim placerat facer possim assum.

Lorem ipsum dolor sit amet, consectetuer adipiscing elit, sed diam nonummy nibh euismod tincidunt ut laoreet dolore magna Lorem ipsum dolor sit amet, consectetuer adipiscing elit, sed diam nonummy nibh euismod tincidunt ut laoreet dolore magna aliquam erat volutpat. Ut wisi enim ad minim veniam, quis nostrud exerci tation ullam corper suscipit lobortis nisl ut aliquip ex ea commodo consequat.

MUSIC IN BRIEF

Lorem ipsum dolor sit amet, consectetuer adipiscing elit, sed diam nonummy. Nibh euismod tincidunt ut laoreet dolore magna aliquam erat volutpat. > Ut wisi enim ad minim veniam, quis nostrud exerci tation ullam corper suscipit lobortis nisl ut aliquip ex ea commodo consequat. > Duis autem vel eum iriure dolor in hendrerit in vulputate velit esse molestie consequat, vel illum dolore eu feugiat nulla.

Clubs IN BRIEF

Lorem ipsum dolor sit amet, consectetuer adipiscing elit, sed diam nonummy. Nibh euismod tincidunt ut laoreet dolore magna aliquam erat volutpat. > Ut wisi enim ad minim veniam, quis nostrud exerci tation ullam corper suscipit lobortis nisl ut aliquip ex ea commodo consequat. > Duis autem vel eum iriure dolor in hendrerit in vulputate velit esse molestie consequat, vel illum dolore eu feugiat nulla.

Academics IN BRIEF

Lorem ipsum dolor sit amet, consectetuer adipiscing elit. > Sed diam nonummy nibh euismod tincidunt ut laoreet dolore magna aliquam erat volutpat. > Ut wisi enim ad minim veniam, quis nostrud exerci tation ullam corper suscipit lobortis nisl ut aliquip ex ea commodo consequat. > Duis autem vel eum iriure dolor in hendrerit in vulputate velit esse molestie consequat, vel illum dolore eu feugiat nulla.

Sports in Brief

Lorem ipsum dolor sit amet, consectetuer adipiscing elit, sed diam nonummy. Nibh euismod tincidunt ut laoreet dolore magna aliquam erat volutpat. > Ut wisi enim ad minim veniam, quis nostrud exerci tation ullam corper suscipit lobortis nisl ut aliquip ex ea commodo consequat. > Duis autem vel eum iriure dolor in hendrerit in vulputate velit esse molestie consequat. > Vel illum dolore eu feugiat nulla.

Honors in Brief

Lorem ipsum dolor sit amet, consectetuer adipiscing elit, sed diam nonummy. > Nibh euismod tincidunt ut laoreet dolore magna aliquam erat volutpat. Ut wisi enim ad minim veniam, quis nostrud exerci tation ullam corper suscipit lobortis nisl ut aliquip ex ea commodo consequat. > Duis autem vel eum iriure dolor in hendrerit in vulputate velit esse molestie consequat, vel illum dolore eu feugiat nulla.

PTA announces scholarships, academic programs, and senior Baccalaureate

REPORTED BY GLENN EXAMPLE

Lorem ipsum dolor sit amet, consectetuer adipiscing elit, sed diam nonummy nibh euismod tincidunt ut laoreet dolore magna aliquam erat volutpat. Ut wisi enim ad minim veniam, quis nostrud exerci tation ullam corper suscipit lobortis nisl ut aliquip ex ea commodo consequat. Duis autem vel eum iriure dolor in hendrerit in vulputate velit esse molestie consequat, vel illum dolore eu feugiat nulla facilisis at vero eros et accumsan et iusto odio dignissim qui blandit praesent luptatum zzril delenit augue duis dolore te feugait nulla facilisi.

Lorem ipsum dolor sit amet, consectetuer adipiscing elit, sed diam nonummy nibh euismod tincidunt ut volutpat. Ut wisi enim ad minim veniam, quis nostrud exerci tation ullamcorper suscipit lobortis nisl ut aliquip ex ea commodo consequat. Duis autem vel eum iriure dolor in hendrerit in vulputate velit esse molestie consequat, vel illum dolore eu feugiat nulla facilisis at vero eros et Nam liber tempor cum soluta nobis eleifend.

Contact Jody Example: 987 654 3210 or name@emailaddressz.com; More: http://www.yourwebaddressz.com/articles/storyname.htm

SAMPLER HIGH SCHOOL NEWS 3028 Example Road, P.O. Box 1245 Your City, ST 12345-6789 987 654 3210 987 654 3210 Fax info@emailaddressz.com www.yourwebaddressz.org

PRINCIPAL Roberta Example, name@emailaddressz.com

ASSISTANT PRINCIPAL Eric Example, name@emailaddressz.com

Fran Example, name@emailaddressz.com

ACTIVITIES DIRECTOR
Dean Example, name@emailaddressz.com

PTA PRESIDENT Louis Example, name@emailaddressz.com

SCA PRESIDENT
Mike Example, name@emailaddressz.com

© 20?? Your Company. All rights reserved.

- 00 - 6

> E 8.5 W 11 H

April Calendar

DATE	DAY	TIME	EVENT	PLACE	CONTACT
12	Tuesday	8:15 AM	Marching Band Practice	Football field	Sam Example
12	Tuesday	9:00 AM	Pep raily	Field house	Marsha Example
)2	Tuesday	7:00 PM	Boys Volleyball (Home)	Gym	Harry Example
00	Day	0:00 PM	Description lorem ipsum dolor	Place	Name Example
00	Day	0:00 PM	Description lorem ipsum dolor	Place	Name Example
00	Day	0:00 PM	Description lorem ipsum dolor	Place	Name Example
00	Day	0:00 PM	Description forem ipsum dolor	Place	Name Example
		200000000000000000000000000000000000000			
00	Day	0:00 PM	Description Duis autem vel eum iriure	Place Place	Name Example
00	Day	0:00 PM 0:00 PM	Description lorem ipsum dolor Description lorem ipsum dolor	Place	Name Example Name Example
-	Day				
00	Day	0:00 PM	Description lorem ipsum dolor	Place	Name Example
00	Day	0:00 PM	Description Duis autem vel eum iriure	Place	Name Example
00	Day	0:00 PM	Description lorem ipsum dolor	Place	Name Example
10	Day	0:00 PM	Description lorem ipsum dolor	Place	Name Example
00	Day	0:00 PM	Description lorem ipsum dolor	Place	Name Example
00	Day	0:00 PM	Description forem ipsum dolor	Place	Name Example
00	Day	0:00 PM	Description Duis autem vel eum iriure	Place	Name Example
00	Day	0:00 PM	Description lorem ipsum dolor	Place	Name Example
00	Day	0:00 PM	Description lorem ipsum dolor	Place	Name Example
00	Day	0:00 PM	Description lorem ipsum dolor	Place	Name Example
00	Day	0:00 PM	Description forem ipsum dolor	Place	Name Example
00		0:00 PM		Place	Name Example
	Day		Description lorem ipsum dolor	Place	Name Example
00	Day Day	0:00 PM 0:00 PM	Description Duis autem vel eum iriure Description lorem ipsum dolor	Place	Name Example
00	Day	0:00 PM	Description forem ipsum dolor	Place	Name Example
00	Day	0:00 PM	Description Duis autem vel eum iriure	Place	Name Example
00	Day	0:00 PM	Description larem ipsum dolor	Place	Name Example
		5.55.000000			
00	Day	0:00 PM 0:00 PM	Description lorem ipsum dolor Description Duis autem vel eum iriure	Place Place	Name Example Name Example
,,,	Day	0:00 PM	Description Duis autem ver eum inure		
00	Day	0:00 PM	Description lorem ipsum dolor	Place	Name Example
00	Day	0:00 PM	Description lorem ipsum dolor	Place	Name Example
00	Day	0:00 PM	Description Duis autem vel eum iriure	Place	Name Example
00	Day	0:00 PM	Description Duis autem vel eum iriure	Place	Name Example
00	Day	0:00 PM	Description lorem ipsum dolor	Place	Name Example
00	Day	0:00 PM	Description lorem ipsum dolor	Place	Name Example
00	Day	0:00 PM	Description Duis autem vel eum iriure	Place	Name Example
00	Day	0:00 PM	Description lorem ipsum dolor	Place	Name Example
00	Day	0:00 PM	Description lorem ipsum dolor	Place	Name Example
00	Day	0:00 PM	Description lorem ipsum dolor	Place	Name Example
00	Day	0:00 PM	Description lorem ipsum dolor	Place	Name Example
00	Day	0:00 PM	Description Duis autem vel eum iriure	Place	Name Example
00	Day	0:00 PM	Description lorem ipsum dolor	Place	Name Example
00	Day	0:00 PM	Description lorem ipsum dolor	Place	Name Example
00	Day	0:00 PM	Description lorem ipsum dolor	Place	Name Example
00	Day	0:00 PM	Description forem ipsum dolor	Place	Name Example
00	Day	0:00 PM	Description Duis autem vel eum iriure	Place	Name Example
00	Day	0:00 PM	Description lorem ipsum dolor	Place	Name Example
00	Day	0:00 PM	Description lorem ipsum dolor	Place	Name Example
00	Day	0:00 PM	Description forem ipsum dolor	Place	Name Example
00	Day	0:00 PM	Description lorem ipsum dolor Description lorem ipsum dolor	Place	Name Example
00	Day	0:00 PM	Description Duis autem vel eum iriure	Place	Name Example
00	Day	0:00 PM	Description lorem ipsum dolor	Place	Name Example
00	Day	0:00 PM	Description forem ipsum dolor	Place	Name Example
00	Day	0:00 PM	Description Duis autem vel eum iriure	Place	Name Example
1	Day	0:00 PM	Description Duis autem vel eum iriure	Place	Name Example
00					

APRIL 20??: News, events, and resources for

Survey reveals where and how Sampler High students spend free time

REPORTED BY JODY EXAMPLE

Lorem ipsum dolor sit amet, consectetuer adipiscing elit, sed diam nonummy nibh euismod tincidunt ut lorered dolore magna aliquam erat volutpat. Ut wisi enim ad minim veniam, quis nostrud exerci tation ullam corper suscipit lobortis nisl ut aliquip ex ea commodo consequat. Duis autem vel cum iriure dolor in hendrerit in vulputate velti esse molestie consequat, vel illum dolore eu feugiat nulla facilisis at vero eros et accumsan et iusto adio dignissism qui blandit pracesent luptatum zzril delenit augue duis dolore te feugait nulla facilisi.

Lorem ipsum dolor sit amet, consectetuer adopticing elit, sed diam nonummy nibh euismod tincidunt ut laoreet dolore magna aliquam erat volutpat. Ut wisi enim ad minim veniam, quis nostrud exerci taiton ullamcorper suscipit lobortis nisl ut aliquip ex ea commodo consequat. Duis autem vel eum iriure dolor in hendreit in vulputate velit esse molestie consequat, vel illum dolore eu feugiat nulla facilisis at vero eros et Nam liber tempor cum soluta nobis eleifend option congue nihil imperdiet doming id quod mazim placerat facer possim assum.

Lorem ijssum dolor sit amet, consectetuer adipsicing elit, sed diam nonummy nibh cuismod tincidunt til aoreet dolore magna aliquam erat volutpat. Ut wisi enim ad minim veniam, quis nostrud exerci tation ullamcorper suscipit lobortis nisl ut aliquije ex ea commodo consequat. Duis autem vel eum iriure dolor in henderei in vulputate velit esse molestie consequat, vel illum dolore eu feugiat nulla facilisis at vere ors et Nam liber tempor cum soluta nobis eleifend option congue nihil imperdiet doming id quod mazim placerat facer possim assum.

Contact Jody Example: 987 654 3210 or name@emailaddressz.com; More: http://www.yourwebaddressz.com/articles/storyname.htm

Cover (page 1)

1"SAMPLER" Franklin Gothic Book Condensed, 20/
17pt, align left; "NEWS" Impact, 82pt, align left;
"YELLOW" Franklin Gothic Book Condensed, 7/6pt,
align left; Date/defining phrase Franklin Gothic Book
Condensed, 8/8pt, align left; 2 Headline Franklin
Gothic Book Condensed, 20/20pt, align left;
Contributor Franklin Gothic Book Condensed, 8pt,
align left; Text Minon Condensed, 10/11.5pt, align
left; 3 Title Impact, 82pt, align left; Title tag Franklin
Gothic Book Condensed, 14pt, align left; Text Minon
Condensed, 10/11.5pt, align left; 4 Contact link
Franklin Gothic Book Condensed, 8pt, align left;
5 Masthead Franklin Gothic Book Condensed,
9/10pt, align left; Copyright Franklin Gothic Book
Condensed, 7pt, align left; 6 Line .5pt

Back cover (page 4)

1"SAMPLER" Franklin Gothic Book Condensed, 20/17pt, align left; "NEWS" Impact, 82pt, align left; "YELLOW" Franklin Gothic Book Condensed, 7/6pt, align left; Date/defining phrase Franklin Gothic Book Condensed, 8/8pt, align left; 2 Headline Franklin Gothic Book Condensed, 20/20pt, align left; Contributor Franklin Gothic Book Condensed, 8pt, align left; Text Minon Condensed, 10/11.5pt, align left; 3 Title Impact, 32pt, align left; Title tag Franklin Gothic Book Condensed, 14pt, align left; Text Minon Condensed, 10/11.5pt, align left; 4 Contact link Franklin Gothic Book Condensed, 8pt, align left; 5 Masthead Franklin Gothic Book Condensed, 9/10pt, align left; Copyright Franklin Gothic Book Condensed, 7pt, align left; 6 Line .5pt; 7 Headline Franklin Gothic Book Condensed, 20pt, align left; Text calendar Franklin Gothic Book Condensed, 7/9pt, align left; 8 "SAMPLER" Franklin Gothic Book Condensed, 13/11pt, align left; "NEWS" Impact, 47pt, align left; "YELLOW" Franklin Gothic Book Condensed, 4/4pt, align left; Date/defining phrase Franklin Gothic Book Condensed, 8/8pt, align left

Color

Printed in black.

SOURCE Illustrations: Yellow jacket (pg. 1) from ArtWorks Mascots from Dynamic Graphics, 800-255-8800, 309-688-8800, www.dgusa.com, © Dynamic Graphics, all rights reserved.

SOURCE Type Families: Franklin Gothic, Impact, Minion, Adobe Systems, Inc. 800-682-3623, www.adobe.com/type.

PART 2: DESIGN RECIPES

Pages 2 & 3

9 Title Impact, 30pt, align left; Headline Franklin Gothic Book Condensed, 20/20pt, align left; Contributor Franklin Gothic Book Condensed, 8pt, align left; Text Minon Condensed, 10/11.5pt, align left; 10 Line .5pt; 11 Caption Franklin Gothic Book Condensed, 7/8pt, align left; 12 Contact link Franklin Gothic Book Condensed, 8pt, align left

Color

Printed in black and white.

SOURCE Illustrations: Marching band (pg. 3) from Image Club ArtRoom Musicville from Eyewire, 800-661-9410, 403-262-8008, www.eyewire.com. © Eyewire, Inc., all rights reserved; Students/hallway, Dictionary, Student/ diploma (pg. 3) from Photo-Objects 50,000, Vol II from Hemera Technologies 819-772-8200, www.hemera.com, © Hemera Technologies Inc., all rights reserved; Runners (pg. 3) ClickArt 200,000 from Broderbund, available from software retailers worldwide, © T/Maker, all rights reserved.

Adobe Systems, Inc. 800-682-3623, www.adobe.com/ type.

Music

Marching Band headed for statewide competition in Charlottesville

Lorem ipsum dolor sit amet, consectetuer adipiscing elit, sed diam nonummy nibh euismod tincidunt ut laoreet dolore magna aliquam erat volutpat. Ut wisi enim ad minim veniam, quis

nostrud exerci tation ullam corper suscipit lobortis nisl ut aliquip ex ea commodo consequat. Duis autem vel eum iriure dolor in hendrerit in vulputate velit esse molestie consequat, vel illum dolore eu feugiat nulla facilisis at vero eros et accumsan et iusto odio dignissim qui blandit praesent luptatum zzril delenit augue duis dolore

te feugait nulla facilisi. Lorem ipsum dolor sit amet, consectetuer adipiscing elit, sed diam nonummy nibh euismod tincidunt ut laoree dolore magna aliquam erat volutpat. Ut wisi enim ad minim veniam, quis nostrud exerci tation ullamcorper suscipit lobortis nisl ut aliquip ex ea commodo consequat. Duis autem vel eum iriure dolor in hendrerit

in vulputate velit esse molestie consequat, vel illum dolore eu feugiat nulla facilisis at vero eros et. Nam liber tempor cum soluta nobis eleifend option

Clubs

Club leaders tackle rebuilding bylaws from the ground up Lorem ipsum dolor sit amet, consectetue adipiscing elit, sed diam nonummy nibh euismod tincidunt ut laoreet dolore magna aliquam erat volutpat. Ut wisi enim ad minim veniam, quis

nostrud exerci tation ullam corper suscipit lobortis nisl ut aliquip ex ea commodo consequat. Duis autem vel eum iriure dolor in hendrerit in vulputate velit esse molestie consequat, vel illum dolore eu feugiat nulla facilisis at vero eros et accumsan et iusto odio dignissim qui blandit praesent luptatum zzril delenit augue duis dolore

te feugait nulla facilisi. Lorem ipsum dolor sit amet, consectetuer adipiscing elit, sed diam nonummy nibh euismod tincidunt ut laoreet dolore magna aliquam erat volutpat. Ut wisi enim ad minim veniam, quis nostrud exerci tation ullamcorper suscipit lobortis nisl ut aliquip ex ea commodo consequat. Duis autem vel eum iriure dolor in hendrerit

in vulputate velt ein miner door in menderite in vulputate velt esse molestie consequat, vel illum dolore eu feugiat nulla facilisis at vero eros et. Nam liber tempor cum soluta nobis eleifend option

Academics

New courses: Public speaking, real-world marketing, and computer programming

Lorem ipsum dolor sit amet, consectetuer adipiscing elit, sed diam nonummy nibh euismod tincidunt ut laoreet dolore magna aliquam erat volutpat. Ut wisi enim ad minim veniam, quis nostrud exerci tation ullam corper suscipit

lobortis nisl ut aliquip ex ea commodo consequal Duis autem vel eum iriure dolor in hendrerit in vulputate velit esse molestie consequat, vel illum dolore eu feugiat nulla facilisis at vero eros et accumsan et iusto odio dignissim qui blandit praesent luptatum zzril delenit augue duis dolore

te feugait nulla facilisi. Lorem ipsum dolor sit amet, consectetuer adipiscing elit, sed diam nonummy nibh euismod tincidunt ut laoreet dolore magna aliquam erat volutpat. Ut wisi enim ad minim veniam, quis nostrud exerci tation ullamcorper suscipit lobortis nisl ut aliquip ex ea commodo consequat.

Duis autem vel eum iriure dolor in hendrerit in vulputate velit esse molestie consequat, vel illum dolore eu feugiat nulla facilisis at vero eros et. Nam liber tempor cum soluta nobis eleifend option

Sports

Cross country training takes on a special meaning for Coach Example

Lorem ipsum dolor sit amet, consectetuer adipiscing elit, sed diam nonummy nibh euismod tincidunt ut laoreet dolore magna aliquam erat volutpat. Ut wisi enim ad minim veniam, quis nostrud exerci tation ullam corper suscipit lobortis nisl ut aliquip ex ea commodo consequat Duis autem vel eum iriure dolor in hendrerit

in vulputate velit esse molestie consequat, vel illum dolore eu feugiat nulla facilisis at vero eros et accumsan et iusto odio dignissim qui blandit praesent luptatum zzril delenit augue duis dolore

te feugait nulla facilisi. Lorem ipsum dolor sit amet, consectetuer adipiscing elit, sed diam nonummy nibh euismod tincidunt ut laoreet dolore magna aliquam erat volutpat. Ut wisi enim ad minim veniam, quis nostrud exerci tation ullamcorper suscipit lobortis nisl ut aliquip ex ea

Duis autem vel eum iriure dolor in hendrerit in vulputate velit esse molestie consequat, vel illum dolore eu feugiat nulla facilisis at vero eros et. Nam liber tempor cum soluta nobis eleifend option

Honors

National Honor Society ratchets up membership qualifications

Lorem ipsum dolor sit amet, consectetuer adipiscing elit, sed diam nonummy nibh euismod tincidunt ut laoreet dolore magna aliquam erat volutpat. Ut wisi enim ad minim veniam, quis nostrud exerci tation ullam corper suscipit lobortis nisl ut aliquip ex ea commodo consequat Duis autem vel eum iriure dolor in hendrerit

in vulputate velit esse molestie consequat, vel illum dolore eu feugiat nulla facilisis at vero eros et accumsan et iusto odio dignissim qui blandit praesent luptatum zzril delenit augue duis dolore

արդիսավումիրավումիումիանիականիակարկումիականիականիականիականի

te feugait nulla facilisi. Lorem ipsum dolor sit amet, consectetuer adipiscing elit, sed diam nonummy nibh euismod tincidunt ut laoreet dolore magna aliquam erat volutpat. Ut wisi enim ad minim veniam, quis nostrud exerci tation ullamcorper suscipit lobortis nisl ut aliquip ex ea commodo consequat.

Duis autem vel eum iriure dolor in hendrerit in vulputate velit esse molestie consequat, vel illum dolore eu feugiat nulla facilisis at vero eros et. Nam liber tempor cum soluta nobis eleifend option

SOURCE Type Families: Franklin Gothic, Impact, Minion,

congue nihil imperdiet doming id quod mazim

placerat facer possim assum.

Lorem ipsum dolor sit amet, consectetuer adipiscing elit, sed diam nonummy nibh euismod aupscing ent, sed daam nonummy none cuismod tincidunt ut laorect dolore magna aliquam erat volutpat. Ut wis ienim ad minim veniam, quis nostrud exerci tation ullamcorper suscipit loborits nistl ut aliquip ex ea commodo consequat praesent luptatum zzril delenit augue duis dolore te feugait nulla facilist. Lorem ipsum dolor sit amet, consectetuer adipiscing elit, sed diam nonummy nibh euismod tincidunt ut lao dolore magna aliquam erat volutpat. Suscipit lobortis nisl ut aliquip ex ea commodo

congue nihil imperdiet doming id quod mazim placerat facer possim assum. Lorem ipsum dolor sit amet, consectetuer

adipiscing elit, sed diam nonummy nibh euismod tincidunt ut laoreet dolore magna aliquam erat volutpat. Ut wisi enim ad minim veniam, quis nostrud exerci tation ullamcorper suscipit lobortis nisl ut aliquip ex ea commodo consequat praesent luptatum zzril delenit augue duis dolore te feugait nulla facilisi. Lorem ipsum dolor sit amet, consectetuer adipiscing elit, sed diam nonummy nibh euismod tincidunt ut lac dolore magna aliquam erat volutpat. Ut wisi enim.

congue nihil imperdiet doming id quod mazim placerat facer possim assum. Lorem ipsum dolor sit amet, consectetuer adipiscing elit, sed diam nonummy nibh euismod tincidunt ut laoreet dolore magna aliquam erat volutpat. Ut wisi enim ad minim veniam, quis nostrud exerci tation ullamcorper suscipit lobortis nisl ut aliquip ex ea commodo consequat praesent luptatum zzril delenit augue duis dolore te feugait nulla facilisi. Lorem ipsum dolor sit amet, consectetuer adipiscing elit, sed diam nonummy

nibh euismod tincidunt ut lao dolore magna aliquam erat volutpat. Ut wisi enim ad min im veniam, quis nostrud suscipit lobortis nisl ut aliquip ex ea commodo consequat.

Contact Murray Example: 987 654 3210 or name@emailaddressz.com; More: http://www.yourwebaddressz.com/articles/storyname.htm

ongue nihil imperdiet doming id quod mazim

congue nini imperiore doming id quod mazim placerat facer possim assum. Lorem ipsum dolor sit amet, consectetuer adipiscing elit, sed diam nonummy nibh euismod incidunt ut laroret dolore magna aliquam erat volutpat. Ut wisi enim ad minim veniam, quis voutpat. O was enim ao minim venam, quis nostrud exerci tation ullamorper suscipit lobortis nisl ut aliquip ex ea commodo consequat praesent luptatum zzril delenit augue duis dolore te feugait nulla facilisi. Lorem ipsum dolor sit amet, consectetuer adipiscing elit, sed diam nonummy

nibh euismod tincidunt ut lao dolore magna aliquam erat volutpat. Ut wisi enim ad min im veniam, quis nostrud exerci ea commodo consequat. Duis autem vel eum iriure dolor in hendrerit in vulputate velit esse molestie consequat. Contact Brandon Example: 987 654 3210 or name@emailaddressz.com/ More: http://www.yourwebaddressz.com/ articles/storyname.htm

congue nihil imperdiet doming id quod mazim placerat facer possim assum.

Lorem ipsum dolor sit amet, consectetuer adipiscing elit, sed diam nonummy nibh euismod tincidunt ut laoreet dolore magna aliquam erat volutpat. Ut wisi enim ad minim veniam, quis voutpat. Ut wis entra ad minim ventam, quis nostrud exerci tation ullamcorper suscipit lobortis nisl ut aliquip ex ea commodo consequat praesent luptatum zzril delenit augue duis dolore te feugait nulla facilisi. Lorem ipsum dolor sit amet, consectetuer adipiscing elit, sed diam nonummy

nibh euismod tincidunt ut lao dolore magna aliquam erat volutpat. Ut wisi enim ad min im veniam, quis nostrud exerci tation ullamcorper suscipit lobortis nisl ut aliquip

 $\lim_{\substack{b \in \mathbb{N} \\ \text{stw}}} \frac{1}{4} \lim_{\substack{b \in \mathbb{N} \\ \text{the state of the state of the$

157

Glossary

Bit-mapped graphics See Paint graphics.

Bleed The layout image area that extends beyond the trim edge.

CMYK See Four-color process.

Coated stock Paper coated with a thin layer of clay-like substrate that creates a smooth, flat surface ideal for printing colored inks and superfine detail such as photographs. *See also* Uncoated stock.

Cropping The act of eliminating certain parts of an illustration.

Defining phrase A five- to fifteen-word phrase that details the describes the scope of the newsletter. May include elements such as the intended audience, the general subject, reader benefits, and the name of the publisher.

Design The process of arranging elements and information on a page in a way that improves its communication.

Design grid The invisible framework on which a page is designed.

Draw graphics Graphics created using objects such as lines, ovals, rectangles, and curves in a program such as Adobe Illustrator, CorelDRAW, or Macromedia FreeHand. Common draw file formats include: Encapsulated PostScript (EPS) and Windows Metafiles (WMF). Also referred to as "vector" or "object-oriented" graphics. *See also* Paint graphics.

Expert newsletter Provides information, statistics, advice, and instruction for the price of a subscription

Eyebrow Introductory/identifying text above a headline.

Font There is disagreement over the current definition of this term. For the purposes of this book, a font is a typeface in digital form. *See also* Typeface and Type family.

Four-color process A printing process that primarily uses cyan, magenta, yellow, and black (referred to as CMYK) to reproduce color photographs and other materials that contain a range of colors that cannot economically be reproduced using individual solid ink colors. *See also* Solid color.

Ghosting A doubled or blurred image on the printed sheet, typically caused by a misapplication of ink on the rollers.

Hickey A spot or other imperfection on the printed sheet caused by dirt or paper particles that adhere to the plate or rollers during printing.

Icon An image that suggests its meaning—for example, an open padlock represents the state of being unlocked.

Kerning The space between typeface characters.

Leading The amount of vertical space between the baselines of a typeface. Expressed as 12/18pt, which means the size of the specified type is 12pt and the spacing between lines is 18pt.

Logo The combination of a name, a symbol, and a short tag line. At a glance, identifies the nature of your product or service, transmits the benefit of using it, and defines your attitude about it.

Lorem ipsum Scrambled Latin text used by designers to demonstrate the approximate number of words it will take to fill an area of the layout before the actual text is specified.

Masthead The block of information that defines the publication, posts legal information, identifies the publisher and the key contributors, and provides contact information.

Mottle Uneven, spotty areas of ink coverage on a printed sheet.

Nameplate The logo-like banner that typically appears at the top of page one of a newsletter. May include the name of the publication, the name of the publisher, the defining phrase, the issue date, volume and issue numbers.

Newsletter A condensed periodical used to communicate specialized editorial information.

Object-oriented graphics See Draw graphics.

Page flow Diagram that shows the sequence of pages and how they are printed front to back.

Paint graphics Graphics created on a grid of tiny rectangles called pixels. Each pixel can be a different color or shade of gray. Created in a program such as Adobe Photoshop or Jasc Software's Paint Shop Pro. Common paint file formats include Joint Photographic Experts Group (JPEG or JPG) and Tagged-Image File Format (TIFF or TIF). Also referred to as "raster" or "bit-mapped" graphics. See also Draw graphics.

Picture font Collection of images that are installed like a font and produced by typing on the computer keyboard.

Pinhole A speck on a printed sheet caused by a hole in the printing plate negative.

Preflight The process of gathering together and reviewing all the elements necessary for translating the designer's information to a commercial printer's computer software and printing presses.

Prepress process The series of steps taken to prepare a project for printing.

Press check The process of reviewing a job on the printing press at the beginning of the press run. Provides an opportunity for slight color adjustments of process colors.

Promotional newsletter Used to educate readers about a certain area of interest and to provide solutions, some of which come in the form of the publisher's products, services, or way of thinking.

Proof A mock page or series of pages produced prior to printing by a commercial printer to demonstrate how a finished printed job will look.

Raster graphics See Paint graphics.

Reader profile A list of attributes that identifies the characteristics of the reader the publication is designed to attract.

Registration The process by which multiple printing images are aligned.

Relationship newsletter Used to inform the reader about a group to which they belong or might consider joining. It promotes the group's shared philosophy, a calendar of events, notices of meetings, individual and group milestones, member profiles, and so on.

Royalty-free In most cases, grants the buyer unlimited (within the vendor's license agreement) use of a photograph or illustration. *See also* Stock.

Running head The text and graphics, typically located at the top or bottom of most pages, that reminds the reader where they are—the publication name, the page number, perhaps the subject of the publication or its defining phrase, and so on.

Saddle-stitch Process of stapling two or more signatures on the fold.

Sans serif A type character that does not have an end stroke or "foot."

Serif The end stroke, or "foot," of a type character.

Sign A shorthand device that stands for something else—for example, the @ sign, which stands for "at."

Signature A printed, folded sheet.

Skew A crooked image in a printed sheet caused by a misaligned plate or careless trimming.

Solid color A specific ink color produced by a specific manufacturer. Typically matched using a printed source book such as a PANTONE formula quide.

Spread Two facing pages.

Stock (1) In most cases, grants the buyer one-time use of a photograph or illustration for a specific project. *See also* Royalty-free. (2) The substrate on which printing is applied—in most cases, paper.

Stroke The line that surrounds the solid area of a shape or typeface character. In a drawing software program, strokes can be widened or eliminated, and strokes and fills can be assigned different colors.

Style (1) The visual and emotional mood of your organization. It is the combination of the message, how it is presented, the images used to illustrate it, the stance of the layout, and the choices of typefaces and color. (2) Feature of a desktop publishing program used to apply multiple paragraph attributes to a paragraph of text with a single keystroke. May include attributes such as its typeface, its size, bold, italic, all caps, underline, and whether the paragraph is indented, has extra space above or below it, is hyphenated, and if it is aligned right, left, centered, or justified.

Symbol A visible image of something that is invisible—for example, an hourglass represents the idea of time.

Tint A tone of a solid color expressed as a percentage.

Trap The hairline overlap between colors necessary to eliminate gaps between colors.

Trim The page dimension on which a final printed sheet is cut.

Type family Two or more typefaces with a common design, including weights, widths, and slopes. *See also* Typeface and Font.

Typeface One variation of a type family with a specific weight (i.e., light, regular, bold), width (i.e., condensed, narrow, extended), or slope (i.e., roman, italic). *See also* Type family and Font.

Trademark The United States Patent and Trademark Office defines a trademark as "a word, phrase, symbol, or design, or combination of words, phrases, symbols, or designs, which identifies and distinguishes the source of the goods or services of one party from those of others."

Uncoated stock Paper with no applied surface. *See also* Coated stock.

Vector graphics See Draw graphics.

Index

administration, 49	design techniques	illustration	printing, 44-47
administrator, role of, 23, 25	adding depth, 137	artwork and photographs,	proofing, 45-47
adverting, 57, 81	blocks,73	34-35	color, 38
	color tints, 81	commissioning artwork, 35	cost estimates, 42
benefits, 16	contact links, 97	placement, 38	finding a printer, 40-43
bit-mapped graphics, 27	decosntructing, 105	standardizing sizes, 89	preparation, 44-47
brainstorming, 35	details, 73	styles of, 137	process color, see four-color
budget, 23	emphasis, 113	illustrator, role of, 23	process
printing estimates, 47	focal point, 57	Joint Photographic Experts Group	promotion, 23, 25
postpress adjustments, 47	focus, 81	(JPEG) file format, 27	proofreading, 39
business/organization types	folds, 153	jolt thinking, 17	postal regulations, 14, 39, 121
audio, 118	illustration styles, 137	<i>y</i> .	PostScript, 27
automobile, 78	information graphics, 105	legal issues, 23, 25, 33	production artist, role of, 23, 24
church, 94	magazine model, 145		publisher, role of, 23
construction, 62	metaphors, 137	maps, 73	<u></u>
education, 150	newspaper, 102	mailing, 14, 48-49	raster graphics, 27
food, 134	news briefs, 153	guidelines and regulations,	reader profile, 13
governing, 126	redundancy, 145	14, 39, 121	research, 12-15, 21
financial, 102, 118	teasers, 105	lists, 13-14, 49	royalty-free photographs, 33
gardening, 54	text and illustration, 113	review, 39	royally nee photographs, 33
manufacturing, 110	text leader, 145	United States Postal Service, 14	sheet size, 19
music, 118	desktop publishing software, 27	marketing plan, 17	sheet size types, (flat sheet, wxh)
scientific, 142	distribution, 23, 25	masthead, 37	8.5 by 11 inches, 146
travel,70	drawing software, 27	measurement conversion table, 53	8.5 by 14 inches, 62
writing, 86	drawing software, 27	mission, 10–11	9 by 6 inches, 118
witting, 80	editor, role of, 23, 24	1111331011, 10–11	11 by 17 inches, 102
salandars 57 101 152		newsletter	
calendars, 57, 101, 153	editorial calendar, 31		17 by 11 inches, 54, 70, 78, 86,
charts and graphs, 105, 109, 113, 140	EPS, see PostScript	defined, 10	94, 110, 126, 134, 154
clip art, 35	CI	models, 18-19	software, 26-27
CMYK, see Four-color process	file	nameplate, 29, 37	recommendations, 52
color, 38	compatability, 41	naming, 28-29	solid color, 38
style, 129	preparation, 37		stock art, 35
tints, 81	sharing, 27	object-oriented gaphics, 27	style, 20–21
color examples	focal point, 57	Ogilvy, David, 34	styles, software, 37
one-color, 62, 102, 150	fonts, 36		system requirements, 27
two-color, 54, 78, 94, 126	format, 18-19	page layout, 21 paint software, 23	
four-color, 70, 110, 118, 134	format types	PANTONE Colors, 38	Tagged-Image File Format (TIFF), 27
four-color cover, one-color text,	booklet, 54, 70, 79, 94, 110, 126,	paper, 41	testing, 29
86, 142	134, 142	photographs	tools, software, 26–27
competition, 13, 21	jacket, 87	cropping, 129	trademark, 28
content, 19, 30-33	letter, 62	custom, 34	Trademark Electronic Service System
developer , role of, 24	newspaper, 102	royalty-free, 34	(TESS), 29
mix, 30-31	postcard, 118	planning, 16-17	text, length of, 97
formulas, 31	unusual fold, 150	form, 24-25	typefaces, 37
coupon,65	unusual shape, 142	postage	
	four-color process, 38	rates, 48-49	vector gaphics, 27
defining phrase, 29	frequency, 19	saving on, 65	voice, 21
delegating responsibility, 22		postcards, 118	
designer, role of, 23, 24	grid, 37	preflighting, 45	Web integration, 97
		preprinting, 65	writer, role of, 23
	hardware, 7, 27	press check, 45	writer's guidelines, 30
		prepress, 44-45	

printer, role of, 23, 25